Murat Gül is Professor of Architecture at Istanbul Technical University, Turkey. He has previously taught at the TOBB University of Economics and Technology in Ankara, Turkey, the International University of Sarajevo, Bosnia-Herzegovina, the University of Sydney, Australia and Mimar Sinan Fine Arts University in Istanbul, Turkey. He is the author of *The Emergence of Modern Istanbul: Transformation and Modernisation of a City* (I.B.Tauris, 2009) and co-author of *Istanbul Architecture* (2013).

'*Architecture and the Turkish City* is a fine representative example of the emerging integrated urban history that grasps the overall dynamic driving development in cities, the most complex of social creations.'

<div align="right">Harry Margalit, Associate Professor in Architecture,
The University of New South Wales</div>

'This is a volume worthy of a spectacular city. Thoughtful, intensely scholarly but also highly readable, it weaves together the broad processes of economic and political change and the specifics of urban development and design, especially in recent decades. It is a timely book that also constitutes a new benchmark for the potential of urban studies.'

<div align="right">Andrew Kirby, Editor of *Cities: The International Journal of Urban Policy and Planning* and Professor of Social and Behavioral Sciences, Arizona State University</div>

Architecture and the Turkish City

An Urban History of Istanbul since the Ottomans

MURAT GÜL

I.B. TAURIS
LONDON • NEW YORK • OXFORD • NEW DELHI • SYDNEY

I.B. TAURIS
Bloomsbury Publishing Plc
50 Bedford Square, London, WC1B 3DP, UK
1385 Broadway, New York, NY 10018, USA
29 Earlsfort Terrace, Dublin 2, Ireland

BLOOMSBURY, I.B. TAURIS and the I.B. Tauris logo
are trademarks of Bloomsbury Publishing Plc

First published 2017
This paperback edition published by I.B. Tauris in 2025

Copyright © Murat Gül 2017

Murat Gül has asserted his right under the Copyright,
Designs and Patents Act, 1988, to be identified as Author of this work.

All rights reserved. No part of this publication may be reproduced or
transmitted in any form or by any means, electronic or mechanical,
including photocopying, recording, or any information storage or retrieval
system, without prior permission in writing from the publishers.

Bloomsbury Publishing Plc does not have any control over, or responsibility for,
any third-party websites referred to or in this book. All internet addresses given
in this book were correct at the time of going to press. The author and publisher
regret any inconvenience caused if addresses have changed or sites have
ceased to exist, but can accept no responsibility for any such changes.

A catalogue record for this book is available from the British Library.

A catalog record for this book is available from the Library of Congress.

ISBN: PB: 978-0-7556-5627-1
HB: 978-1-7845-3105-8
ePDF: 978-1-7867-3230-9
eBook: 978-1-7867-2230-0

To find out more about our authors and books visit www.bloomsbury.com
and sign up for our newsletters.

Contents

	List of Illustrations	vi
	Acknowledgements	x
	Introduction	1
1	Late Ottoman Istanbul: early modernity, nationalism and the end of an empire	9
2	Republican Istanbul: secularisation of the old city	45
3	1950s Istanbul: postwar dynamics and change	87
4	Istanbul between two coups: many plans, many failures	117
5	The 1980s: Istanbul encounters neo-liberalism	153
6	The 1990s: political instability, financial crises and architecture adrift	183
7	From 2000: marching towards a global city	213
	Epilogue	259
	Notes	269
	Bibliography	303
	Index	310

List of Illustrations

1	Map of Istanbul, Ebru Şevkin	8
2	Nuruosmaniye Mosque, Aras Neftçi	12
3	Dolmabahçe Palace, entrance to the State Apartments, Aras Neftçi	16
4	Ministry of War entry gate, Murat Gül	18
5	Pertevniyal Valide Mosque, c.1900, Library of Congress	19
6	Çırağan Palace, Murat Gül	20
7	The German Fountain at Sultanahmet, c.1900s, Library of Congress	22
8	Vallaury's Imperial Museum, Aras Neftçi	24
9	The rear view of the Ottoman Bank (centre left) from the Golden Horn, Library of Congress	25
10	The Pera Palace Hotel, Murat Gül	27
11	The Botter Apartment Building in Beyoğlu, Murat Gül	28
12	A timber Art Nouveau house in Arnavutköy on the European shores of the Bosphorus, Murat Gül	29
13	Haydarpaşa Railway Terminus, Aras Neftçi	30
14	The monumental gate of the Public Debts Administration Building, Aras Neftçi	35
15	The Imperial School of Medicine at Haydarpaşa on the Asian side of Istanbul, Aras Neftçi	36
16	The Ministry of Post and Telegraph building (present-day General Post Office) at Sirkeci, Aras Neftçi	39
17	The commanding view of the Land and Titles Office facing the Sultanahmet Mosque, Murat Gül	40
18	The Fourth Vakıf Han, Aras Neftçi	41
19	The Republic Monument at Taksim Square, c.1940s, MSGSÜ, Restoration Department Archives, Istanbul	49
20	The İzmir Palace Apartment Building in Maçka, Aras Neftçi	52
21	Harikzedegan Apartments in Laleli, Murat Gül	53
22	The major aspects of Prost's plan for Istanbul, Atatürk Library, Istanbul Metropolitan Municipality	56
23	The Atatürk Boulevard, c.1940s, Reproduced from *Cumhuriyet Devrinde İstanbul* (Istanbul: İstanbul Belediyesi, Neşriyat ve İstatistik Müdürlüğü, 1949)	57

List of Illustrations

24	Eminönü and Galata Bridge after demolitions, *c.*1940s, Yapı Kredi History Archives, Selahattin Giz Collection, Istanbul	58
25	İnönü Promenade, Reproduced from *Güzelleşen İstanbul* (Istanbul: İstanbul Belediyesi, 1943)	59
26	The Ceylan Apartment Building in Talimhane, Rahmi M. Koç Archive & SALT Research, Sedad Hakkı Eldem Archive	62
27	The Üçler Apartment Building in Gümüşsuyu, Aras Neftçi	63
28	An Art Deco apartment building in Maçka, Aras Neftçi	65
29	An Art Deco residential building in Ordu Street, Historic Peninsula, Murat Gül	66
30	Atatürk's Sea Pavilion in Florya, Aras Neftçi	67
31	Tüten Apartment Building in Gümüşsuyu, Murat Gül	69
32	Kadıköy People's House, Güney Family Archives	73
33	Ayaşlı Yalısı in Beylerbeyi, on the Asian shore of the Bosphorus, Rahmi M. Koç Archive & SALT Research, Sedad Hakkı Eldem Archive	78
34	Taşlık Coffee House, MSGSÜ Photo Studio, courtesy of Nezih Aysel	79
35	Istanbul University Faculty of Letters, Murat Gül	80
36	Open-air theatre completed in 1947, Reproduced from *Cumhuriyet Devrinde İstanbul* (Istanbul: İstanbul Belediyesi Neşriyat ve İstatistik Müdürlüğü, 1949)	83
37	The Sports and Exhibition Palace opened its doors in 1949, Reproduced from *Cumhuriyet Devrinde İstanbul* (Istanbul: İstanbul Belediyesi Neşriyat ve İstatistik Müdürlüğü, 1949)	84
38	Justice Palace in Sultanahmet, Aras Neftçi	85
39	Vatan, Millet, Ordu streets and Atatürk Boulevard intersect in Aksaray, *c.*1960s, Yapı Kredi History Archives, Selahattin Giz Collection, Istanbul	93
40	Istanbul Hilton Hotel, *c.*1957, Rahmi M. Koç Archive & SALT Research, Sedad Hakkı Eldem Archive	97
41	Hilton's porte-cochère designed by Eldem, Rahmi M. Koç Archive & SALT Research, Sedad Hakkı Eldem Archive	99
42	Çınar Hotel in Yeşilköy, courtesy of Hilal Çınar	102
43	Tarabya Hotel, Aras Neftçi	102
44	Istanbul Municipal Palace, Aras Neftçi	103
45	Levent housing complex, Reproduced from *Arkitekt* 3 (1956), p.178	106
46	Hukukçular Sitesi, Aras Neftçi	107
47	İETT housing complex (1958–62) in Okmeydanı, designed by Leyla Turgut and Berkok İlkünsal, Salt Research, Architecture and Design Archive. Photo: Gültekin Çizgen	108

List of Illustrations

48	Ataköy housing complex, Salt Research, Architecture and Design Archive. Photo: Gültekin Çizgen	109
49	Atatürk Cultural Centre (AKM), front facade, c.1960s, SALT Research, Tabanlıoğlu Archive	111
50	Emerging *gecekondu* dwellings in remote districts of Asian Istanbul, Aras Neftçi	122
51	Social Security Complex in Zeyrek, Rahmi M. Koç Archive & SALT Research, Sedad Hakkı Eldem Archive	128
52	An internal courtyard, İMÇ blocks, Murat Gül	129
53	Former Sheraton Hotel, Aras Neftçi	132
54	Harbiye Orduevi, Aras Neftçi	133
55	Odakule building in Beyoğlu, Aras Neftçi	134
56	Seventeenth District Headquarters of the Directorate of Highways in Zincirlikuyu, courtesy of Mehmet Konuralp	136
57	The Bosphorus Bridge, Murat Gül	138
58	Tercüman Newspaper Headquarters, Aras Neftçi	140
59	İstanbul Reklam Ajansı, Murat Gül	141
60	Atatürk Library, Aras Neftçi	142
61	Multi-storey tenements emerged in former *gecekondu* districts, Anatolian side of Istanbul, Aras Neftçi	147
62	The cultural landscape of Istanbul dominated by apartments, a view from Üsküdar, Aras Neftçi	148
63	*Gecekondu* areas on the European side of Istanbul stretch upwards, Aras Neftçi	157
64	New parks constructed by the Dalan administration along the shores of the Golden Horn, Aras Neftçi	161
65	Fatih Sultan Mehmet Bridge, Aras Neftçi	166
66	The winning design scheme for Taksim Square by Vedat and Hakan Dalokay, Murat Gül personal archives	169
67	Galleria Shopping Centre in Ataköy, SALT Research, M. Ekrem Çalıkoğlu Archive. Photo: M. Ekrem Çalıkoğlu	173
68	Swisshotel Bosphorus located above Dolmabahçe Palace, Murat Gül	175
69	Alarko Holding Headquarters in Maslak, Rahmi M. Koç Archive & SALT Research, Sedad Hakkı Eldem Archive	177
70	Milli Reasürans building in Maçka, Aras Neftçi	181
71	The Park Hotel construction, following partial demolition (the line indicates the proposed building envelope), Aras Neftçi, Ebru Şevkin (drawing)	186
72	Capitol Shopping Centre, Aras Neftçi	188

List of Illustrations

73	The Sabancı Centre, Murat Gül	191
74	İşbank Towers, Aras Neftçi	192
75	Süzer Plaza or Gökkafes overlooking the mid-nineteenth-century Bezmi Alem Valide Sultan Mosque in Dolmabahçe, Murat Gül	198
76	Sabah Newspaper Building, courtesy of Mehmet Konuralp	201
77	Bank Ekspres building in Maslak, Murat Gül	203
78	Former Shell Headquarters in Nakkaştepe, Murat Gül	205
79	Beybi Giz Plaza in Maslak designed by Can Elgiz, Murat Gül	206
80	HSBC Headquarters in Levent designed by Haluk Tümay, Aras Neftçi	207
81	Süleyman Demirel Cultural Centre at Istanbul Technical University's Ayazağa campus, Aras Neftçi	208
82	The rail bridge spanning the Golden Horn, Aras Neftçi	217
83	Yavuz Sultan Selim Bridge, Murat Gül	225
84	TOKİ mass housing in Kayaşehir in European side of Istanbul, courtesy of TOKİ	231
85	Varyap Meridian in Ataşehir West, Murat Gül	233
86	Apartment blocks in the Ataşehir housing complex constructed in the 1990s, Murat Gül	234
87	Gated residential compounds in Ataşehir West, Murat Gül	235
88	Copybook residential buildings constructed in Sulukule, Aras Neftçi	237
89	Trump Towers in Mecidiyeköy, Aras Neftçi	241
90	Astoria Towers in Gayrettepe, Aras Neftçi	242
91	Metrocity in Levent, Aras Neftçi	243
92	Kanyon Shopping Centre in Levent, Murat Gül	244
93	Istanbul Sapphire in the Fourth Levent, Murat Gül	245
94	Sharp contrast: the high-rise developments including the Crystal Tower by Pei Cobb Freed & Partners (bottom left) and the vast neighbourhood blanketed with tenements in Gültepe (right), Murat Gül	246
95	Istanbul's new skyline as viewed from the Historic Peninsula, Murat Gül	248
96	The Topkapı Palace and high-rise buildings in Asian Istanbul, Ebru Şevkin	248
97	Zorlu Centre in Zincirlikuyu, Aras Neftçi	250
98	16-9 blocks, Sultanahmet Mosque (left) and Hagia Sophia (right) from Üsküdar, Aras Neftçi	252
99	An aerial view of Taksim Square and Gezi Park in the mid-1990s, Aras Neftçi	253
100	The new mosque constructed on Çamlıca Hill, Aras Neftçi	260

Acknowledgements

Like the countless number of authors who have focused on this great city, it was Istanbul's incredibly rich history and astonishing dynamism that inspired me to write this book about its architecture and urban history since the late Ottomans. As an architectural and urban historian who has grown up, been educated and worked in Istanbul – as well as living in various other countries and cities – I had contrasting feelings at the beginning. On the one hand the task was very charming, as the architectural heritage of Istanbul represents a range of fashions and construction technologies (which also shape its urban landscape), providing me with a great deal of material. On the other hand, the complex array of political, social and economic forces, which formed a mostly invisible background, made my assignment quite challenging. After three years of work, sometimes intensively fertile but other times interrupted by unexpected obstacles, the book is finally finished, and I am very glad that the mission is complete!

As with every book, many individuals, organisations and institutions gave me assistance, advice, useful information and a myriad of different forms of help. Firstly, I would like to thank Dr Aras Neftçi for his generous assistance in sharing his incredible photographic archive with me. I would also like to extend my gratitude to Dr Mevlude Kaptı, Dr Jale Beşkonaklı, Dr Nezih Aysel and Ebru Şevkin for their generous help in accessing some valuable material used in this book. I gratefully remember my fruitful conversations on Istanbul architecture with my very esteemed friend Trevor Howells, who unexpectedly passed away last year. I am indebted to my previous and current editors at I.B.Tauris, Maria Marsh, Baillie Card, Sophie Rudland and Lisa Goodrum, who have overseen every stage of this book. My special thanks go to Lianne Hall, my copy-editor, who has spent colossal time and effort helping me turn my manuscript into a book. And, finally, I owe a deep gratitude to Figen and Ömer, my dearest family, for their enduring support, cheery encouragement and unending patience.

Introduction

Writing about the history of a city is rather a complex and challenging task. It is especially so if the topic is concerned with one of the oldest and most significant cities on the globe. Istanbul presents such a challenge. Indeed, few cities have been as prized as Istanbul. The Greeks, Romans, Venetians, Arabs, Crusaders and the Turks all strived to control this strategically located site, straddling two continents. Armies fought over the city, empires made it their capital. First the Eastern Roman, then the Byzantine and Ottoman empires designated this great city as their heartland. As waves of power, religion and culture buffeted the city, its name changed from Byzantium, to Constantinople and, finally, to Istanbul. The empires have now faded but Istanbul remains. This catalogue of change has forged a unique identity for the city, and today Istanbul is the cultural and economic force of modern Turkey.

While cities are set within an environmental context which often includes remnant forms of natural features, such as rivers, bays or mountains, they are indeed great man-made environments composed of a large number of smaller scale artefacts, such as buildings, bridges, roads, ports and many other kinds of infrastructural facilities. However, this physical manifestation is not sufficient to describe a city. More important than this urban morphology is the complex array of social, cultural, economic and political relationships encapsulated in this giant setting. Therefore, writing a comprehensive history of a city is beyond the capacity of any single specialist and requires a collaborative study by experts from many fields, ranging from social scientists to architects, political analysts and scholars focusing on growing environmental problems. That is why urban history is a relatively recent and rapidly expanding field of historical study.

Architecture and the Turkish City

In the nineteenth century urban history had begun to be written about as part of architectural history by historians whose primary focus was the physical manifestations of the 'beautiful' buildings, parks or piazzas created by men living in ancient times. The opening remarks of A. D. Hamlin's legendary book, *The Text Book of the History of Architecture*, illustrates this outlook vividly: 'A history of architecture is a record of man's efforts to build beautifully'.[1] This approach retained its popularity until the 1960s when a group of historians led by H. J. Dyos in the Gilbert Murray Hall at the University of Leicester marked in 1966 the opening of a new era in the discipline of urban history.[2] For these ambitious scholars from various disciplines, the history of a city was no longer caged within the 'narrow perspective' of architectural historians, but had become an interdisciplinary area of research. Termed by Spiro Kostof as 'new urban history',[3] this approach drew into its ambit for the first time several aspects of social life, such as criminality, urban housing, economics, politics, gender, neighbourhood issues and cross-cultural relationships.

Hence scholars began to use and analyse data derived from archival sources, such as censuses, tax records and legislation, to write their revised urban histories. The social historian Eric J. Hobsbawm defined this new urban history as a specific branch of general social history. He described the city as a 'geographically limited and coherent unit', viewing it as a large laboratory in which social historians could execute analytical research on social, technical and political aspects of societies. According to Hobsbawm, cities display social transformations more visibly than any other organism and, therefore, the crucial issue for social historians is urban history rather than the physical urban form of the city.[4]

This new approach correspondingly influenced architectural historians, especially after the 1980s, who first tried to understand, then later incorporated information made readily available by scholars from 'sister disciplines'. Yet the main focus, as manifested in John Summerson's remarks in the 1960s, was still the 'tangible substance, the stuff of the city' and 'the physical mass of marble, bricks and mortar, steel and concrete, tarmac and rubble, metal conduits and rails'. Thus the urban historian should use the social, economic and political aspects of history to understand the 'artefact'.[5]

Consequently, today's literature on the urban history of all major cities of the world encompasses rich, substantial and wide-ranging sources, varying from architectural history books to essays on empirical studies of citizens' behaviours, research papers on the economic history of urbanites and analyses of the use of smart technologies in cities. Focusing on very specific subtopics, these fascinating

micro-histories fill significant gaps in the field by providing much-needed detailed information, which is usually missing in books that offer a comprehensive history of cities.

From this perspective, describing the relationship between cities and politics plays an important role in writing the histories of cities. As noted by Wim Blockmans, throughout history cities have always been 'theatres' where political regimes show their ideology and social practices.[6] Kostof illustrates this very vital bond between politics and urban forms by describing urban spaces as platforms used to 'stage spectacles in which the citizenry participated as players and audience' and by arguing that 'the dramatization of urban form was a function of autocracy' from the political point of view.[7] Architecture and urban planning, by their very nature, are powerful tools that have been used by various political regimes to stamp their ideologies upon cities. This is especially the case for Istanbul. The city's architecture and urban form are two important arenas where both promising advances and significant shortcomings in politics, the economy and social life intersect. It is here that the dynamics of political and social change in Turkey can be most vividly traced and understood. That is why, in this book about Istanbul since the late Ottoman era, I have specifically looked at the relationship between politics and social change on one hand, and architecture and the built form on the other. More precisely, this book investigates explicitly how the social, political and economic events that occurred in Turkey during this period shaped the architecture and built environment of the country's biggest city.

With its population of over 14 million and its location spanning two continents, Istanbul is, and has always been, the economic and cultural centre of Turkey. Today Istanbul is marching quickly towards becoming a global city. Many multinational conglomerates have located their regional headquarters in the city since Istanbul has captured the attention of international financial centres. Istanbul alone generates 30 per cent of Turkey's gross domestic product, and accounts for 53 per cent of its total exports and over 55 per cent of its imports. The real estate market is experiencing a boom with luxurious residential estates in the form of gated communities and fancy shopping malls cropping up in almost every neighbourhood. Mirroring the vibrant economy, new high-rise office towers now dominate the city's skyline. Forty-nine universities are currently operating in the city, bringing a lively intellectual life to Istanbul. The government has either launched, or recently completed, mega projects, including the construction of new crossings both above and beneath the Bosphorus, a brand-new gigantic airport

and even the carving out of a canal for a 'second Bosphorus' linking the Black Sea to the Sea of Marmara.

But there is another, very different picture of Istanbul. Despite all the achievements of recent years, Istanbul dwellers today spend hours in bumper-to-bumper traffic, they enjoy very little green space for public recreation, they deal with increasing living costs and, more importantly, they wait fearfully for the earthquake that is expected to happen within the next few decades. In terms of architecture, mega projects with large budgets and the signatures of local or internationally-celebrated architects are rising side-by-side with tenements of little design merit. The dualities of this modern city make Istanbul a very interesting case study in urban history.

Modern Istanbul: a mirror of Turkish political history

The Ottoman Empire experienced a long and painful period of political reform in the nineteenth century. During this phase young Ottoman bureaucrats tried unsuccessfully to usher in several planning reforms in their capital city, at a time when the empire was heading towards collapse. First France, then Germany, were sources of inspiration for the Turkish modernisers of the late Ottoman era. The establishment of the Turkish Republic in 1923, however, saw the country increasingly turn to the West for ideas about how to develop a modern culture. Under 27 years of single-party rule and guided by the principles advanced by Mustafa Kemal Atatürk, founder of modern Turkey, the Republican administration made sweeping changes to Turkey's political, social and economic structures to align them more closely with Western political systems, practices and social mores.

Following the World War II, Turkey entered a new period of modernisation when it adopted a Western democratic model of government as its political system. This was a significant turning point in the country's history as it aligned itself economically, militarily and politically with Western-bloc countries in the Cold War era. Similar to countries in many parts of the world, Turkey took as its role model the United States of America. Making Turkey a 'Little America' became the favoured dictum of the time. Following turbulent political upheavals in the 1960s and 1970s, another chapter opened in Turkey's political history in the early 1980s when significant reforms to its economic system exposed the country to competitive global markets. The popular slogan employed by the politicians of the 1980s was 'Skipping an age'. The spring brought by economic prosperity and political stabilisation, however, was

Introduction

short-lived and by the 1990s Turkey found itself in another phase of political chaos and economic downturn. Since the early years of the new millennium, the country has begun to undergo a major political transformation under the direction of the AK Party government, which came to power in 2002. This new government with strong Islamic roots has introduced many changes to the country's social, political and economic systems. As a result, Turkey has now embarked on a new geo-political direction by strengthening its regional power through political and economic ties to the Middle East and the Balkans.

The urban and architectural history of Istanbul has followed a parallel path to the city's tangled political and economic history. In other words, architecture and urban planning are the two key areas where this political saga can be most clearly traced and analysed. In line with its political modernisation, the seeds of modern architecture in the Ottoman capital were sown in the last decades of the nineteenth century and, in particular, in the early years of the twentieth century. The political ideology of Turkism, which emerged in the dying years of the Ottoman Empire as a reaction to rapid Ottoman decline, saw the birth of a revivalist architectural style championed by young Turkish architects. In line with the Republican agenda of rejuvenation, European modernism became the instrumental style to shape the architecture of Turkey in the 1930s. Istanbul, however, was immune from this radical shift in architectural fashion as the city was neglected politically by the elite and had lost its administrative privileges. The regime later changed its attitude and attempted to modernise the city in line with the Republican spirit. Harsh economic conditions, however, barred the implementation of many of the works proposed to make Istanbul a truly modern city. The dynamics of the period following World War II were played out in Istanbul with the arrival of the International Style, which was enthusiastically applied to hotels and public buildings. This same period also saw major infrastructure projects for Istanbul, resulting in a wholesale transformation of the urban morphology of the historic city.

During the 1960s and 1970s Turkey tried to establish a planned economy while, at the same time, intense political unrest began to arise between newly emerging leftist political movements and various right-wing groups. In this highly polarised atmosphere, Turkish architects and planners acquired a self-appointed 'social responsibility' which was mirrored in their architectural rhetoric and practice. Significant migration from rural areas to Istanbul, which began in the post-war period, also intensified during those decades, bringing a new phenomenon to Turkish architecture and urbanism: *gecekondu* or shanty buildings constructed illegally on public lands. This brought with it a new set of social problems, on a

scale never previously experienced. Perhaps the most remarkable outcome of this period was the realisation of a century-long dream to link Europe to Asia by a bridge over the Bosphorus.

In 1980 Turkey experienced a second military intervention. The period following the military coup saw Turkish architects introduced to the modern building materials and construction techniques that flourished under the liberal policies of governments in the 1980s. Turkish construction companies began to win large subcontracts in the Middle East and North Africa. During this period Istanbul also saw some noticeable investment projects that coloured the social life of the city's inhabitants. This included the construction of the first shopping malls, luxurious hotels, lavish residential complexes and high-rise office towers. The second phase of major urban interventions also realised in this period included the demolition of historic quarters along the shores of the Golden Horn and littoral landfill roads along the shores of the Bosphorus and Sea of Marmara on the Asian side of the city. The troubled period of the 1990s also had an impact on architecture in Istanbul with the building industry experiencing a downturn and consequently, except for sporadic works, no significant architectural achievements were seen in the city.

The real boom in Istanbul's architecture came in the early 2000s when the Turkish economy started to recover and new economic relationships were established with other countries in the region. Since 2002 change on an unprecedented scale has occurred in Turkey's social, cultural and economic life, resulting in significant segregation of the urban environment of Istanbul and many other Turkish cities. In this period Istanbul, with the aim of becoming a global city, has opened itself increasingly to international finance and experienced the emergence of new spaces of consumption, the rapid expansion of real estate and the service industry, and the gentrification of urban quarters. The well-to-do stratum of society has now moved to luxurious gated compounds with swimming pools, manicured gardens and recreational facilities. Proliferating on every corner of the city, shopping malls and high-rise office towers have been the rising stars of Istanbul architecture in this period. Redundant publicly-owned sites in the city have been offered to both Turkish and international investors. In the meantime, the image of the city has been upgraded by newly opened underground lines, improvements in roads, new theatres, art galleries and sports fields. Along with this 'fancy architecture', Istanbul has been subject to some 'crazy urban development projects', initiated by an ambitious government to prepare the historic city for the country's new role in its region.

Introduction

On the one hand, these glistening achievements have transformed Istanbul into a city on the move and a global hub. Civic amenities have been significantly improved, hundreds of ethnic restaurants and chic cafes now offer world-class entertainment opportunities for the Turkish well-to-do and foreign expatriates, and English has become a language constantly heard in the subways, shopping malls and other semi-privatised public spaces. On the other hand, for the urban poor and other disadvantaged groups, Istanbul is becoming a more difficult city to live in and the sharp contrast between physical manifestations in different parts of the city has further divided the fragmented social structure. Critical questions await to be addressed: are all these frenzied developments and urban gentrifications sustainable? Can the delicate balance between the much-needed infrastructure works, the architectural upkeep and the natural and cultural landscapes of the city be taken into account?

With this important city linking Europe to the Middle East now poised at the beginning of a new era, I believe that looking at the architecture and urban form of Istanbul through a fresh lens will help us to understand the complex history that has shaped so many confronting ideas, practices and realities. Going beyond the urban fabric and pure architectural styles or the physical manifestations of Istanbul's cultural landscapes and places, this book explores the story of architecture and the urban place within its social, cultural and political context. It follows a chronological structure to encompass all the periods in this narrative of a city. From the ageing Ottoman capital of the late nineteenth and early twentieth centuries to the international city of today, Istanbul has been shaped and transformed over more than 150 years of major political and social change. My aim is to tell this remarkable story, both the good and the bad.

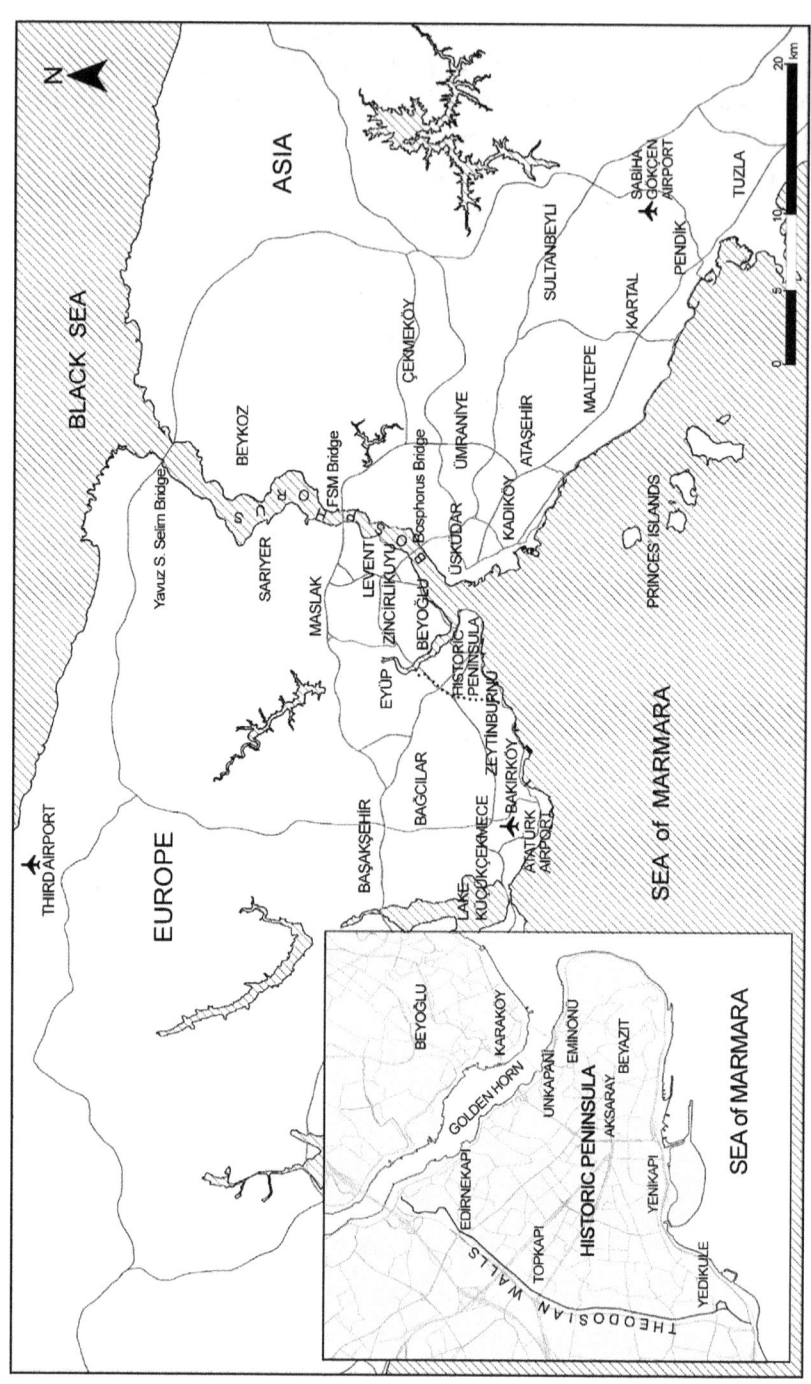

Image 1 Map of Istanbul, Ebru Şevkin

1

Late Ottoman Istanbul: early modernity, nationalism and the end of an empire

Istanbul encountered the nineteenth century under very specific and difficult circumstances. At the turn of the century it was a chaotic, overcrowded and poorly administered city. Istanbul was the capital of the ageing Ottoman Empire, and was the object of a succession of painful reforms as the Ottomans attempted to modernise the historic city. These initiatives to revitalise the old capital often followed overarching Ottoman reforms in politics, economics and the military – all with the aim of saving the empire from a total collapse in the highly challenging political conditions of the century.

The journey taken by Istanbul throughout the nineteenth century, however, was not unique to Turkey. Contrary to the accounts of mainstream Turkish historiography, which often portrays this last century of the Ottoman Empire through a dark lens, the problems faced by Istanbul were very much the same as the challenges confronted by other major European cities. For Istanbul, like many Western cities, the main goals were always to implement some basic hygienic standards, improve building quality and establish reliable public transport. In addition, regularising the crooked street pattern, preventing catastrophic fires and setting up an effective municipal structure based on European models were other significant initiatives required to deal with the tribulations faced exclusively by the Ottoman administration. In order to meet these targets, the Ottomans had been trying diligently to implement initiatives ranging from small-scale street enlargements to mega projects connecting Europe to Asia, both above and below the Bosphorus. Most of these large-scale attempts bore the signatures of European experts and none of them left the drafting board, simply remaining as fascinating examples that illustrated the passionate aspiration of the Ottoman Empire to change and modernise itself. In most cases, these projects were the

proposals of young Ottoman bureaucrats and diplomats who had familiarised themselves with vibrant European urban life whilst stationed in Paris, London, Vienna or Berlin.[1]

Belying general assumptions, Istanbul was not late in implementing technological improvements. In line with Ottoman integration with the Western capitalist economy, state-of-the-art advances appeared in Ottoman Istanbul not long after they first arrived in Western cities. For example, just 11 years after Samuel Morse sent his famous experimental cable message between Capitol in Washington, DC, and Mt. Clare Depot in Baltimore, Istanbul was connected to the major European capitals by telegraphic lines in 1855 during the Crimean War (1853–6).[2] In 1840, the very same year that the Uniform Penny Post was established in the United Kingdom, the Ministry of Post was inaugurated in the Ottoman capital. The postal services previously conducted by the military could now be systemised by a special office in a centralised manner.[3] Steamships appeared in the Ottoman capital in the 1820s, not long after their first appearance in major European ports. The development of rail transport came to the Ottoman Empire a little later than some other Western countries but once the railway arrived it was embraced with a passion by the Ottoman administration. The first intercity railway was opened in 1866, 36 years after the construction of the Liverpool–Manchester line, when a British company laid the rails between İzmir and Aydın, two important cities in Western Anatolia. In 1871 the Istanbul–Edirne route was completed and a year later the railway was extended to Dedeağaç, and then Sofia in 1874. At times enthusiasm for the railway overrode all other concerns, most famously when plans for the line to Sarayburnu proposed that the track pass through the lower reaches of the gardens of Topkapı Palace. The controversy came to a close with Sultan Abdülaziz's famous statement, 'The railway must come to Istanbul, even if it has to pass through my own back'. Trains also began to operate on the Asian side of the city when the Haydarpaşa–İzmit line was completed in 1873. From the 1850s, the Ottoman capital saw emerging public transport with the introduction of steam ferries criss-crossing the Bosphorus and horse-drawn trams linking the major hubs of the city.[4] Designed by the French engineer Eugène Henri Gavand, an underground railway tunnel between Karaköy and Galata was put in service in 1875. Although only 554 metres long, this state-of-the-art steam-engine funicular system was the second of its kind in the world.[5] Even technological improvements in entertainment came quickly to Ottoman Istanbul. Cinema, for example, appeared in Istanbul in 1896, only one year after the first film was screened by the Lumière brothers in Paris.[6]

Changing architectural tastes and new building types

Changes of taste in architectural style and alterations to the urban morphology of Istanbul always followed and mirrored the reforms made in the political and social structure of the empire. A long and traumatic debate in the Ottoman administration instigated after humiliating defeats by European armies in the last quarter of the seventeenth century brought about the modernisation of the Ottoman army by the agency of imported Western military expertise in the mid-eighteenth century.[7] The Westernisation of the army gradually spread across other aspects of the social and cultural life of Ottoman society, and architecture, by its very nature, was not an exception to this process. The classical flavours of the Ottoman architectural vocabulary began to fade away from the mid-eighteenth century, with glimpses of the impact of European Baroque architecture appearing in Istanbul.[8] The Nuruosmaniye Mosque (1753–5) was the first major Ottoman structure where the impact of the European Baroque style could be vividly seen in S and C-shaped ornaments, scrolling cornices and the overall curvilinear character of the building.[9] Subsequently, the impact of European architectural styles intensified, especially in the early decades of the nineteenth century when almost all public buildings constructed bore the impact of fashionable Western styles such as Baroque, Rococo and French Empire.

Political reforms initiated by Selim III (r. 1789–1807) in the last phase of the eighteenth century signalled larger scale changes for the following decades, and paved the way for his cousin and successor, Mahmud II (r. 1808–39), to introduce a large number of material changes to the Ottoman Empire. During his reign rebellious Janissaries were crushed and replaced by a modern army, the bureaucracy was restructured completely, consultative councils were established, and an urban management system was redrafted. With the abolishment of the Janissaries – who under the *kadı* or the juridical authority also held significant responsibilities for civic duties in Istanbul, such as security, street cleaning and firefighting – a new department, İhtisab Nazırlığı (Ministry of Taxation and Urban Affairs), was established.[10] Shortly after the death of Mahmud II, all these reforms were codified by the declaration of an imperial edict by his son, Abdülmecid (r. 1839–61), in 1839. Known as Tanzimat (Reorganisation), the edict was prepared by a group of young Ottoman bureaucrats led by Mustafa Reşid Pasha, the Minister for Foreign Affairs.[11] The creators of the edict were familiar with European politics and culture and saw the adoption of Western norms as the only recipe to save the ageing empire from collapse. With the declaration of the edict a new era known

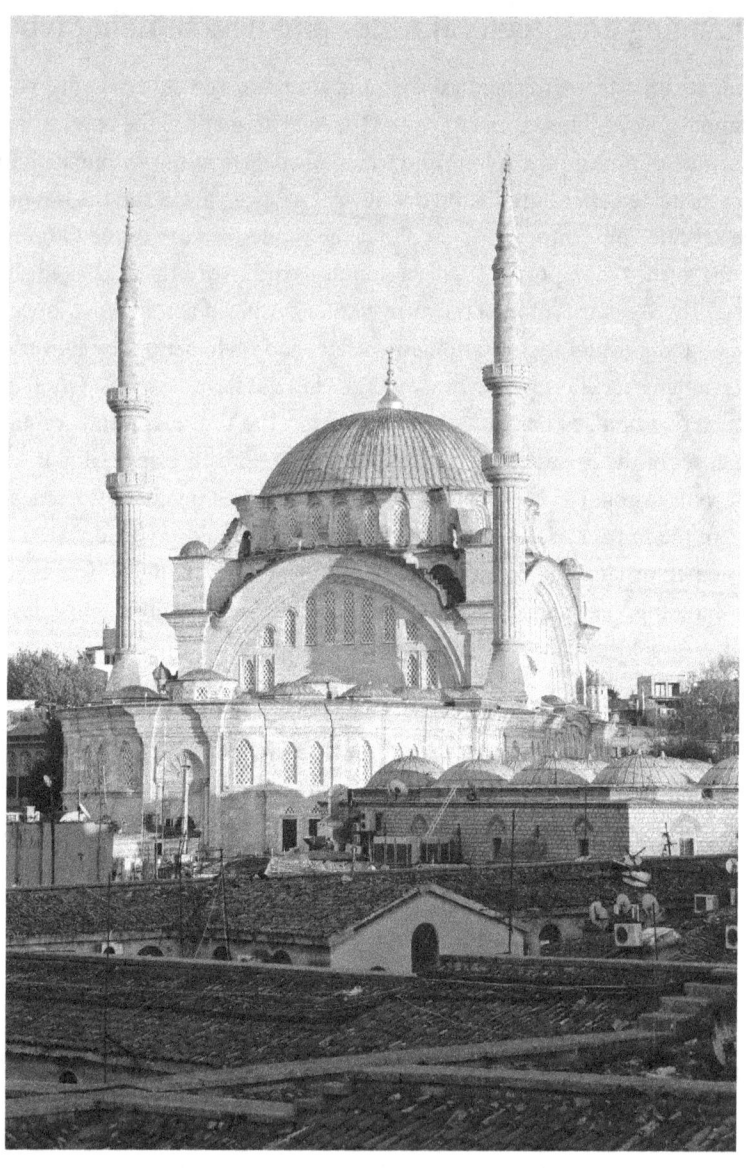

Image 2 Nuruosmaniye Mosque, Aras Neftçi

as the Tanzimat Period (1839–76) was opened in Turkish history. The reforms included the secularisation and formalisation of education and justice, differentiation of the administrative structure along functional lines, introduction of a new provincial administration, creation of a new elite bureaucratic system, abolition of the patrimonial taxation system, creation of a monetised system to levy taxes and, finally, the establishment of an Ottoman parliament and constitution.[12]

The change in the administrative structure of the empire was evident in the emerging modern bureaucracy. The total number of public servants, for example, increased eighteenfold and reached 35,000 in 1908.[13] State affairs, as a consequence, were no longer run from within the thick walls of imperial palaces or the mansions of high-ranking Ottoman pashas or bureaucrats but instead were conducted inside purpose-built ministerial offices. As the Ottoman Empire changed as a result of its integration with world economics, the building types in its capital varied as well. The prevailing structures of classical Ottoman Istanbul were the large sultanic mosques that dominated the legendary silhouette of the Historic Peninsula[14] with their lofty domes and pencil-thin minarets. Public buildings – often part of a large complex or *külliye* – such as *medrese*s (schools), *hamam*s (public baths), hospices and libraries were the other important buildings of Ottoman Istanbul in the classical era.

In the rapidly changing world of the nineteenth century, Ottoman cities, especially Istanbul, now called for other kinds of buildings to feed the demands of this new world. The changing civic services required modern public buildings such as schools, post offices, ferry wharves and train stations. Integration with the world capitalist economy brought with it modern office buildings, banks, hotels and entertainment venues for the emerging Ottoman bourgeoisie. Above all, the modernisation programme for the Ottoman army required large-scale barracks, hospitals and other buildings, which all necessitated construction in European style. For this reason, from the late eighteenth century the most sizable buildings in the Ottoman capital were no longer mosques but gigantic military barracks that hosted the Europeanised army. Without exception, all of these new barracks were constructed outside the walls encircling the historic city of Istanbul. The intense building activity also resulted in a sweeping shift in the urban geography of the city. Beyoğlu, across the Golden Horn became a rising star of nineteenth-century Istanbul, in particular.[15] This was due not only to the colossal military barracks constructed there, but also because of the increasingly Western style of public life and activities that occurred in the streets of this most Europeanised quarter of the city. That is why, when the Ottoman administration decided to implement a municipal organisation based

on European norms, Pera became the first quarter of the city in which this system was put into action as an exemplar model.[16]

In part, this transformation in society, politics and bureaucracy allowed the birth of architecture as a profession in the modern sense. A significant step in this penetrating reform process was the replacement of the Hassa Mimarlar Ocağı, the Corps of Royal Architects responsible for building activities in the empire, with the Ebniye-i Hassa Müdürlüğü (Directorate of Royal Buildings) in 1831.[17] Şehreminliği, the office responsible for the construction and upkeep of royal buildings, was also amalgamated with the newly established directorate. This action was not mere Westernisation but rather an inevitable result of the changing conditions. In the classical Ottoman system, with its absence of private ownership and a modern economy, the only area where architecture could be expressed was limited to religious buildings, imperial palaces and mansions, and some other civic buildings such as public baths and religious schools. Working under sultanic patronage in the firmly established traditions of the classical period of the Ottoman Empire, the aged imperial architectural office was far from possessing the ability to satisfy the needs of the changing society. As a result, building activities in Istanbul in the nineteenth century passed swiftly to the hands of foreign, Levantine or non-Muslim groups that had benefited from the far-reaching Westernisation of the Ottoman Empire and had direct contact with European cultures and societies.

The Balyans: the apostles of architectural change

Unique in the creative history of Turkey, the Balyan family of architects served the Ottoman Empire over three generations and were the most important figures of this period. One of the well-known Armenian families of Ottoman Turkey (originally from Central Anatolia), the Balyans were active from the mid-eighteenth to the late nineteenth century, and the six members of the family who served a succession of seven sultans (from Selim III to Abdülhamid II) played a pivotal role in the introduction and popularisation of Western architectural styles in Istanbul.[18]

The influence of the Balyans, however, is a controversial topic in Turkish architectural history as various contrasting analyses offer very different accounts of the roles played by Balyan family members in nineteenth-century Ottoman architecture. Based primarily on interpretations by local Armenian writers, modern Turkish architectural historiography in general portrays the Balyans as designers of a wide array of important and prestigious buildings in the Ottoman capital,

ranging from imperial palaces and mosques to small pavilions. The sources to which these accounts refer are mainly chronicles, family memoirs and other documents kept by the local Armenian community in Istanbul and, in many cases, these sources overemphasise the role played by the creativity of the Balyans and other Armenians in the modernisation of the Ottoman Empire. Alternatively, recently unearthed material from the Ottoman archives and a careful reading of Ottoman architectural books published in the late nineteenth century raise some serious questions about this general acceptance and provide convincing evidence that challenges the perceived image of the Balyans in late Ottoman architecture.[19] From this perspective, the Balyans in many cases were portrayed as contractors rather than architects and, in other cases, were named in corruption scandals and charged with serious offences.[20]

Regardless of this controversy about their exact role, the Balyans, through the buildings they either designed or constructed, were pioneers of the transformation of the Ottoman capital throughout the nineteenth century. Although, as noted above, the Baroque came to Istanbul in the mid-eighteenth century, the designers of the buildings constructed in that period did not merely copy Western styles. Instead, they created an interesting and highly original interpretation of the European Baroque in the Ottoman manner, as vividly evident in the Nuruosmaniye Mosque. By contrast, in this later period the buildings constructed by the Balyans directly employed stylistic elements of the French Baroque, Rococo and Empire styles on Ottoman buildings, and such an attitude brought with it an interesting marriage of architectural styles, especially in mosques, tombs and other religious buildings.

Nothing shows this sharp transformation in architectural tastes more than Dolmabahçe Palace. Sitting on the European shores of the Bosphorus and constructed during the Crimean War, the new palace was designed collaboratively by a group of architects and builders, namely Garabet Balyan, his son Nikogos, local Greek master Evanis Kalfa and Englishman William James Smith who also designed the British Embassy in Istanbul in consultation with Sir Charles Barry. Hosting the imperial court during the heyday of the Ottoman Empire and sitting on the tip of the Historic Peninsula, Topkapı Palace was developed incrementally over four centuries with additions and progressive changes made by successive sultans. The concentrated and complex array of structures is composed of mainly single or double-storeyed buildings aligning various courtyards and interconnected by columned arcades and passageways. The striking architectural composition and refreshing and pleasant atmosphere of Topkapı

Image 3 Dolmabahçe Palace, entrance to the State Apartments, Aras Neftçi

Palace, however, was far from representing the spirit of the rapidly changing cultural norms of the nineteenth century. In contrast to the out-of-fashion architectural representation of the old palace, Dolmabahçe conceived a unified entity adorned both externally and internally with European Baroque and Rococo styles and endowed lavishly with European furniture, clocks, vases, crystals and more, all vividly signalling that the modernisation of the Ottoman Empire was now irreversible.

Search for a new Ottoman architecture

The first cracks in this long and well-established hegemony of Western architectural tastes and the monopoly of non-Muslim architects in Ottoman architecture appeared as early as the 1860s. The embryonic seeds of this change in architectural styles coincided with a series of political events that brought about the movement known as Ottomanism. Organised by a group of young bureaucrats and students called Genç Osmanlılar (Young Ottomans or, as commonly named in the West, *Jeunes-Turcs*), the main objective of this movement was to counterbalance the extreme Westernisation of the state apparatus that had occurred during the

Tanzimat Period. Ultimately, the reforms that had been made since the beginning of the Tanzimat Period were not based on popular demands, but came as an elite-driven programme that saw the adoption of Western standards in all aspects of life as the only solution for saving the empire from collapse. The great majority of those in the Muslim stratum of Ottoman society received little or no benefit from the reforms as the new order mainly helped non-Muslims to increase their political power and wealth in the system. On the other hand, although the reforms brought some improvements to the state apparatus, a modern and sustainable economy could not be established and, as a result, the Ottoman Empire became more dependent on the Great Powers and took on an increasingly indebted role in the international financial system. Severely critical of this bitter picture, the Young Ottomans – who had grown up under the Tanzimat environment and were much influenced by the European ideals of liberalism and nationalism – saw the political ideology of Ottomanism as a means to create a national Ottoman identity. According to the Young Ottomans, the new political order, which would be a combination of liberalism and nationalism with Islamic culture, would allow all segments of society to live together in harmony, regardless of their ethnic or religious origins, under the new concepts of *vatan* (fatherland), *millet* (nation) and *hürriyet* (freedom).[21]

The first clear signal of the impact of this political movement on architecture came as early as the 1870s with an architectural book titled *Usul-i Mimari-i Osmani* (Principles of Ottoman Architecture), a comprehensive study on history and the notion of Ottoman art and architecture. Commissioned by the Ministry of Public Works of the Abdülaziz era and authored by a group of people led by İbrahim Edhem Pasha, the book was specifically prepared for the 1873 Vienna International Exposition. The *Usul-i Mimari*, published in Turkish, French and German, studied and documented the classical Ottoman buildings and aimed to display the high-level artistic and systematic qualities of Ottoman architecture. Mirroring revivalist tendencies in Western Europe – such as John Ruskin's writings in England and Eugène Viollet-le-duc's formulations in France – the book aimed to classify the classical orders and ornamental patterns of Ottoman architecture as a source of inspiration for Ottoman architects in this rapidly changing world of the late nineteenth century.[22]

As a result of this emerging awareness of Ottoman identity, the first examples of revivalist architecture surfaced as early as the 1860s. Interestingly, the initial trials of this Oriental revivalism came from European architects who often collaged selected decorative elements of Islamic architecture on the facades of buildings

Image 4 Ministry of War entry gate, Murat Gül

composed upon strong principles of Western architectural styles. The ornamental source of inspiration for this movement, however, was not classical Ottoman architecture. In many buildings the pseudo-Moorish, very fashionable all around the Western world since the 1800s, was the preferred genre. Designed by French architect Marie-Auguste Antoine Bourgeois in 1866, the monumental gateway to the Ministry of War building in Beyazıt is the most notable example of this style. With its triple-arched composition, the gateway's architectonic composition bears a Roman triumphal arch associated with a central horseshoe arch, alternate coloured voussoirs and stone carvings on the facade which borrow heavily from the Islamic architecture of the North African coast.

Religious architecture too was much influenced by this fashion. Pertevniyal Valide Mosque, constructed in 1871 in Aksaray at the very centre of the Historic Peninsula, was one of the earliest but, at the same time, prime examples of this new trend. Designed collaboratively by Sarkis Balyan and the Italian-Levantine Pietro Montani and commissioned by the mother of Abdülaziz, the mosque is one of the most notable examples of the Azizian period, and was referred

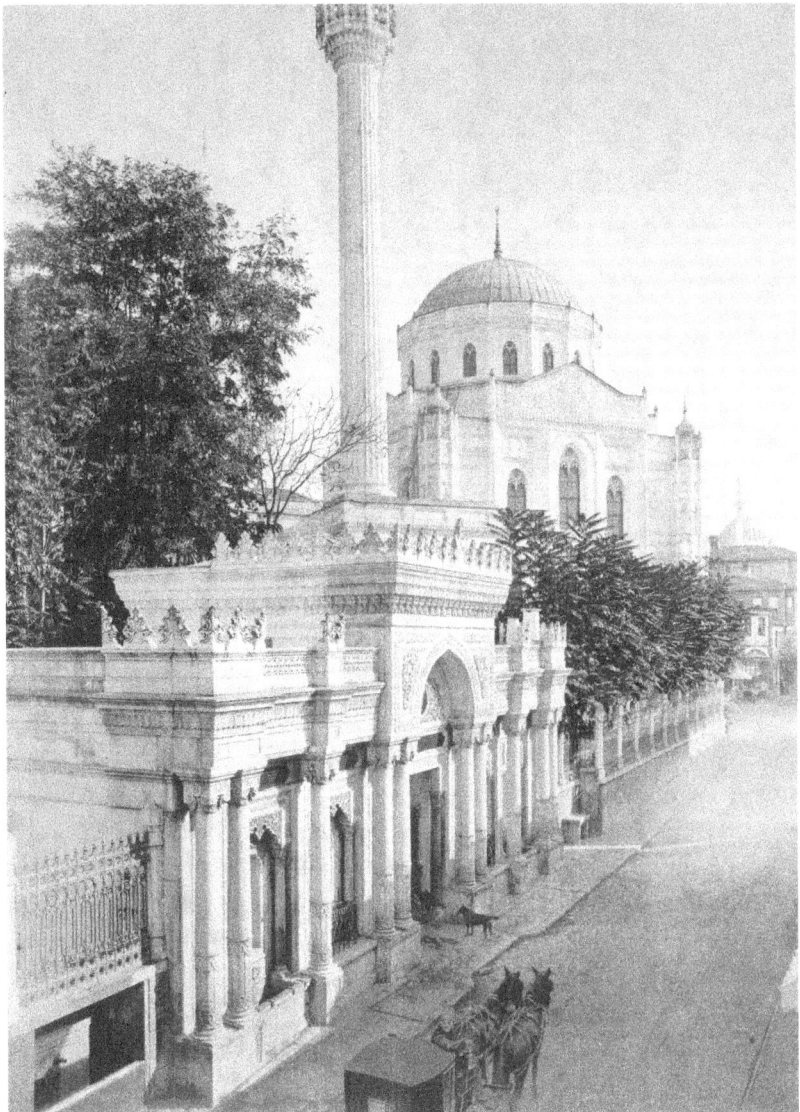

Image 5 Pertevniyal Valide Mosque, *c*.1900, Library of Congress

to in the *Usul-i Mimari* as an example of 'Ottoman Renaissance' in architecture.[23] Stylistically, the mosque is eclectic and borrows many different elements from various sources. Unlike classical Ottoman mosques, the dome sits on a stretched drum and this arrangement refers to Byzantine church architecture.

Image 6 Çırağan Palace, Murat Gül

Reminiscent of Indian architecture, four heavily decorated turrets are placed in the corners of the square-plan mosque. The internal decoration is also inspired by Mogul or North African motifs. The pointed arched windows, which help the mosque's overall verticality, are also reminiscent of Gothic features. And, finally, the triangular pediments positioned on all facades are suggestive of the monumental gates opening to the courtyards of the great sultanic mosques of the classical Ottoman period.

The different stylistic approaches between two coastal palaces that were constructed within less than 20 years of each other in the mid-nineteenth century also explicitly show this swift transition from European architecture to an eclectic style with profound Oriental flavour. Unlike its predecessor Dolmabahçe, the new Çırağan Palace (1860–72) embodied strong Oriental character created by motifs derived from the Alhambra Palace in Spanish Andalucia, as well as Gothic features discreetly used in window tracery on building facades. Designed by Sarkis Balyan, the palace, like the Pertevniyal Mosque, was proudly represented in *Usul-i Mimari* as an ultimate fulfilment of Ottoman Renaissance.

The Hamidian era: Istanbul between modernisation and absolutism

The mid-1870s brought a crucial turning point in Ottoman history. The two decades following the Crimean War intensified the Ottoman Empire's dependency on the European powers. The continuous wars on the one hand and the modernisation attempts of the army and navy on the other, together with the cost of financing the construction of Western-style palaces, brought the Ottoman state to a financial crisis and bankruptcy in 1876. These bitter conditions brought about a bureaucratic coup against Abdülaziz who lost his throne on 30 May 1876. After the brief rule of Murad V, who suffered serious psychiatric problems, Abdülhamid II began his 33-year rule of the country. Although the new sultan came to power with a pledge to establish a constitutional monarchy – and indeed he kept his promise and drafted the first Ottoman constitution in 1876 and assembled the Ottoman parliament the following year – this first democratic experience of the Ottoman Empire was short-lived. The 1877–8 war with Russia was disastrous for the Ottomans as the Russian army reached the outskirts of Istanbul, and the invasion of the Ottoman capital was only avoided with the help of European powers. At the end of the war, the Ottoman Empire lost the control of Bosnia-Herzegovina and Bulgaria in the west and Kars and Batum in the east. Furthermore, Cyprus was given to the British as compensation for their help in the war. This dramatic territorial loss brought massive migration towards the remaining provinces of the empire, especially Istanbul. In the three years following 1882 Istanbul's population more than doubled and reached over 870,000.[24] Under such bitter political conditions, Abdülhamid II suspended the parliament and assumed absolute rule. This brought an abrupt end to the Tanzimat era during which bureaucrats adorned with Western values had significant control of the state apparatus.

Political Islam was the most effective tool in Abdülhamid's hands and he used it against not only his domestic rivals who demanded constitutionalism but also the Western powers gradually controlling the remote Ottoman territories. The Sultan saw, and presented, himself as the 'Protector of the Islamic World', hoping that this title would better enable him to deal with the European powers. One of the most important consequences of this new political climate was the emerging and promising relationship between the Ottomans and the German Empire – a rising European power that did not have a colony on Muslim lands. The most symbolic evidence of this alliance was a highly decorative fountain that was gifted by the German Empire to mark Kaiser Wilhelm II's second visit to Istanbul

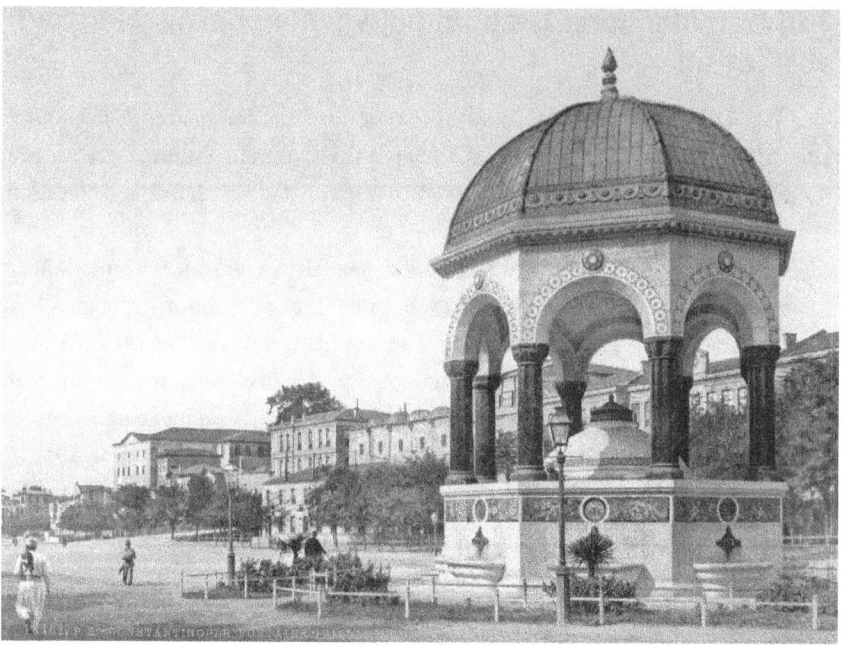

Image 7 The German Fountain at Sultanahmet, *c*.1900s, Library of Congress

in 1898. Designed by a group of architects led by Max Spitta, Wilhelm's own architect, the fountain was pre-fabricated in Berlin, shipped to Istanbul and was assembled in the most prominent part of the Ottoman capital, Sultanahmet Square or the old Hippodrome. The fountain alluded to the long-defunct Holy Roman Empire, by then embodied by Wilhelm's German Empire, and the Ottoman Empire as the inheritor of, and successor to, the Eastern Roman Empire. Neo-Byzantine in character, the fountain also followed closely the form of ablution fountains located in large sultanic mosque courtyards. The eight green porphyry columns rise from the octagonal base to carry semicircular arches, which in turn support its distinct ribbed dome, clad in copper and covered inside with mosaics. Positioned between the arches are eight medallions: four in green representing Islam and engraved with the monogram of Abdülhamid II and four in blue representing Prussia and carrying Wilhelm II's insignia.

Without doubt, Abdülhamid II is one of the most contentious rulers throughout the six centuries of Ottoman history. He successfully implemented many reforms to modernise the empire, and laid the foundation stones of modern Turkey. The most significant reform of the Hamidian period was the

establishment of modern educational institutions in almost every field. Modern primary and secondary schools were set up for both male and female students. Vocational schools and higher education institutions were opened in law, mining, commerce, agriculture and forestry, medicine and veterinary medicine. Architectural education in a modern sense was also established in this period. Founded in 1883 by Turkish painter and intellectual Osman Hamdi Bey, the Sanayi-i Nefise Mekteb-i Âlisi (Academy of Fine Arts) was based on the French École des Beaux-Arts model and included the departments of architecture, painting, sculpture and calligraphy. All departments were headed by qualified French or Italian instructors. A year later, in 1884, architectural subjects began to be taught at the newly established Hendese-i Mülkiye Mektebi (School of Civil Engineering) which was part of the Imperial School of Engineering or Mühendishane-i Berri Hümayun, originally established in 1773. Unlike at the Academy, the architectural subjects in this new school were taught by German and Austrian instructors led by August Jasmund, a Prussian architect who came to Turkey during the reign of Abdülhamid II.[25]

There is another side to this story, however. The reforms conducted by Abdülhamid took place under an autocratic regime. Due to his extreme fear of conspiracies, Istanbul became an open-air prison with spies at every corner of the city who reported perceived, imagined or even manufactured political conspiracies to Yıldız Palace. Abdülhamid's extreme paranoia about an upheaval against him impacted all aspects of his administration. The navy, for example, was not permitted to leave the Golden Horn and the army had to perform its military exercises without bullets. Furthermore, electricity, trams and telephones were all banned in Istanbul as the Sultan saw such technological devices as potential tools that could be used in a possible coup against him.[26]

Whether Abdülhamid was a 'great sultan' or a 'paranoid autocrat' is a vibrant topic of debate in modern Turkish historiography. What is certain, however, is that the intense institutionalisation of education, bureaucracy and other public affairs brought frenzied construction activity to the Ottoman capital during the Hamidian years. Numerous schools, wharves, docs, offices and many other kinds of buildings were built in Istanbul, in particular the Galata and Pera districts. Frequently designed by European and Levantine architects, these buildings form one of the most significant layers of Ottoman architectural heritage in Istanbul today. It should also be noted that despite the rhetoric of political Islam, European architectural styles during the reign of Abdülhamid II regained their popularity, although they would soon be challenged by emerging revivalist architectural genres.

Alexandre Vallaury: a gifted Levantine

If the Balyans were pioneers of the official architecture of this transitional period, Alexandre Vallaury was the rising star of the non-religious and non-royal architecture of Istanbul in the late nineteenth century. Son of Francesco Vallaury, a famous pastry cook, Alexandre was born in Istanbul in 1850. Although the roots of the family are not entirely clear, Vallaury's Levantine family seems to have had French origins and his subsequent training and architectural output owes a strong debt to France. Vallaury established his solid grounding in classical and historicist architectural design during his education between 1869 and 1878 at the École des Beaux-Arts in Paris. In 1883, soon after his return to Istanbul, Vallaury was appointed to the job of establishing the first architecture school of Turkey at the Academy of Fine Arts, where he continued to teach for the next 24 years. His achievements in the architectural profession were highly recognised and Vallaury was awarded the Légion d'Honneur by the French government in 1896. Vallaury's opportunity came after a major earthquake in 1894 when he received several large-scale commissions from the Ottoman government to design public buildings.[27] Many other major projects came his way for French companies and

Image 8 Vallaury's Imperial Museum, Aras Neftçi

other prestigious clients. Although he employed various styles in his wide-ranging architectural portfolio, Neoclassical and Beaux-Arts were two significant styles that Vallaury always admired, and this is vividly explicit in three major buildings he designed in the last decades of the nineteenth century.

Vallaury established a strong friendship with Osman Hamdi Bey, the curator of the newly founded Müze-i Hümayun or the Imperial Museum, and the two men shared a love of classical antiquity and its material culture. This collaboration brought about Vallaury's first, and perhaps most prestigious, project: a building for the museum. Constructed within the first courtyard of Topkapı Palace, the museum was one of the most iridescent symbols of the dramatic reforms of the Ottoman Empire made during the reign of Abdülhamid II.[28] In this U-shaped building – completed in three stages in 1891, 1903 and 1907 – Vallaury employed firm Beaux-Arts principles such as strong classical details, absolute symmetry and axial plan layout. The building's main facade is composed within a strict rhythm of recessed window bays, each set positioned between giant fluted Ionic pilasters topped by oversized cornice brackets below an undecorated entablature. Although

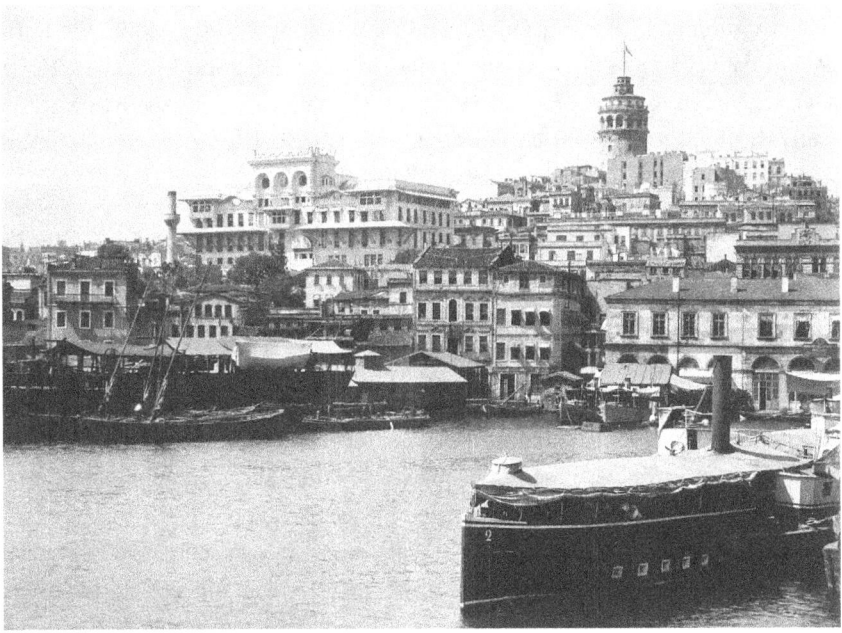

Image 9 The rear view of the Ottoman Bank (centre left) from the Golden Horn, Library of Congress

Topkapı Palace developed incrementally over centuries and, therefore, contained many different buildings commissioned by successive sultans in different architectural styles which mirrored the tastes of their time, Vallaury's museum was the first building which was constructed in a truly European style in the imperial court of the Ottoman Empire.[29]

Vallaury's second major commission was across the Golden Horn in Galata. This time he was hired by the Bank-ı Osmanî-i Şahane, or the Imperial Ottoman Bank, which was founded in Istanbul as a joint venture between French and British banks and the Ottoman government upon the end of the Crimean War in 1856. The bank played a significant role in the financial affairs of the state, particularly during the public debt crisis, and functioned as the central bank of the Ottoman Empire.[30] Completed in 1892, the headquarters of the Imperial Ottoman Bank was designed as a grand Beaux-Arts commercial palazzo rising over a solid four storeys and with a commanding presence on present-day Bankalar Street. Despite the building's overall effect – the air of a massive, impregnable commercial palazzo of the most lavish proportions – the back facade facing the Golden Horn has a distinctly Oriental character with Neo-Baroque features. Although no evidence is available, perhaps he deliberately employed here an architectural language appropriate for establishing a smoother communication with the Historic Peninsula. Vallaury's third important Neoclassical building was Pera Palace Hotel. Constructed in the 1890s in the manner of a Renaissance palazzo, the six-storey hotel was built to receive rich European and American tourists arriving on the Orient Express, the famous train from Paris.

Art Nouveau: a prized style

Amongst Western artistic fashions, Art Nouveau had a distinguished place in Abdülhamid's Istanbul. Pioneered by a gifted Italian architect, Raimondo Tomasso D'Aronco, whose Turkish career begun in 1893 with an invitation to prepare designs for the Istanbul Exhibition of Agriculture and Industry planned for 1896,[31] and who was fervently supported by his great patron Abdülhamid, this new style came to the Ottoman capital at the same time as it first appeared in European cities. Although relatively short-lived, Art Nouveau was a very influential movement and was the first serious attempt to escape the eclectic and historical styles that dominated European art for centuries. It was actually a 'total' art style that swept through the decorative arts and architecture and paved the way to Modernism in Western art and architecture in the succeeding decades. Acceptance of such an

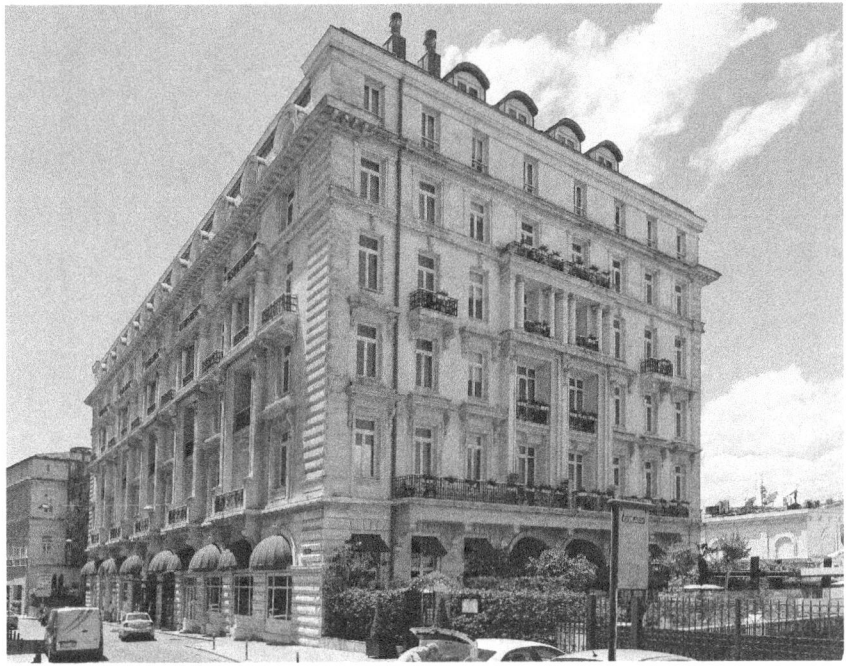

Image 10 The Pera Palace Hotel, Murat Gül

avant-garde artistic movement by an 'autocratic' sultan emphasises the progressiveness of Abdülhamid's reign. The Imperial Stables at Yıldız Palace, the Şeyh Zafir Tomb and Library at Beşiktaş and, in particular, the apartment building in the Grande Rue de Pera designed for Abdülhamid's Dutch private tailor, Jean Botter, are prime examples of the different shades of Art Nouveau architecture in Istanbul bearing the signature of D'Aronco.

In addition to those significant examples, 1900s Istanbul contained buildings representing high quality Art Nouveau on almost every corner of the city. Sitting opposite the Ministry of Post and Telegraph Building in Sirkeci, the Vlora Han, for example, is an outstanding Art Nouveau commercial building, although its designer is not known. Furthermore, Art Nouveau in Istanbul was not a fashion limited only to elite architects and prestigious buildings, but was also well digested by a wide spectrum of the construction industry of late Ottoman Istanbul. The most vivid examples of its wide-ranging acceptance are the timber residential buildings adorned with Art Nouveau motifs in Arnavutköy, Üküdar, Princes' Islands and many other districts, making Istanbul one of the most exclusive

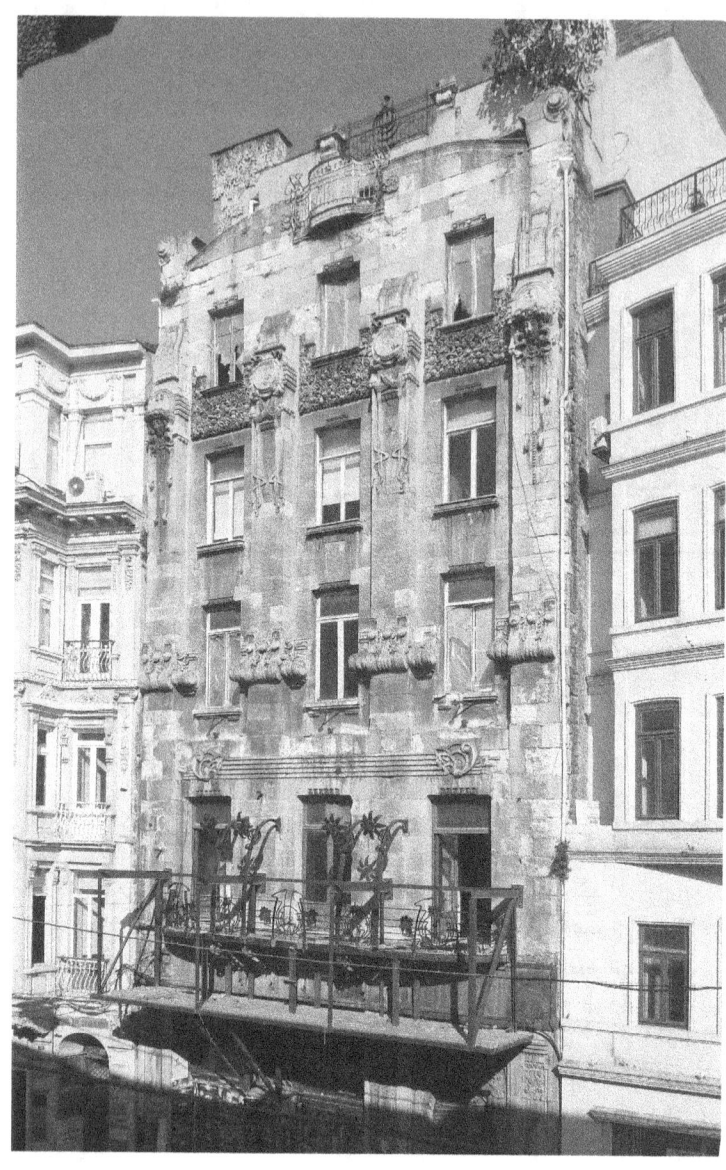

Image 11 The Botter Apartment Building in Beyoğlu, Murat Gül

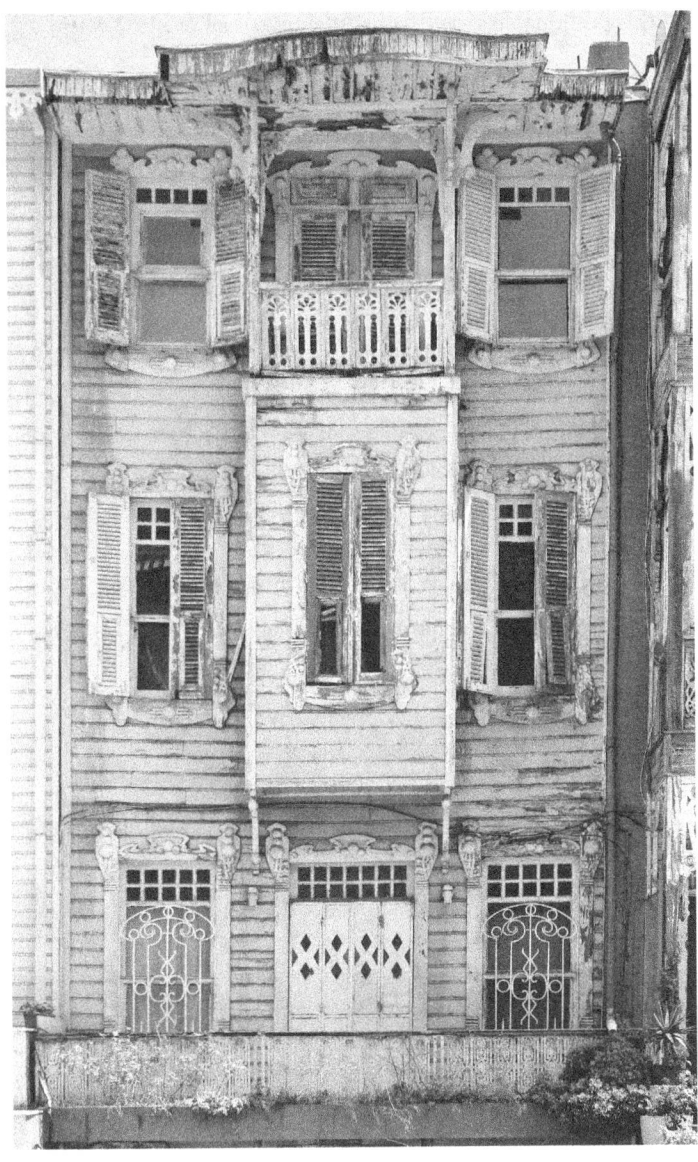

Image 12 A timber Art Nouveau house in Arnavutköy on the European shores of the Bosphorus, Murat Gül

centres of this fashionable style that became prized all over the world in the early twentieth century.

Alongside Art Nouveau, the cosmopolitan social and cultural structure of Istanbul was mirrored in the architecture of the city. Some major buildings in European architectural styles were built in the last decades of the Ottoman Empire. Designed by two German architects Otto Ritter and Helmuth Cuno between 1905 and 1908, the Haydarpaşa Railway Terminus is the most impressive building to bear European architectural tastes in late Ottoman Istanbul. Sitting on the shores of the Marmara Sea at the end of the Anatolian Railway Line, the terminus building owes nothing to Turkish architecture and is much grander than its counterpart in Sirkeci in the European part of the city. With its flamboyant design, the station is ebulliently German Neo-Renaissance and emulates European castle architecture explicitly in its circular turrets and conical spires. The construction cost of this large terminus was indeed financed by the German Empire as the starting point of the famous Baghdad railway project, and it was given as a 'gift' by Kaiser Wilhelm II to Sultan Abdülhamid II. In other words, if the fountain in Sultanahmet Square was the engagement ring, the railway terminus in Haydarpaşa was a generous dowry for the Turkish–German alliance.[32]

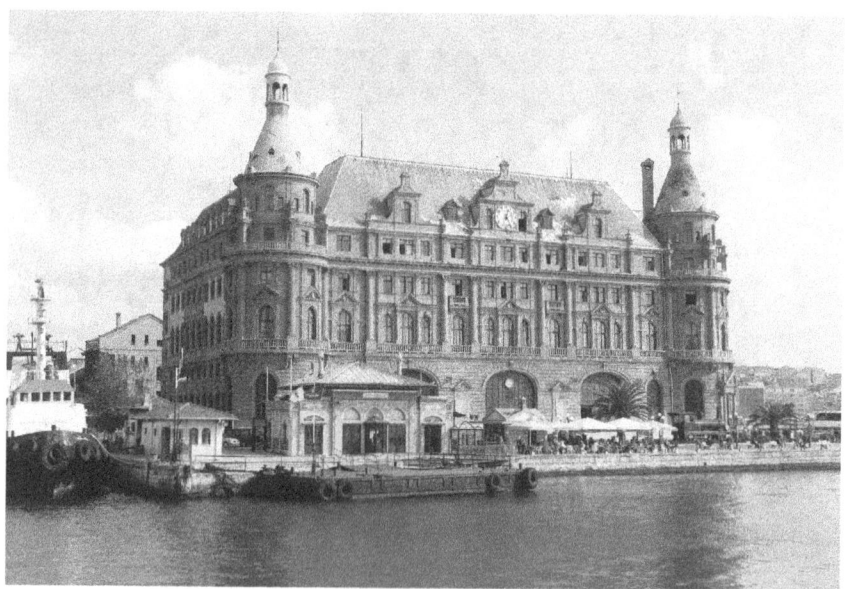

Image 13 Haydarpaşa Railway Terminus, Aras Neftçi

Of course, the Westernisation of Istanbul architecture was not limited to only those buildings bearing the signatures of famous architects. In the second part of the nineteenth century, Ottoman Istanbul, in particular Galata and Pera, saw the construction of many buildings representing different shades of fashionable Western styles, ranging from Neoclassical, to late Baroque, Belle Époque, Neo-Gothic and other eclectic styles. Designed by non-Muslim Ottoman, Levantine or Turkish architects, these buildings were strong indications of the change occurring in the social, cultural and political life of the late Ottoman Empire.

The Ottoman dream: a brand-new Istanbul

Abdülhamid's Istanbul also saw large-scale urban renewal projects by European experts, although none of these left the drawing board. Istanbul's rotten condition at the turn of the century not only created a deep dissatisfaction among the city's population but also featured frequently in the writings of European observers published in Western newspapers. Such embarrassing accounts provoked the Ottoman administration to find a blanket solution to this ongoing problem. The most notable proposal came from a prominent French architect, Joseph Antoine Bouvard, who held prestigious positions such as the inspector-general of the Architectural Department of the City of Paris and the chief of the Architecture Department of the Universal Exposition of Paris in 1900.[33] For his first attempt, Bouvard did not come to Istanbul but made proposals for the major urban quarters of the Ottoman capital based on photographs of city. These works, however, were impractical as Bouvard considered each of the centres individually without a holistic approach and, most significantly, completely ignored Istanbul's dominant topography. As a result, the Frenchman's projects remained as somewhat unrealistic and naive proposals that aimed to Westernise the old Ottoman capital with European-style buildings and squares. For his second attempt, Bouvard made a short visit to Istanbul in 1908 and inspected the city personally. The French architect, who at the time was undertaking a master plan of Buenos Aires, was offered 25,000 francs but he declined the job as there were no adequate maps of Istanbul that could be used for the intended master plan.[34] Despite the optimistic hopes of Ottoman bureaucrats, it soon became clear that a wholesale transformation of the city could only be a dream under these circumstances.

Some interesting infrastructure projects proposed for Istanbul were other showstopper initiatives in Abdülhamid's Istanbul. The Ottoman integration with the world's capitalist economy whetted the appetite of some Western entrepreneurs

who tried to inject generous international capital into Istanbul as a promising business investment. One of those projects was the proposed construction of a bridge over the Bosphorus. The initial surveys instigated in the late 1870s but the first viable proposal came from two American engineers James Buchanan Eads and A. O. Lambert in 1877.[35] They proposed a three-spanned iron bridge between Rumelihisarı and Anadoluhisarı, providing a railway linking Europe to Asia.[36] Three years later a French syndicate offered another proposal for the same location. This time the bridge would have a single span of 800 metres.[37] However, the most ambitious bridge project came a decade later from French engineer Joseph Ferdinand Arnodin, who was the co-inventor of transporter bridges. His proposal comprised two bridges and an accompanying rail ring encircling the city. The first bridge was designed as a transporter bridge between Sarayburnu and Üsküdar. Similar to Arnodin's other transporter bridges, this was an engineering splendour to be made of iron pylons and trusses. The second bridge, named Hamidiye, was a suspended bridge between Rumelihisarı on the European shores of the Bosphorus and Kandilli on the Asian side of the city. The bridge was designed over five massive masonry pillars to provide for railway, vehicular and pedestrian traffic. Unlike the austere nature of the first bridge, Hamidiye was to be an overly decorated bridge reflecting the revivalist tendencies of its era.[38] None of these bridge projects, however, could be realised and Istanbul waited another 73 years for a bridge connecting Europe to Asia over the Bosphorus.

Young Turks and the Second Constitutional Era: from Oriental to Ottoman Revival architecture

Political opposition against Abdülhamid's regime began to be established as early as the 1880s by a group of students, young bureaucrats and military cadets who demanded the resumption of the Ottoman parliament, which had been suspended soon after the 1877–8 Ottoman–Russian War. The opposition groups, similar to their predecessors of the 1860s, called themselves *Genç Türkler* (Young Turks) and formed a secret political organisation named İttihat ve Terakki Cemiyeti (The Committee of Union and Progress or CUP). After many efforts over many years, the CUP was successful in forcing the Sultan to resurrect the parliament in 1908, and overthrew him a year later. Intellectually shaped by the social views of Ziya Gökalp, the prominent theoretician and ideologue and the father of political Turkish nationalism, the CUP tried to establish Turkish nationalism as the official social politic of the state, especially after the disastrous Balkan Wars of 1912

and 1913.[39] The CUP administration, however, could not bring about the intended democracy as the coming years saw continuous plots and conspiracies combined with autocratic rule, more extreme than during Abdülhamid's reign. The administration eventually took the Ottoman Empire to the point of collapse after World War I.

Under these bitter political conditions, Turkish nationalism gained a new pace. The continual loss of territories and weakening economic structure proved that Ottomanism, despite the optimism of the Young Ottomans, did not work as an effective political tool to reverse the gradual collapse of the aging empire. In particular, the mass migration of the Turkish population from Eastern Europe, Crimea, the Caucasus region and other lost lands helped raise awareness of 'Turkishness' in the leading political circles of the Ottoman elite. Led by Gökalp, Turkish nationalism increased its influence in the intellectual and political circles of the Ottoman Empire from the early years of the new century. According to Gökalp, who had been strongly influenced by Emile Durkheim's sociological view, culture and civilisation were two different concepts and the latter could be taken from the West, as evident in the case of Japan. Culture, however, was an authentic notion which must be based upon the nation's own characteristics and history. Nations must have a 'shared consciousness' in order to survive and individuals should be representative of this common awareness. Gökalp, therefore, saw nationality and religion as two equal ingredients of modern Turkish national identity, and he promoted the use of the Turkish language in every part of the Ottoman Empire.[40] In line with those developments religion as the key consciousness of Ottoman society was gradually challenged by nationalism, which was defined as Turkishness.[41]

The political change in favour of Turkishness was also echoed in the Sanayi-i Nefise Mektebi, and Vallaury was replaced by Vedat Bey as the head of the Architectural Department, and Turkish and Muslim instructors were employed at the school after 1908. The rising nationalism soon showed its influence in the architecture of the city. Under this political atmosphere the revivalist style gradually became an official architectural genre of the last phase of the Ottoman Empire. In other words, the dominance of political Turkism was manifested through the public buildings that were built in a revivalist style considered appropriate to the emerging nationalism. In this sense, architecture provided a rhetorical tool for the Ottoman administration by which the synthesis of nationalism and religion could be portrayed vividly to the society.

The path of this radical shift towards the national architecture had already become apparent as early as the mid-1880s. In this context, the use of imported

stylistic elements from remote Islamic cultures was gradually abandoned towards the end of the century. The buildings constructed in revivalist style at this stage show more domestic features, including figures derived from Ottoman and Seljuk architecture. Designed by Vallaury and constructed in 1897, the Duyun-u Umumiye or Ottoman Public Debt Administration Building is one of the early and most notable examples of this transitional period in revivalist tastes. Occupying a deeply sloping site with a commanding view of the Golden Horn and the Bosphorus, the building was designed to house the office that was established after the Ottoman Empire's bankruptcy in 1876 to administrate the financial liabilities of the state. Authorised to collect taxes to secure debts directly on the behalf of European creditors, the Office of Public Debts provided assurances to foreign investors and merchants, and accelerated the integration of the Ottoman Empire into the world economy. The importance of the building's function was mirrored by its overall composition and facade arrangement where many characteristics of monumental Ottoman and Seljuk architecture were skilfully adapted on strong Beaux-Arts principles of order and symmetry. In particular, the principal doorway entry, formed by a three-storey lofty pointed arch, drew strongly on Seljuk architecture. The curved deep roof overhangs and flattened pointed arches also reflected the Baroque influences in Ottoman architecture, which had been employed since the mid-eighteenth century.

The other noteworthy building of this transitional revivalist architecture was the Mekteb-i Tıbbıye-i Şahane, or the Imperial School of Medicine, constructed in Üsküdar on the Asian side of Istanbul between 1893 and 1903. The design was an outcome of collaboration between Vallaury and D'Aronco. The Medical School building occupies a huge quadrangle measuring 180 metres by 125 metres and like its neighbour, Selimiye Barracks, it enjoys commanding views of the Bosphorus and dominates the skyline of the Asian shores of Istanbul. The Ottoman administration made every effort to make the school the equal of its counterparts in Europe. Best quality stones and marbles were taken from West Anatolian quarries, lime was imported from Marseilles, structural ironwork was brought from Belgium and metal joinery was imported from Austria. Its strategic location, colossal dimensions and the use of fine building materials vividly illustrate the importance of Abdülhamid's reforms in educational arena. Stylistically, the building represents hybrid characteristics. The very dynamic manifestation of the eastern facade is ornamented by Orientalist motifs such as onion-domes and finials with Baroque inspired curvilinear roof awnings. Facing to the Bosphorus, the western facade, in contrast, displays a monolithic building envelope adorned by large pointed-arched

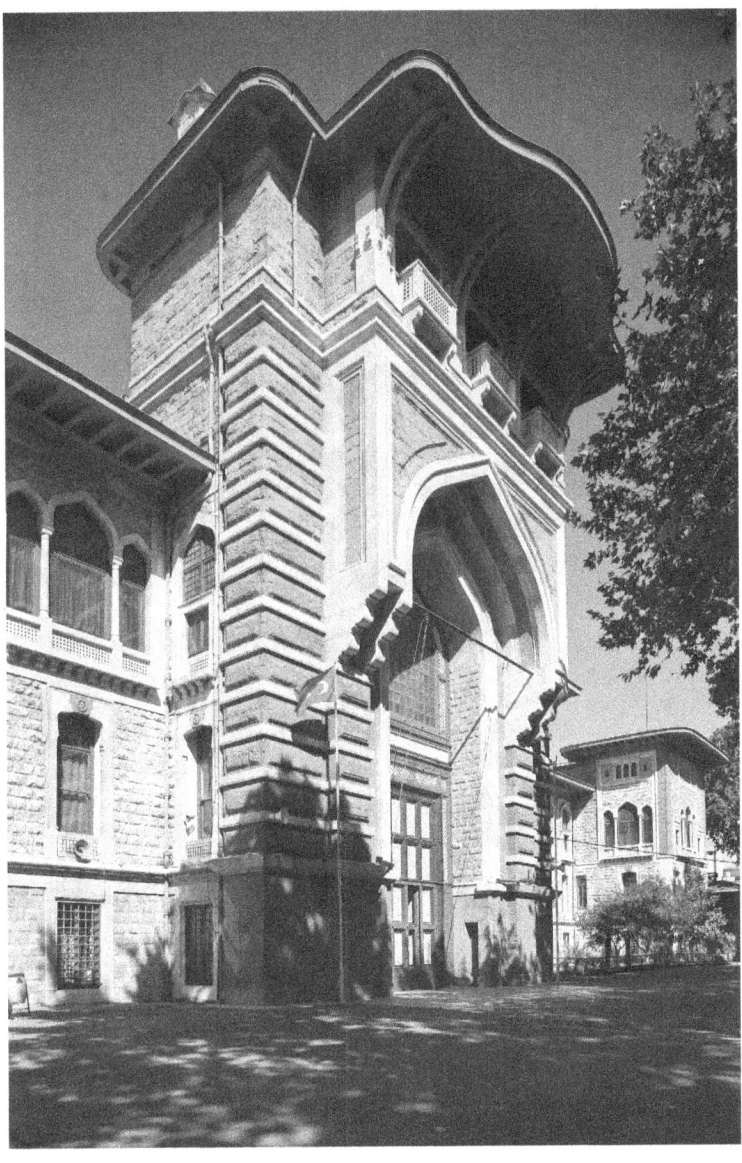

Image 14 The monumental gate of the Public Debts Administration Building, Aras Neftçi

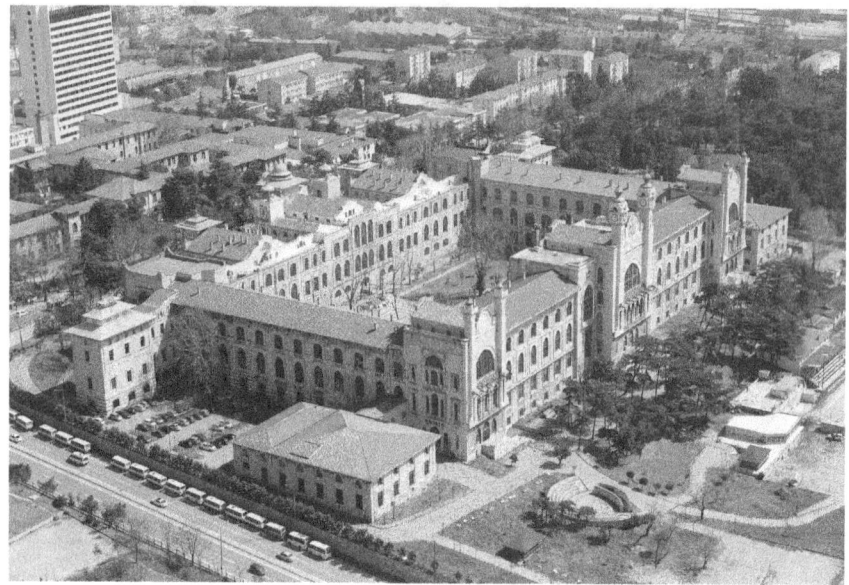

Image 15 The Imperial School of Medicine at Haydarpaşa on the Asian side of Istanbul, Aras Neftçi

openings drew upon classical Ottoman architecture and twin clock towers reminiscent of Seljukid *medreses*.

Following the preliminary examples of this nationalist spirit in architecture, the genuine Ottoman Revival came at the turn of the century with works by two prominent Turkish architects. Born in the early 1870s in Istanbul, Kemalettin Bey was one of the most influential architects of the late Ottoman period. Following completion of his first professional education at the School of Civil Engineering under the guidance of German and Austrian instructors, Kemalettin worked as the assistant to Jasmund, who was an instructor at the Engineering School, until he was sent to Berlin in 1895 to continue his architectural education at Charlottenburg School of Technology where he studied for two years. After graduation he stayed in Germany for another two and a half years and worked in various architects' offices, and probably went to Rome as well.[42] In 1900 he returned to his post at the Civil Engineering School, and two years later he also began to work at the Ministry of War where he was further introduced to a growing sense of Turkish nationalism. In 1922 Kemalettin was invited by the Supreme Muslim Council of the Islamic State of Palestine, under British mandate, to undertake the restoration works of Masjid Al-Aksa in Jerusalem, and this work brought him

honorific membership of the Royal Institute of British Architects.[43] The other significant figure of this period was Vedat Bey. He was born in Istanbul in 1873 as the son of Sırrı Pasha, the governor of Baghdad, and composer Leyla Hanım. Following his education at the most prestigious school in the Ottoman capital, the Galatasaray School, he went to Paris and enrolled at the École Monge. In the following years Vedat Bey studied at the École Centrale and later was admitted to the École des Beaux-Arts in Paris where he obtained his architectural education. Upon his return to Turkey, Vedat Bey worked at Şehremaneti (Municipality) and in the ministries of Postal Services and War.[44]

No other architects influenced Turkish architecture more than these two leading figures, who continued their professional work until the early decades of the twentieth century. Kemalettin Bey and Vedat Bey were two Turkish architects who were not only experienced with classical Turkish masterpieces but also had a good command of Western architecture, as they had familiarised themselves with it during their professional educations in Europe. These two prominent architects, together with the pupils who were educated by them, created the new Turkish architecture and designed many buildings in Istanbul that made a significant impact on the city's cultural landscape.

The Ottoman Revival style had a hybrid character. On the one hand, designers were seduced by the muscular glory of the sixteenth-century Ottoman masterpieces. The most distinguished elements of classical Ottoman architecture, such as pointed arches, *muqarnas* and lozenge column capitals, Rumi motifs and rosettes, and tiled facade decorations were favoured treatments for decorating Ottoman Revival buildings. On the other hand, the buildings in terms of their general outline characterised principles of Western architectural traditions, especially the Beaux-Arts style: regularity, axial arrangement and symmetry of the plan layout and facade organisation. This dual characteristic of Ottoman Revival was a rational outcome of the traits of its designers: Western architectural education and social awareness strongly blended with national sentiments. Also, the rationalist temperament of this architectural fashion was a natural outcome of the overall modernisation of the state apparatus of the Ottoman Empire.

The retrospective stylistic elements in Ottoman architecture followed a pattern that was characteristic of many countries at the *fin de siècle*. As part of the new world order that came after industrialisation and colonialism, 'national' architectural styles became effective tools for political ideologies in this rapidly changing world. In Victorian Britain, Gothic Revival or Neo-Gothic was a

fashionable architectural style for domestic, ecclesiastical and public buildings, and also became a vivid symbol of colonialism across the lands ruled or administered by Britain. In a general sense, it came into existence as a reaction to the centuries-long hegemony of neo-classical styles over genuine English forms. In North America too, neo-Gothic was not only a preferred style for churches but also colleges and university buildings, as well as some early skyscrapers. Moreover, various tones of revivalism inspired by past forms of other cultures were also used across the globe. Spanish colonial architecture, for example, was another revivalist style which was much preferred in parts of the United States in the early twentieth century. In Egypt Neo-Mamluk buildings were designed as part of the Egyptian modernisation process. The Austro-Hungarian Empire supported pseudo-Moorish architecture in its new Muslim dominated territories, such as Bosnia and Herzegovina, as part of its colonising programme. Without doubt, the architects that patronised the Ottoman Revival were very much aware of these trends, and had opportunities to familiarise themselves with both theories and examples of revivalism during their years of education in Europe.

The first major architectural project of this new period came with Vedat Bey's design of the Ministry of Post and Telegraph building in Sirkeci. Constructed between 1905 and 1909, the layout of this large building mirrored similar building types in the West, with a lofty atrium centrally placed on the plan. Thanks to new technologies such as reinforced concrete and steel, this large space was covered by a coloured glass roof. The entry was designed through a loggia accessed by white marble stairs. The symmetrically arranged main facade, which extended 90 metres, represented other characteristics of Beaux-Arts including regularity and axial arrangement. Similar to its contemporaries, the pointed arched windows, roof overhangs and tiled panels formed the Ottoman Revivalist flavour of the building. Two small domes positioned on either end of the front facade completed the strong symmetrical arrangement.

The Defter-i Hakani, or the Land and Titles Office, was the second major project bearing the signature of Vedat Bey. Completed in 1908, the immense public building was constructed next to the ancient Hippodrome on a site which was previously occupied by the sixteenth-century İbrahim Pasha Palace. Similar to other revivalist examples, the building had a symmetrical composition and its main facade was arranged on strong Beaux-Arts principles such as regularity and axiality. In terms of its artistic expression, the four-storey masonry building was adorned by selective decorative elements, all derived from classical Ottoman architecture. The pointed arched windows, *muqarnas* buttresses, deep timber roof

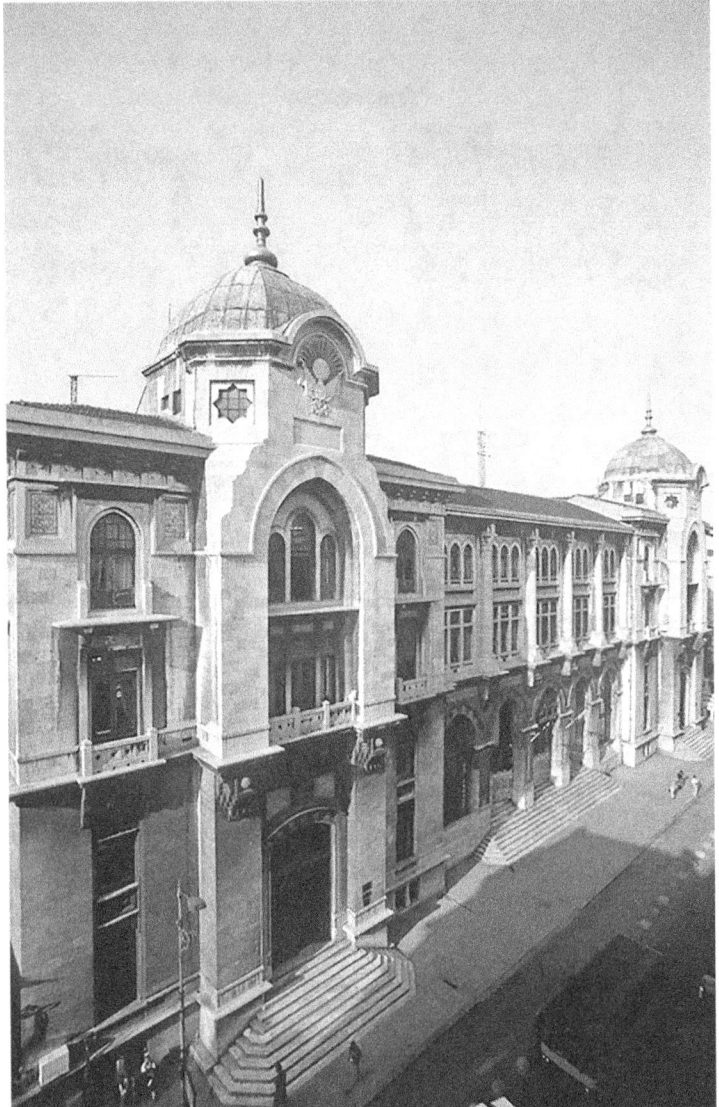

Image 16 The Ministry of Post and Telegraph building (present-day General Post Office) at Sirkeci, Aras Neftçi

overhangs and tiled panels together formed a collage of components borrowed from the sixteenth-century masterpieces of Ottoman architecture.

Kemalettin Bey, who then was appointed to the newly established Committee of Buildings and Renovation under the Ministry of Public Works, was given the

Image 17 The commanding view of the Land and Titles Office facing the Sultanahmet Mosque, Murat Gül

task of designing seven commercial office buildings by the Ministry of Pious Foundation between 1911 and 1925. Named Vakıf Hans, these buildings in the Historic Peninsula of Istanbul were early examples of large-scale, multi-storey office buildings equipped with modern technologies such as central heating, electricity and lifts. The first Vakıf Han was designed in 1911 and completed in 1918. The six-storey building comprised 50 offices on the upper floors and a large commercial area covering the entire ground floor. The following years saw the construction of four more office buildings, but the last two of the seven were never constructed. The fourth Vakıf Han, the largest of the series, was designed in 1911 but difficult economic conditions before, and during, World War I delayed the completion of the building until 1926. The building of six storeys, plus a basement, was constructed with a steel frame and facades visible from the street were made with clear-cut stone. Despite its irregular plan layout, the building's main facade embodied a strong symmetrical arrangement formed on axial and regular composition. Ottoman Revivalism is evident with the facade ornamentation by *muqarnas* brackets and string courses, pointed arched penetration, tiled panels and rosettes and reliefs derived from classical Ottoman architecture. Similar to

Image 18 The Fourth Vakıf Han, Aras Neftçi

Vedat Bey's Ministry of Post and Telegraph building, the absolute symmetry of the building's principal facade is completed by two onion-domes skilfully positioned at each end of the long building.

Retrospectively named the *Birinci Milli Mimari Üslubu*, or 'First National Style of Architecture', by twentieth-century architectural historians, this new style was not only executed by Turkish architects but also passionately exercised by non-Muslim Ottoman and Levantine architects in the last years of the Ottoman Empire. Born in Istanbul in 1873, Giulio Mongeri, a Levantine architect of Italian extraction, was amongst the significant architects of this period. He was one of the most celebrated graduates of the Brera Academy in Milan, where he studied under Camillo Boito who enjoyed a reputation for building restorations. Mongeri's Turkish career was very productive. In 1909 he was appointed to the Sanayi-i Nefise Mektebi as an instructor and worked there until he returned to Italy in 1912.[45] Upon his return to Turkey in 1918, where he stayed until 1930, Mongeri completed a wide range of buildings in Istanbul, Bursa and Ankara, not only in Ottoman Revival style but also neo-Gothic, neo-Byzantine, Milanese or Florentine palazzo styles.

The end of Ottoman Istanbul

All the buildings constructed throughout the nineteenth and early twentieth centuries, regardless of their stylistic attributes, changed the urban morphology of Istanbul dramatically. The architectural character of Ottoman Istanbul until the mid-nineteenth century was predominantly determined by large sultanic mosques and the *medrese*s, *hamam*s and other ancillary buildings associated with them. Although the embryonic seeds of Westernisation were sown in the mid-eighteenth century with the arrival of French Baroque, the buildings constructed in this period did not produce an arresting change to the urban landscape of the city. The artistic inspiration was imported from Europe yet the buildings that those styles were implemented upon were classical Ottoman religious and public buildings. That is why the fusion of established Ottoman and Baroque and Rococo styles produced a unique Turkish architecture. Conversely, the architectural products of the second half of the nineteenth and early twentieth centuries, namely lavish coastal palaces, military barracks, schools, commercial buildings, post offices and other public and civic structures, were all new building types required by a modernising society. It was these buildings, with their bulky envelopes, that began to challenge the classical urban morphology of the city.

The intense building activity and growing impact of Turkish architects brought about the first professional organisation for architects soon after the commencement of the Second Constitutional Era (1908–19). It came as an initiative of Kemalettin Bey and was founded in late 1908 as the Osmanlı Mühendis ve Mimar Cemiyeti, or the Society of Ottoman Engineers and Architects. Although the society began to publish its magazine in 1912, just before the Balkan Wars, it soon became a dysfunctional organisation. Turkey had to wait almost 40 years for a new professional organisation formed by practising architects.[46]

During this period Istanbul also witnessed significant infrastructure works, which improved public amenity in the city significantly. Despite the bitter political and economic conditions experienced in the dying years of the aged empire, the Ottoman administration managed to undertake costly public buildings and other important civic projects, such as the renewal of the bridge over the Golden Horn, the introduction of electric tram lines in 1912, the construction of electricity and telephone networks between 1912 and 1914, the laying of sewage lines, and the construction of public parks and recreational areas. Street regularisations, according to plans drafted by European engineers, were also undertaken in the areas destroyed by catastrophic fires.[47] This gave Istanbul the first large boulevard

of 50-metres width, although it was only partially built, between Yenikapı and Aksaray.[48]

This gradual change also attracted criticism from Ottoman intellectuals who saw such attempts as intruding upon Istanbul's historic character. According to Kemalettin Bey, the urban regularisation works carried out in Istanbul had a shattering impact on the city. Reminiscent of William Morris' Arts and Crafts concept, Kemalettin in his writings defended the revival of traditional building techniques against the cheap industrial products imported from European countries. He expostulated that the road works conducted by 'tram engineers' had the aim of simply opening up large boulevards without taking into consideration the city's supreme characteristics. For him, similar devastating works had been made in European cities but the Europeans had realised their mistakes and changed their policies to keep the historic character of their cities.[49] What is interesting to note here is that although Kemalettin Bey was highly critical of urban modernisation, his buildings were indeed the product of this process and were themselves seen as incongruous by others. According to Mehmed Ziya Bey, a founding member of both the High Council of Education and the Museum of Islamic Foundation, the Fourth Vakıf Han, with its bulky envelope, cut natural ventilation and generated an adverse impact on the perception of the city from the Golden Horn.[50]

While all these changes were gradually morphing the Ottoman capital into modern Istanbul, the Ottoman Empire was being challenged by severe social, economic and political problems. The continual loss of territories and military defeats, massive immigration, bitter economic conditions and political instability led to the collapse of the aged empire after World War I. At the end of this long and painful journey, Istanbul was occupied by British forces on 13 November 1918. This occupation and subsequent political developments of the following few years brought a decisive end to the Ottoman Istanbul of four and a half centuries, and the city would soon find itself in a totally different atmosphere where its modernisation would continue under very different circumstances.

2

Republican Istanbul: secularisation of the old city

In 1923 the modern Turkish Republic was established from the ashes of the Ottoman Empire after a successful military campaign by the national resistance movement against the British, French, Italian and, in particular, Greek forces that occupied the last remaining parts of the empire immediately after World War I. Led by Mustafa Kemal, who later adopted the surname Atatürk, 'Father of the Turks', this new era marked the beginning of an intensive phase of modernisation, bringing fundamental institutional change to the country's political, social and economic structures. Although the Turkish modernisation process had taken many important steps since the late eighteenth century, the reform project drafted by the Republican administration was much more radical. Its aim was the wholesale transformation of the multi-ethnic Ottoman society into a modern and Westernised Turkish nation.

In line with this sweeping reform agenda, the Sultanate was abolished and members of the royal family were banned from living in the new Turkey. For the Republican modernisers, religion was the primary reason for the backwardness of the country, and they therefore targeted all religious institutions and conducted a rigorous secularisation process. The Caliphate, the most prestigious Islamic establishment, was abolished in 1924. This was followed by the closing of religious lodges, banning the use of Islamic titles, removing religious education from school curricula and forbidding visits to the shrines and tombs of sacred dignitaries. Soon the radical reform programme was expanded and targeted all institutions of the old regime. With the aim of 'achieving the level of contemporary civilisations', all aspects of Turkish social and cultural life were rearranged according to Western standards and cultural norms. The legislative structure was redrafted entirely, with the adoption of new legal codes borrowed from the Swiss, German and Italian

systems. Reforms were extended further and the Arabic script was replaced by the Roman alphabet, the Islamic lunar calendar was substituted with the Gregorian calendar, Sunday was declared an official holiday instead of the Islamic Friday and the metric system of measurement was adopted. The reforms in the sociocultural area included the adoption of the *Surname Act*, granting political equality for women as well as outlawing religious rules governing marriage and inheritance. These reforms brought radical changes to almost all aspects of Turkish cultural life. From simple eating habits to entertainment and dressing, all were completely redesigned according to Western cultural mores.

For Istanbul, the most far-reaching decision taken by the Republican administration was the selection of Ankara, then a modest central Anatolian town of 20,000 people, as the capital of the new republic. If the new regime wanted to create a brand new Turkish identity, Istanbul was definitely not the place to do it. Replacing the aged capital was a logical choice for the new regime as it wanted to cut all ties with the previous Ottoman culture and open a new page in Turkish history. Istanbul, in the eyes of the Republican modernisers, was both socially and physically associated with the old system and the symbol of a degraded and corrupt Ottoman identity. Its crooked streets lined with grimy timber dwellings, the strict social control by religious authorities in traditional neighbourhoods, and the cosmopolitan social structure comprised of many different ethnic and religious communities were all emblematic characteristics that the Republicans wanted to remove from the new system. Ankara, on the other hand, was already the centre for the national resistance movement following the control of Istanbul by occupying armies after World War I. The National Assembly was set up there in 1920 during the most difficult of the resistance years. Ankara was also located geographically at the centre of Anatolia and linked with Istanbul and Konya by railway lines. The small Anatolian town was ideal for the creation of a new centre in accordance with the Republican modernisation programme. Thus all financial sources were canalised to create a new capital for the young Turkish Republic,[1] and the new vision for Ankara came into being guided by prize-winning urban plans drafted by German planner Hermann Jansen.[2]

The relocation of the capital to Ankara, however, was not an easy task for the government. Istanbul had been the capital of the Ottoman Empire for almost five centuries. In the eyes of many intellectuals and bureaucrats who had strong emotional connections to the city, the transfer to Ankara was a temporary move whilst Istanbul was under occupation. To break these hopes, the Republican administration took a series of tactical steps. On 6 October 1923, seven days

before Ankara was declared the new capital, Mustafa Kemal, in his meeting with representatives of the Istanbul press in İzmit (a small city to the east of Istanbul), emphasised the importance of selecting a geographically secure location for the capital of the new Turkey. When the bill proposing the relocation of the capital was introduced at the Assembly, it also proposed to keep Istanbul as the seat of the Caliphate. This decision gave Turkey two capitals until the Caliphate was abolished the following year.

Istanbul, which for decades had already been struggling with severe social problems, now saw bitter days. During the occupation all investments had been suspended and basic municipal services, which were already far from being satisfactory before the war, were now performed only at the most minimum of levels. Cemil Pasha, who was twice mayor of Istanbul in 1912 and 1919, tells in his memoirs of finding the city in a miserable condition upon his return from Geneva to Istanbul in 1919. Istanbul, in Cemil Pasha's words, was highly damaged, dirty and neglected. Streets were out of repair and full of rubbish, hygiene was non-existent, parks and recreation areas that had been built in the early 1910s were now in ruins. In particular, Gülhane Park, which had been constructed within part of Topkapı Palace's gardens at Cemil Pasha's particular initiative as the personal physician of the Sultan, had become stables for the horses of the French contingents.[3]

Istanbul's rich cosmopolitan demographic structure changed dramatically throughout the early years of the Republican period. In 1885 Muslim inhabitants represented 44 per cent of the Ottoman capital. This figure rose dramatically and reached 64 per cent in 1927. The pre-war population of the city also showed a sharp 50 per cent decline to 704,825 in the same year.[4] In response to the new political programme to create a national bourgeoisie, the majority of non-Muslim merchants, businessmen, artisans and shopkeepers, who had dominated the economic life of the city, left Istanbul. Although the Exchange of Population Protocol, signed between Turkey and Greece as an annexure to the 1923 Lausanne Treaty, exempted the Greek population of Istanbul, which had resided in the city prior to 1918, from the compulsory immigration, many Greeks of Istanbul left the city in the early years of the republic. Between 1922 and 1926, according to different sources, from 70,000 to 150,000 Greeks emigrated from Istanbul.[5] As noted by Mahmut Celâl Bey (Bayar), then the minister for Development and Settlement Affairs for the Population Exchange between Turkey and Greece, the great majority of the Greeks leaving Turkey were businessmen, members of guilds or artisans who had played important roles in the economic life of Turkey in general and Istanbul in particular.[6]

The Armenian population of Istanbul had also been affected by political tensions since the late nineteenth century. The bloody occupation of the Ottoman Bank headquarters by Armenian militants in Istanbul in 1896 was the turning point in the Turkish–Armenian relationship.[7] The situation worsened after an unsuccessful assassination attempt on Abdülhamid II in 1905 by a group of Armenian saboteurs. Although Armenians of Istanbul, except for unmarried males, were exempted from the *tehcir* (compulsory relocation) during World War I, many members of the Armenian community left the city in 1922 just before the establishment of the Turkish Republic. This period also saw some symbolic steps taken by the Republican administration. The Post Office, for example, began to return all letters addressed to 'Constantinople', and the Grande Rue de Pera, the most significant thoroughfare of the city, was renamed 'İstiklal' (Independence).

Predictably, the declaration of Ankara as the new capital was not well received in Istanbul. With this important political decision Istanbul lost all the administrative and political privileges it had gained over centuries. The Republican regime conducted a psychological war against the resistance to its reform programme. Above all, the loyalists of the old regime were still very powerful in Istanbul. The press published articles to criticise the reform agenda conducted by the Republicans, in particular the abolishment of the Caliphate. For many intellectuals, bureaucrats and diplomats, residing in Ankara was temporary and soon they would escape from the 'dusty and boring' Anatolian town and resume their colourful life in Istanbul. In a telling sign of the neglect of the old capital, Mustafa Kemal did not visit the most significant city of Turkey until 1927, although he toured the entire country and passed through the Bosphorus in the preceding years.

The removal of the capital to Ankara also weakened the economic life of the city. As a result of the relocation of governmental offices and institutions to the new capital, tens of thousands of public servants in Istanbul lost their jobs. Furthermore, the Great Depression of 1929 also affected Istanbul deeply.[8] Political disregard turned into economic negligence in the early years of the 1930s. The limited resources of the state were diverted to develop Ankara and other Anatolian cities. One of the vivid indications of this neglect was Istanbul's very limited existence in the First Five Year Development Plan which was drafted for the period of 1934–9. The only noteworthy investment proposed for Istanbul in the plan was the establishment of the Paşabahçe Glass and Bottle Factory which had been first initiated in the late Ottoman period.[9]

Republican Istanbul: secularisation of the old city

While Ankara was becoming the rising star of the new Turkey, Istanbul had to accustom itself to its new status and to challenging conditions. In April 1923 Haydar Bey was appointed the first Republican mayor of the city. He was replaced by Emin Bey who remained in the office until 1928. Muhittin Bey became the third Republican mayor of Istanbul and remained in the position until the end of 1938. In terms of urban affairs, the years between 1923 and 1933 represented a very quiet period for Istanbul. Apart from some works delayed due to World War I and then the occupation, no large-scale development occurred in the city. A redevelopment plan made by German planner Carl Christoph Lörcher, who also drafted the first, but unexecuted, plan of Ankara in 1924, remained on paper. The construction of the 30-metre-wide Fevzi Paşa Street, linking Fatih to Edinekapı on the Theodosian Walls, and the reorganisation of Beyazıt Square (the ancient Forum Tauri) with a decorative pool at its centre were amongst the few noteworthy developments that occurred in the second half of the 1920s in Istanbul. Yet the most symbolic urban landmark of this period was the construction of the Republic Monument in Taksim in 1928. Designed by Italian sculptor Pietro Canonica, and encircled by a delicately designed landscape by Guilio Mongeri, the monument depicts Mustafa Kemal and two other prominent figures of the republic, İsmet Pasha and Marshal Fevzi Pasha, as well as scenes representing the

Image 19 The Republic Monument at Taksim Square, *c*.1940s, MSGSÜ, Restoration Department Archives, Istanbul

National Independence War and the establishment of the republic.¹⁰ Most interestingly, Mikhail Frunze and Kliment Voroshilov, leading figures of the 1917 Russian Revolution, are discreetly positioned behind Mustafa Kemal, acknowledging the help sent by the Soviets during the National Resistance years.

Despite all the difficulties and neglect, Istanbul was still the most strategic and significant centre of Turkey. It retained its status as the hub of intellectual life in the country. Although the new government, between 1925 and 1936, opened a group of schools in law, education, social and political sciences in Ankara, Istanbul was the main Turkish city offering Turkish citizens higher education in many areas, ranging from engineering to medicine. Istanbul was also the most industrialised city of Turkey. A quick review of the available statistics vividly demonstrates Istanbul's leading position in the new Turkey. For example, between 1932 and 1944, the era marked by the *Teşviki Sanayi Kanunu* (The Industrial Support Act), 25 per cent of all Turkish industrial establishments were located in Istanbul, and 35 per cent of the added value created by those establishments was generated in Istanbul.¹¹ In 1933, of the total 7,133 motor vehicles in Turkey, 2,326 were registered in Istanbul.¹²

Architecture in the early Republican years

In the 1920s Ottoman Revivalism was still the most preferred architectural fashion in Turkey. The prominent figures of this style, Kemalettin Bey, Vedat Bey and Mongeri, were called to Ankara and commissioned to design new buildings for the city. Selecting the most prominent Ottoman Revivalist architects to construct Ankara was an ironic choice for the regime, which wanted to cut all ties with Ottoman culture and create a brand new modernist city. The result was that in the 1920s many buildings in Ankara – the National Assembly, banks, hotels and other public buildings – were paradoxically constructed in Neo-Ottoman style. This retrospective stylistic choice could only be possible under a political atmosphere where many Republican elites were still advocating a smoother reform programme which did not require the total denial of Ottoman cultural norms. Towards the end of the 1920s, however, Ottoman Revivalism was completely abandoned in favour of European modernism when the Republican elites who demanded a much more radical transformation agenda consolidated their power in the state apparatus and crushed their political opponents.

Known in Turkey as *Kübik Mimari* (Cubic Architecture), the fashionable tones of European modernism gained full-scale acceptance in official architectural works from the early days of the 1930s. The new Turkish state was established as

Republican Istanbul: secularisation of the old city

a fresh beginning in Turkish history with almost no regard to the *ancien régime*. The new Turkish architecture, in line with this overall policy of denial and in the eyes of the elite, required cutting all ties with the old styles and traditions of the Ottoman Empire. Cubic forms were seen as the most appropriate way to express the rationalist, dynamic and secular character of the new state. Behçet and Bedretttin, two young architects of 1930s Turkey, wrote: 'The great Turkish nation did not consider modernising *fez* but replaced it with the hat in making revolution in dressing. They did not try to revise the Arabic script but replaced it with the Latin alphabet. Today's Turkish architects too abandoned the forms containing domes, floral motifs and tiles. They are walking on a new and logical path'.[13] Thus a group of German speaking architects – Wilhelm Schütte, Margarete Schütte-Lihotzky, Ernst Egli, Bruno Taut, Martin Elsaesser and Clemens Holzmeister – were commissioned to create the new Ankara. In the meantime, following Mongeri and Vedat Bey, Egli was appointed in 1930 as the director of the sole architectural school in Turkey and he redesigned the entire curriculum, which had been modelled on the French Ecolé des Beaux-Arts system when it was established in 1883. The radical transition to European modernism was also evident in the terminology associated with architecture. In the same year, Sanayi-i Nefise Mektebi Âlisi, the Ottoman–Turkish name of the school, was modernised and became Güzel Sanatlar Akademisi (The Academy of Fine Arts). In 1934 the state officials urged the editors of the architectural magazine *Mimar* to replace its Arabic origin name. After considering various options, *Arkitekt* was chosen by the editors which was inspired by a Finnish architectural magazine *Arkkitehti*.[14] Authors of *Arkitekt* began to use *ar* (derived from the French *arts*) instead of *sanat* (another word of Arabic origin) for art. The heading of the magazine's last section, *Haberler* (a word of Arabic origin meaning news), was replaced with the modern Turkish word *Duyumlar*. When the Surname Act came into force in the same year, the leading art and architectural historian of Turkey, Celâl Esad Bey, took *Arseven* as his surname, meaning 'art-lover'.

The sweeping impact of European Modernism, however, was not felt in Istanbul, and transition from Neo-Ottoman architecture to 1930s modern architecture was much smoother in Istanbul than in Ankara. Throughout the 1920s, Ottoman Revivalism kept its prominence and almost all noteworthy buildings continued to be designed in this retrospective style. One of Kemalettin Bey's prominent works, the Fourth Vakıf Han in Sirkeci, which had been interrupted during the war and following occupation, was finally able to be completed in 1926. New commercial buildings in Ottoman Revivalist style were also constructed across the Golden

Image 20 The İzmir Palace Apartment Building in Maçka, Aras Neftçi

Horn in Galata and Beyoğlu, the two most Europeanised districts of the city. The Elhamra Han in İstiklal Street is the prime example of this style and was completed in 1920. The İzmir Palace apartment building in Maçka district is another interesting example of this period. Designed by J. d'Armi in 1925, this seven-storey building pushes the limits of the Ottoman Revivalist style in a mannerist way. The cantilevered corner rectangular bay at 45 degrees is topped by a freestanding

Republican Istanbul: secularisation of the old city

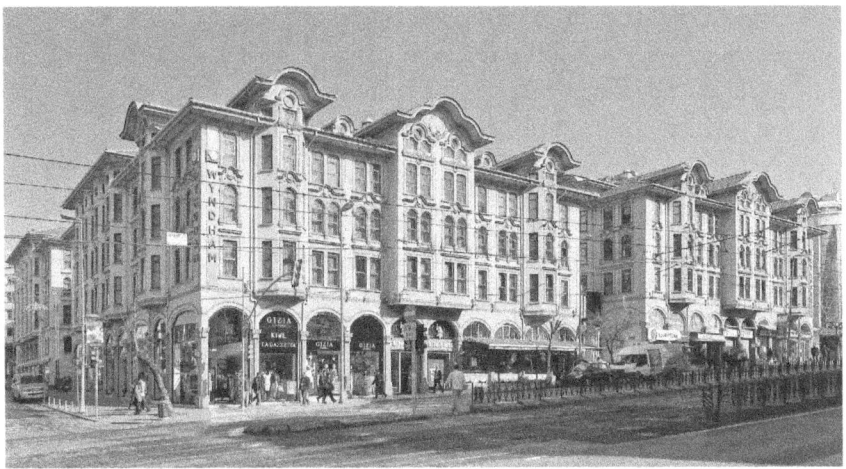

Image 21 Harikzedegan Apartments in Laleli, Murat Gül

octagonal pavilion, and the canopy over the roof terrace and the decorative elements in the iron balcony balustrades provide an interesting marriage between Ottoman Revival, Modernist and Art Deco styles.

The most remarkable residential project of the era in Istanbul, however, was the Harikzedegan apartment buildings (Apartments for Fire Victims), constructed in Laleli at the very centre of the Historic Peninsula. This multi-storey apartment complex bears the signature of Kemalettin Bey. The reinforced concrete residential complex was originally designed for those who lost their homes in a devastating fire in 1918 that affected Cibali, Altımermer and Fatih districts, and was completed in 1922. Encircling a cruciform courtyard, the four blocks comprise a total of 124 units, with their own courtyards, which are accessed by open corridors and serviced by staircases with circular landings. The ground floors comprise 25 shops fronting two streets. Stylistically, the residential complex differs from the other buildings designed by Kemalettin Bey. The curvilinear roof overhangs and the arched and circular windows successfully correspond with the adjoining mid-eighteenth-century Laleli Mosque designed in Ottoman Baroque style. Perhaps the most notable design feature of the residential complex is the semi-octagonal bay windows. Octagonal oriel was a significant stylistic element in English architecture that had become fashionable in turn-of-the-century Germany, and Kemalettin Bey probably became familiar with this English influence during his years in Germany and imported the feature to Istanbul. Although the apartments were designed as a social housing project, they were the first

dwellings in the Istanbul Peninsula equipped with running water, a common laundry and electricity. For this reason, the luxury apartments were never occupied by the intended users and, after the establishment of the Republic, the building was given to the Turkish Aviation Agency and rented out. The residential complex then became known as Tayyare Apartmanları (Aircraft Apartments).

Modernising Istanbul: Prostian years

Following a decade of neglect, the first signal of the government's intent to remodel Istanbul in line with the Kemalist spirit came in 1933 when an international urban planning competition was organised. Three European experts were invited to enter the contest: Donat Alfred Agache, Hermann Ehlgötz and Henri Prost. The latter, who was then the head of the Planning Bureau of Paris, declined the offer and another French planner Jacques-Henri Lambert joined the competition on the recommendation of the French Embassy in Ankara. All three participants were experienced urban planners who had worked on numerous significant projects. French architect and urban planner Agache had completed the plans for Dunkerque, Creil and Poitiers in his home country. He was also the author of the third-prize-winning urban design scheme for the Australian capital, Canberra. Ehlgötz was a proficient German urban planner who worked as a professor at the Department of Urban Planning in the Technische Hochschule in Berlin. The master plan of Essen was his most prominent work. The other French planner, Lambert, worked in New York and Chicago in the United States and served as Prost's deputy in Paris.

Providing an effective road network, introducing zoning, creating recreational areas and preserving Istanbul's heritage and archaeological potential were common themes shared by all three proposals. After detailed investigations, Ehlgözt's proposal was selected by the panel as his plan was seen as the most realistic and the least intrusive upon the historical and natural characteristics of the city.[15] Ehlgötz's scheme, however, was not implemented by the government.[16] In the meantime, another noteworthy proposal for the redevelopment of Istanbul came from the prominent Swiss-born architect, Le Corbusier, in 1933. He proposed the preservation of old Istanbul and the creation of new districts outside the city walls. Le Corbusier's proposal met the same fate as Ehlgözt's scheme and was not favoured by the government. As Le Corbusier admitted many years later, suggesting the retention of the historic city without any major interventions was a strategic mistake as the government's aim was to change the physical and social morphology of the old Ottoman capital to align the city with its modernisation agenda for the whole country.[17]

Republican Istanbul: secularisation of the old city

Unsatisfied by the results of the previous attempts, the government knocked on the door of Henri Prost once again. The French planner had an esteemed reputation and his professional portfolio included many prestigious positions and works in Paris, Antwerp, St Tropez and St Raphael. Prost knew Istanbul from the years of his early career as he had visited the city twice, in 1905 and 1907, when he was studying at the French Institute at the Villa Medici in Rome, and had been awarded the prestigious *Prix de Rome*. In addition to his shining professional skills as an urban planner, his experience in modernising French-mandated traditional Islamic cities in North Africa was highly valued by the Republican government which wanted to undertake a similar modernisation of the old Ottoman capital.

Prost, who had declined to participate in the 1933 competition, accepted the offer this time and came to Istanbul in 1936. He stayed in the city as its chief planner for 14 years until 1950 and worked with three governor-mayors: Muhittin Üstündağ (1928–38), Lütfi Kırdar (1938–49) and Fahrettin Kerim Gökay (1949–57). Following a two-year preparation period, his plans were given approval by Istanbul Municipality in 1938 and then by the Ministry of Public Works the following year. The atmosphere at the Municipal Assembly was very cheerful. After century-long efforts Istanbul would finally have large avenues, parks, promenades and squares similar to its European counterparts. Furthermore, all those proposals would bear the signature of a skilled urban planner.

Prost did not prepare an overarching master plan covering the entire metropolitan area of Istanbul. Instead, he made separate plans for Istanbul Peninsula, Galata/Beyoğlu district, Üsküdar, Eyüp and Princes' Islands. Six principles underpinned his plans for the Historic Peninsula and Beyoğlu: improving the old street network by constructing large boulevards, clearing the environments surrounding monuments, rehabilitating the poorly serviced neighbourhoods and increasing hygienic standards, introducing zoning, conserving historic monuments and national beauties and, finally, preserving the legendary silhouette of the city which was crowned by domes and minarets from significant sightlines.[18] However, the division of the city into residential, commercial and industrial zones and the setting up of an effective transportation network were the priorities for the French urban planner. Above all, Prost's vision for Istanbul was based on the idea of establishing uninterrupted motorcar traffic throughout the city. In the Historic Peninsula Prost proposed large streets of up to 50-metres width connecting the important centres of the city to each other. Eminönü, for example, was to be connected to Sultanahmet and Süleymaniye by wide avenues. The large boulevard made on the recommendations of André Auric that connected Yenikapı to Aksaray in the early twentieth century, was to be extended

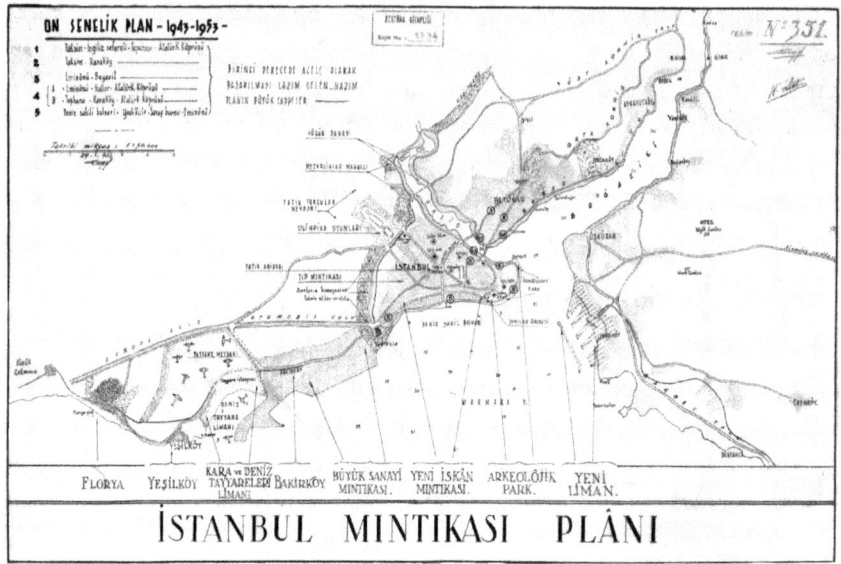

Image 22 The major aspects of Prost's plan for Istanbul, Atatürk Library, Istanbul Metropolitan Municipality

to the shores of the Golden Horn over Şehzadebaşı. Even the Grand Bazaar was to be surrounded by large streets. And, finally, the old city was to be encircled by two littoral avenues along the shores of the Sea of Marmara and the Golden Horn. Prost's proposal for the other side of the Golden Horn was even more radical. According to his plan, large roads associated with tunnels and viaducts were going to crisscross the entire region. In terms of the existing urban fabric, Prost was also recommending some extreme schemes. The entire area bounded by the northern shores of the Golden Horn and Taksim, for example, was to be demolished and reconstructed. In the Historic Peninsula his plan envisaged the creation of modern residential quarters, in particular in the western half of the peninsula. Constructing large parks and archaeological zones, both in the Historic Peninsula and in Beyoğlu, and converting the Golden Horn into an industrial zone were other significant aspects of Prost's plans. All these works were to signify a brand new Istanbul designed in accordance with modern urban principles.

Prost, despite his 14-year service and the optimism he created among the Republican elites, could only complete some of his works. Apart from a number of roads and parks, many of his proposals never left the drafting board. The bitter economic conditions during World War II were the main reason why many

Republican Istanbul: secularisation of the old city

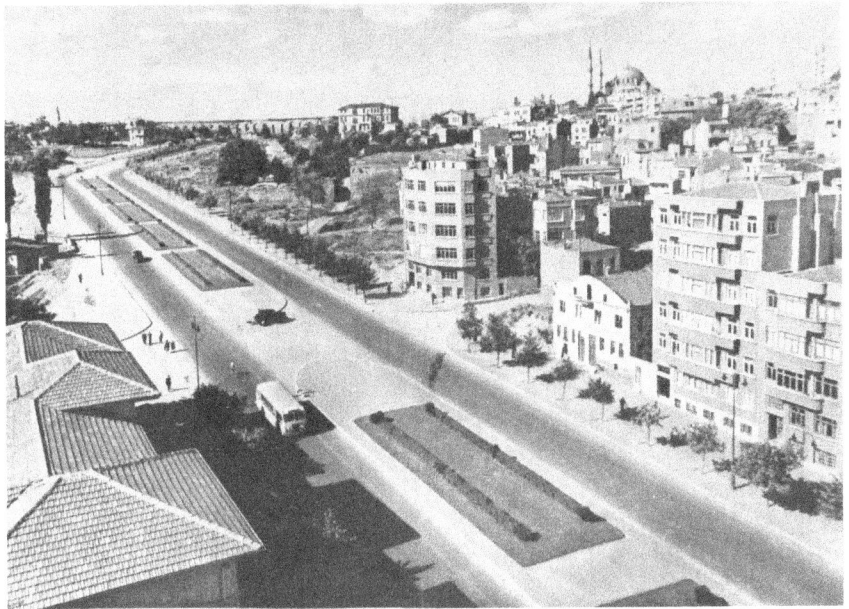

Image 23 The Atatürk Boulevard, c.1940s, Reproduced from *Cumhuriyet Devrinde İstanbul* (Istanbul: İstanbul Belediyesi, Neşriyat ve İstatistik Müdürlüğü, 1949)

of Prost's projects could not be implemented. The roads, squares and parks contained in the master plans were costly projects, and the government was unable to finance them while at the same time mobilising all its efforts in the defence sector. Furthermore, some of Prost's projects were unrealistic and not feasible. Many of the roads Prost proposed, in particular in Beyoğlu district, ignored the dominant topography of the city and required unnecessary demolitions that were difficult to justify. Moreover, his master plans were not supported by solid statistical data. Prost, for example, did not estimate the future population of Istanbul. Although his plans were based on the idea of establishing an effective vehicular traffic network, there was no data available to support his argument.

In the Historic Peninsula, the extension of Auric's large avenue to Unkapanı on the southern shores of the Golden Horn was the most strategic work Prost managed to complete. The large road, which slices the peninsula into two parts, was named Atatürk Boulevard and linked old Istanbul to Beyoğlu by way of Atatürk Bridge over the Golden Horn. The construction of a new square in Eminönü was the other significant work in old Istanbul, but it could only be partially completed. Although many buildings within the proximity of the Yeni Mosque were

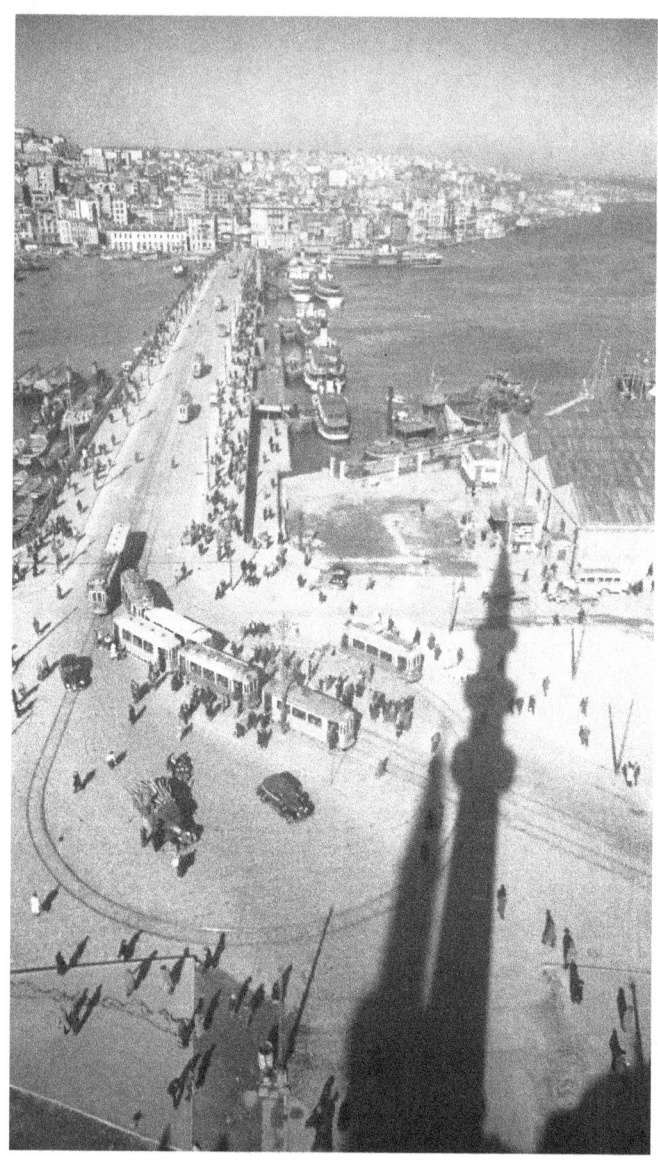

Image 24 Eminönü and Galata Bridge after demolitions, c.1940s, Yapı Kredi History Archives, Selahattin Giz Collection, Istanbul

Republican Istanbul: secularisation of the old city

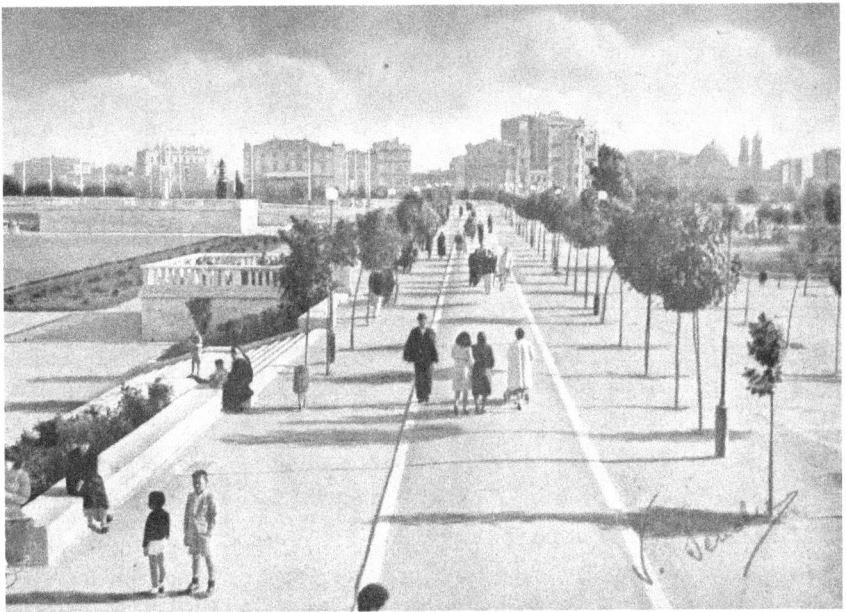

Image 25 İnönü Promenade, Reproduced from *Güzelleşen İstanbul* (Istanbul: İstanbul Belediyesi, 1943)

demolished, the new building blocks were not constructed, with the result that the area became a gigantic void without any architectural character.

Across the Golden Horn, the impact of Prost's projects was more intense. The reorganisation of Taksim district was the most significant work Prost was able to accomplish during his term in Istanbul. The late Ottoman Artillery Barracks were demolished and a new promenade was constructed. Named after İsmet İnönü, the second president of Turkey, İnönü Gezisi (İnönü Promenade) was completed by the construction of Maçka Park, an open-air theatre and a football stadium and, finally, the reorganisation of Taksim Square. These works were the most significant outcome of Prost's period in Istanbul during which he attempted to address the demanding Kemalist principles in order to transform Turkish society through architecture and urban design. In sharp contrast to old Istanbul's restrictive social atmosphere of religious-bound norms and customs, Taksim became the place where men and women could mix and participate equally in social and recreational activities of a secular nature.

The cultural landscape of Istanbul represented in Prost's vision was very much consistent with Kemalist rhetoric of the creation of a young and Westernised

country. His plans contained many strategic tools to shake up the existing social structure and the traditional urban morphology of the city. The large avenues would help to mobilise society and, therefore, would break the strict social control of the *mahalle* or the traditional neighbourhood. The parks and promenades would provide opportunity for the population of Istanbul to experience more freedom in their social and public life. Prost's reluctance to calculate future population increase in Istanbul was also consistent with the regime's overall social policy of retaining the overwhelmingly agrarian character of Turkey. As will be discussed in later parts of this chapter, in the 1930s peasantism had considerable acceptance among the different levels of the administration. For many Kemalists, the widely held view was that the masses should be kept in the villages and immigration to the cities should be discouraged. In the absence of reliable industry, increasing the population of the cities would create serious social problems which would affect the indoctrination efforts being made to seed the Kemalist spirit into the society.

Despite this intense ideological motivation, Prost's impact on the genuine problems of the city was modest and many of his efforts would not go beyond mere cosmetic applications. These shortcomings in Prost's plan, and the false and utopian assumptions upon which they were based, would soon become apparent after the end of World War II when Turkey would embark upon a new political era and Istanbul would reassume its pivotal role as the social and economic hub of the country.

The 1930s: Istanbul's 'apartmentisation'

While Istanbul's energised search for a modernising plan culminated in Prost's appointment, the architecture of the city underwent a smooth transformation from Ottoman Revivalism to early examples of modern architecture. This was most evident in its residential apartment buildings. Apartment living was not a new phenomenon in Istanbul as many multi-storey residential dwellings had been constructed from the 1890s in the Beyoğlu, Şişli and Nişantaşı districts of the Ottoman capital. The city had suffered from sporadic fires since the sixteenth century, which in many cases destroyed thousands of buildings and entire neighbourhoods. As a consequence, the city authorities tried to ban the construction of timber buildings and encouraged masonry structures in Istanbul. This was especially so in the newer parts of Istanbul that mainly emerged after the mid-nineteenth century. Designed primarily by non-Muslim Ottoman and Levantine architects, these apartment buildings represented the plurality and cosmopolitanism of Ottoman society and offer a broad

spectrum of styles from Neo-classical to Art Nouveau. In the early twentieth century, living in an apartment became a status symbol in Turkish society. Apartment living, with its modern layouts, running water and central heating, showed a deep contrast to life in the 'dilapidated' timber houses that lined the crooked streets of the Historic Peninsula. This preference for apartments was voiced by Prost in one of his later articles as, 'Turkish women do not want their old houses with *kafes* [timber window lattices] anymore... Some of them look for apartments equipped with lifts, central heating and hot water in every season'.[19] Nothing shows this fashion more vividly than a famous Turkish operetta, *Lüküs Hayat* (Luxurious Life), composed by Cemal Reşit Rey and written by his brother, Ekrem Reşit Rey, in 1933. The operetta humorously tells the story of the challenges faced by ordinary Turks when encountering extreme Westernisation. The irony here is that the operetta, which ridiculed the reactions of Turkish citizens to the European way of life, was itself a product of the Republican cultural shift towards Western civilisation. The major song of the operetta titled *Şişli'de Bir Apartıman* (An Apartment in Şişli) portrays apartment living as one of the most important symbols of a modern luxurious life, along with ownership of automobiles, modern furniture and oil paintings.

Residential architecture, especially in the form of multi-floor residential flat buildings, was therefore the most common architectural practice of 1930s Istanbul. Since all government efforts were being canalised for the creation of Ankara, Istanbul did not see any noteworthy public architecture throughout the 1930s. At the same time, since almost all major commissions in Ankara, such as ministerial buildings, offices and other public buildings, were given to European architects, residential development in Istanbul was the only substantial area where domestic architects could execute their profession during the 1930s.[20] Therefore, residential architecture was the solitary significant market for architects at a time when the city was seeing an influx of immigrants, occupation by foreign armies, demographic sterilisation by nationalistic policies, a dwindling population and, finally, a decade of political negligence by the new regime. Also, construction of residential apartment buildings was one of the safest investment choices for entrepreneurs during the harsh economic conditions of the 1930s. In a shrinking economy investment in real estate became an attractive business option for many capital owners. That is why in just six years, between 1928 and 1934, a total of 1,301 residential apartment buildings were constructed in Istanbul.[21]

The great majority of these new buildings were raised in Beyoğlu. Talimhane, Gümüşsuyu, Cihangir, Nişantaşı and Şişli were the most popular locations for multi-storey residential buildings in Istanbul. Named after their owners,

Image 26 The Ceylan Apartment Building in Talimhane, Rahmi M. Koç Archive & SALT Research, Sedad Hakkı Eldem Archive

the buildings were the showpieces of Turkish residential architecture and were equipped with modern devices such as central heating, electric lifts, running hot water and hygienic kitchens and bathrooms. Their size, location and services, such as laundries, garages and common areas, were all perceived as symbols of status by their owners. In the absence of residential flat ownership in the Turkish legal system of the 1930s, the apartment buildings were known colloquially as *kira evi* (rental houses), whereby the entire building belonged to a single owner and

apartments were rented out for income.²² Rather than describing a single unit in a building, in the Turkish language *apartman* (apartment) became a generic name for an entire building comprising a number of units.

Designed in 1933 by Sedad Hakkı Eldem, who at that time was a recent graduate of the Fine Arts Academy, Ceylan Apartmanı in Talimhane is one of the leading examples of this trend in Istanbul architecture. Sitting on a slightly sloping triangular lot in one of the city's most desired locations, the residential building comprises six large apartments occupying the entirety of each floor, two shops, a lofty entry hall on the ground floor and a basement reserved for services. The terrace is accessed by a cage-lift and was envisaged as a bar area. Soon after the completion of the Ceylan Apartment Building, Talimhane saw the construction of numerous residential flat buildings, making the district the most modern part of the city. Bearing the signature of notable twentieth-century architect Seyfi Arkan, Üçler Apartment Building is one of the largest examples of this trend in Gümüşsuyu. Strategically located next to the former German Embassy, this seven-storey building includes luxurious duplex apartments, equipped with contemporary services and constructed with quality building materials. Externally, the L-shaped, prismatic building envelope is accentuated with long cantilevered balconies and a flat rooftop canopy, all of which represent stylistic traits of Modernism.

Image 27 The Üçler Apartment Building in Gümüşsuyu, Aras Neftçi

Art Deco: a prized architectural style in 1930s Istanbul

If Central European modernism was the leading architectural style of Ankara, Art Deco was the most fashionable genre of Istanbul architecture in the 1930s. Emerging in the mid-1920s in France, Art Deco was an early modern style which was inspired by many different sources from around the world. It became an international movement that influenced many areas of design, ranging from furniture to jewellery to industrial design to graphic arts. As a fusion of 'traditional' and 'modern' in terms of its stylistic characteristics, with craft-based materials and workmanship and a machine age aesthetic, Art Deco was perhaps the artistic expression most appropriate to modernising Istanbul in the early Republican era. In other words, unlike Ankara where the Republican elite wanted to open a blank page and create a new capital from scratch, Istanbul had a cosmopolitan character and its inclusive social make-up meant that Art Deco was perceived as an apposite stylistic tool to achieve a smoother transition towards modernism. Since the early periods of Turkish modernisation in the mid-eighteenth century, Istanbul's architecture had always followed developments in European architecture. All styles, ranging from Baroque to French Empire to Eclecticism to National Revivalism, were passionately employed in the city by both Ottoman and foreign architects. In particular, Art Nouveau, the antecedent of Art Deco, was zealously supported by the Ottoman elite and much loved by Istanbul's inhabitants. Art Deco was not an exception and became very popular in 1930s Istanbul where it was implemented enthusiastically in residential architecture.[23] Thus many apartment buildings constructed in Istanbul in the 1930s exhibit Art Deco features, most evidently in doorways, balustrades of balconies, stuccoed string courses and decorative reliefs on building facades. The most characteristic features of the Art Deco style, such as zigzag motifs, chevron patterns, intersecting squares, flower sprays and arrow shapes, embellished the facades of these apartments. This was especially so in Cihangir, which had been destroyed by a great fire in 1915 and redesigned in accordance with new plans drafted by the municipality in the 1930s.

Art Deco was not only popular for residential flat buildings but was also utilised for shops, cinemas and other buildings in pre–World War II Istanbul. Designed by architect Edoardo de Nari, Glorya Cinema in Beyoğlu was one of the prime examples of Art Deco architecture in Istanbul. Superb quality Art Deco features were represented in this building, especially the interior details of the foyer and the theatre, such as ceiling patterns, furniture and illumination

Image 28 An Art Deco apartment building in Maçka, Aras Neftçi

appliques, and the cinema's entrance from the street.[24] Another notable example is the Kurukahveci Mehmed Efendi, a famous coffee trader and brewer in Tahtakale. Located next to the seventeenth-century Spice Bazaar, this double-storey shop and manufacturing facility is a prime example of Art Deco in Istanbul, despite

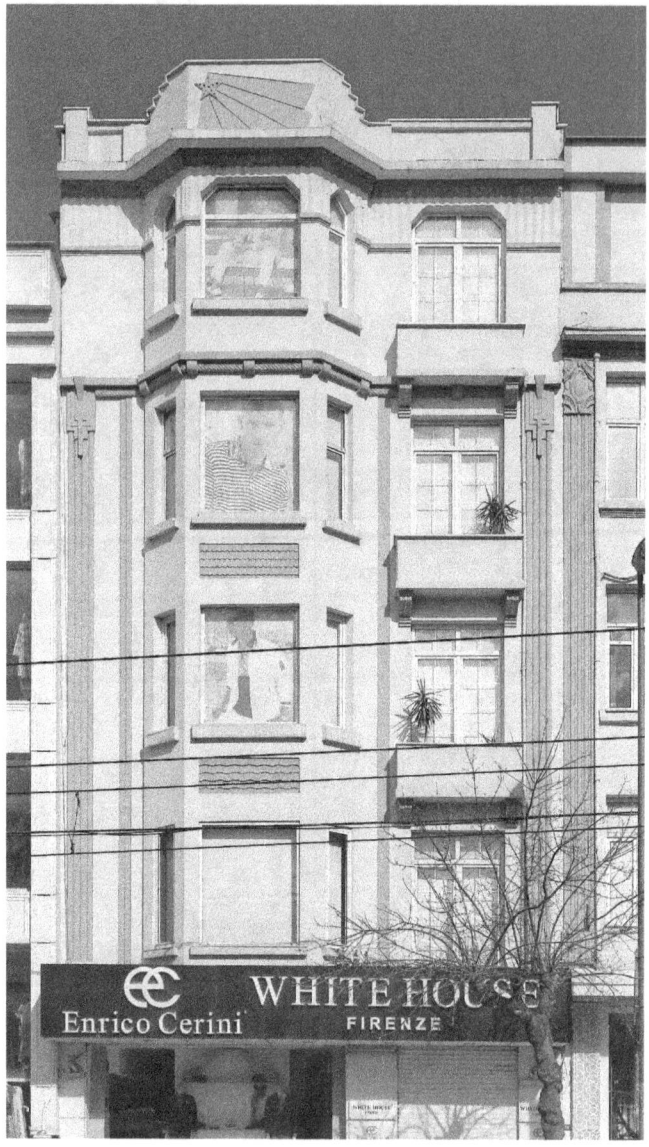

Image 29 An Art Deco residential building in Ordu Street, Historic Peninsula, Murat Gül

its modest size. Mimar Zühtü, the architect for the coffee brewer, relates how he visited European cities to familiarise himself with the latest Art Deco buildings and this inspired him to incorporate the features of the fashionable style into his building in Istanbul. In this case, Art Deco was not only an architectural expression

Republican Istanbul: secularisation of the old city

for the building but also a vivid symbol of corporate identity, as is evident in the company's logo and promotional materials.[25]

Another interesting piece of architecture of 1930s Istanbul is a seaside pavilion designed by Seyfi Arkan for Atatürk's convalescence during his final years. Sitting on the western fringes of Istanbul on the shores of the Sea of Marmara, Florya was then a rural and seasonal residential district where Istanbul's citizens first encountered beach culture in a modern sense.[26] In the mid-1930s new projects were prepared for Florya with the aim of creating 'the most modern beach in in the world'. The construction of the beach was part of the Kemalist modernisation programme in that it was a location where men and women could mix in a Western manner. Even before the completion of the pavilion, Atatürk often visited Florya beach, and photographs depicting him wearing a swimsuit or rowing a boat were frequently published in Turkish newspapers.[27] The Florya Sea Pavilion is a structure that hovers above the sea – supported on steel piles driven into the seabed – and it is connected to the sandy beach by a footbridge. The geometric form of the single-storey timber building consists of two intersecting rectangles. Atatürk's study, reception hall and guest rooms occupy prime position and enjoy an expansive view of the Sea of Marmara, while service areas are located in the wing leading to

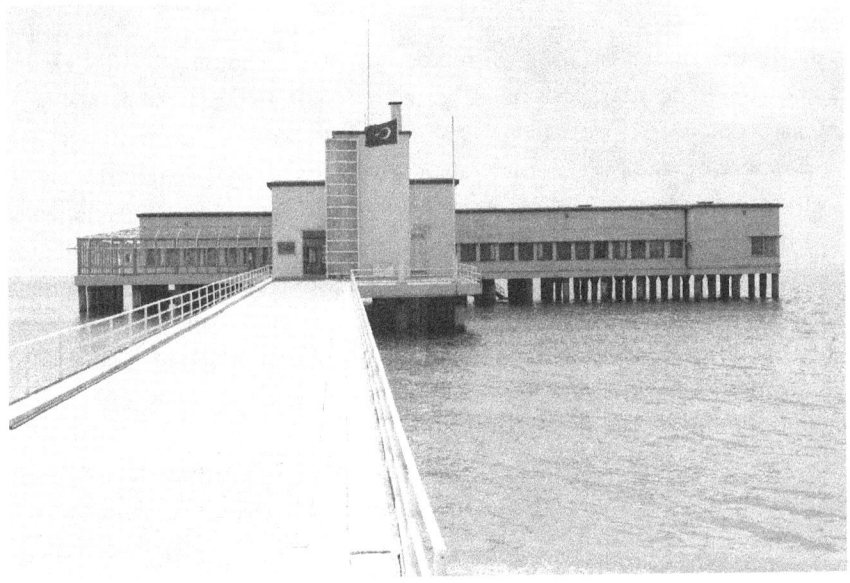

Image 30 Atatürk's Sea Pavilion in Florya, Aras Neftçi

the shore. Built in the summer of 1935 in an astonishing 48 days, the flat-roofed pavilion is clad externally with whitewashed timber boarding. Projecting seaward from the reception hall is a private jetty. While the building's overall stylistic genre is distinctly modernist, its bold geometric form, extended window bays, curved terrace serving the reception hall and porthole-style windows on the service wing add a flavour of Streamline Moderne, a late branch of the Art Deco movement.

The most striking example of Streamline Moderne in Istanbul, however, is the Tüten Apartment Building in Gümüşsuyu. Designed in 1936 by Adil Denktaş for Sabri Tüten, a wealthy tobacco merchant who was also a cabinet minister in the Ankara government during the national resistance war, the reinforced concrete building presents a sumptuous apartment on each floor with large living spaces and six bedrooms.[28] Porthole and strip windows with semicircular ends and curved balconies provide a compelling sense of streamlining, a stylistic character so elegantly expressed by the ocean liner *SS Normandie* which entered service in 1935. The sharp contrast between the modern features of Tüten Apartment and its florid turn-of-the-century neighbour, Gümüşsu Palace, which is a grand example of a Belle Époque building, shows vividly the stylistic diversity of multi-storeyed residential architecture in Istanbul within three decades.

Despite its popularity, apartment living had always been condemned by various groups on social grounds since the early years of Turkish modernisation in the nineteenth century. Mustafa Reşid Pasha, the creator of the famous Tanzimat Edict in 1839, advocated the English model of detached housing over the French approach of multi-storey apartments when he was an Ottoman diplomat stationed in major European capitals. In his opinion, the latter were not suitable for Turkish society where privacy was a major component of family life.[29] Many Turkish intellectuals of the early Republican years shared Reşid Pasha's concerns and, while apartment buildings were mushrooming in the city, criticisms of this trend were crystallising in intellectual circles where these buildings were seen to be counter to Turkish culture. In the eyes of many people, apartment living was alien to the values of Turkish society, and the buildings were considered monstrous intruders on the beauties of Istanbul. For example, Yahya Kemal, a famous Turkish poet and intellectual, was opposed to the new apartment buildings and suggested a new development plan for Cihangir district that included low-rise houses, green areas and viewing terraces.[30] Similarly, according to Osman Nuri Ergin, the new apartments in Cihangir were 'skyscrapers' which had killed Istanbul.[31] Perhaps the most noteworthy objection towards apartment living came from Kemalettin Bey. In one of his articles published in 1917 Kemalettin Bey, referring to recent

Republican Istanbul: secularisation of the old city

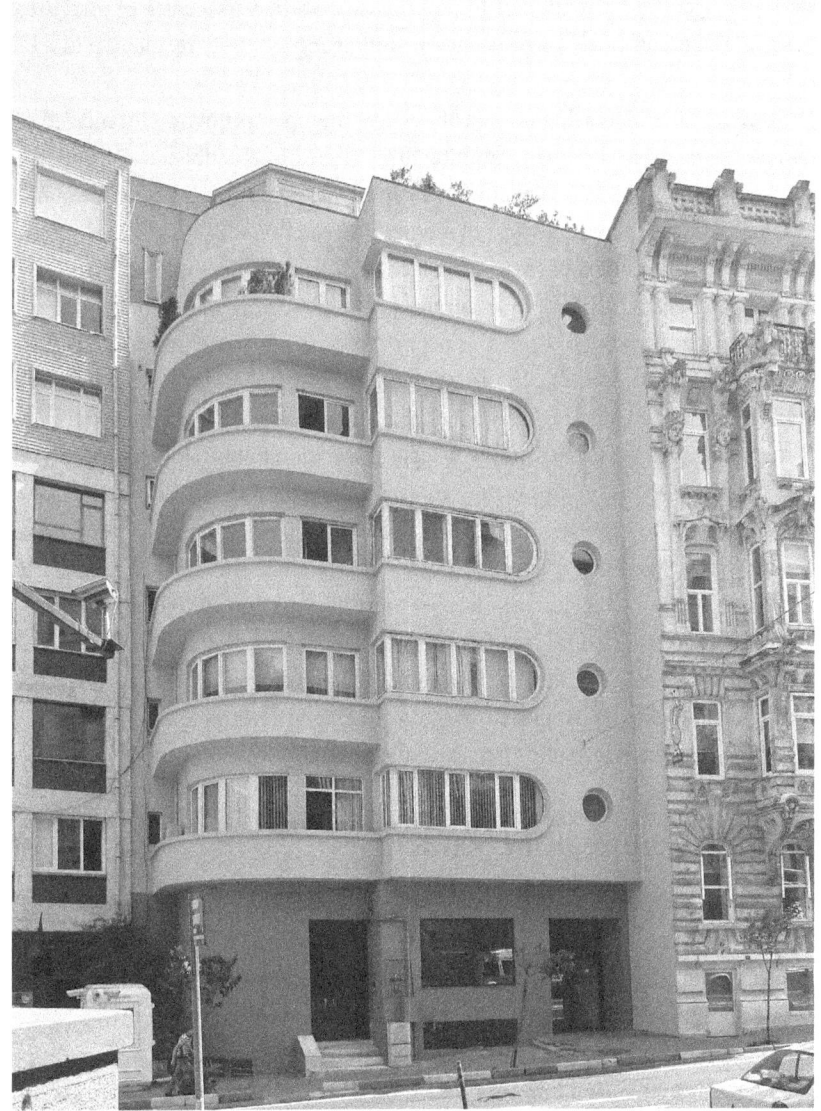

Image 31 Tüten Apartment Building in Gümüşsuyu, Murat Gül

discussions in Germany, vehemently criticised apartment living and suggested private dwellings as the most suitable model for the Turkish and Islamic lifestyle. It is ironic that despite his strong anti-apartment position, and just a couple of years after he penned such concerns, Kemalettin Bey as noted earlier, would go on to design

Istanbul's largest apartment building of the time at the very centre of the Historic Peninsula. Furthermore, he constructed similar multi-storey residential blocks in Ankara.

Similarly, the increasing popularity of apartments was not a well-received phenomenon amongst some elite architectural circles of Republican Turkey. Many architects raised objections against the rapidly growing trend of *apartmanlaşma* or apartmentisation and advocated single-house ownership on cultural grounds. A report jointly published by a group of architects following the First Turkish Building Congress in 1946, for example, strongly recommended detached houses against apartments as the most appropriate type of residential architecture in Turkey on cultural grounds. In this respect the emerging apartment districts such as Talimhane and Cihangir were labelled as 'uncivilised'.[32] Apartments were seen not only as an inappropriate mode of accommodation but also perceived as a vivid symbol of non-Muslim minorities in Istanbul's cultural landscape since many grand multi-storey residential buildings were constructed by rich non-Muslims, who had controlled the economic life of the city since the late Ottoman period. The assumptions and concerns raised by these various figures would prove to have some substance in the long-term future. The apartment buildings constructed in the 1930s were the starting point of a long and continuous process of apartmentisation in Istanbul, a development which would bring a negative connotation in the following decades, especially after World War II.

Return to nationalistic tendencies

With Ankara being shaped by the hands of a group of European architects and Istanbul's future given over to the French urban planner Prost, a strong opposition against the hegemony of Europeans began emerging among young Turkish architects. For many Turkish architects, the government's complaisance for Western architects was a serious mistake. They believed Western architects were not only producing design without an adequate level of knowledge of the local conditions but were also creating obstacles for local professionals.[33]

Mimar and then *Arkitekt* had a specific mission to promote Turkish architects who, in the eyes of many young architects of the early republic, were in a discriminatory competition with their Western counterparts. For this reason, many articles raising concerns about the government's preference for European architects were published in the magazine throughout the 1930s. Mimar Abidin Bey, for example, in an article published in 1933 complains about foreign architects

being hired for important buildings and demands opportunities be granted for Turkish architects.[34] Similarly, Burhan Arif, in his article published in the same year, strongly criticises the government's plan to hire a foreign expert to prepare the urban redevelopment plans for Istanbul. For him, Istanbul's planning was 'a universe of its own kind with distinguishing individual features' and it would be strategic mistake 'to liken it to a French, German or American one'. Istanbul had 'a unique aesthetic quality' and foreigners could not perceive it without being 'Oriental' themselves by living and working in the city for a long period.[35] Another strong objection to European architects came from Aptullah Ziya who, in his very critical writings in *Arkitekt*, described the foreign architects hired by the government as professionals with limited skills. Ziya compared these architects to their predecessors who since the Tulip Era (1718–30) had come to Turkey and 'poisoned' Turkish architecture, and described them as bringing a new version of this 'alien' art. Young Turkish architects, who had grown up under the revolutionary spirit of the republic, rebelled against this new wave of architectural intruders.[36] Nothing shows this objection more explicitly than an article published in *Mimar* in 1933. In this highly emotive and critical article, Abidin Bey summarised the hegemony of Western architects in Turkey with the following words:

> Many years have passed before realising that the foreigners [architects] were also humans with limited power and sense of aesthetics which could not be overcome by working hard. In the meantime, young Turkish architects were trying to improve themselves. They have grown like a shy adoptive child in a careless and unconfident environment. Without money and modern equipment, they made efforts to get experience. They raised themselves with a passion towards their profession under difficult conditions.[37]

The same years also saw a more general objection to international trends in architecture. Behçet and Bedrettin, in their article comparing national and international developments in architecture, claimed that building materials such as sand, stone, iron and glass were not the ultimate goals of architecture, but the context formed by both natural and cultural localities. In this sense, cubic architecture and its primary material, reinforced concrete, were their targets. According to Behçet and Bedrettin, 'reinforced concrete' could create neither an architecture nor an international architecture called 'cubic'. These could only be tools in the hands of various nations to create their national architecture, which should be both 'rational' and 'national'. And, finally, in the eyes of these two young Turkish architects only

national art would survive and create history. International art would not survive and could not be considered as a source of pride.[38]

In addition to professional suspiciousness, the emergence of a nationalistic predisposition in architecture had more solid bases. Nationalistic policies, similar to those in many European countries, had a rising importance in Turkish politics in the 1930s. As noted above, the main goal of Kemalist reformers was to create a Turkish nation from the ashes of the multi-ethnic empire. Hence Turkishness, which was a significant aspect of official politics under the CUP administration from the early twentieth century, kept its prominence after the establishment of the new Turkish Republic in 1923. The nationalist tone in Turkish politics gained apace, especially in the early 1930s when the Republican modernisers consolidated their power and eliminated their opponents from the political arena. If the erasure of the Ottoman identity from the social, political and cultural life of the new state was the foremost goal of the Kemalist modernisers, the establishment of a national policy on the Turkish identity was the second major target of the new republic. The Republican People's Party (RPP), the sole political party of the early Republican era, extended its power and established a single-party regime where the entirety of politics was run as a single-handed project. In 1931 at the Third Congress of the RPP six basic principles of the party were defined. Named as republicanism, statism, populism, revolutionism, nationalism and laicism, together they became known as 'Kemalism', and were represented in the RPP's Art Deco inspired emblem as six arrows.[39]

Under this political atmosphere and in pursuance of the 'unification of forces' many cultural and intellectual organisations were forced to join official institutions. For example, Türk Ocakları (Turkish Hearts), which was founded to promote Turkish nationalism in the dying years of the Ottoman Empire, was abolished in 1931. As the country's most important autonomous intellectual and political institution, it was alleged by the regime to be a potential political threat. Its closure was followed by the establishment of Halkevleri (People's Houses) in 1932. Serving as adult education centres similar to those of the authoritarian regimes of Germany and Italy, the People's Houses were managed and financed by the ruling RPP. The aim was to propagate official ideology to the masses through lectures, concerts, art performances, theatre and sport. Initially, only 14 houses were opened in various cities in Anatolia, but their number increased dramatically over time and they were soon established in every city of Turkey.[40]

In many towns the buildings which were previously occupied by Turkish Hearts were given to the People's Houses. In others, smart buildings were constructed in

Republican Istanbul: secularisation of the old city

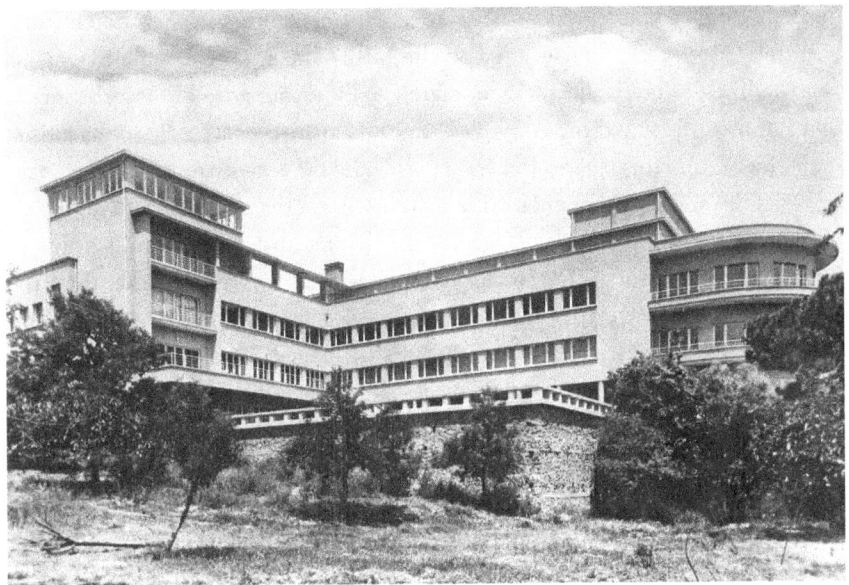

Image 32 Kadıköy People's House, Güney Family Archives

the most significant locations of the town and city centres. With the aim of competing with the dominant role of the mosque in the silhouette of Anatolian towns and cities, the People's Houses exhibited modern architectural features. In Istanbul a total of seven houses were opened between 1932 and 1935, and by 1940 this figure reached 11. Designed by Rükneddin Güney, winner of a national architectural competition, the Kadıköy People's House is one of the symbolic examples of early Republican architecture in Istanbul. Having a Z-shaped plan layout, the building is formed by a well-considered combination of rectangular and semi-cylindrical masses. Accessed through a large front courtyard, the rear of the building opens onto an elevated terrace. Stylistically, it shows the major influences of 1930s modernism, which was rare in Istanbul, such as prismatic building envelopes, glazed surfaces, horizontally arranged strip windows, and semi-circular building ends with cantilevered balconies.

In line with this political agenda, Turkish history was rewritten by the elites of the new regime. Much historical and linguistic research focused on the origins of the Turks and their language, as asserted in the *Türk Tarih Tezi* (Turkish History Thesis) and the *Güneş Dil Teorisi* (Sun Language Theory). These efforts endeavoured to prove that the Turks contributed to civilisation long before the existence

of the Ottoman Empire when they developed a civilisation in their homeland in Central Asia, a place that had witnessed the birth of many other civilisations. When a great drought forced the Turks to migrate to different parts of the world, including Europe, Africa and the Americas, they established many civilisations in their new lands. From this perspective, the Hittites and the Sumerians, earlier occupants of Anatolia and Mesopotamia, were believed to be the ancestors of present-day Turks. Similarly, the Sun Language Theory claimed that ancient Turkish was the origin of many, if not all, the languages of the world.[41] In order to prove these theses, many works were presented by politicians, historians and other academics. Anthropological works claimed that the Turks belonged to the Caucasian race, with white skin, tall stature and, in many cases, light-coloured eyes.[42]

This political climate was mirrored in Turkish architecture, with nationalistic tones expressed in many ways. The new architecture, according to young Turkish architects, should develop an answer to the works of foreign architects, and such a response should be based on intrinsic qualities of Turkish culture. For them, motivation from the past was necessary to create a new Turkish architecture. However, the source of inspiration for such a new architecture could not be the masterpieces of Ottoman architecture. Instead, vernacular buildings, where the Turkish spirit was more evident, should be taken as models for the new architecture.[43]

Inspired by the autocratic regimes of countries such as Italy and Germany, young Turkish architects advocated a 'national style'. According to B. O. Celâl, the Russians had returned to their authentic sources to create a national style in literature and in many other areas of art. Similarly, Germans, following World War I, had changed their attitude and subjugated art to nationalistic sentiments. And, finally, the Italians had constructed 'national and immortal' vestiges. Turkish architects and artists, accordingly, should also look for the untouched elements of Turkish arts as their source of inspiration.[44]

The 'untouched elements' of Turkish arts were the hidden treasures of the Turkish culture, and these were the main inspiration for Turkish architects who focused on vernacular architecture to seek some stimulus in order to create a national style. According to many architects and artists of the era, Turkish art and architecture were not limited solely to Ottoman architecture but had influenced the cultural arts of a vast area from Central Asia to Anatolia, a claim that was parallel to the principles asserted in the Turkish History Thesis. Turkish architecture, in the eyes of these groups, was substantially different to other Oriental and Islamic architectures and, therefore, could not be categorised as a subheading of Islamic architecture, as it was often described in the writings of Western scholars.

If Arab and Persian architectures were irregular, disproportional and excessively ornamented, Turkish architecture, in contrast, was rational, logically structured and neatly ornamented.[45] Also, the urban structure of Arab cities, when compared to their Turkish counterparts, was found to be indistinct and primitive.[46] Furthermore, vernacular Turkish architecture, in the minds of the Kemalist intelligentsia, was open for evolution in line with technological improvements, not unlike the Western tradition of art and architecture.

Another significant factor for the increasing awareness of the vernacular architecture of Anatolia was political peasantism. First appearing in the late Ottoman period and gaining new momentum in the 1930s, peasantism become one of the most influential socio-political movements in Turkey, especially in the academic circles of Istanbul University. According to leading Turkish academics such as Ömer Lütfi Barkan, Ziayeddin Fahri Fındıkoğlu and Ömer Celâl Sarc, who had completed their education in Germany and France, and their German colleagues who had sought refuge in Turkey and now worked in Istanbul University, the city was the source of all evil with its degenerate class struggles, unemployment, economic depression and social unrest. This brawny, anti-urban bias coupled with a strong stand against political and economic liberalism had led such intellectuals to see the peasantry as the real drive behind the Turkish revolution. The peasantist rhetoric was very powerful, and the regime took every measure to retain the overwhelming agrarian character of Turkey.[47] Opportunities for industrial employment in big cities was very limited, and under such conditions immigration to the cities would have created a genuine threat to the Kemalist objective of maintaining control of the society. The short-lived democratic experience of the mid-1920s and early 1930s revealed clearly that the impact of the Kemalist spirit was limited, even in the big cities where the literacy rate was relatively high. Potential immigration bringing uneducated crowds to the large cities would have produced social chaos.[48]

The Kemalist regime, therefore, conducted a well-crafted policy to lock the peasants in their villages, prevent immigration, downplay the attractions of city life and, more importantly, educate the rural population about the merits of Kemalist ideology. Hence a distinct style of education was needed for village children whereby practical knowledge was prioritised rather than theoretically based learning. To achieve this goal, special educational organisations called Köy Enstitüleri, or Village Institutes, were established in 1940, and students were selected from the peasantry and required to work for many years in their assigned villages.[49] The importance of the village and its contribution to national development

was frequently cited in the official declarations and political propaganda of the government. Influenced by this intense peasantist rhetoric, Turkish architects now focused on the principles of the 'scientific planning' of villages.[50]

Inspired by the German *Sozialpolitic*, Turkish peasantism advocated the creation of small-scale farmer homesteads (based on the model of *Erbhof* in National Socialist Germany) to prevent mass immigration from rural areas to big cities. The regime's ideologists at every level had also taken strong pro-peasant positions at various institutions, resulting in peasantism becoming one of the most powerful policy choices of the late 1930s. In the eyes of Turkish peasantists, if cities were places of chaos and corruption, villages were genuine symbols of the noble, untouched, intelligent and pragmatic character of the Turkish nation. In this imaginary picture, peasants who lived in parts of Anatolia that had experienced no occupation by foreign armies and virtually no contact with the outside world were seen as the unadulterated representatives of the Turkish race. The villagers were not 'poisoned' by capitalist ideology, and were regarded as a source of strong soldiers for the army.

Emergence of the Second National Style of Architecture

The European architects, including Paul Bonatz, Egli and Holzmeister, who came to Turkey and worked on the creation of the new capital and remodelling architectural education in the country, also contributed to the discussion and advocated a new Turkish architecture. According to these foreign architects – many of whom had either taken refuge from, or left after disagreements with, the National Socialists in Germany – 'context' in architecture, such as topography, sun, air, wind and vegetation, was paramount and Anatolian vernacular houses were the ideal source of inspiration for modern Turkish architecture.[51] Therefore, in 1930s Turkey, architectural trends were very much consistent with the overall social politics of the regime in which the peasantry and village life were glorified in many aspects.

The emergence of a new national architectural style was possible under this ideological atmosphere which blended with the political, social and cultural circumstances of the time. Yet unlike the model subscribed to by many young architects, who were advocating the creation of an authentic Turkish modern architecture grounded upon the virtues of the Anatolian village, the national movement – in a similar way to its precedent executed by Vedat Bey and Kemalettin Bey a couple of

decades earlier – preferred to import stylistic elements directly from old buildings. Perhaps the only difference between this new movement and the First National Architectural Style was that the new national architecture was not necessarily fed by the monumental Ottoman masterpieces. Designers working in the new national style frequently employed motifs derived from vernacular Turkish architecture.

The leading figure of this style was Sedad Hakkı Eldem, who would soon become the most eminent Turkish architect of the twentieth century. Born in Istanbul in 1908 to a noble family, Eldem completed his primary and secondary education in Geneva and Munich where his father was the Ottoman ambassador. He then returned to Istanbul to study architecture at the Academy of Fine Arts and graduated in 1928. In the following years Eldem travelled to Europe and worked with Auguste Perret in France and Hans Poelzig in Germany. Those years, as well as his childhood, allowed Eldem to familiarise himself with and study European culture and architecture. In 1930 he returned to Istanbul and began to work with Mongeri who was then the director of the architecture department at the Academy. In 1932 he began his academic career at the Academy as an assistant. In 1934 Eldem started National Architecture Seminars at the Academy where he and his pupils searched for, and studied, traditional timber Turkish houses. Out of those seminars emerged a series of important texts published in *Arkitekt* magazine, and these later formed a comprehensive three-volume book written by Eldem called *Türk Evi* or *Turkish House*. The main idea of the seminars was that the traditional Turkish house, with its functional layout, modular structure and simple construction methods, could be a valuable source of inspiration for contemporary living. The codification of the national architecture, retrospectively titled in Turkish architectural historiography as the *İkinci Milli Mimari Üslubu* or 'Second National Style of Architecture', was rooted in these seminars.

The early examples of national architecture inspired by old timber houses were designed by Eldem in the form of *yalı* or waterfront mansions. Ayaşlı Yalısı and Tahsin Günel Yalısı were both constructed in 1938 and were notable examples of this architecture constructed along the shores of the Bosphorus. In these palatial waterfront houses, Eldem applied the traditional inner-sofa scheme, which is a prevalent layout of Turkish houses, where self-contained rooms are lined around a common central hall called a sofa. Fenestrated by modularly arranged rectangular window bays and topped with a tiled pitched roof, the external articulation of these houses was also strongly reminiscent of traditional Turkish houses.

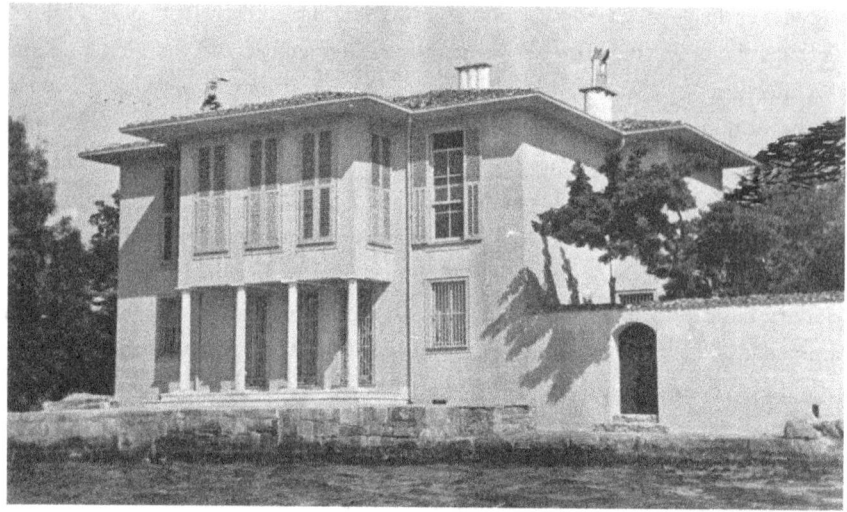

Image 33 Ayaşlı Yalısı in Beylerbeyi, on the Asian shore of the Bosphorus, Rahmi M. Koç Archive & SALT Research, Sedad Hakkı Eldem Archive

Nothing shows the impact of traditional Turkish houses on Eldem's architecture better than the Taşlık Coffee House, constructed in 1948. Located at the top of the slopes behind Dolmabahçe Palace, and sitting on a site overlooking the Bosphorus which was originally spared for the building of a mosque intended for Sultan Abdülaziz,[52] this is a small but very influential work by Eldem. He took the *divanhane* (guest room) of the late-seventeenth-century Ottoman waterfront mansion, Amcazade Hüseyin Paşa Yalısı, as the model for his design. Built as a reinforced concrete structure with timber cladding, the coffee house represented all the spatial and stylistic characteristics of the *yalı* in an elegant way.[53] Eldem's efforts to reinterpret traditional dwellings were much appreciated by the architectural critics of the time. In an article published in *Arkitekt* in 1938, for example, Ayaşlı Yalısı was hailed as a 'promising trial' that epitomised the national architectural character, particularly in comparison with the 'fibreless buildings' constructed at the time.[54]

Apart from small-scale residential buildings, the most fertile example of the Second National Architectural Style in Istanbul was the Istanbul University Faculty of Science and Letters in Laleli, constructed between 1942 and 1943. It was designed collaboratively by Eldem and Emin Onat, and represented the spirit

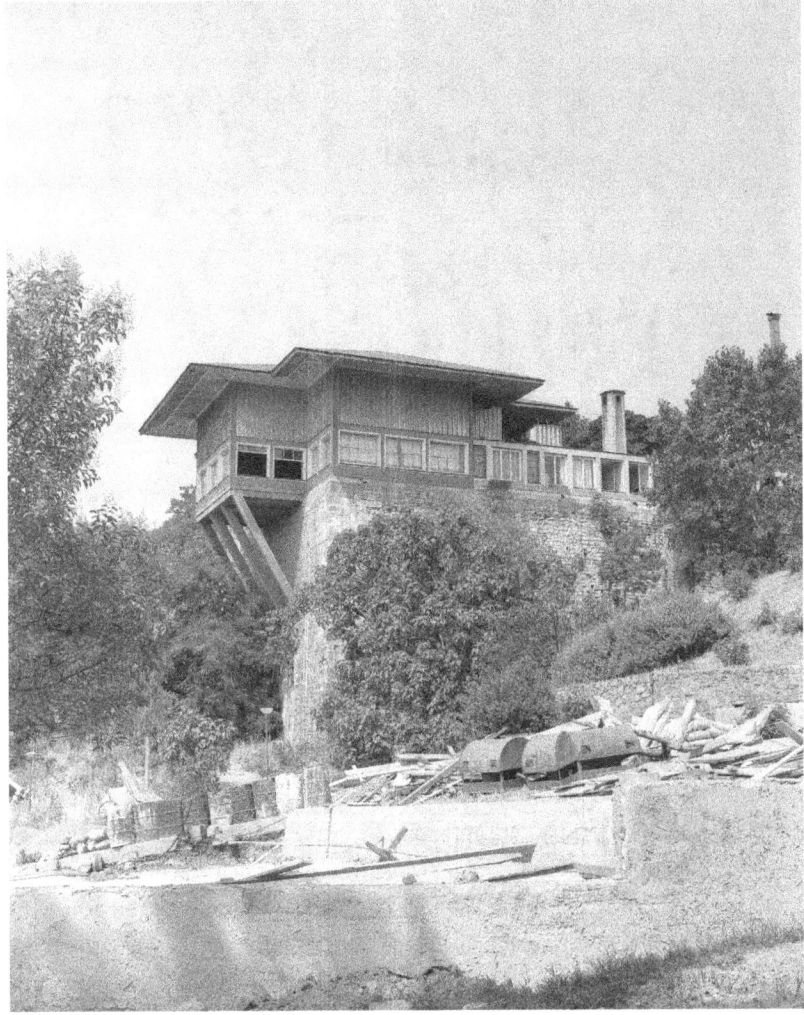

Image 34 Taşlık Coffee House, MSGSÜ Photo Studio, courtesy of Nezih Aysel

of national architecture on a monumental scale. The use of light-coloured stone, pink stuccoed brickwork, tall wall openings and large quantities of marble, as well as wide roof overhangs and regular window casements (borrowed from vernacular Turkish architecture) successfully ornamented this large building at the very centre of the Historic Peninsula.

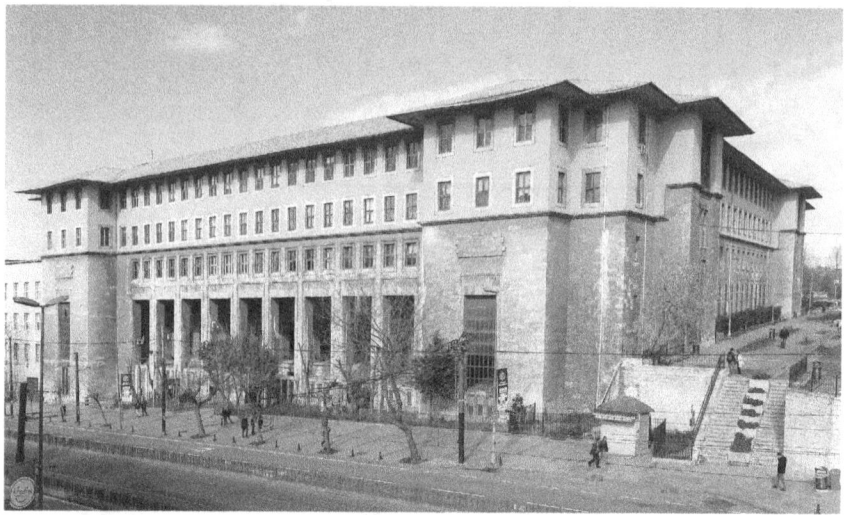

Image 35 Istanbul University Faculty of Letters, Murat Gül

Postwar Istanbul

Turkey, despite pressure by both Germany and the Allies to join World War II, managed successfully to stay out of the fire engulfing the whole of Europe and many other places across the globe.[55] Yet the imminent threat forced the government to take extraordinary precautions. The army was mobilised and all sources were canalised to the defence sector. This prevented much-needed investment in the infrastructure of the country, which had been created from the ashes of the Ottoman Empire less than two decades earlier. Furthermore, after Atatürk's death the regime intensified its autocratic face and implemented harsh policies, both in social and economic fields. The high inflation, scarcity of basic commodities, black market economy and a severe drought brought new burdens to the shoulders of those from all strata of society.

Without a doubt, the peasantry, which then formed 80 per cent of the population, was the stratum of society most affected by the bitter economic conditions. The circumstances in villages were quite different to those portrayed in the illusory pictures of peasantist circles. As vividly portrayed in Mahmut Makal's sensational 1950 novel, *Bizim Köy* (Our Village), the great majority of Turkish villages lacked basic infrastructure such as reliable roads, any kind of sanitary facilities or civic services.[56] Many Turkish villages were impoverished as the government had seized

a great portion of the crop production and kept it in silos for potential harsh times should Turkey be forced to join the war. Only ten out of 40,000 villages in Turkey were electrified even as late as 1953, and during the long winter months many villages were separated from the rest of the world due to poor roads. In the absence of irrigation systems, the peasantry was totally dependent on natural weather conditions, and the techniques used in agriculture were not far from those of the Middle Ages. Combined with such sweepingly severe conditions, heavy taxation and the autocratic conduct of gendarmes created a deep frustration with the government among the peasantry.

In the cities, where support for the Kemalist regime was the strongest, the situation was not much better. Harsh economic conditions caused deep dissatisfaction amongst the wealthier classes, including bureaucrats and especially non-Muslim merchants and businessmen who were forced to pay very high taxes.[57] The high inflation, coupled with heavy-handed and unfair official controls on prices and profit margins, affected the purchasing power of public servants and the middle classes and created black markets in the big cities, especially in Istanbul. The electricity supply in the biggest city of the country, for example, was problematic. Despite modest upgrades made in 1914, Silahtarağa Power Plant inflicted frequent cuts that adversely affected the life of city inhabitants. Public transport ran with limited resources, and the lack of spare parts and sustainable maintenance caused frequent interruptions.[58]

At the end of the war, Turkey had to make a choice in the new world order. Under the growing threat of Soviet Russia, Turkey opted for placement in the Western Bloc. Firstly, the government switched to a multi-party system immediately after the war, and this action shook the foundation stones of the regime. Although the 1946 elections did not bring about a change of government, the unexpected success achieved by the newly established Democrat Party was good enough to ring alarm bells for the Republicans, who had been running the country as the sole political party since its establishment in 1923.[59] In the following years, the government undertook some important steps to liberalise the country's economy, social life and even religious affairs. The media and universities were allowed greater freedom, and staunch Kemalist personalities were gradually removed and more liberal politicians took their seats both in the party and the government. The postwar period also saw a strong political relationship develop between Turkey and the United States of America. The new motto of the government was to make Turkey 'a little America' in its region.[60] Although Turkey had not entered the war, it was included in the European Recovery Programme and entitled to receive the

famous Marshall Plan assistance, as well as other American financial and military aid.⁶¹ In line with Turkey's role in the postwar order, mechanisation of agriculture and the establishment of an effective transportation network based on improved roads and highways were put into action immediately.⁶²

The changing political atmosphere was echoed in Istanbul, which was faced with a massive population influx from rural Turkey. The mechanisation of agriculture, on the one hand, and the relaxation of social policies, on the other, emptied the villages and the jobless crowds poured into cities, in particular Istanbul. Within the decade following the end of World War II, Istanbul's population saw a dramatic 47 per cent increase. This sensational population growth also brought the shortcomings of Prost's master plan into sharp focus. Since being appointed as the chief planner in 1936, the French planner had not forecast any noteworthy increases in Istanbul's population, and had only conducted some piecemeal beautification projects. Neither the municipality nor the central government had any plans to accommodate the growing number of migrants flooding into the city. In other words, this was the end of the peasantist utopia, which had been created by the elites of the regime in the mid-1930s. The already inadequate infrastructure and insufficient building stock triggered the illegal occupation of public lands for shanty houses on the outskirts of the city, such as Kazlıçeşme and Zeytinburnu. This was the beginning of Istanbul's chronic urban problem: *gecekondu* (literally meaning 'built-at-night') or squatter housing for the poor migrants.

Architecture in transition

While Istanbul struggled with these social problems, which were also affecting its urban development, some noteworthy architecture began to appear in the landscape of the city, in line with recommendations made by Prost. A football stadium named after İnönü was built by Italian architect Paolo Vietti-Violi, in collaboration with local architects Şinasi Şahingiray and Fazıl Aysu, and was constructed in a very controversial place, immediately behind the Dolmabahçe Palace and the mosque. Construction of the stadium, which required the demolition of imperial stables belonging to Dolmabahçe Palace, commenced in 1939 but, like many other projects, its completion was delayed by wartime conditions until 1947. The other project was an open-air theatre, which was carved into the slopes of the hill behind the stadium. Designed by Turkish architects Nihad Yücel and Nahid Uysal, the ashlar masonry theatre follows the plan of ancient Greek theatres: a semi-circular *koilon* of nearly

Republican Istanbul: secularisation of the old city

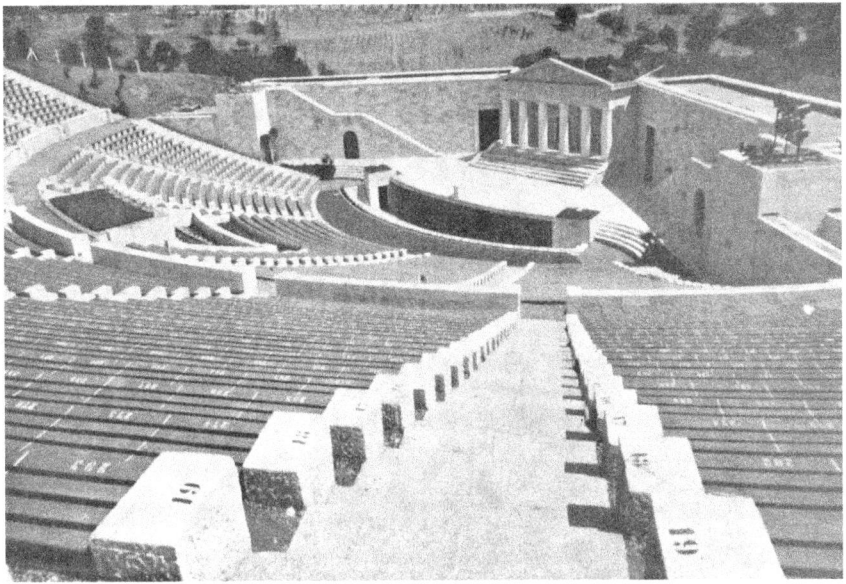

Image 36 Open-air theatre completed in 1947, Reproduced from *Cumhuriyet Devrinde İstanbul* (Istanbul: İstanbul Belediyesi Neşriyat ve İstatistik Müdürlüğü, 1949)

4,000 seating capacity and a centrally positioned circular *orchestra* or stage, backed by a rectangular *skene*. The Spor ve Sergi Sarayı (Sports and Exhibition Palace) was another large-scale project constructed in the vicinity. Designed by the same trio who constructed the football stadium, the rectangular prismatic building was constructed in reinforced concrete and, with retractable timber and steel stands, functioned both as an indoor sports hall and an exhibition space. The building, which remained the sole large sports hall in Istanbul until 1988, opened in 1949 and hosted the European Wrestling Championship as its first major event. All these three projects are located around Prost's Taksim, Maçka Park and İnönü Promenade, and with all dedicated to the cultural, sports and recreational endeavours of the city dwellers, they made the district the most modern part of Istanbul.

Although the above buildings were significant components of the social modernisation of Istanbul, from a stylistic perspective they represented an outdated 1930s architectural fashion that had a wide popularity in fascist states such as Italy and Germany. Their robust character, ostentatious dimensions and simplistic ornamental manifestations were successful in portraying the autocratic characteristics of the single-party rule in Turkey. Surprisingly, the real break in this stylistic

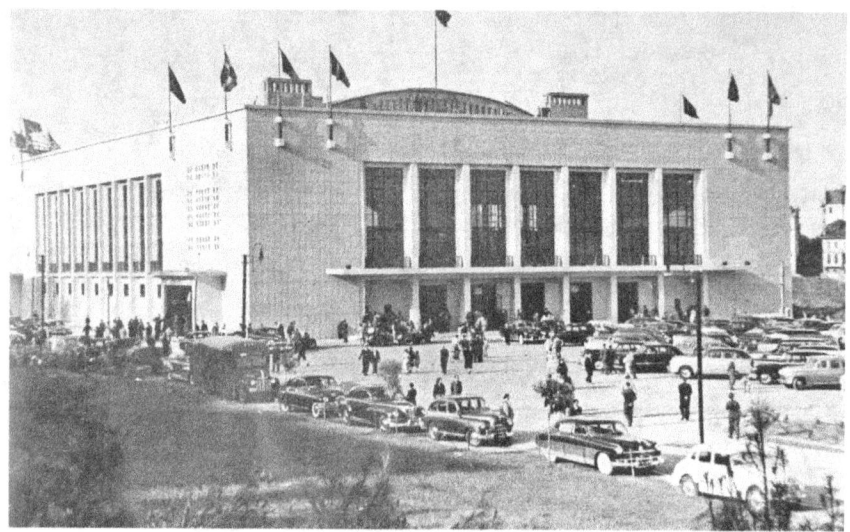

Image 37 The Sports and Exhibition Palace opened its doors in 1949, Reproduced from *Cumhuriyet Devrinde İstanbul* (Istanbul: İstanbul Belediyesi Neşriyat ve İstatistik Müdürlüğü, 1949)

hegemony of fascist influenced architecture appeared across the Golden Horn, at the very centre of the Historic Peninsula. After various abortive attempts and the consideration of alternative sites since the mid-1930s, a site located next to the Land and Titles Office in Sultanahmet was finally selected for the construction of a new justice complex for Istanbul in 1949. A national architectural competition was organised in the same year.[63]

Bearing the signatures of Eldem and Onat, the winning design for the Justice Palace proposed a large complex comprising of two main building blocks. The first block was designed to accommodate the courts and was positioned immediately behind the remnants of İbrahim Pasha Palace, parallel to the axis of the ancient hippodrome. The second block was planned to house offices for magistrates, judges and administration staff and was proposed to the north-east of the first block between Divanyolu, or the old Byzantine *mese*, and Sultanhamet Square. The construction of the first section was delayed and was only able to commence in July 1951.[64] The building, however, was completed in a short period of time and opened its doors in 1952. The four-storey building had an elongated layout in which courtrooms were positioned perpendicular to a long corridor. The basement floors were carved into a very sensitive archaeological area containing the

Republican Istanbul: secularisation of the old city

Image 38 Justice Palace in Sultanahmet, Aras Neftçi

relics of edifices associated with the old hippodrome. It was because of this sensitivity that the second block was at first deferred and, following various amended plans, withdrawn completely in the 1970s. Stylistically, the Justice Palace represented a stripped form of nationalism. While it embodied some features of the Second National Architectural Style, such as large roof overhangs and modular rectangular fenestrations inspired by vernacular Turkish houses, the expression of the concrete columns and floor slabs on the facades and the simplified facade composition gave sturdy signals of the forthcoming International Style, which would become very popular in Turkey in the next decade under a new political climate.

3

1950s Istanbul: postwar dynamics and change

The year 1950 opened a new chapter in modern Turkish history. The second multi-party election was held on 14 May and brought an outstanding victory to the Democrat Party (DP). Despite all the new opportunities and the relaxation of social and economic policies that followed the alarming 1946 election, the Republican People's Party (RPP) was unable to gain public support to continue its government. During the election campaign the DP rhetoric employed the famous motto, '*Yeter Söz Milletindir*' (Enough, the nation has the word), which was popular with the masses, and the party went on to gain 53 per cent of the total vote. This spectacular success gave 396 seats to the Democrats in the 487-seat parliament. Soon after, the Grand National Assembly elected Celâl Bayar as the president and Adnan Menderes became the prime minister. The DP clinched its success by winning the municipal elections held on 3 September 1950, in which it took 560 of the total 600 municipalities in Turkey. In Istanbul the DP's victory was astonishing with the party winning all seats in the Municipal Assembly. Within a couple of months Turkish political life was totally reshaped, and after 27 years of continuous rule the RPP was removed from office.[1]

The elections brought a series of important changes to Turkish politics. The mass of society was given the opportunity to express its preferences in the political arena for the first time in Turkish history. If the RPP's political base was the alliance between the military and bureaucratic elite of the centre and traditional notables in the countryside, the DP was the voice of the 'peripheral' stratum of Turkish society. Thus, regardless of their different expectations, interests or cultural traditions, supporters from very different segments of society were attracted to the DP, including the commercial bourgeoisie, the intelligentsia, workers, the urban poor, religious groups, landlords in the countryside and other smaller social groups such as Communists and non-Muslim minorities that had been excluded

from the political system by the single-party regime. However, the most dedicated support for the DP came from the countryside. During his ten years in office, Menderes, a large farm owner himself, abandoned the peasantist policies of the Kemalist regime and canalised significant financial support to farmers, subsidised agricultural products and took important steps to establish modern irrigation systems and modernise animal husbandry.[2] Within ten years of the arrival of the Democrat administration the cultivated land area increased by 90 per cent and reached 25.3 million hectares, and the number of tractors in Turkish villages soared threefold to more than 42,000.[3] For this reason, Turkey saw a spectacular increase in its total harvest, making it one of the leading grain exporters in the world in 1953.[4]

This remarkable improvement in the countryside combined with other significant achievements in road making and energy production. New dams constructed by the DP increased the energy production by a factor of four, reaching 2.8 billion kWh in 1960.[5] Thanks to generous American technical and financial assistance, Turkey witnessed a boom in road making, with the total length of hard-surfaced roads increasing from 930 kilometres in 1948 to about 7,300 kilometres in 1961.[6] Travel time between Istanbul and Ankara was reduced from 13 hours to 6.5 hours. Better roads and a growing economy boosted motor vehicle ownership, and the total number of motor vehicles on Turkey's roads rose from 20,231 in 1948 to 102,806 in 1960.[7] This astonishing investment in the country's primitive infrastructure brought with it significant social implications. The impact of substantial improvements in the road network, as well as the mechanisation of agriculture, were soon felt in the countryside, and the changes opened the doors of the Turkish village to the outside world for the first time in the history. The peasantry benefited from this opportunity and Turkey saw a dramatic social mobilisation after the early 1950s. Surplus manpower generated by the mechanising of Turkish villages now poured into big cities, in particular Istanbul.[8] Between 1950 and 1960, the city saw a 50 per cent population increase and reached a total of over 1.5 million.[9]

A series of noteworthy developments in the social sphere complemented the improvements in the economy, agriculture and infrastructure. Education, for example, saw some remarkable leaps in this period. The number of schools, both at primary and secondary levels, increased by around 90 per cent and the literacy rate rose steadily from 32 per cent in 1950 to 46 per cent in 1965.[10] The relaxed democratic atmosphere opened new avenues to the press, and the number of daily newspapers in Turkey surged from 72 to 566 in ten years. In

the same period the circulation figures also showed an amazing upturn from 300,000 to 1,411,000.[11] The number of books published annually remained around 2,600 between 1936 and 1950, but this figure soared to over 4,000 by the end of the Democrat period.[12] The relaxation of policies governing religious activities, which had already begun during the last years of the RPP administration, was further accelerated by allowing religious groups to express their ideas in the political system for the first time since 1923. In this context some symbolic steps, such as ceasing the ban on the recital of *ezan* (call to prayer) in Arabic and allowing religious programmes to be broadcast on the radio, further increased the popularity of the DP administration across a vast stratum of Turkish society.

In line with the overall political transformation under the DP administration, Turkey saw important changes in its legal system regulating construction and urban management. In 1951 the Gayrimenkul Eski Eserler ve Anıtlar Yüksek Kurulu (High Council of Immovable Heritage Items and Monuments) was established as the consent authority for heritage-listed items and sites.[13] Professional organisations were instituted, including the Chamber of Architects which was established in 1954 and became a legal body with licensing power for practising architects. The same year also saw some changes in the *Tapu Kanunu* (Title Act) with multiple ownership of a property introduced into the Turkish legal system for the first time.[14] This was followed by the *İmar Kanunu* (Redevelopment Act) of 1956, enabling municipalities to enforce planning controls not only within the boundaries of their local government areas but also in peripheral districts encircling the core municipal zones. In the same year the Municipality of Istanbul published the *İstanbul İmar Talimatnamesi* (Istanbul Redevelopment Regulation). The final link in this chain was a new expropriation act which superseded many other planning control instruments and allowed greater flexibility in land expropriations. All this legislation was extensively employed in the following years by the government in carrying out Istanbul's redevelopment.

Istanbul in the early Democrat years

Although Istanbul was politically neglected and had lost its administrative functions in the early Republican years, it was still the major intellectual, economic and social hub of Turkey. If Ankara was the modern, planned and secular face of the new Turkey, Istanbul represented its cosmopolitan, spontaneous and religiously oriented expression. Despite all of the Republican administration's efforts

to create a new national centre in Ankara, Istanbul's pre-eminent position as the cultural and economic magnet of Turkish society remained unchallenged. For many people, the modern administrative buildings, large boulevards, geometrically planned parks and monuments of Ankara could not rival the natural beauty and richness of Istanbul's medieval character, which was marked by the domes and pencil-thin minarets of Ottoman mosques, twisted streets surrounded by timber dwellings and markets full of colourful goods imported from all over the world. That is why for many Turkish citizens, the best part of Ankara, as articulated by eminent Turkish poet Yahya Kemal, was still the road back to Istanbul.

Istanbul's strategic importance in the postwar era was once again highlighted by international political dynamics. In this new world order, polarised between the US-led Western alliance and the Soviet Union's communist bloc, Turkey acted as an important ally of the United States on the eastern front. At the same time, three decades of neglect were finally over for Istanbul and it was ready to retake its pivotal role in Turkey and the region. Internally, the political dynamics of the democratic system made Istanbul a showcase where the government's achievements in this most important city could be successfully presented to the rest of the country. For this reason, Menderes launched his candidature for the 1950 general elections from Istanbul rather than from his home town of Aydın.

Under this political atmosphere *İstanbul'un imarı* (the redevelopment of Istanbul) was prioritised by the Democrat administration from its very early days in power. According to the Democrats, Istanbul under the RPP administration had been abandoned and driven into a city of decay.[15] The DP representatives, therefore, frequently used the theme of neglect in their speeches and promised the return of the city to its glorious days. The first key action came in late December 1950 with the dismissal of Henri Prost. The DP delegates in the Municipal Assembly claimed that despite his long service of 14 years, the French urban designer had not achieved any serious results and Istanbul's problems had grown to an intolerable level. Furthermore, the DP representatives argued that Prost had not educated any Turkish planners and had become open to political manipulations by RPP politicians. It was time for Istanbul to be given into the hands of Turkish professionals who were familiar with the historic, natural and social characteristics of this ancient city. All this criticism removed Prost from his long-term position as the chief planner of Istanbul in December 1950.[16]

Following Prost's departure, the municipality established in 1951 an interim commission, composed of a number of Turkish planners and architects, to review his plans.[17] The commission inspected the plans extensively and found many

shortcomings. The documents drafted by the French planner were considered extremely superficial, to be lacking in essential data and critical analysis, and aiming for beautification rather than solutions to the real problems of the city.[18] According to the commission, the French planner did not use any statistical data, except for calculating the number of barges in the Golden Horn, and did not create a long-term projection for the growth of the city. The interim team was followed by a permanent commission (also known as Müşavirler Heyeti) in 1952 which was assigned to prepare a new plan for Istanbul. After a long period under Prost's hegemony, the planning of Istanbul was finally handed over to Turkish experts, as had been demanded repeatedly by young local professionals since the 1930s. The permanent commission worked for three years and produced two plans for the Istanbul Peninsula and Beyoğlu district.[19] Although both commissions had severely criticised Prost's plans and their suggestions were based on extensive research carried out collaboratively with many organisations, the new plans did not present any viable alternative to the French planner's proposals. In fact, the principal features proposed by Prost, such as opening large avenues and industrialising the Golden Horn, remained in the commission's plans. In the meantime, Istanbul continued to grow with the arrival of migrants and an increasing number of *gecekondu*s. The city also faced more serious traffic problems with a dramatically increased number of motor vehicles on its streets.[20]

Istanbul reshaped: Menderes' redevelopment programme 1956–60

The government's response to such undesirable conditions came in the autumn of 1956 when Menderes officially launched his famous redevelopment programme in a press conference on 23 September.[21] The prime minister was proposing the most radical redevelopment scheme the city had ever seen in its modern history. The most significant problem, as had been the case for Prost and his predecessors, was the lack of an operative road network in Istanbul. Construction of large boulevards linking important centres of the city, therefore, was the leitmotif of Menderes' redevelopment programme. Regularising the crooked street patterns, demolishing buildings in the vicinity of the grand mosques and, by these works, increasing Istanbul's attractiveness for foreign visitors were the other significant targets set by the prime minister.

Like many postwar politicians all around the world, Menderes considered highways one of the undisputed symbols of development and progress. Thanks

to the mass production of more affordable motorcars after the war, and the need to accommodate them in the urban landscape, many cities around the world were dismantling tramlines and opening large streets for cars. By unshackling people from rigid public transport timetables and allowing them to travel at will, the car was seen as a real liberator of the masses. In order to establish an effective road network in Istanbul, several major arteries both within and outside the Historic Peninsula were proposed in the redevelopment programme. They would connect the major commercial centres and encircle the shores of the Sea of Marmara and the Golden Horn.[22]

The works, which had already commenced prior to the prime minister's address to the press, gained momentum and Istanbul was turned into a huge construction site. In the Historic Peninsula, Aksaray was linked to the Theodosian Walls by two very large avenues: Vatan and Millet streets. These roads, together with the previously constructed Atatürk Boulevard, transformed Aksaray into a significant traffic intersection at the heart of the old city. The other significant work was the completion of the unexecuted sections of the old Divanyolu–Ordu Street axis. The first section, between Sultanahmet and Çemberlitaş, was enlarged in the late 1860s under the direction of the Islahat-ı Turuk Komisyonu (Commission of Road Improvements).[23] The western portion, between Beyazıt and Aksaray, was first constructed in the early twentieth century by the French engineer André Auric and later completed in the early 1930s. The only remaining section, between Çemberlitaş and Beyazıt, formed a bottleneck creating traffic congestion. Prost had made a suggestion for this location in the early 1940s but, like many of his proposals, it could not be executed. After fiery debates amongst many institutions, this section of the road was opened in 1957. The new road required the most controversial demolitions of Menderes' redevelopment programme; both the eighteenth-century Han of Hasan Paşa and Simkeşhane, the former Ottoman mint and workshop for spinners of silver threads, were partially bulldozed.[24]

The other significant work was the construction of a littoral avenue along the shores of the Sea of Marmara between Sirkeci and Bakırköy. The new work was the biggest land reclamation project in Turkey and required the partial demolition of ancient sea walls. Named Kennedy Street, this coastal avenue dramatically changed the city's appearance from the sea, which had already been altered to some extent by the construction of the railroad in the late Ottoman period. A similar littoral boulevard was also constructed along the southern banks of the Golden Horn between Eminönü and Unkapanı. Named Ragıp Gümüşpala Street,

1950s Istanbul: postwar dynamics and change

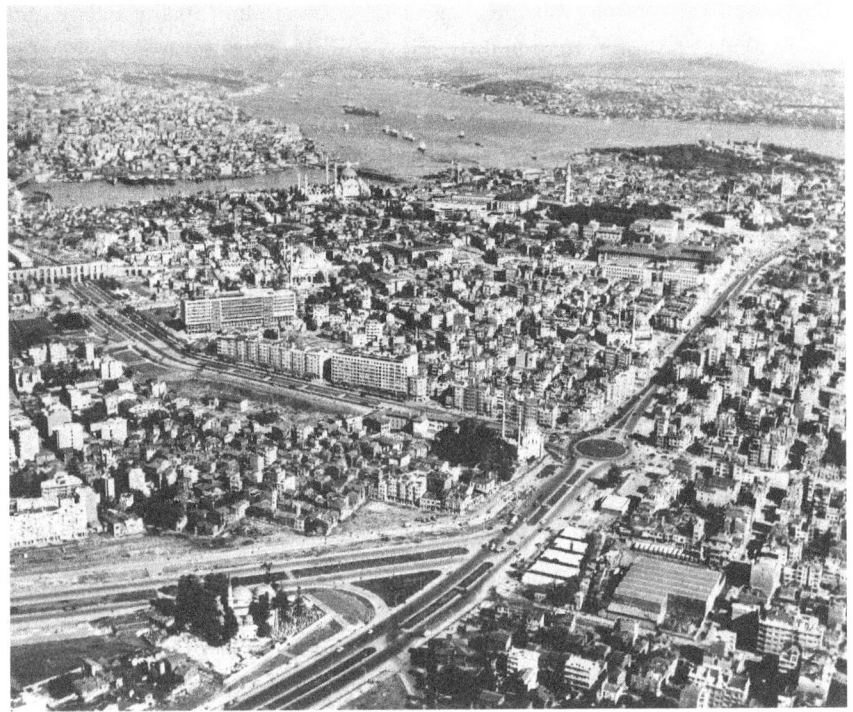

Image 39 Vatan, Millet, Ordu streets and Atatürk Boulevard intersect in Aksaray, c.1960s, Yapı Kredi History Archives, Selahattin Giz Collection, Istanbul

this road resulted in the demolition of the old ramparts, as well as a fish market, a fruit and vegetable market constructed in the 1940s and many other traditional buildings that had occupied this busy port, which had been one of the most important parts of the city since ancient times. Across the Golden Horn a square in Karaköy was constructed, and a road linking the new square to Kabataş was enlarged. A public square was constructed in Beşiktaş and linked to Levent by a wide road named after the famous sixteenth-century Ottoman admiral, Barbaros. On the Asian side, Bağdat Street, between Kadıköy and Bostancı, was enlarged and took its current shape, and a new motorway between Harem and Pendik was constructed. All these works required the demolition of more than 5,000 buildings, mostly dwellings but also some religious and civic structures.[25]

Menderes conducted the overall programme as the project coordinator, and regularly visited the sites and discussed the details of the works with technical personnel. The government canalised all available sources to the redevelopment

of Istanbul. The central government agencies, Istanbul Municipality and pension funds all played various roles in financing the works. Even the army supplied its manpower and machinery. The technical aspects of the works were carried out by a large group of professionals, both in the municipality and in other offices specifically set up to implement the redevelopment programme. Foreign experts were also brought on board. The German planner Hans Högg, who had previously worked in Istanbul during his doctoral studies, and Italian architect and urban planner Luigi Piccinato played important roles in the process.

Menderes' redevelopment programme attracted wide support from almost every segment of society. The press, for example, was very supportive and all newspapers, regardless of their political persuasion, widely welcomed the demolition of old buildings and the opening of large boulevards and squares.[26] Even political rivals of the DP appreciated the redevelopment works. According to Metin Toker, a leading pro-Republican commentator and son-in-law of İnönü, the redevelopment works and other projects proved that the Democrat politicians had better foresight and a grander vision then their political opponents.[27] Support for redevelopment also came from within architectural circles, particularly at the early stages of the redevelopment works. According to Zeki Sayar, the editor of *Arkitekt*, the municipality's limited budget and experience made the central government's assistance for Istanbul's redevelopment indispensable. Menderes' urban renewal programme, according to Sayar, was the largest and most positive urban initiative that Istanbul's streets had seen since the works carried out by Cemil Topuzlu, the renowned mayor of Istanbul, in the early twentieth century.[28] For the foreign experts who had been invited to Istanbul to take roles in the redevelopment programme, Menderes was a hero. According to Piccinato, for example, Menderes' redevelopment works had 'awakened a sleeping city'. Istanbul, he argued, had three major advantages: its geographic location; its modern legislative framework; and, finally, the prime minister's great plans for the city.[29]

The new fashion: International Style

While Istanbul's urban form was redesigned by the ambitious prime minister, the post-1945 opportunities in Turkish political, economic and social life brought new perspectives to almost all segments of society. Architecture, by its very nature, was not immune from this dramatic transformation of the country and soon aligned itself with the changing conditions. Economic development

1950s Istanbul: postwar dynamics and change

brought new opportunities for architects, and architecture became more independent from the state and official commissions. As noted earlier, in the nineteenth century architecture emerged as a profession in the modern sense, in line with the modernisation of society. This time, the liberal economic model and multiparty democracy after World War II offered a wider practising market for Turkish architects. The state was no longer the sole client for large-scale projects as the emerging Turkish bourgeoisie began to hire architects to design their buildings, ranging from residential dwellings to hotels, small-scale office buildings and industrial plants. Hence these years saw the opening of the first truly private architectural offices in Turkey, which operated in a similar way to those of Western counties.[30]

Turkey's changing international political relationship with the Western world also played a significant role in shaping the growing architectural profession. As noted earlier, Turkey had already established close ties with the United States immediately following World War II, and had received significant financial and military aid.[31] In the following years this collaboration was extended to other areas, such as road making,[32] industry and education. The Fulbright agreement, designed to facilitate exchange of scholars between the two countries, was signed in 1949.[33] The early DP years saw the Turkish–American alliance further intensified and, after sending troops to the Korean War, Turkey became a member of NATO in 1952.[34] With this important step Turkish armed forces were completely remodelled according to American standards, and the brightest Turkish cadets were sent to the West Point Military Academy in the United States, where they were exposed to American ideals. It was these officers who would later play an important role in Turkey by their frequent interventions in politics in the polarised world order of the Cold War period.

Along with the growing Turkish–American alliance, the third phase of Turkish modernisation had begun and this trend was very much shaped by the material symbols of American culture, similar to many countries in Europe and other parts of the world. American automobiles, electrical household appliances and Hollywood films were the most readily appreciated symbols of this new era. Turkey's cooperation with the United States also brought new opportunities for Turkish architecture. A new architectural school was founded in 1956 within the newly established Middle East Technical University in Ankara, which was modelled on the University of Pennsylvania and supported by the American administration. Turkish architects were offered grants to visit the United States through the Fulbright agreement. Yet, without doubt, the most iconic symbol of this alliance in architecture was

the Istanbul Hilton Hotel (1951–5). In the highly polarised postwar world order, American architectural tastes had become a powerful tool to display the strength of American culture to the rest of the world. In particular, the Hilton chain of hotels played a significant role in this propaganda campaign of the Cold War era, and 17 Hilton hotels opened in different countries outside the United States between 1949 and 1966. These hotels were intended to display American wealth after the war and its hegemony in the canonical architectural medium. For American visitors, Hilton hotels created 'a home away from home' with their lawns, swimming pools and tennis courts, all inspired by American suburbia. For local communities, the Hilton hotel was a powerful image demonstrating American luxury with its direct telephone lines, air-conditioned guest rooms equipped with radios, cocktail lounges and nicely decorated large lobbies. As a powerful propaganda tool the openings of Hilton hotels abroad were marked by extravagant parties, adorned with the participation of American celebrities who were carried to the country by Pan American Airlines, another American icon of the Cold War era.[35]

As the largest city of Turkey and located at the border of Soviet influence, Istanbul was the perfect location for the first Hilton hotel in Europe. For this reason, the initial idea of constructing a Hilton hotel in Istanbul came from the International Cooperation Administration (ICA), the office coordinating American financial aid in Europe in accordance with the Marshall Plan. Along with more extensive projects, such as the mechanisation of agriculture and construction of highways, the ICA saw the Hilton project as an important propaganda tool to illustrate American influence in Turkey not only to the masses but, more importantly, to neighbouring communist regimes. The Turkish government was also very pleased by this generous offer and proposed a site in the Talimhane district of Taksim for the new hotel. The Hilton representatives, however, required a grander location and claimed a site in Elmadağ.[36] Accessed from the tree-lined Cumhuriyet Avenue, the site was a 'hidden paradise' isolated from the crowds of the city and overlooking magnificent views of the Bosphorus. The hotel's site was also in the vicinity of the important buildings and sites of modern Istanbul, such as Taksim Square, İnönü Promenade, Maçka Park, the Open Air Theatre and the Sports and Exhibition Palace. Following various meetings between Turkish state officials and representatives of the Marshall Plan Office in Turkey, the contract for the 300-room hotel was signed on 15 December 1950.[37] The task of designing the hotel was given to the famous American architect partnership Skidmore, Owings & Merrill (SOM). The overall design bears the signatures of Gordon Bunshaft and his assistant Natalie de Blois from SOM and Sedad Hakkı Eldem, who also joined

1950s Istanbul: postwar dynamics and change

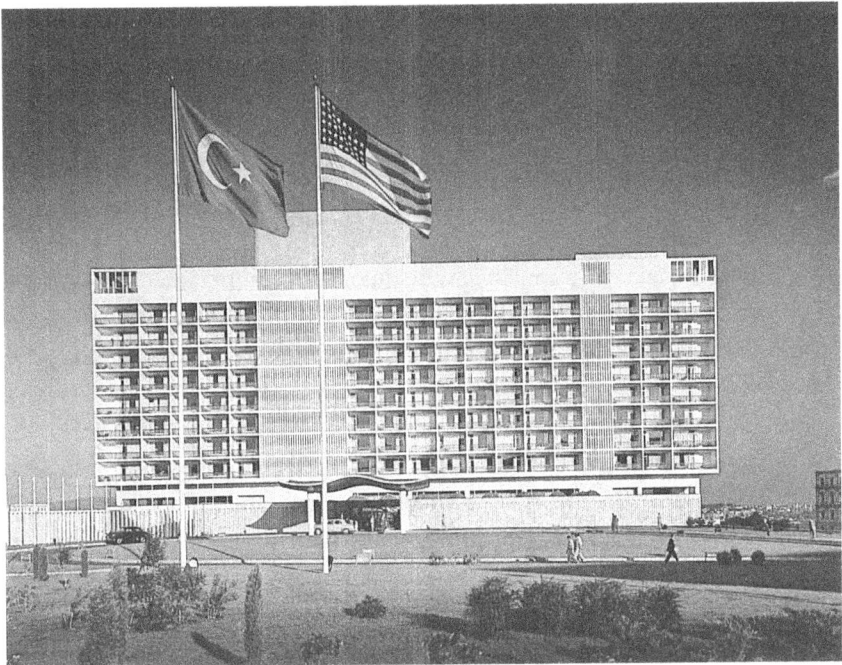

Image 40 Istanbul Hilton Hotel, *c.*1957, Rahmi M. Koç Archive & SALT Research, Sedad Hakkı Eldem Archive

the team as the local architect to oversee the construction process.[38] SOM was an architectural practice favoured by the American government, which hired the firm for the construction of many official buildings, both inside and outside the United States. According to the agreement, the cost of the architectural project was paid for by the funds allocated to Turkey through the Marshall Plan. Emekli Sandığı (Turkish Public Servants' Pension Fund) financed the project with the loans provided by the Bank of America and ICA.[39] This model, engaging local funds and American foreign aid, worked so well that it was implemented in subsequent Hilton contracts in Cairo, Athens and Berlin.

Although the hotel was scheduled for completion in 1953 on the 500th anniversary of the Turkish conquest of Istanbul, the foundation stone was only laid on 16 April 1952 and construction was not completed until 1955. The Istanbul Hilton opened its doors to guests on 20 May and the official opening ceremony was marked with a grand ball on 10 June. Like many other Hilton openings, the ball featured American celebrities, including Hollywood stars Ann Miller, Merle

Oberon, Irene Dunne and Terry Moore, and their visit to Istanbul was heavily broadcast in Turkish media.

Architecturally, the new hotel was strongly influenced by Le Corbusier's Unité d'habitation housing development in Marseilles; it comprised a robust concrete rectangular prism of nine floors rising above a set-backed ground floor, lifted on *pilotis* and finished with flat rooftop. The grid was powerfully emphasised by horizontal concrete slabs and vertical concrete walls, highlighting room balconies uniformly arranged throughout the eastern and western facades. The entry to Cumhuriyet Avenue was marked by a group of commercial spaces placed under a thin U-shaped concrete canopy, which together formed a grand gatehouse to the hotel complex. The most prominent shop at the northwest end of the gate was spared for the office of Pan American Airlines.

As initially envisaged by the hotel's financiers, there were some Turkish and Oriental design motifs incorporated into the overall modern architectural style of the hotel. The hotel management frequently used this contrasting theme – an exciting modern building juxtaposed with images of Ottoman mosques and the city's medieval silhouette – in their promotional material. Features with local or exotic flavours that were designed by Eldem and purposefully used to decorate this ultra-modern structure included the domes placed in the roof of the restaurant and in the pavilions alongside the swimming pool, and the ceramic wall tiles in the lobby and the Tulip Room, a place inspired by *The Arabian Nights*. However, Eldem's most lyrical touch was the hovering canopy of the porte-cochère, a thin and crimped concrete slab with a delicate coloured mosaic on its underside. Popularly named the 'flying carpet', it was indeed a modern interpretation of the Gate of Felicity, the highly decorated entrance to the inner courtyard of Topkapı Palace.

Hilton was the first large-scale building in Istanbul designed in the postwar International Style, and its clear-cut concrete structure, prismatic building envelope and large glass walls astonished Istanbul. The approach to the construction of this large hotel was also new in Turkey. Apart from the sand and rubble, almost every building material was imported from abroad. While steel, cement and glass were supplied by Germany, marble and ceramics were brought from Italy. Technical equipment such as lifts and air conditioning units were imported from the United States, and German firms carried out the construction. The air-conditioned rooms, modern lifts and delicately decorated interiors were all inspirational features for Turkish architects and made the Hilton a consummate school for the hospitality industry in Turkey. The Turkish staff employed at the

1950s Istanbul: postwar dynamics and change

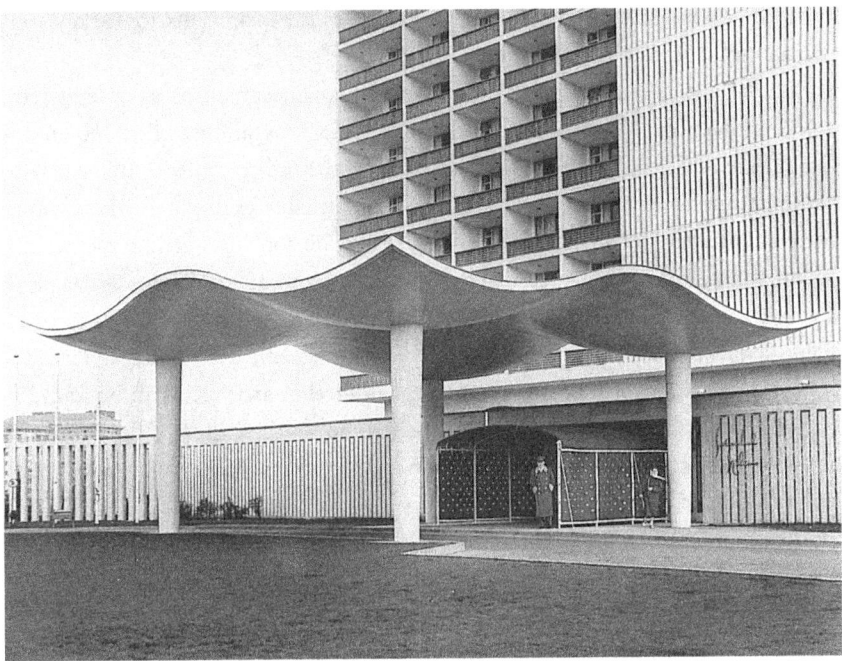

Image 41 Hilton's porte-cochère designed by Eldem, Rahmi M. Koç Archive & SALT Research, Sedad Hakkı Eldem Archive

hotel (many of whom were graduates of American high schools in Istanbul) were carefully selected and sent to the United States for further education in their areas. Turkish architectural practice also learned a lot from the Hilton construction. Many Turkish architects first encountered modern building materials and construction techniques with the Istanbul Hilton. The bathroom sinks placed on stone benches and associated timber cabinets used in the hotel, for example, became a style name in Turkish architectural jargon, *Hilton tipi* (Hilton style), which is still used today.

Like its predecessor the Pera Palace Hotel, the Istanbul Hilton became a status symbol for the wealthier stratum of Turkish society. Its rolling lawns, delicately manicured gardens, tennis courts and swimming pool caused a sensation and made the Hilton the most sought-after venue for wedding parties of wealthier Turkish families and corporate dinners of large companies, and it became a very popular destination for Turkish and foreign celebrities. Commonly known as 'the hotel with 300 rooms', the Hilton's progress was reported by Turkish newspapers on a regular basis from the very early stages of the project to the opening day.

Interviews with Hilton company representatives on their visits to Turkey were extensively reported in Turkish dailies.

It is also interesting to note that despite this widespread press coverage, the sole architectural magazine of Turkey, *Arkitekt*, was almost silent about the Istanbul Hilton. Except for an article describing the project in 1952, the magazine published no story or critique of the most remarkable example of International Style architecture in Turkey.[40] Although the reason for this startling oversight is unknown, it can be speculated that the practice of commissioning foreign experts, a sensitive concern in Turkish architectural circles since the 1930s, was not welcomed by Turkish architects and, therefore, the magazine deliberately ignored the project. One indication of this resentment of foreign architects can be found in Zeki Sayar's article in *Arkitekt* in 1953 where he, as the editor of the magazine, severely criticised the Ministry of Public Works' policy of hiring foreign architects and engineers for their offices.[41]

Another curious point concerning the history of the Istanbul Hilton is Eldem's participation in the project team. As the pioneer of the Second National Architectural Style, Eldem's role in this iconic modern building is seen by many scholars as a radical shift in his career. In this sense, Eldem's new position is appraised within a larger political framework concerning the changing ethnicity and demographic make-up of Turkish society in the postwar years. According to this view, as a result of the gradual departure of non-Muslim minorities from Istanbul and the emergence of the Turkish bourgeoisie, nationalistic tendencies in architecture were no longer seen as necessary. Hence Eldem, and other Turkish architects, abandoned the national style inspired by Ottoman public and vernacular architecture and, instead, intended to show their nationalistic credentials through their engagement with international professionalism.[42] However, this view necessitates further examination, as although the large population exchanges between Greece and Turkey in the early Republican years resulted in strong demographic changes in some Anatolian cities, Istanbul was immune from this policy. Sizable communities of Greeks, Armenians and Jews still resided in the city until the 1960s. Also, although there was vivid antagonism towards foreign architects in the 1930s and 1940s, such feelings were not necessarily directed towards the local non-Muslim stratum of Turkey's population, despite the strong measures conducted by the government to highlight the Turkish character of the new state at this time. Eldem's work in the Istanbul Hilton does require close scrutiny, but it should not be forgotten that his role in the Istanbul Hilton was limited, and indeed he was deliberately chosen as the local architect who could spice up the modern

1950s Istanbul: postwar dynamics and change

American building with some Turkish window dressing, as evident in the 'flying carpet' at the hotel's entrance. It should also be noted that Eldem had already given signals of his search for a new style when he designed the Justice Palace in Sultanahmet in collaboration with Emin Onat. Furthermore, the Istanbul Hilton was the largest architectural commission in Istanbul since the late Ottoman period and brought new advances in technology and materials to Turkey. Regardless of stylistic tendencies, any architect in 1950s Turkey given an opportunity to work on such a large project would accept the offer. Eldem's flirtation with the International Style, however, was short-lived and after some smaller scale projects, such as the Rıza Derviş house on Büyükada, the largest of the Princes' Islands in the Sea of Marmara, he soon returned to seek further inspiration from the local qualities of Turkish architecture. This is most evident in the Social Security Complex project which is reviewed in the following section of this book.

The Istanbul Hilton soon became a model for other hotels constructed in the city in the following years. The Tarabya Hotel, on the upper European shores of the Bosphorus, was greatly inspired by the architectural expression of the Istanbul Hilton. Designed by Turkish architect Kadri Erdoğan in 1957, this hotel used the same modular grid (balconies encircled by horizontal and vertical concrete strips) along its main facade facing the Bosphorus. Even the curvilinear natural shoreline did not break the overall architectural language, as the building followed the curve of the shore but still employed the gridiron. Another example that mirrored the Istanbul Hilton was constructed in 1959 in Yeşilköy, on the western shores of the Sea of Marmara in European Istanbul. Collaboratively designed by a Turkish team of architects, Rana Zıpçı, Ahmet Akın and Emin Ertam, the overall building envelope of the Çınar Hotel was a rectangular prism rising over a set-backed ground floor, finished with a flat rooftop and a modular grid facade arrangement, all of which mimicked the Hilton hotel. Another case of this new trend was the new accommodation block for the Anadolu Club on Büyükada, which was designed by Turgut Cansever and Abdurrahman Hancı after a design competition in 1951 and was completed in 1957. Although it was designed before the Istanbul Hilton, the new accommodation block, with its strong prismatic appearance, large glass curtain walls and rooftop crowned by a slender upwardly curving canopy, demonstrated advanced expression of modernist architectural principles and was influenced very much by Le Corbusier's principles.

While Istanbul was introduced to the International Style by the Hilton and subsequent hotels constructed in various parts of the city, the most significant building

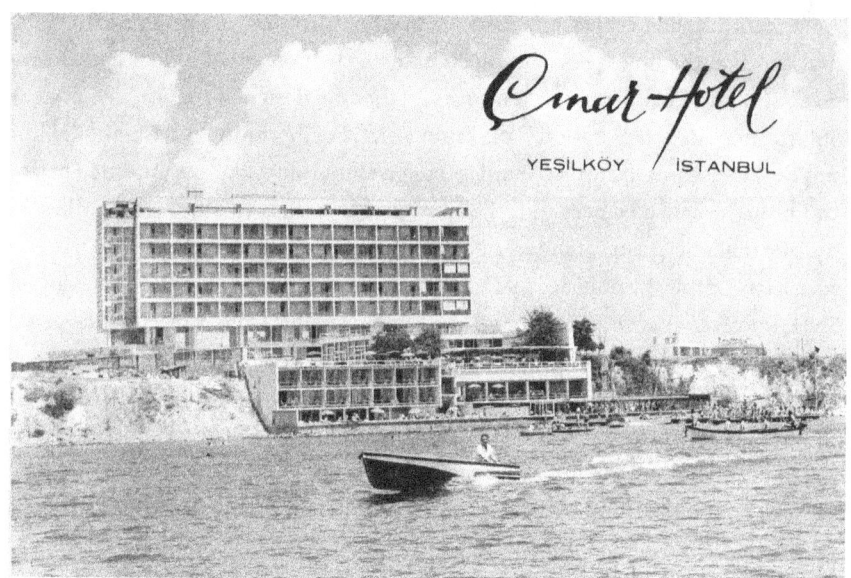

Image 42 Çınar Hotel in Yeşilköy, courtesy of Hilal Çınar

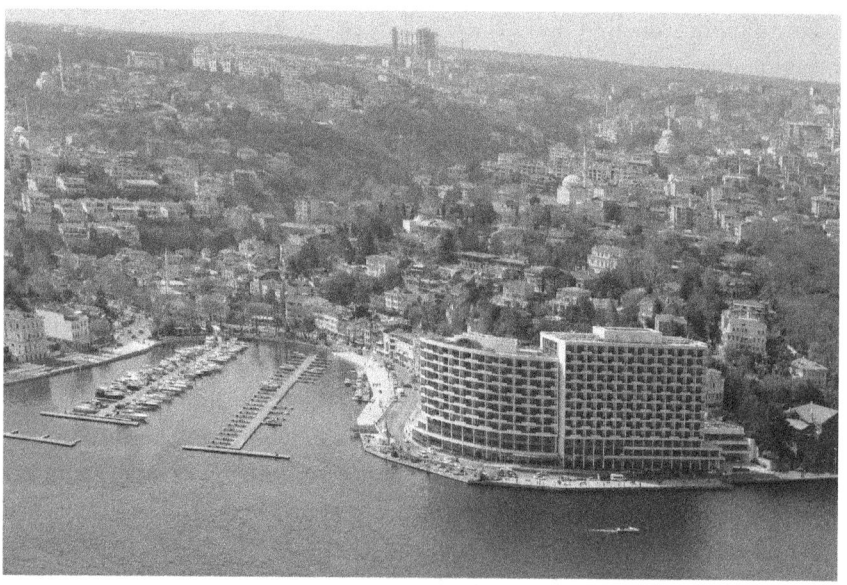

Image 43 Tarabya Hotel, Aras Neftçi

1950s Istanbul: postwar dynamics and change

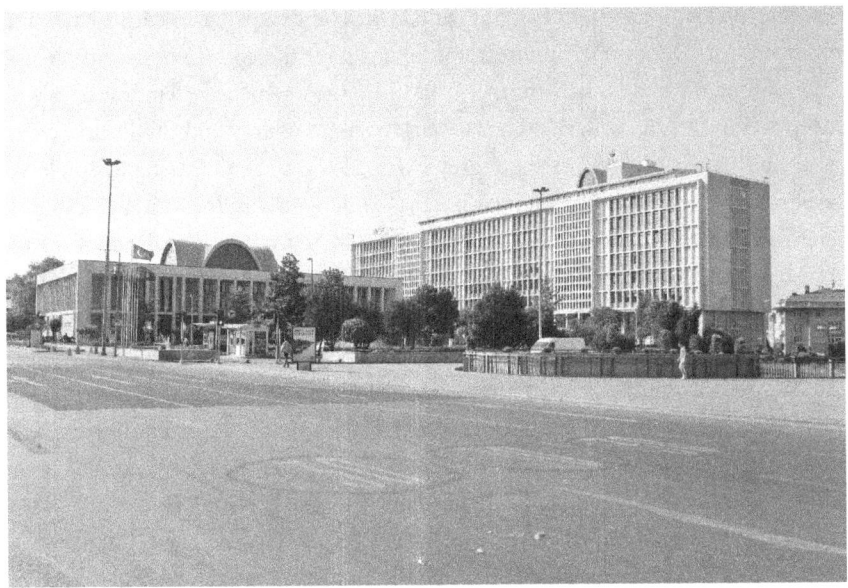

Image 44 Istanbul Municipal Palace, Aras Neftçi

designed in this style appeared at the centre of the Historic Peninsula. The site at the corner of Atatürk Boulevard and Şehzadebaşı Street selected for a new municipal town hall (officially called İstanbul Belediye Sarayı or Istanbul Municipal Palace) was just across from the sixteenth-century mosque Şehzade – designed by the legendary Ottoman architect Sinan in memory of Şehzade Mehmed, the son and intended heir of Süleyman I who predeceased his father. Since the mid-1940s, the municipality had wanted to construct a new town hall to mark in 1953 the 500th anniversary of the Turkish conquest of Istanbul. Initially, a prominent figure such as Bonatz or Onat was considered as the architect for the new town hall. This idea, however, attracted strong criticism from other architects and, after consideration of various options, a national design competition was organised in April 1953.[43] The competition panel, chaired by Onat, selected Nevzat Erol's project. Construction began later in the same year, but the project was only completed seven years later in 1960.[44]

The winning design comprised two rectangular buildings: the municipal hall and the administrative office building. The eight-storey office block was raised on *pilotis* and finished with a terrace rooftop. Positioned perpendicularly to the office wing was the municipal hall, a three-storey rectangular box which accommodated a large auditorium designed for the meetings of the municipal assembly. Together

they formed an L-shape, in front of which was a landscaped area with a large decorative pool. The overall architectural language of the complex was simple and represented the major characteristics of Modernism. Repetitive window bays with deep architraves, mosaic claddings in various tones of grey and rhythmical recessive wall panels covered in small grey stone tiles gave the building a simple yet elegant outlook with its rectangular prisms. Architecturally, the most eye-catching feature of the complex was the two parabolic arched vaults atop the roofs of the two blocks. Clad in turquoise mosaics, they are reminiscent of the works of Oscar Niemeyer and Félix Candela, the two universally prominent figures of postwar architecture.

Without a doubt, constructing such a large complex on a topographically dominant site in the historic core of Istanbul was a radical decision. It is interesting to note that not only the winning design but also all the award recipients in the design competition – Kemali Söylemezoğlu, Turhan Ökeren, Rüknettin Güney – favoured the International Style.[45] Their projects too included an L-shape layout comprising rectangular prisms. Although the building attracted severe criticism in architectural circles in the following decades due to its visual impact on the historic city, its intrusions on the archaeological remains on the site – mosaics of Byzantine periods – and its impact on the nearby remains of an Ottoman bath, it did not raise any concerns at the time with either the selection panel members or the architectural critiques. In contrast, according to the principal of the Istanbul Archaeology Museum, the new constructions such as the Justice Palace and the Municipal Palace created opportunities to understand the hidden archaeological treasures of the city.[46]

Residential architecture

While postwar modernism was employed eagerly by architects of large-scale hotels and public buildings, the residential architecture of Istanbul was also influenced by this architectural fashion in the 1950s. As noted in earlier sections, the traditional domestic architecture of Istanbul – mostly formed by two to three-storey timber dwellings lining narrow and twisted streets – gave way to multi-storey apartment buildings in the Beyoğlu district of the city in the late nineteenth century. This trend continued in Ottoman Istanbul in the early twentieth century and then in the subsequent Republican era with the introduction of Art Nouveau and Art Deco apartment buildings. Such transformation, especially in the Republican period, was smooth as it evolved in a city which prior to World War II was

1950s Istanbul: postwar dynamics and change

immune from any population increase, and it mainly targeted the rehabilitation of old building stock and elegant projects to make profits for private investors.

Conditions after the war, however, were quite different. The mass influx of people caused serious housing problems in Istanbul from the mid-1940s. Istanbul saw a real boom in the construction of residential apartment buildings in the decade following World War II.[47] *Gecekondu*s were formulated by newcomers in response to the housing shortage and, in most cases, the municipal officials closed their eyes to such illegal building activity. Although various proposals were made by foreign experts to address the housing problems of the city, no definite plan could be put into action.[48] Perhaps the most noteworthy development of the government was the establishment in 1946 of the Emlak Kredi Bankası (EKB), a state-owned credit bank to finance housing projects in Turkey.[49] In 1953 the government increased the bank's capital by 300 per cent to 300 million Turkish liras, and this investment boosted the bank's capacity to finance larger projects, both in Istanbul and other parts of the country.

In the early postwar years a new type of residential architecture appeared in Turkey. Influenced by the English Garden City Movement, freestanding villas or terraced town houses began to be constructed in the late 1940s and early 1950s, first in Ankara then in Istanbul. In Istanbul one of the earliest examples of this movement was in Üsküdar, on the Asian side of the city. The first phase of Koşuyolu Evleri comprised 103 houses jointly financed by the EKB and Istanbul Municipality. Despite their modest size, these houses offered an appealing alternative for low-income citizens to live in well-planned and hygienic dwellings.

Another major project financed by the EKB in Istanbul was the Levent housing complex. Named after the Ottoman marines who had established an earlier farm and barracks on the site, the Levent project originally comprised 391 single or double-storey villas. Designed collaboratively by Kemal Ahmet Aru and Rebii Gorbon between 1947 and 1950, the villas were of various sizes and targeted the middle class inhabitants of the city.[50] The popularity of the project prompted a second and third stage in the following years. The Levent housing project was one of the earliest developments in Turkey whereby buyers were provided with long-term loans of up to 20 years.

The fourth stage of the development came in 1956 as residential apartment buildings. Aru worked alone on this stage, which comprised a total of 345 units in different sizes, 70 shops located on ground floors, and other ancillary buildings such as a kindergarten, cinema, tennis courts and other social and recreational facilities.[51] The architectural expression of the apartment blocks, which varied

Image 45 Levent housing complex, reproduced from *Arkitekt* 3 (1956), p. 178

from three to ten storeys, was very much consistent with the spirit of the time. The overall articulation of the blocks was a rectangular prism. Large glazed modular window openings and repetitive cantilevered or inset balconies were the features that provided dynamism to an otherwise simple architectural expression.

This last stage of the Levent housing project was a milestone in residential architecture in Istanbul and became a source of inspiration for many future developments. In the following years Istanbul saw a number of different developments designed in different shades of the International Style. Designed collaboratively by Halûk Baysal and Melih Birsel in 1957, the Hukukçular Sitesi in Mecidiyeköy was an important design comprising a total of 66 three-bedroom units in three different types: single, duplex and semi-duplex. Despite drawing its stylistic inspiration from Le Corbusier's Unité d'habitation, which was a social housing project, Hukukçular Sitesi was intended to attract the interest of the wealthier inhabitants of the city, and the apartments were equipped with double bathrooms, open kitchens and large balconies.[52] Living in modern flats in multi-storey blocks was much favoured by city dwellers, and similar developments were repeated in different parts of Istanbul in the late 1950s, such as the residential apartment blocks constructed in 1957 on Atatürk Boulevard in Aksaray and the İETT housing complex in Okmeydanı.

1950s Istanbul: postwar dynamics and change

Image 46 Hukukçular Sitesi, Aras Neftçi

The most significant residential project of 1950s Istanbul, however, was Ataköy housing complex. Located on the westernmost edge of the city in Bakırköy, on the shores of the Sea of Marmara, the project was designed as a large satellite settlement. A new littoral road, Kennedy Street, made this part of Istanbul easily

Image 47 İETT housing complex (1958–62) in Okmeydanı, designed by Leyla Turgut and Berkok İlkünsal, Salt Research, Architecture and Design Archive. Photo: Gültekin Çizgen

accessible, and the large Baruthane site near the airport was the most suitable place to establish a truly modern settlement consisting not only of modern residential buildings but also hotels, camping areas, beaches, restaurants and other recreational facilities. In order to facilitate the project, the government established an office in the EKB, led by Ertuğrul Menteşe who had previously run the planning bureau of the Istanbul Municipality. The Italian planner Piccinato, who had been invited to Turkey to participate in the redevelopment works in Istanbul, also worked as a consultant.[53]

According to the plans, the initial phase of the complex would have 618 units on 55 blocks ranging from three to 13 storeys. The apartment sizes ranged from 85 to 240 square metres based on five different layouts.[54] The projects for the first group of blocks bear the signatures of a group of Turkish architects: Ertuğrul Menteşe, Ümit Asutay, Yümnü Tayfun, Muhteşem Giray, Eyüb Kömürcüoğlu and Tuğrul Akçura.[55] President Bayar and Prime Minister Menderes laid the foundation stone for the first stage on 15 September 1957, and the construction works were completed in 1962. The great popularity of the project prompted the immediate start of the second phase, which included 702 apartments based on six different layouts.

1950s Istanbul: postwar dynamics and change

Image 48 Ataköy housing complex, Salt Research, Architecture and Design Archive. Photo: Gültekin Çizgen

All these new residential projects in Istanbul complied with the CIAM (Congrès Internationaux d'Architecture Moderne 1928–59) principles that inspired many housing projects in different parts of the world, such as Le Corbusier's Unité d'habitation in Marseilles and Berlin, Golden Lane Estate in London by Chamberlin, Powell and Bon and Blues Point Tower in Sydney by Harry Seidler. In the Ataköy development the same principles also guided the design: the new apartments were airy, adequately ventilated, light and rationally planned. The building envelopes were mostly formed by simple cubic forms and large window openings, and both horizontal and vertical structural lines

provided a clear message that the skin was no longer bounded by the structural system. Ornaments were either non-existent or kept to a minimum, such as the modern mosaic motifs positioned on building facades in the Levent apartment blocks.

Despite such up-to-date qualities in the dwellings, neither the Levent apartment blocks nor the Ataköy project were drafted to address the growing problem of housing in Istanbul. In contrast, such projects with their delicately manicured gardens, high quality building materials, large floor spaces of up to 240 square metres and, in some examples, even maid rooms aimed to attract upper income groups of the city. From this perspective, these projects cannot be considered as examples of the social housing projects that were popular in many war-torn cities in Europe. On the contrary, they were rising status symbols for the wealthier stratum of Turkish society, which had just stepped into a new phase of modernisation in the postwar social and economic conditions. The popularity and commercial success of the Fourth Levent and Ataköy estates made these projects role models for future mass housing projects in Istanbul in the following decades, in particular after the 1980s. Many similar housing projects were implemented by state-sponsored agencies, banks and private developers in various parts of the city. Rather than an effective tool to solve the dire housing problems of Istanbul, such developments boosted land speculation and eventually paved the way to gated communities, a popular phenomenon of Turkish residential architecture today.

Opera house: a decades-long dream

Although many projects took years to complete in mid-twentieth-century Istanbul, no other building in the city had such a complicated and long history as the opera house. The construction of the building proceeded painfully over three decades. Initial proposals for an opera house for Istanbul were first voiced by Lütfi Kırdar, governor-mayor of Istanbul, just before World War II. Like many other initiatives of the period, the wartime conditions delayed the beginning of the project and, after consultation with the French architect Auguste Perret, the task of designing an opera building was given to two Turkish architects, Feridun Kip and Rükneddin Güney, in 1946. Influenced by Perret's early Modernist designs, the proposal included a large opera hall, a concert hall and an exhibition hall. The foundation stone was laid in the same year and the building, similar to many other projects, was planned for completion before 1953, the 500th anniversary of the Turkish conquest

of Istanbul. Financial difficulties on the one hand and political developments on the other, however, caused significant delays and the municipality transferred the site to the Ministry of Public Works. The government, after consultation with Bonatz and Holzmeister gave the task to Hayati Tabanlıoğlu, who was then a member of the ministry's design team, in 1956.

Tabanlıoğlu made significant changes in the design and converted the building from an opera house to a multifunctional cultural centre. In addition to the 1,300-seat capacity auditorium, the new design included a 500-seat concert hall, a 250-seat theatre, a cinema and associated art galleries and multifunctional foyers. After a 13-year construction period, the complex named as the Istanbul Cultural Palace was finally opened with a performance of Giuseppe Verdi's *Aida* in 1969. However, the building's run of bad luck was not over as a year later it was engulfed by fire, causing significant damage to the auditorium and stage. Tabanlıoğlu undertook the substantial program of repair and rebuilding with assistance from German engineer Willi Ehle, who was responsible for the stage and technical aspects of the project. The renovated building was renamed

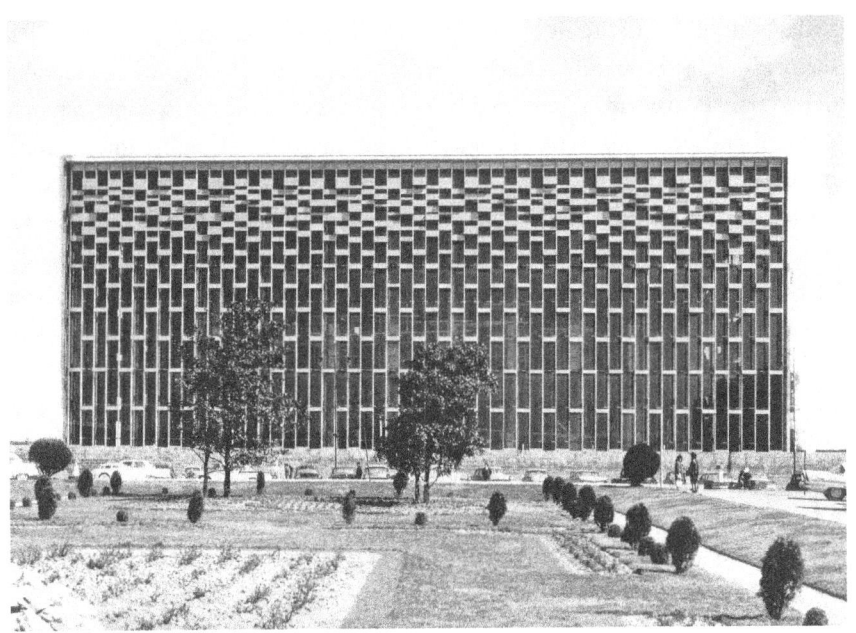

Image 49 Atatürk Cultural Centre (AKM), front facade, *c.*1960s, SALT Research, Tabanlıoğlu Archive

Atatürk Kültür Merkezi (Atatürk Cultural Centre), popularly known as AKM, and re-opened in 1978.

The architectural expression of AKM embodies many of the typical features of Modernism. The building form is comprised of three rectangular prisms. The front section containing the foyer and the halls reads from Taksim Square as a simple glazed rectangular box. The public facade, which draws its inspiration from a rising stage curtain, is made up of aluminium blades to provide sun shading. Its uninterrupted glass curtain wall and the suspended spiral staircase of the foyer were unprecedented in Istanbul's architecture at the time of their construction. The side and rear facades were designed simply, without any decorative features. The interior of the building was finished throughout with plain, yet high quality, detailing that includes delicately selected artwork bearing signatures of various Turkish painters and sculptors. All this makes the AKM one of the most prestigious public buildings of 1970s Turkey.

The end of the DP era

The optimism in Turkey, boosted by the positive and progressive political and social atmosphere of the early 1950s, gradually evaporated in the second part of the decade. The economic miracle came to an abrupt end when the remarkable developments in agriculture ceased in 1954 as a result of decreased international demand and declining prices in international markets. Changing international market conditions, on the one hand, and harsh climatic conditions in the countryside, on the other, reduced economic growth from an amazing rate of 13 per cent per annum to 4 per cent. Moreover, the weakening foreign economic assistance and deficient foreign investment brought a sharp decline in the Turkish economy. All these bitter conditions led to an austere shortage of consumer goods and mushrooming black markets in the big cities. Finally, as a result of the shrinking economy, Turkey's total public debt more than doubled in the final five years of the decade.

This sharp economic downturn exerted a severe influence on overall political and social life in Turkey. In response to these economic difficulties, the government adopted a repressive position and overturned its liberal policy programme for one of centralised control. Despite all these problems, the DP won the 1957 elections, but this time with a reduced majority. Yet the intense partisanship and profound intolerance of political rivals brought an end to the alliance between the middle class intelligentsia and the Democrats. The rising political tension was also

fuelled by the RPP's implacable opposition, which asserted that everything the DP did was at fault, and this led the government to take a tougher position against the opposition.

The high political tension also ignited some unfortunate social events. The Turkish–Greek relationship in the 1950s began to turn sour over the Cyprus problem. The Turkish government and the general public had concerns about Greek plans for annexing the island to mainland Greece. In this political atmosphere on the night of 6 September 1955 a demonstration started in Istanbul against the Greek minority, following fabricated news that had appeared in newspapers avowing that Atatürk's house in Thessaloniki had been blown-up by Greek nationalists. Protests, which seem to have been sparked by the government, quickly escalated beyond control and turned into a riot with devastating consequences. Although security was re-established within a few days, Istanbul lost the last remaining remnants of its cosmopolitan character, as many Greeks who no longer felt themselves secure left the city.

The economic difficulties and increasing social unrest allowed the Kemalist establishment to galvanise anger against the ruling DP. The DP's liberal policies had created a new middle class in the large cities and these groups gradually extended their powerbase under the Democrat administration. This new emerging bourgeoisie, in the eyes of the Republican elite, was economically corrupt and socially reactionary. Ostensibly, this was a fight between the Republican modernisers who wanted to retain gains brought about by the Kemalist reforms and reactionary groups that had grown under the DP's political agenda. In reality, it was a power struggle between the old elites who had benefited from the protective policies of the single-party regime and the new elites of Turkey emerging under the auspices of the Democrat government.

Amidst all this political turbulence, Istanbul's redevelopment had gradually become a hot topic. In the city murmurs had already started as the redevelopment works progressed. In particular, crudely executed land and building exportations – in some cases the property owners were forced to vacate their buildings and lands without appropriate compensation – created a deep anxiety in society. Also, as many works began simultaneously in different parts of the city, Istanbul was turned into a large construction site, and this also created a general disquiet amongst the public. In this heavy political climate the very positive tones of the assessments by architectural circles also began to change in the later stages of the redevelopment.[56] According to some critics, works were not based on appropriately prepared plans and were carried out on an ad hoc basis. The political

opponents of the DP also claimed that Menderes used Istanbul's redevelopment to mask the government's deficiencies in overall economic policies and to ease the general dissatisfaction in the society.

This increasing political malaise and social discontent came to an end on 27 May 1960 when the DP government was overthrown by a military coup d'état.[57] Menderes and Bayar were arrested, as well as all DP representatives in the parliament and members of the municipal councils. Following a long trial at a special court set up by the military junta, Menderes and his two cabinet ministers were executed in September 1961. The so-called *İstimlâk Yolsuzluğu Davası* (Case of Corrupt Expropriation), more commonly known as the *İmar Davası* (Case of Redevelopment), was one of 19 cases brought against Menderes and the DP administration. In this case Menderes and his colleagues in the government and municipality were accused of unlawful expropriation of private properties without proper compensation, inappropriate use of public resources and other related corruption allegations. During the long trials Menderes was faced with severe accusations by the prosecutors and some witnesses.

In many instances Menderes confronted his accusers alone as the great majority of the mayors, municipal officials and other public servants who had worked with the prime minister in the redevelopment works did not accept any responsibility, as they stated that they merely followed orders and blamed Menderes for conducting the works in his own way. On the other hand, Menderes, in his defence, argued that everything progressed along a definite programme and in accordance with the existing legal documents. Moreover, the prime minister stated that the works had been conducted in accordance with the plans firstly prepared by Prost and subsequently revised by the Turkish and foreign experts who had taken serious roles in the redevelopment programme. At the end of the trials the court found Menderes and some of his colleagues guilty, but the Redevelopment Case, similar to other cases, was amalgamated with the Violation of Constitution Case whereby the prime minister was found guilty and executed accordingly.[58]

The four years between 1956 and 1960 represent one of the most important periods in the modern history of Istanbul. In this period Istanbul finally succeeded in opening up the large boulevards which had been envisaged for almost 150 years through many attempts by Ottoman and Republican administrations to solve the city's chronic urban problems. His ambition and dedication make Menderes the most significant and, at the same time, controversial figure in this long journey towards the transformation of Istanbul into a modern metropolis.

1950s Istanbul: postwar dynamics and change

The physical morphology of the old city – the Historic Peninsula, Beyoğlu and Beşiktaş – was predominantly shaped by the redevelopment programme conducted by Menderes. That is why Menderes is depicted in the accounts of contemporary scholars as a figure who acted solely on political motives and destroyed Istanbul's historic characteristics. He was also blamed for conducting the redevelopment on an ad hoc basis, without consultation with qualified experts and, more importantly, without a definite plan.

Certainly, the above claims do have some validity. It is correct to say that Menderes personally conducted many works, and some decisions were taken arbitrarily on the construction sites. Also, the municipality and the government took a crude approach in some expropriation cases, and this caused anxiety among certain segments of the society. However, a more detailed reading of available materials tells a different story. Firstly, it should be noted that Menderes was not the first figure to propose and execute the opening of large roads in Istanbul. Before him, many proposals were made and some of them partially executed, and the prime minister inherited a rich legacy in this respect. The economic developments of the time and the financial resources which Menderes held in his hands enabled him to execute these costly projects, which had been attempted unsuccessfully by his predecessors, both in the nineteenth and early twentieth centuries. Secondly, his programme was, in fact, based on plans. The major roads he constructed were contained in earlier plans first prepared by Prost and later detailed by Turkish and foreign experts in the early years of the 1950s. And, thirdly, Menderes' redevelopment was not a single-handed project as many experts, both Turkish and foreign, took significant roles in the works. While Menderes' ambition and personal involvement in the redevelopment programme cannot be denied, the works were carried out in accordance with the input and guidance of the many professionals who worked in different offices specifically dealing with the redevelopment programme. From this angle, it can be speculated that the foreign economic aid, growing economy, planning legacy and accumulated problems of the city would together have forced any political leader to respond to 1950s Istanbul in a similar way to Menderes, regardless of the political tendencies of the government or the personality traits of its leader.

Although the DP era saw a dramatic conclusion and many projects conducted in this period created much controversy, the ten years beginning from 1950 left many significant marks on the physical morphology of Istanbul. And all these marks guided the future development of the city both in desirable and undesirable

ways. The redevelopment programme based on Modernist design principles, the prismatic buildings erected in the postwar International Style, and the modern housing complexes constructed in different parts of the city were important turning points in the city's modern history and paved the way for more ambitious and dynamic progress in the decades to come.

4

Istanbul between two coups: many plans, many failures

The military coup of 27 May 1960 launched a new era in Turkish history. The army's intervention in politics created contrasting reactions in different segments of society. Some student groups, the high-ranking bureaucracy and the Kemalist intelligentsia in Ankara and Istanbul joyfully welcomed the army's takeover. The rest of the country, however, was silent and the masses followed with disapprobation the trial of Menderes and the entire cabinet of Democrat Party (DP) officials, which resulted in the execution of the prime minister and two of his cabinet colleagues.

The months following 27 May saw a wholesale remodelling of the Turkish political system, leading some scholars to describe this era as the Second Republic of Turkey.[1] Following the closure of the parliament, a new constitution was drafted by a group of professors of law appointed by the military junta. In this new system parliament consisted of two chambers, an upper house called the senate and a lower house, and all legislation was required to pass both chambers. The main aim was to prevent a monopoly of power, which could be gained by a party who had the National Assembly. The new constitution brought some important democratic rights for Turkey and established a constitutional court. It granted autonomy to the universities, permitted labour organisations to conduct strikes and brought many other social opportunities for various segments of society. On the other hand, the new system had much less faith in politicians and tried to limit the power of political parties as much as possible. For example, the members of the National Union Committee, which was established by the military junta to run the country immediately following the coup, were granted permanent membership of the senate. The military was also given a constitutional role in politics through the establishment of the National Security Council, whereby the head of the Turkish

Armed Forces and other high-ranking generals could act as politicians and intervene in the governing of the country in a wide spectrum of areas, ranging from foreign policy to education, the legal system and economic development.

Notwithstanding all these efforts, the remnants of the DP retained their power base and their popularity with the masses. The first signal of this support came in a public referendum for the new constitution which was held on 9 July 1961. Despite all the one-sided propaganda and anti-DP rhetoric, only 61 per cent of the total vote was in favour of the new constitution. The support for the DP spirit became more apparent in the parliamentary elections held on 15 October of the same year. The Republican Peoples Party (RPP) led by İsmet İnönü gained a disappointing 37 per cent of the votes and only won the elections by a small margin. On the other hand, the remnants of the DP, organised under the Adalet Partisi or Justice Party (JP) and Yeni Türkiye Partisi or New Turkey Party, gained almost 50 per cent of the total vote.[2] The JP's success became more explicit when it overwhelmingly won the 1963 municipal elections in Turkey, including Istanbul.[3] This was the first time that mayors were selected by the public in Turkey. Until then, mayors had been appointed by the central government, and in Istanbul, Ankara and İzmir mayors also served as the governors. In Istanbul the High Election Committee vetoed the JP's candidate, but this decision came after the votes were counted.[4] This step made the RPP candidate, Haşim İşcan, the mayor of Istanbul but caused a large outcry from the JP. The popularity of the pro-DP politicians was further accelerated in the 1965 elections. This time the JP, led by its new leader Süleyman Demirel who would dominate Turkish political life for the next four decades, crushed its political opponents and gained 53 per cent of the total vote.[5]

While the successors of the DP took control of government, the RPP also saw a radical shift in its internal affairs. Since its establishment in 1920 the RPP had always represented the establishment, and had relied on an unwritten alliance between the military and civil bureaucracy and the provincial notables who had absolute control of the peasantry through centuries-long traditional ties. The RPP, therefore, represented the cold and autocratic face of the state, and this very powerful bureaucracy had lost sympathy with the larger stratum of Turkish society. All the election results since 1950 proved vividly that the existing party policies did not work in a multiparty democratic system and, despite unconditional support for the RPP by both the army and the bureaucracy, the party's popularity saw a gradual erosion in almost all segments of society. The first crack in this party profile came in the lead-up to the 1965 elections when the RPP began to position itself to the left-of-centre in the political

spectrum. The architect of this policy shift was Bülent Ecevit, a rising star in the party who convinced İnönü that the future of the party lay in attracting the votes of the urban poor, namely the workers and inhabitants of the *gecekondus*. The new tactic worked well and demonstrated its earliest results in the 1968 local elections when the RPP increased its vote in the big cities.[6]

Planned economy

The magical word of the 1960s was 'planning'. Despite all the remarkable achievements in the economy and infrastructure, the previous DP administration did not walk on a path drawn up by an overall economic plan. In fact, 'planning' was amongst the words most disliked by Menderes who associated the term with Communism. In the post-1960 system the aim was to establish an industrialised economy based on carefully prepared plans drafted by technocrats, rather than to allow politicians to act freely on their own wishes. Hence the 1960 constitution established an autonomous Devlet Planlama Teşkilatı (State Planning Office) with extensive regulatory power in economic, social and cultural fields. This was followed in 1963 by the reinstatement of five-year development plans similar to those experienced in the 1930s. Also in this period, Turkey switched to an economic growth model based on imports subsidising industry, where domestic production was protected by high custom tariffs and the Turkish lira was artificially valued against foreign currencies.[7] This created a floating internal market in which all sectors were monopolised by one or two large Turkish companies that did not have to compete with the world market and made remarkable profits under the auspices of protective economic policies. Agriculture was the other sector which saw very generous support by the government through the guaranteed purchase of agricultural products by public enterprises at unrealistic prices. These measures created optimism in the Turkish economy and a positive atmosphere. Indeed, Turkish economic indicators were sparkling. The average 6 per cent annual growth rates coupled with a 20 per cent increase in real income figures between 1963 and 1969 brought confidence to the wider strata of society.[8] The promising economic indicators brought many advances to the lives of ordinary Turkish citizens. Home appliances, for example, became more affordable in the 1960s. In 1959 Arçelik produced Turkey's first washing machine and a year later the same company began to produce refrigerators. In 1966 the first Turkish-made automobile, Anadol, was also put on the market, and the Turkish Radio and

Television Corporation launched trial TV broadcasting in 1968 from their studios established in Ankara.⁹

Emerging popular subculture

While the politics and overall economic dynamics of Turkey were redrafted in favour of a more balanced distribution of political power and a planned economy, Istanbul entered an experimental stage where these overall policies were tested in terms of urban planning. The growing economy and the mechanisation of agriculture since the early 1950s had turned Istanbul into a city with 'its stone and soil made of gold' in the eyes of the hundreds of thousands of migrants who had left their villages and flooded into the city. The modernisation of agriculture was further intensified in the 1960s and this trend coincided with the integration of villages with regional markets. All these developments eliminated small-scale husbandry and forced surplus manpower to seek new horizons in the larger cities, particularly Istanbul, in order to earn a living. Rural migrants made up 8 per cent of the total population of Turkey in 1950 and this figure reached 12 per cent in 1965. Again, the total population of the cities rose from 19 per cent in 1950 to 36 per cent in 1970. In 1965, 1.4 million inhabitants of Istanbul, or more than half of the total population, were born outside Istanbul.¹⁰

There were three major social and cultural consequences of this immense mobility. The first was the problem of *gecekondu*. Insufficient building stock and the lack of well-planned strategies to cater for the masses that poured into the big cities forced the newcomers to find their own solutions. High inflation and expensive rents did not allow them to find proper accommodation at affordable prices. The construction industry was primarily run by private developers, without any operative regulatory input from government agencies. The social housing projects executed in the 1950s were experimental, mainly targeted rich segments of society, and could not provide a reliable response to the growing population. Hence the new inhabitants of the city were forced to construct unauthorised shelters on publicly owned lands on the outskirts of the urban centres.

Unauthorised building activity was not a new phenomenon in Turkey. Ottoman Istanbul, especially after the second half of the nineteenth century, saw massive population influx when the Empire lost vast territories in Eastern Europe, and this social mobilisation resulted in the construction of shelters in different parts of the city, even in some cases in the courtyards of great sultanic mosques. Thanks to peasantist policies, the early Republican years were quieter

Istanbul between two coups: many plans, many failures

in Istanbul. The only exception was the immigrants who came to Turkey from abroad and settled in different areas and then moved to, and lived in, *gecekondu*s in the Zeytinburnu district of the city. However, as noted in earlier chapters, Istanbul encountered the *gecekondu* problem in a real sense after World War II when the slums in Zeytinburnu swiftly extended their borders and began to spread to the other parts of the city in the second half of the 1940s. The number of shanty houses in the city was around 8,000 in 1950 and this figure dramatically increased in the following years to reach around 120,000 in 1960, 131,000 in 1966 and 195,000 in 1972.[11]

Exhausted by this fast-growing struggle, municipalities and central government agencies tried desperately to create alternative solutions within the legal framework. In 1963 a law passed by the parliament required municipalities to provide basic services to the *gecekondu* neighbourhoods. This was followed by the *Gecekondu Kanunu* (Gecekondu Act), which was enacted in 1966. By this legislation *gecekondu* was recognised as a reality in the Turkish legal system. According to this act, buildings which were capable of rehabilitation would be renovated, the others would be demolished and necessary precautions taken to inhibit new *gecekondu* districts. However, neither of these measures worked, and the *gecekondu* problem continued to grow over the following decades.

The *gecekondu* areas appeared haphazardly and were located close to the industrial districts along the shores of the Golden Horn and, in the 1970s, behind the pharmaceutical and electrical factories lining Büyükdere Street in Levent. These buildings were mainly single-storey basic structures that created a village-like environment. Electricity, running water and sewerage were absent, and the *gecekondu* neighbourhoods lacked any civic services. The contrast between the social structure of the two sides of Büyükdere Street, Levent and Gültepe, was the first of its kind to be seen in Istanbul. The suburbs of Levent, Etiler and Akatlar that overlooked the Bosphorus were primarily occupied by upper middle class dwellers, whereas the slopes that faced the Kağıthane Stream were blanketed by *gecekondu*s packed with domestic migrants. This trend – a sharp division in the social make-up of areas bordered by a street or a highway – was repeated in various other parts of Istanbul over the next decades as many *gecekondu* areas would emerge in the vicinity of wealthier quarters of the city. This close proximity of slum dwellings to the upmarket districts also brought a very pragmatic labour market for the *gecekondu* dwellers. While the males were working in industrial plants and construction sites, female members of *gecekondu* families began to work in middle and upper middle class homes in domestic services, such as cleaning, ironing and cooking.

Architecture and the Turkish City

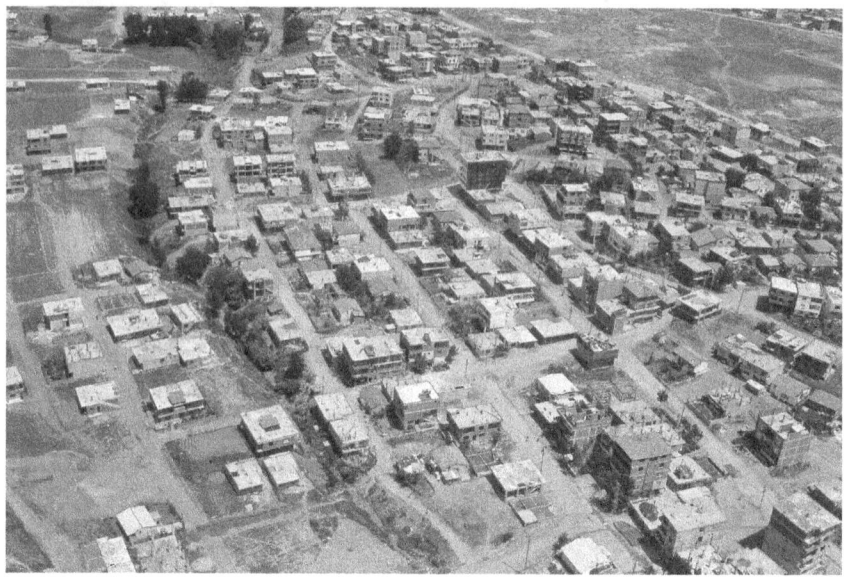

Image 50 Emerging *gecekondu* dwellings in remote districts of Asian Istanbul, Aras Neftçi

The second consequence of the rapid urbanisation of Istanbul was experienced in transportation. Like many cities around the world in the postwar period, Istanbul ceased tram services, dismantling its tram network in 1961.[12] The new boulevards opened in the city would now allow more efficient travel by private cars, and trams which operated at an average speed of only seven kilometres per hour were no longer wanted. To address the problem of transport for the masses, Istanbul was introduced to a new mode of public transport: the trolleybus. The initial project for the trolleybus network was carried out in 1956 and then vehicles were ordered from an Italian company in 1957. The first trolleybus line was established between Topkapı and Eminönü on 27 May 1961, the first anniversary of the 1960 military coup. In the following years the network was extended to 45 kilometres and the number of vehicles increased to 101 in 1968.[13] Yet neither the aged bus fleet nor the new trolleybuses operated by the municipality were sufficient to meet the increasing demand for public transport. As a result, apart from the buses and trolleybuses, Istanbul's most authentic mode of public transport was the *dolmuş* or shared taxi that travelled a set route at a fixed price. Although the first *dolmuş* appeared in the city in the 1930s when groups of customers began organising their trips to reduce the cost of a single ride, it became popular concurrently with the

growth of *gecekondus* after World War II as a result of the insufficient public transport provided by the municipality. Ten per cent of the entire public transport system in Istanbul in 1950 was provided by *dolmuş*, and this figure increased to 20 per cent in 1955. In 1954 the municipality established regulations and this gave *dolmuş* a legal status. Initially, *dolmuş* vehicles were created in local workshops by modifying large cars to extend their chassis and increasing passenger capacities to seven people. After 1960 larger capacity minibuses were added to *dolmuş* fleets in the city, and the share of *dolmuş* in overall public transport increased to almost 50 per cent in the 1970s.[14]

In addition to *gecekondu* and *dolmuş*, the third significant product of the rapid urbanisation came in the field of music. Emerging in big cities in the 1960s, *arabesk* (spelt *arabesque* in English) was a popular musical style that represented migrant culture in Turkey. It took its inspiration from Arabic music, in particular mainstream Egyptian compositions, and mixed it with the tunes of Turkish folk songs. Similar to 1960s rock music in England and the United States, *arabesk* served as a vehicle for cultural and social movements and represented protest culture. The lyrics were often concerned with romantic love but in most cases they were expressed in a melancholic manner that reflected the miserable conditions of migrants who had encountered an 'alien' environment in the big cities and had been forced to live in depressing *gecekondu* districts. In intellectual circles the music was seen as sentimental or sleazy and labelled '*minibüs musikisi*' (music of the minibus or *dolmuş*), and was fervently despised. Despite this kind of music being forbidden on Turkish radio and the sole state-owned television station for more than three decades, the *arabesk* stars produced many bestselling records.[15]

New hopes: plans guiding Istanbul

The era following the 1960 coup was one of general optimism and created hope in architectural circles for better planning initiatives for Istanbul. Many in the architectural community who had vehemently criticised Menderes' urban interventions now called for a new kind of thinking in urban redevelopment based on appropriately drafted plans. For these groups, the 'dark days' of the previous decade were now in the past and there was no reason not to be hopeful for the future of the city. The Chamber of Architects showed their gratitude for the military takeover by sending a cable message immediately after the coup to General Cemal Gürsel, the head of the military administration.[16] Also, according to Zeki Sayar, the military coup terminated the previous 'depression that

harmed the artistic and technical life' of Turkey. For the editor of *Arkitekt*, who had vehemently supported the demolitions in the early days of the DP's redevelopment programme, the 'amateurs' [read Menderes], who had made significant mistakes by not listening to experts and had conducted all works according to their political will, would no longer have any chance to intervene in redevelopment works.[17] Similarly, Hulusi Güngör, the editor of the new architectural magazine *Mimarlık*, published by the Chamber of Architects, believed that a programme based on planned development was finally in place. By this act, the mistakes of the past would not be repeated and Istanbul's development would be guided by properly prepared plans.[18]

The initial position taken by the military government was promising and buoyed such sanguineness. According to the new administration, similar to planning at the state level in the economy, industry and many other areas, Istanbul's urban expansion should also be guided by well-established plans. Hence the Ministry of Redevelopment and Settlement established the Marmara Regional Planning Office (MRPO) in late 1960. The main objective of this office was to coordinate the planning policies of cities within the Marmara Region (Istanbul, Tekirdağ, Kırklareli, Edirne, Çanakkale, Balıkesir, Bursa, İzmit and Sakarya) and to offer more detailed planning legislation and instruments for the whole region. In the meantime, a specific agency named İstanbul Nazım Plan Bürosu (Istanbul Master Plan Bureau) was established within the ministry to undertake the urban planning of Istanbul under the directions of MRPO.

The MRPO drafted a regional plan called the East Marmara Regional Planning Study in 1963. According to the projections contained within the plan, the east Marmara axis between Istanbul, İzmit and Sakarya would be rapidly industrialised and urbanised. From this perspective, Istanbul's future population in 1980 was estimated as five million. The principles set by the study had been widely accepted, both by the relevant state institutions and by professional organisations such as the Chamber of Commerce and the Chamber of Industry. Although the plan could not be formally implemented because of the lack of subsequent detailed works, the eastern Marmara region turned haphazardly into the industrial hub of Turkey as many factories, plants and oil refineries were lined along the narrow coastal strip by the shores of the Sea of Marmara in the 1960s and the following decades. This intense urbanisation also brought with it a population boom in the vicinity of the industrial plants, making the east Marmara region the most densely populated area in Turkey.

While Istanbul had been included in the regional plans, the city itself saw some changes in its administration and planning affairs. Immediately after the 1960

Istanbul between two coups: many plans, many failures

coup the military junta appointed Colonel Refik Tulga as the mayor and governor. The two offices previously run by Hans Högg in the Municipality and Luigi Piccinato under the Bank of Provinces were closed down, and a new bureau called the Development Planning Directorate was established at Istanbul Municipality in 1961 to undertake urban planning works. By this decision the municipality aimed to amalgamate different offices under one roof and coordinate the redevelopment works in a central office. Turkish architect Turgut Cansever was appointed as the head of this new directorate, and an action plan was prepared to guide Istanbul's future urban redevelopment for the next 20 years. The new office first drafted a plan called *İstanbul Mücavir Sahalar Planı* (Plan of Istanbul's Adjoining Lands) in 1961. The main objective of this plan was to prohibit the subdivision of lands and construction in areas that were yet to be planned. Under the new political climate the plan also required public participation in decision making. The optimism, however, was short-lived and trials to implement the plan concluded unsuccessfully. Neither the relevant government agencies nor the public supported the philosophy behind the plan. The restrictions proposed in its clauses were found to be too rigid and to barricade the construction activities that were the most dynamic player in the Turkish economy.

In the meantime, Piccinato completed his master plan in late 1960 and submitted it to the Ministry of Redevelopment and Settlement for approval. His plan estimated Istanbul's future population as three million and proposed a linear city expansion along the east–west axis. The Italian planner strongly advocated decentralisation of the city and relocation of the existing industrial plants to the easternmost fringes of Istanbul. For him, Istanbul should no longer accommodate serious industry but become a commercial and cultural centre. Since the existing cores, the Historic Peninsula and Beyoğlu, were already densely populated, no new developments were proposed in those centres and new residential areas were offered on the shores of the Sea of Marmara on both the European and Asian sides of the city. A highway associated with bridges over the Golden Horn and the Bosphorus would provide a rapid link between those new suburbs. All these new residential districts would be served by their own centres. Under the influence of the strong anti-Menderes rhetoric of the era, Piccinato changed his views radically on Menderes' urban redevelopment. The Italian planner, who had previously had seen the former prime minister as one of the three great opportunities for Istanbul, now vehemently criticised the works that had been completed between 1956 and 1960. His plan, however, could not secure approval by the government and required modification according to the regional planning documents.

The widespread optimism in architectural circles with respect to better planning policy after the 1960 coup was gradually eroded. Neither the offices established by the central government nor the municipality's new approach brought about any viable solution to the planning problems of Istanbul. Instead, all those institutions worked separately, without any coordination, and produced many plans which did not address each other. The resulting hubbub infuriated the mayor, Colonel Tulga, who complained about the lack of appropriately qualified technical personnel in the country and labelled Turkish architects and engineers as 'too lazy'. Piccinato was called upon one more time to conduct the redevelopment plans for the city.[19] The Italian expert soon returned to Istanbul and worked as an advisor to the ministry on planning works. Piccinato insisted on his 1960 planning suggestions and proposed that Istanbul's planning should be considered within its region and that the city should have a linear expansion along the shores of the Marmara Sea. This chaos and the divergence of planning principles led Cansever to resign from his post at the Municipal Directory in 1963.

Istanbul's architecture post-1960

Similar to turning points in the preceding decades, the changing political atmosphere of the country in the period following the 1960 military coup shaped architectural practice in Turkey. The 'anti-Menderes' rhetoric of the era deeply influenced architectural circles in Turkey. In particular, a group of leftist architects who took control of the Chamber of Architects in the mid-1960s gained a 'self-adorned social responsibility' with the aim of shaping the future of the country. According to these architects, headed by Vedat Dalokay and others, the main task of the profession was not limited to providing the architectural services needed by society, but also creating, with other 'revolutionary' groups, a political and social order that concurred with socialist and, even communist, principles.[20]

Under this political atmosphere, the International Style, which had dominated Turkish architectural practice throughout the 1950s, began to lose its distinct status. The buildings designed in this style were associated too closely with the DP era when, according to leftist architects, American imperialism had played a determining role in the fate of the country. On the other hand, in the West the prismatic aesthetic of the International Style and the principles formulated by Le Corbusier and other leading figures of twentieth-century modernist architecture had already begun to be shaken in the mid-1950s. Young architects of the era now sought new approaches to overcome the simplistic forms of modern architecture and the strict rules that aimed

to shape cities in accordance with functionality theory. Such criticisms led a group of young architects to form Team X (also referred to as Team Ten) that seriously challenged the pedantic slant towards urbanism of CIAM, and such criticism finally led to the dissolution of CIAM in 1959. Both domestic political concerns and new trends in architecture in the Western world led many Turkish architects to seek alternative approaches and, in many instances, their new attitudes employed inspiration from local qualities and became known internationally as 'New Regionalism'. Ironically, new trends in American architecture also continued to guide Turkish architects in this period, despite strong anti-American feelings. Frank Lloyd Wright's organic architecture and Louis Kahn's New Brutalism were two significant sources of inspiration for Turkish architects in the 1960s and 1970s.[21]

Two manifest examples of such an approach can be seen in the Historic Peninsula. The first project was the Sosyal Sigortalar Kurumu (Social Security Complex) in Zeyrek. Commissioned by the İşçi Sigortaları Kurumu (Workers' Insurances Corporation) and designed by Sedad Hakkı Eldem, the complex was located on a triangular sloping site on Atatürk Boulevard, between the Valens Aqueducts and Unkapanı. The building form comprised five major building blocks of different sizes positioned along a wide enclosed corridor on a North–South axis. The blocks accommodated offices, a banking branch, medical clinics and a cafeteria. The separation between the blocks broke up the large building envelope and provided a harmonious composition for its sensitive location. In particular, the building's cascading form successfully occupied its sloping site, which was surrounded by traditional timber houses and located near the Byzantine Church of Pantocrator (Zeyrek Mosque). In this project, Eldem now abandoned his temporary engagement with the International Style and returned to his original source of inspiration: traditional Turkish vernacular architecture. Although Eldem here employed a local architectural language motivated by the surrounding urban fabric, his design approach was different from his earlier Second National Architecture. Rather than directly importing old Ottoman forms, Eldem opted for an interpretive attitude that used the spatial qualities of Turkish vernacular houses in a modern manner, an approach that was explicitly represented in the overall architectural manifestation of the building.[22] Modular window bays emphasised by pre-cast concrete mullions, wide roof overhangs attached to the rooftop terraces and cantilevered facades were all modern designs that established a strong relationship with the language of the historic precinct. The project's efficacious interaction with its locality would bring the Social Security Complex the prestigious Aga Khan Award for Architecture in 1986.

Architecture and the Turkish City

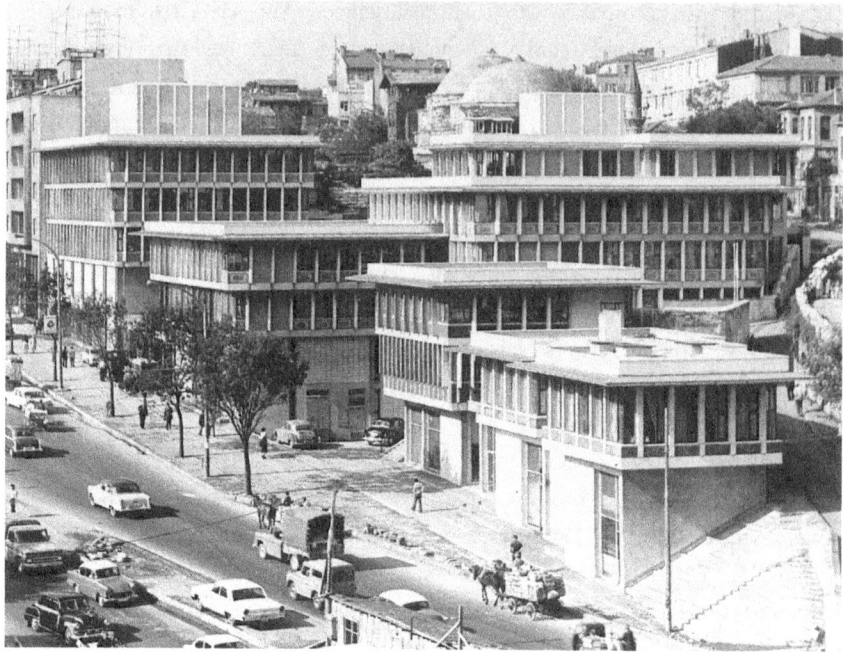

Image 51 Social Security Complex in Zeyrek, Rahmi M. Koç Archive & SALT Research, Sedad Hakkı Eldem Archive

The second project was located across Atatürk Boulevard in the Unkapanı district. The sloping site from the Valens Aqueducts to the Shores of the Golden Horn along the eastern side of the boulevard was considered for a large complex called İstanbul Manifaturacılar Çarşısı (İMÇ) or the Textile Merchants' Bazaar in the mid-1950s. Menderes, in the press conference officially launching his redevelopment programme on 23 September 1956, promised to construct a large and modern compound for the textile retailers. An urban design competition was organised in the following year, and the first prize went to Tarık Aka, Özdemir Akverdi, Cihat Fındıkoğlu, Kamil Bayur and Orhan Şahinler. Vahit Erhan and Hüseyin Baran received the second prize and Doğan Tekeli and Sami Sisa held the third prize.[23] The results of the competition were further studied by a planning committee under the direction of Piccinato, and following a subsequent design competition the proposal by Tekeli, Sisa and Metin Hepgüler was selected for implementation. The construction of the complex however, was delayed and only commenced after the military coup in 1961, with the first phase being completed in early 1967. The project occupied an extended strip along the eastern side

Istanbul between two coups: many plans, many failures

of Atatürk Boulevard and comprised around 1,100 shops, depots and associated spaces. In a similar way to Aldo van Eyck's orphanage in Amsterdam, the large complex employed a fragmented approach. A group of rectangular low-rise blocks (mostly two to three floors) was interconnected by corridors and open courtyards, and the overall complex was successfully placed on the historically sensitive site. Yet, unlike Eldem's Social Security Complex, the İMÇ's architecture did not take any stylistic inspiration from its existing context, and instead preferred a modern

Image 52 An internal courtyard, İMÇ blocks, Murat Gül

manifestation readily visible in the rectilinear expressions of the building envelopes, the modern construction materials, such as exposed concrete and glass, and the precast sun shading elements on the building facades. In the 1970s the later phases of the İMÇ gradually became the headquarters of the Turkish music industry as many musical producers set up their businesses in the complex. It was especially so for *arabesk* music production as İMÇ became the first destination for those migrants who sought a glamorous future similar to that of their role models, Orhan Gencebay and Ferdi Tayfur, the pioneers of the *arabesk* music of Turkey, who had migrated to Istanbul themselves from their provinces in Anatolia. This marriage between the iconic representative of Istanbul's modern architecture and the most popular expression of *gecekondu* culture brought an interesting synthesis to the socio-cultural landscape of Turkey.

The first skyscrapers

If large boulevards were the defining urban works of the 1950s, high-rise buildings were the rising stars of 1970s Istanbul. Unlike many other cities of the postwar era that first encountered important examples of high-rise primarily as office buildings, Istanbul met its first 'skyscrapers' with the construction of four large-scale hotels, all opened in the mid-1970s. These hotels not only increased the tourism potential of the city but, more importantly, emerged as the tower blocks that would come to dominate the skyline of Istanbul. Although the military barracks constructed in Beyoğlu and some large-scale buildings, such as the Public Debts Office building or the Vakıf Hans in the Historic Peninsula, had slightly altered the city's legendary outline in the late nineteenth century, Istanbul's medieval silhouette formed of the domes and minarets of the Ottoman masterpieces had remained unchallenged for centuries. Even the construction of the Hilton Hotel and the Municipal Town Hall with their massive cubic masses did not result in a radical change in the overall vista of the city from the sea or the Asian shores of the Bosphorus. However, the hotels constructed in the 1970s were the first buildings to challenge the historic character of Istanbul's skyline.

The first hotel was in close proximity to the Hilton. This time the site chosen for this large tourism complex initiated by the Directorate of Pious Foundations was at the north-eastern corner of the İnönü Promenade, which then was occupied by Taksim Gazinosu, a public club designed by Rükneddin Güney. In order to select the best design, an international design competition was organised in 1959, and a total of 11 projects were submitted by architects from five different

countries, including Turkey. The panel headed by Piccinato selected a design for the hotel by AHE (a consortium of local architects including Kemal Ahmet Aru, Hande Suher, Mehmet Ali Handan, Yalçın Emiroğlu, Tekin Aydın and Altay Erol).[24] After almost a decade-long delay, the foundation stone for the hotel was laid on 28 March 1968 by the prime minister, Demirel.[25] At the same time the management of the hotel was given to the American Sheraton Group with a guaranteed 2 per cent annual payment.[26] The construction took seven years, and the hotel was opened on 2 August 1975. In the polarised political atmosphere of the 1970s the opening of the hotel, similar to almost all other issues, became a political hullabaloo. Ahmet İsvan, the mayor of Istanbul from the opposition RPP, declared the hotel unauthorised and would not issue the occupation permit on safety grounds. Demirel, in the opening ceremony, mocked the mayor and stated that 'hopefully we will open hundreds of such unauthorised buildings'.[27] This was the first major development where construction permits were controversially granted without a transparent approval process, an approach that would continue up until the present day for many significant developments changing the urban landscape of Istanbul. According to Demirel, who like Menderes set rapid economic development as the most urgent priority, tourism was 'the industry without chimneys' and Istanbul needed at least 20 more hotels of this size. In his mindset such minor inconsistencies as building codes and regulations were 'small details' that could be ignored.[28]

Architecturally, while the Sheraton Hotel's (now named Ceylan Intercontinental Hotel) dynamic geometry differed from the Hilton's robust prismatic envelope, the building still bore the major characteristics of the postwar International Style, sometimes expressed in a Mannerist style. The envelope of the building comprised a split tower of 17 floors of guest rooms that rose over a two-armed podium and splayed out to provide a lofty entrance. The use of exposed concrete and large windows with aluminium framing provided a Brutalist appearance to the hotel.

The second tall building was Harbiye Orduevi, a club and lodging facility exclusively constructed for the accommodation of military officers. This dominant building came after a design competition organised in 1967 in which Metin Hepgüler's proposal was awarded the first prize.[29] Located in close proximity to the Hilton Hotel, in the grounds of the Military Museum, the building, with its exposed concrete facade swathed with repetitive cantilevered balconies, represented Brutalist characteristics, an architectural treatment popular worldwide in the 1960s. When the building opened its doors in 1974, it became the tallest building ever built in Istanbul, vividly symbolising the power of the Turkish armed forces in Turkey's social and political life in the 1970s.

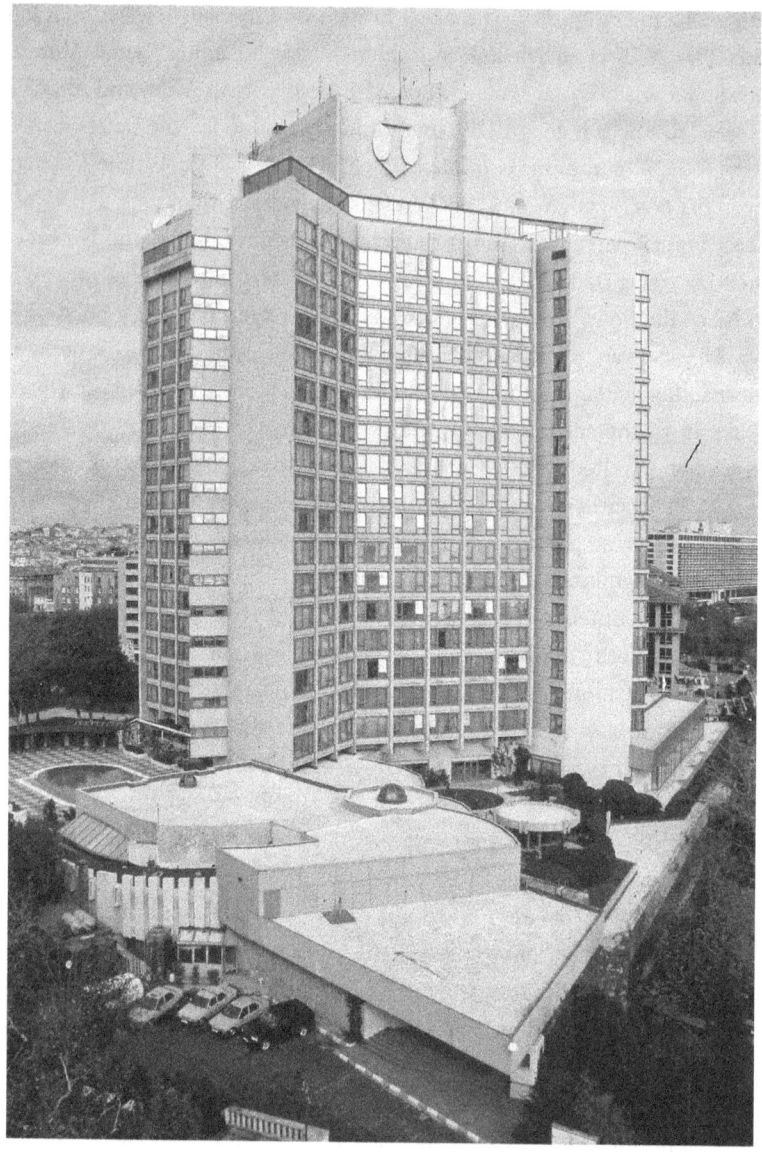

Image 53 Former Sheraton Hotel, Aras Neftçi

The Sheraton Hotel and Orduevi's prevailing roles in Istanbul's skyline were challenged soon after by the Intercontinental Hotel (now named the Marmara Hotel). The new hotel was financed primarily by the Osmanlı Bank and was constructed in Taksim Square across the southern edge of the İnönü Promenade. The

Istanbul between two coups: many plans, many failures

Image 54 Harbiye Orduevi, Aras Neftçi

concept design bears the signatures of two Turkish architects, Rükneddin Güney and Fatin Uran, but upon Güney's death the project was detailed by Uran. The construction commenced in 1971 and the hotel was completed in 1975. The building comprised a rectangular prismatic envelope with 19 floors of accommodation

Image 55 Odakule building in Beyoğlu, Aras Neftçi

placed above a lofty podium.[30] The design attempted to break up the forceful prismatic appearance by the use of precast concrete window mullions.

The fourth hotel constructed in the early 1970s was located in Tepebaşı. Financed by OYAK (Armed Forces Assistance Fund) and designed by Yüksel

Okan, the building project was first commenced in 1968. Like many other buildings, its construction was delayed and did not begin until 1970 and finished in late 1975.[31] The 18-storey reinforced concrete building included a four-storey basement and a rooftop terrace, and occupied a corner site opposite the legendary Pera Palace Hotel which was built in the late nineteenth century on the top of the hill overlooking the Golden Horn. The hotel management was given to French hotel chain Etap Group. With its tall envelope, the hotel was the first modern high-rise building constructed within the historic fabric of the Beyoğlu district.

The fashion for high-rise soon spread to other kinds of buildings and Istanbul saw the construction of new barbicans dominating its skyline. Commissioned by the Istanbul Chamber of Industry in the early 1970s, Odakule was the first tall office block erected in the city. Sitting between İstiklal and Meşrutiyet streets in Beyoğlu, the building was constructed on the site of Carlmann Arcade, a late nineteenth-century commercial building in which the first department store of Istanbul was opened in 1870s by the Levantine Bartolli brothers, who were of Italian origin. The infamous *Varlık Vergisi* (Capital Levy) of the 1940s forced the Carlmann family to cede the building to the Ottoman Bank, which then sold it to the Istanbul Chamber of Industry. Designed collaboratively by Kaya Tecimen and Ali Taner and completed in 1976, Odakule comprised two basement floors, a lofty podium, 17 office floors and a rooftop restaurant. Containing the auditoriums and exhibition halls, the podium extended across the entire site and, reminiscent of earlier nineteenth-century arcades in the district, the ground floor provided a modern pedestrian lane that links the two busiest streets of Beyoğlu. Architecturally, the overall character of the building was defined by the dynamic facade configuration of the tower. Odakule was the first high-rise building in Istanbul where the facades were entirely covered by glass curtain walls carried by aluminium framing. The crystalline appearance of the tower and the mostly unpenetrated facades of the podium provided a balanced contrast to the overall architectural appearance of Odakule.[32]

Perhaps the most arresting high-rise building in Istanbul in the 1970s was Karayolları 17. Bölge Müdürlüğü or the Seventeenth District Headquarters of the Directorate of Highways in Zincirlikuyu. Located on a topographically dominant site on the European exit of the Bosphorus Bridge, the building was part of a group of buildings constructed for the administration and maintenance of the bridge and its connecting highways. The project bears the signature of Mehmet Konuralp, a young Turkish architect who later in his professional career would have a large design portfolio both in Turkey and abroad. The complex included administrative offices, workshops, a research centre, a cafeteria and personnel housing. Designed

and constructed between 1973 and 1977, the buildings in the complex represented one of the prime examples of modern architecture in Istanbul. The rectilinear building envelopes, in some cases balanced by circular or curvilinear masses, horizontal strip windows, an articulated structural grid on the facades and a colour palette of pale white, made this complex a very important and, at the same time, rare example of modern architecture in the Brutalist manner, all of which was reminiscent of Le Corbusier's and Mies van der Rohe's modern traits. The visually dominant component of the complex was the 13-storey office tower located on the northern edge of the site. The Bosphorus Bridge was one of the most significant projects of Turkey

Image 56 Seventeenth District Headquarters of the Directorate of Highways in Zincirlikuyu, courtesy of Mehmet Konuralp

and advanced technologies were employed to realise this century-long dream. Its administrative centre and technical service buildings also displayed the importance of the Bölge Müdürlüğü. It was one of the few buildings in Istanbul where advanced technologies and new materials of the time were employed extensively. The glass curtain walls, aluminium mullions and panels were all new materials in the Turkish building industry. The tower's dark appearance, created by black and grey glass panels, provided a distinctive contrast to the rest of the low-lying buildings in the complex. The Directorate's building remained, until its demolition in recent years, one of the most iconic high-rise towers in the country and was often used in Turkish movies to symbolise power and corporate life in Turkey.

Bridging the Bosphorus

Construction of a bridge spanning the Bosphorus was a century-long dream for both the Ottoman and Republican administrators. During the second half of the nineteenth century Istanbul became one of the most significant destinations in the world for international finance companies to put large-scale projects on the table. The most remarkable proposal of the time was to connect Asia to Europe by construction of a bridge over the Bosphorus. This exciting idea, as noted in earlier chapters, generated various bridge designs from leading international engineers, though none of them were to be realised.

In the early Republican period, the bridge project was again on the agenda. As a true believer in the automobile, Prost included a proposal for a bridge over the Bosphorus in his 1939 master plan. However, the project remained a concept only as the wartime conditions did not allow for the implementation of the French urban designer's modest road proposals, let alone such a costly engineering magnificence. During the DP era, especially between 1955 and 1960, a bridge over the Bosphorus again became a popular topic. News describing various bridge designs frequently appeared in the daily newspapers with sensational headings and various articles falsely described the projected bridge over the Bosphorus as the world's longest bridge. This time the government made a firm decision and in 1955 it engaged American company De Leeuw Charter and Co. to investigate detailed feasibility studies for a bridge between the two sides of the Bosphorus. This was followed by a bridge design by an engineer based in New York, David Steinman, in 1957 and the government then began to seek finance and contracting companies for the construction. However, similar to many other projects, the dire financial conditions and subsequent military coup of 1960 prevented the project from being implemented.

Architecture and the Turkish City

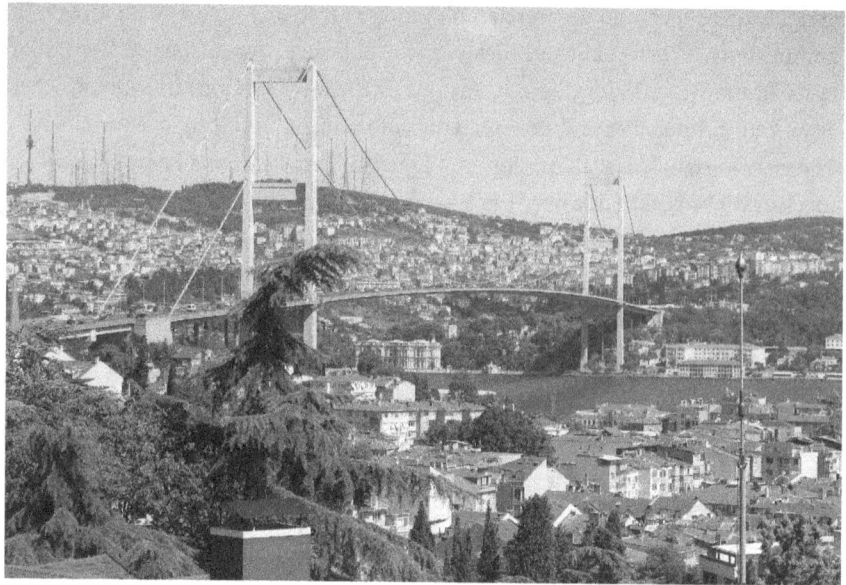

Image 57 The Bosphorus Bridge, Murat Gül

After the 1960 coup, both the municipality and the central government conducted detailed studies to investigate the feasibility of the project. In 1967, the bridge was included in the second five-year development plan drafted for the period between 1968 and 1973. Finally, in 1968 the British firm Freeman, Fox & Partners was commissioned to design a suspension bridge. The project was financed by long-term, low-interest loans obtained from various countries. The foundation stone was laid on 20 February 1970, and the dream came true on 30 October 1973 when the bridge was opened precisely 50 years and one day after the founding of the Republic of Turkey. The toll bridge became the first vehicular link from Europe to Asia since Xerxes' pontoons spanned Hellespont (modern day Gallipoli) in 480 BC.[33] Although a vociferous opposition campaign against the bridge had been conducted since the late 1960s by the Chamber of Architects and some academic circles, who saw the bridge as unnecessary and promoting land speculation, the new bridge was well appreciated by a wide spectrum of Turkish society, regardless of their political leaning. Thousands of Istanbulites poured onto the bridge on the opening day to witness this memorable event. With its total length of 1,560 metres and 1,074-metre central span, the Bosphorus Bridge became the fourth longest bridge in the world and the longest in Europe. It used

steel pylons to support its gravity-anchored cables, from which the 33-metres-wide road deck was suspended 64 metres above the sea level. Unlike many other suspended bridges, the deck was carried by a zig-zag pattern of cables rather than the usual parallel perpendicular rods, which gave the bridge an attractive guise.[34]

The construction of the Bosphorus Bridge and its connecting highways accelerated the spatial transformation of the city and new business districts emerged along the Zinzirlikuyu and Levent axis. Furthermore, as envisaged by the initiators of the Eads & Lambert proposal almost a century earlier, the bridge made the Asian side of the city more accessible, and Kadıköy and surrounds became a prized location in the real estate business of the 1970s and following decades.[35] In the meantime, the construction of the bridge was accompanied by the opening of new automobile factories in Turkey in 1971 by French Renault and Italian Fiat manufacturers, in conjunction with their Turkish partners, OYAK and Koç Holding. As a result, the number of motorcars in Turkey saw a dramatic increase and the figure surged from 130,000 in 1970 to reach over 740,000 in 1980.[36] Under such circumstances, the Bosphorus Bridge initially brought significant convenience in vehicular transport for the citizens of Istanbul, but this utility was only temporary as the new development areas and increasing population soon proved that a single connection between Europe and Asia would not be sufficient, and construction of new bridges and even underground tunnels would become inevitable in the following decades.

Trailblazing architects of the 1970s

In line with the construction materials newly entering the Turkish building industry and the theoretical debates being conducted vigorously in architectural circles, many Turkish architects tried to implement new concepts in their works in the late 1960s and especially in the 1970s. In this sense, Istanbul saw some interesting projects in the 1970s, in addition to the hotel and high-rise office blocks mentioned above. Amongst the most noteworthy projects was the Tercüman Newspaper Building constructed in 1976. *Tercüman* was the most influential right-wing newspaper of the highly politicised 1970s and engaged numerous columnists who were pioneers of the social conservatism of Turkish politics. Designed collaboratively by Günay Çilingiroğlu and Muhlis Tunca, the building was revolutionary in many aspects. The architectural expression highlighted the plain and minimalist language. The building's strip windows and white colour evoked Le Corbusier's early Modern Villa Savoye but its sophisticated geometric form followed the characteristics of the Brutalist fashion of the 1960s and 1970s. The most fascinating aspect of

Architecture and the Turkish City

Image 58 Tercüman Newspaper Headquarters, Aras Neftçi

the Tercüman Building, however, was its extremely large cantilevers, symmetrically positioned on the four corners of the square plan layout. Designed by structural engineer Rasin Etiman and made from pre-stressed reinforced concrete, the corners provided an impressive effect of hovering, which was unprecedented in Turkish architecture. With these characteristics, the Tercüman Building, in a similar way to many other buildings designed as the headquarters of business companies, was purposefully devised to promote corporate identity. Yet what makes this building more interesting was that one of the most technologically advanced and state-of-the-art building designs in 1970s Turkey was financed by a conservative newspaper that supported the JP. Perhaps this was a vivid indication of how Turkish politics was shaped. The right-wing, socially conservative JP, in a similar way to its predecessor the DP, represented the rapid development and industrialisation of Turkey despite the party's conformist tendencies in the social and cultural domains.

An infill office building bearing the signature of the Çilingiroğlu-Tunca team in the late 1960s was another attention-grabbing design, this time in Cağaloğlu on the Historic Peninsula. Following a national design competition in 1968, the building was commissioned by the İstanbul Reklam Ajansı (Istanbul Advertisement Agency) as their headquarters and completed in 1974.[37] Sitting on a corner site, the building successfully represented the Brutalist movement in terms of its

Istanbul between two coups: many plans, many failures

Image 59 İstanbul Reklam Ajansı, Murat Gül

architectonic composition and the use of exposed concrete, which was then rare in Turkey. Reminiscent of the Art and Architecture Building at Yale University in New Haven, Connecticut, (1958–64) by Paul Rudolph, the fragmented building elements and the combined use of large concrete and glass panels softened the overall prismatic building envelope. The project's most significant feature was the relationship it established with the existing nineteenth-century Ottoman tomb of Mahmud Nedim Pasha on the site. The U-shaped building wrapped around the tomb and provided a modern backdrop to the old structure. This approach was considered 'sensitive' in the 1970s when designing in context was an emerging topic in architecture, not only in Turkey but in many parts of the world.

The other eye-catching project of the decade was the Atatürk Library, designed by Eldem for the Koç Foundation and constructed between 1973 and 1975. The building plan followed a proposed, but never built, restaurant by Eldem for the Hilton Hotel. The original design included a library, museum and exhibition hall, but only the library section was realised. The building sits on a rugged and steep site on the western slopes of Maçka Park. The overall geometry consists of one central hexagonal hall and six surrounding hexagonal spaces and a subsidiary

Image 60 Atatürk Library, Aras Neftçi

service block consisting of three hexagons positioned behind the main volume on the street side. The book stalls and reading desks were skilfully positioned on the top floor where readers could appreciate splendid views of the Bosphorus and Maçka Park. Architecturally, the building's pale concrete external facades and the use of a traditional lead roof covering form an essential part of Eldem's controlled articulation. The strong geometric composition of the library is expressed most vigorously in the arrangement of hexahedral domes, each crowned by glass lanterns and providing a very dynamic superstructure. Like many other Eldem works, the Atatürk Library displays a candid understanding of traditional Turkish architectural forms and a skilful interpretation in the modernist manner in terms of the use of materials, colours and detailing.

Istanbul in the troubled years

The 1960s and 1970s were marked not only by rapid economic growth but also by social mobility in Turkish society on a scale not seen before. The growing number of university students and workers, especially in the big cities, prompted an increasing social awareness and politicisation of society, and this process ended with a sharp division between the left and right political groups. The rosy tone of

Istanbul between two coups: many plans, many failures

Americanism in the society in the 1950s gradually dimmed, and although Turkish governments generally retained their loyalty to the Turkish–American alliance, several occasions in the 1960s shook the confidence of Turkish politicians in American policies. The first crack came in 1964 when Turkey tried to conduct a military campaign in Cyprus in an attempt to halt Greek nationalists who wanted to unify the island with mainland Greece and pressurise the Turkish population of the island. The Turkish intervention was stopped when an American objection was sent to the prime minister, İsmet İnönü, by President Lyndon Johnson in the form of a strongly worded letter threatening Turkey. The letter was leaked to the Turkish press and created deep disappointment and even stronger anti-American feelings in the society. The second political crisis came in the late 1960s when the United States put pressure on the Turkish government to ban poppy production. Poppy crops were grown in Western Anatolia for the edible seed and animal fodder and were a strong income for the Turkish peasantry, but the plant could also be used to make opium which was consumed in US markets and this prompted the US government to put pressure on Turkey to stop cultivation of the poppy. In the light of those developments 'American' gradually became a disliked term, both for left and right-wing groups, for differing reasons. For the leftist circles, which were under the guidance of the political ideology of Marxism, the United States was the source of evil and conducted anti-proletariat policies and supported anti-democratic regimes in many different parts of the world. For the right-wing groups, the United States was a threat against Turkish interests, and conservative groups saw American policies in the Muslim world as serving the Zionist ideology of Israel.

The political polarisation extended to such a degree that opposite groups began to fight on university campuses and in workplaces and, finally, anarchy spread on to the streets. In this atmosphere the weakened Demirel government was faced with an ultimatum from the army on 12 March 1971, and Demirel was forced to resign from office. The army appointed Nihat Erim, a right-wing member of the RPP, as the new prime minister. Initially, leftist circles, which interpreted this intervention against the right-wing government as similar to the 1960 coup, supported the army but this assessment soon proved to be wrong as the military-backed government, established primarily by technocrats outside politics, targeted leftist groups as well as right-wing activists.[38] The following years saw many incapable coalition governments formed by both the JP and the RPP, sometimes with unethical political alliances whereby deputies were transferred from one party to another as a result of political bribery and corruption.

Another important event of the 1970s was Turkey's military campaign in Cyprus in 1974. Following the 1964 incident, a second crisis came in 1967 when Greek nationalists in Cyprus were encouraged by the military junta in Athens to realise the unification of the island with Greece, more popularly known as *enosis*. Turkey's intervention was again averted as the Greek junta stepped back. Yet in 1974 the Greek junta conducted a coup against the president and archbishop of Cyprus, Makarios III, and officially announced the *enosis*. This time Turkey, as a guarantor state in accordance with the Cypriot constitution, sent its troops to the island and secured approximately 40 per cent of the land for the Turkish population of Cyprus. This military campaign isolated Turkey in the international arena and the US government placed an embargo on military purchases. The Cyprus campaign and the ensuing international pressure had significant adverse impacts on the Turkish economy, which was already weakened by domestic political crises. International oil crises in 1974 and 1979 resulted in a dramatic increase in petrol prices in Turkey, and this meant that two-thirds of Turkish foreign earnings were spent on paying the oil bill. In big cities, including Istanbul, the central heating systems of many buildings were converted from fuel oil to coal in the late 1970s. Desperate to solve this severe energy shortage, the government issued permits to open coal mining fields in the upper western part of Istanbul, along the shores of the Black Sea, resulting in significant adverse impacts on the greenery of those areas. Electricity supply was also a big problem and daily energy cuts of up to five hours became ordinary practice for the entire country. The trolleybus network in Istanbul was one of the public services most affected by this energy shortage and inoperable trolleybuses frequently occupied the streets of the city.

In order to address these bitter economic conditions, the short-lived governments of the 1970s tried desperately to implement measures such as strict restrictions on imports, printing money and obtaining short-term, high-interest loans from the international floating markets. Those measures did not address the economic difficulties and, conversely, caused a shortage of consumer goods and the emergence of black markets which were the only source of many basic products for ordinary people. In the meantime, the Turkish lira rapidly lost value and inflation rose to a dramatic 70 per cent in the late 1970s. All these deleterious conditions scaled up the political tension and accelerated the polarisation of the society. Almost all segments of society, including workers, teachers, police, healthcare professionals and public servants, were sharply divided and bound to either left or right-wing political ideologies. The Chamber of Architects was not an exception and was heavily involved in the political debate, positioning itself to the left side of the political spectrum. This political

involvement gradually marginalised the Chamber of Architects and prompted them to act as an NGO, often challenging overall government policies regardless of whether the policies related to the profession or not.

'Apartmentisation' continued

Since 1950 Turkey had been gradually industrialised and urbanised, and domestic migration to large cities, especially Istanbul, had grown at an increased rate. Economic indicators vividly show this trend. Turkey's Gross National Product (GNP) in 1950, for example, was around nine million Turkish lira. This figure became 16 million Turkish lira in 1960, 21 million in 1965 and over 40 million in 1972. In 1950, 80 per cent of the GNP was derived from agricultural production but with the industrialisation of Turkey this figure dropped to 55 per cent in 1970. In line with these developments, the share of the population that lived in cities in Turkey rose from 25 per cent in 1950 to 39 per cent in 1970 and 44 per cent in 1980.[39]

Under such economic conditions Istanbul's population continued to grow dramatically and reached over three million by the end of the 1960s and 4.7 million in 1980.[40] This meant that the number of inhabitants of the city approximately quadrupled within the three decades following 1950. While Istanbul saw interesting pieces of architecture arise sporadically during this period, the city continued to grow and the most common types of building practice in the 1970s were 'apartmentisation' on the one hand and *gecekondu* on the other. Within the political tumult of the 1970s the *gecekondu* was no longer an 'innocent shelter' for the desperate migrants who flooded to the city. The 30 years after 1950 saw the emergence of *gecekondu* neighbourhoods blanketing large swathes of land, both on the European and Asian sides of Istanbul. In the highly politicised atmosphere of the 1970s, the *gecekondu* neighbourhoods became the targets of militant factions who were conducting bloody struggles against their opposite groups and the system in general. One vivid example of this strong relationship between the *gecekondu* and politics was the 1 Mayıs Mahallesi (1 May Neighbourhood) on the Asian side of Istanbul. The neighbourhood took its name from International Labour Day, which was passionately 'celebrated' by the leftist political parties, workers' unions and the armed militant groups who took control of the streets in such districts. According to those in leftist circles, this neighbourhood represented the 'glorious resistance of the people' who were faced with fascist pressures and the provocations of the imperialist powers. On the other hand, for conservative groups the neighbourhood was a 'liberated zone' that was outside the control of the legal authorities of the state.[41]

One of the measures to address unauthorised constructions on public lands that the government attempted was establishing new social housing complexes within designated *Gecekondu Önleme Bölgeleri* (Gecekondu Preventing Areas). Consisting of two-bedroom units, these apartments were plain social housing complexes reminiscent of similar projects implemented in Germany and other continental European countries in the early decades of the twentieth century. The plain architectural expression created by repetitive penetrations, cantilevered balconies with simple balustrading details and overall simplicity all recall Adolf Loos' or Walter Gropius' social housing projects in the 1910s and 1920s. One of the notable examples of this policy was the social housing complex containing 360 units in Örnek Mahallesi, which was next to 1 Mayıs Mahallesi.

Nevertheless, despite all the goodwill and effort, these projects could not provide a viable solution to the *gecekondu* problem. Firstly, the number of such buildings was far from being satisfactory and, therefore, they remained only as exemplar projects.[42] The second reason was that over time *gecekondu* areas created their own economy, allowing some individuals and groups who controlled the building activity in those districts to accumulate enormous wealth by the illegal distribution of public lands and by selling building materials and organising manpower. The *gecekondu* dwellers too were reluctant to leave their houses in those neighbourhoods as they became aware that leaving their 'properties' for a modest social unit would not be a logical decision since the *gecekondu* districts, despite all their social and material problems, were a promising investment choice for their future. Politicians also benefitted from the problem. For *gecekondu* inhabitants, political elections meant more occupation of public lands and the extension of the *gecekondu* neighbourhoods. For politicians, this simply meant votes, as there was a mutual, yet unwritten, agreement between them and the residents based on the understanding that providing civic services and legalising *gecekondu* buildings would be the reward for votes. All parties, regardless of their position in the political spectrum, benefitted from this situation. In his election campaign of 1973 Ecevit, the head of the RPP, claimed that 'You will construct your *gecekondu*s no longer at night but during the day. When we get the power, the *gecekondu*s will be turned into *akkondu* (white shelters)'.[43] Similarly, in his election campaign of 1977 Demirel, the leader of the JP, enticed gecekondu dwellers with the carrot: 'Stamp the white horse on the ballots (the symbol of the JP), so that we would turn *gecekondu*s into cities, legalise them and distribute the titles'.[44]

While social, political and economic conditions accelerated the *gecekondu* problem in Istanbul, legal housing developments, in the absence of an overarching project by the government, were left in the hands of municipalities and

Istanbul between two coups: many plans, many failures

small-scale developers. Under this strict economic structure, where industrial production was monopolised by a limited number of entrepreneurs, construction became the only profitable investment choice for small to medium-size businessmen with limited capital. Therefore, *yap-satçı müteahhitlik* (construct and sell developers) became the most profitable business type in Turkey. From the buyers' perspective, real estate was also the sole investment choice as the overall economic structure did not allow any reliable alternative for investment by the general public. Istanbul Stock Exchange, for example, as a modern institution offering investment alternatives in company shares for the public, was not established until much later in 1985.[45] In addition to financial stimulus, the migration from rural areas to Istanbul required more buildings, thereby increasing the number of constructions in the city and requiring more manpower from the rural areas which, therefore, fuelled the migration. And, finally, a new act allowing residential flat ownership passed by the parliament in 1965 stimulated the construction industry significantly.[46]

The resulting residential apartment buildings were negotiated landowner–developer deals that were mutually beneficial to both parties. In this model the

Image 61 Multi-storey tenements emerged in former *gecekondu* districts, Anatolian side of Istanbul, Aras Neftçi

Image 62 The cultural landscape of Istanbul dominated by apartments, a view from Üsküdar, Aras Neftçi

developers constructed the building without any investment in the land and the landowners, in return, received units within the new building which would see high increase in value. This practice was coupled with rigid planning controls but limited urban design guidance and created an outcome with little architectural merit. The great majority of the resulting apartment buildings had poor design qualities. Another significant impact of this process was that not only vacant lands (mainly domestic agricultural parcels) but also Istanbul's timber houses and small-scale townhouses were offered in exchange for multi-floor apartment buildings. In this respect, the low-scale urban character of the traditional neighbourhoods saw a dramatic change in building typology. Moreover, this vertical expansion was made on the existing road and parcel allotments in the old quarters such as Fatih, Beşiktaş and Üsküdar and, therefore, resulted in narrow streets surrounded by buildings of four to six storeys, many of which did not have any car parking facilities or spaces for social amenities.

Boosted by the construction of the Bosphorus Bridge, perhaps the most dramatic change regarding apartmentisation in Istanbul occurred in Kadıköy, along the shores of the Sea of Marmara. Vacant lands, mostly local vegetable gardens, and large timber mansions gave way to reinforced concrete multi-storey

residential blocks. Linking Kadıköy to Bostancı on the shores of the Sea of Marmara, Bağdat Street, including its surrounding areas, was a typical example of this process of transformation. In fact, the street was a historic route that had existed since Byzantine times, and for centuries it had been the starting point for caravans and armies setting off for the eastern fronts of the Ottoman Empire. The construction of the railway line on the Asian side of Istanbul in 1873 was the first significant initiative that prompted the construction of large timber houses in this part of Istanbul. These were summer residences for the bourgeois citizens of Ottoman Istanbul. The years following World War II saw improved accessibility and, therefore, increased land values which caused a sharp increase in the building density. In this period plot ratios became smaller and the houses more modest. In the following years as the area developed Bağdat Street was progressively widened and assumed its present form.

Despite dull design qualities, the residential flat buildings in this area still provide significant information about architectural practice and construction technology in Istanbul. Firstly, in the three decades following World War II reinforced concrete gradually expanded its share of the construction industry, and by the end of the 1970s it became the only method of construction practised. As noted above, since the 1950s and especially during the five-year development plans beginning in the 1960s, construction was the most sponsored industry in Turkey. Hence the production of cement, the main ingredient of concrete, saw a dramatic increase in Turkey with the establishment of 13 new factories in the 1950s. As a result, in this period the total production of cement in Turkey saw a four-fold rise and reached over two million tonnes in 1960. In line with the construction of new plants in the 1960s and 1970s, Turkey's cement production soared to more than 13.8 million tonnes in 1979.[47] As the popularity of reinforced concrete increased, the other methods of construction, such as load-bearing brickwork and timber frames, gradually faded away in the Turkish building industry. There were various reasons for this sharp transformation. Firstly, techniques using a reinforced concrete skeleton gave more flexibility in design, in contrast to the traditional masonry methods. Secondly, construction in reinforced concrete was much faster in comparison to other methods. And thirdly, perhaps most importantly, construction of reinforced concrete, in contrast to bricklaying or stone masonry, did not require skilled manpower. The rapid urbanisation brought thousands of jobless migrants to Istanbul every year and the construction industry was the only option for large groups of people without any skills other than manual labour.[48]

In this environment of rapid urbanisation, the majority of the workers employed in the building industry in Istanbul were part of seasonal teams who came to the city from their villages or towns in Anatolia to work at the construction sites. Almost all of these workers had not received any kind of education in their villages and were mainly illiterate. Each team, headed by a *kalfa* (master), was responsible for separate works. In the absence of modern concrete production plants, sand, rubble and cement were mixed with water on the site by the *betoncu* (concreter) and poured manually within the timber formwork prepared by the *kalıpçı* (moulder). The reinforcement was made by steel roads on site by the *demirci* (steel wroughter). The walls were made up of hollow brick by the *tuğlacı* (bricklayer) and the surfaces were rendered or plastered by the *sıvacı* (renderer). This process was followed by the finishing materials, with many of them being prepared manually by specialised masters. The whole construction site was under the control of a *çavuş*, a kind of foreman, who represented the developer. The architects or construction engineers were mostly absent from the construction sites since their duty, in the eyes of the great majority of the developers, was limited to obtaining the necessary permits from the local authorities. Furthermore, many of the essential building codes were either non-existent or ignored by the developers, and the local authorities tended to close their eyes to non-compliance in return for bribery. All of these processes left the quality of the construction methods and the overall construction of the building to the mercy of developers.

With regard to design, almost all buildings were forcing the limits of the already inadequate planning controls, such as setbacks, building heights and permissible floor space ratio. Thanks to reinforced concrete, above the ground floor cantilevers of up to 1.5 metres were mainly used to maximise the construction area. This arrangement, if the site was not a detached lot, provided corner balconies which, in most cases, were amalgamated with the interior space by the occupants. The buildings were elevated from the ground floor to allow semi-basements for additional floor space. The roof attics were mostly converted into unauthorised additional units, and the backyards, if any space remained, were spared for car parking areas for the exclusive use, in most cases, of the original land owner and the developers. The building facades also displayed the new and popular finishing materials available in the industry. The apartment buildings constructed in the 1960s were mainly finished with render and paint. In the 1970s scratched-render and glazed mosaic became popular on the facades. The most expensive residential flat buildings also used yellow travertine cladding which can be seen in many 1970s apartment buildings along Bağdat Street and in the surrounding areas.

Istanbul between two coups: many plans, many failures

The two decades after the 1960 military coup saw many developments in Istanbul architecture. In line with increasing professionalism and the growing economy, more Turkish architects now had opportunities to follow debates on architecture on the global stage, and consequently they implemented the latest architectural developments in their projects. New professional magazines emerged and the number of design competitions increased. In line with growing social awareness, various forms of art works by leading Turkish artists began to be placed on building facades and in their forecourts.[49] On the technological side, high-rise towers provided the nexus of building activity where Turkish architects and engineers encountered new building materials, construction technologies and international collaboration. Glass curtain walls, pre-stressed reinforced concrete, sophisticated mechanical engineering solutions employed for cultural centres, hotels and office towers, and underground car parking were all amongst the new concepts introduced to Turkish architecture in the 1960s, and especially in the 1970s. On the urban scale, the bridge over the Bosphorus made the Asian side of Istanbul more accessible and this boosted construction of residential apartment buildings. On the other hand, the rapid urbanisation and lack of sufficient public control intensified unauthorised residential architecture and large *gecekondu* districts blanketed the periphery of the city. The political turbulence and anarchy of the late 1970s impacted architecture, as it did many areas of Turkish social, political and economic life. These then were infertile years for Istanbul architecture. Yet all the advancements, innovations, shortcomings and difficulties helped to prepare Turkish architects for a new phase of architectural practice in the following decades, when Istanbul would enter a new chapter and, once again, political conditions would play a role in shaping the city.

5

The 1980s: Istanbul encounters neo-liberalism

The political chaos and anarchy in the streets came to an abrupt end with the intervention of the army on 12 September 1980. Turkey learned of the coup when a statement was made on state radio at 4:30 am indicating that all political activities were banned, the parliament was dismissed and the Turkish Armed Forces had taken control of the country. The aim of the military intervention, according to the armed forces, was to save the state and the Turkish people from political fragmentation, economic collapse, anarchy and violence, all of which were the result of mismanagement by politicians. The junta set up the Milli Güvenlik Konseyi or the National Security Council (NSC) and Kenan Evren, who was then the chief-of-staff, became the head of the council.

In the days following the coup, the NSC rearranged the entire political life and social life of Turkey. The parliament was suspended, all political parties were disbanded and their leaders were detained. A state of emergency was declared, the people placed under curfew at night and no one was allowed to leave the country. Soon after, the number of arrests escalated and, by the end of 1982, in excess of 120,000 people were imprisoned. Labour organisations and professional associations were suspended and strikes declared illegal. Military officers replaced governors, mayors and all senior public servants throughout the country.

In Istanbul three military mayors served between 1980 and 1984.[1] Apart from conducting regular municipal services, perhaps the most surprising work carried out by the military mayors in Istanbul was to paint all of the buildings facing the E5 motorway white, in order to rehabilitate their disorganised appearance and establish 'aesthetic' scenery.[2] Another symbolic decision made by the military administration in Istanbul was to change the names of the most iconic *gecekondu* settlements

of the city. The 1 Mayıs Mahallesi which was the hub of leftist marginal groups in the 1970s, was renamed 'Mustafa Kemal Mahallesi', a vivid signal of the radical change in the overall political atmosphere under the military rule.

Similar to events following the 1960 coup, the military appointed a constitutional committee to write a new constitution. It was chaired by Orhan Aldıkaçtı, a professor of constitutional law at Istanbul University. The draft constitution was put to a public referendum on 7 November 1982 and, with the military's strict control of society and intense propaganda, the vote was overwhelmingly in its favour with 91.4 per cent of the public supporting it. The public approval of the new constitution also made Evren the new president of Turkey.

The third constitution of modern Turkey brought new mechanisms to establish strict control over political life in the country. The NSC's role in the Turkish political system, for example, was elevated and it was given extended power on political matters, despite on paper being established as an advisory council only.[3] The highly politicised intelligentsia became a target. Many professors were fired from the universities even before the new constitution was approved and this practice continued until 1983. Universities were put under the strict control of the centralised Higher Education Council and lost their autonomy, which had been misused in the politically fragmented atmosphere of the 1970s. The new constitution also brought many restrictions on political law, labour organisations, media law and many other aspects of life for Turkish citizens.

Military rule came to an end in 1983 when the junta decided to return the country to democracy. However, only three of the 15 new parties secured the green light from the military rulers to participate in the elections. The Anavatan Partisi or the Motherland Party (MP) won the elections held on 6 November 1983, despite the military junta's palpable support for the Nationalist Democracy Party, which was led by an ex-military general. The MP was led by Turgut Özal, the key player in the economic reform programme conducted in the late 1970s and early 1980s,[4] and it gained a crushing victory by securing 45 per cent of the total vote, which gave the party an absolute majority in the parliament.

The 1983 elections opened new avenues for Turkey as the incoming government followed liberal economic policies and conducted many reforms in the economic arena. Significant infrastructure works in telecommunications and highway transportation were undertaken. Turkey, for example, saw the construction of its first world-class highway in 1984 with a new road link from Istanbul to Adapazarı that reduced travel time between Istanbul and Ankara to five hours.

The 1980s: Istanbul encounters neo-liberalism

New digital telephone switches were installed throughout Turkey, and telephones became affordable for a wide stratum of Turkish society. Electrification of Turkish villages was expanded, and many villages were connected to city centres with all-weather roads.

Under the Özal administration, Turkey undertook a series of market-oriented economic reforms. If 'Making Turkey a little America in its region' was the slogan for the postwar period, 'Skipping an age' and 'Making Turkey Japan in the Near East' were the most popular mottos of Özal's Turkey. For Özal, the economic restructuring of Turkey was paramount. The political stability under his leadership following the 1983 elections revived worldwide confidence, and international financial institutions such as the Organisation for Economic Co-operation and Development (OECD), the World Bank and the International Monetary Fund (IMF) offered Turkey generous credit to finance much-needed infrastructure works in the country. Özal was an experienced technocrat who had held senior positions in key government offices, as well as top-level management roles for the private sector, and had worked as an economist for the World Bank in Washington DC. His courageous initiatives gave a new impetus to the liberalisation of the Turkish economy. After a decade of political instability, Özal's confidence and leadership gave many segments of Turkish society an overarching optimism in the future of the Turkish economy.[5]

Perhaps, more importantly, under Özal's administration Turkey encountered privatisation, which was introduced with the aim of reducing public responsibility for the cumbersome financial burdens created by state-owned and old-fashioned industries. In order to make Turkish export goods financially competitive, the Turkish lira was devalued, the law protecting the Turkish lira was abolished and flexible international exchange rates were instituted for the Turkish currency. The import-substitution economic model was abandoned and export was encouraged. In the four years following the 1983 elections Turkey's exports saw a spectacular threefold increase to over US$10 billion. By the end of the decade this figure reached US$13 billion. Together, these economic polices brought about economic prosperity and between 1984 and 1987 the economy of Turkey grew by 6.7 per cent annually.

In addition to the skills that made him a leading bureaucrat, Özal was also able to present himself as a popular politician who appealed to people across all segments of the political spectrum. While his moderate Islamist background qualified Özal to draw unconditional support from the conservative masses, his promotion of projects that aimed for modernisation and economic reform through

closer integration with the Western world charmed the secular elites of Turkish society. Thus the financial reforms were coupled with a series of significant developments in the social life of the Turkish people. The restriction limiting Turkish citizens to only one visit abroad in a three-year period was lifted, and the US$500 limit on foreign exchange was abandoned. During the period of Özal's rule, Turkey saw the opening of the first Turkish foundation university in 1984 and the emergence of private TV channels from 1990. Furthermore, under the Özal administration a wider stratum of Turkish society encountered imported Western goods, such as electronics, cars, cigarettes, alcoholic beverages, clothes and cosmetics, many of which were previously available only in black markets located in specific locations in the large cities. The economic prosperity and liberal policies laid the foundation stone for consumerism in Turkish society, which had a tremendous hunger for technology and luxury as a result of exposure to the iconic symbols of American consumerism in the 1980s. Turkey's first McDonald's restaurant, for example, was opened in Taksim in 1986 and became a popular destination for the youth of the city.

The period of economic growth and political stabilisation stimulated the construction industry, which had been the main player in the Turkish economy since the 1950s. In the early 1980s Turkish construction companies experienced growth in the number of commissions in Middle Eastern and North African countries. Between 1981 and 1986 the share of international commissions given to Turkish construction companies grew from 0.7 per cent to 3 per cent. Enka, the largest Turkish construction firm, became the world's tenth biggest construction company with a contract portfolio worth a total US$2.1 billion in 1986.[6] This opened new avenues to Turkish engineers and architects who now had a chance to become familiar with larger projects on an international scale. More and more imported building materials and equipment began to be seen in the Turkish building industry. One of the vivid indicators of this development was the number of companies participating in the Yapı Fuarı (Building Fair), in which the key players of the Turkish construction industry had presented annually since 1978. In line with the rising economy, the fair became an international organisation (Turkey Build) in 1984 with a doubling of the number of participants, both from Turkey and abroad.

One of the important decisions made by the Özal government in the area of urban management was an amnesty for *gecekondu* and unauthorised developments. By an act passed in Parliament in 1984 the government aimed to legalise the existing illicit developments constructed on crown lands, as well as other unauthorised and non-compliant buildings in the country.[7] According to some

The 1980s: Istanbul encounters neo-liberalism

estimates, more than half a million buildings in Istanbul were either *gecekondu*s or built contrary to existing planning instruments to some degree. By this act of amnesty the government also aimed to collect revenue by selling the affected public lands to the owners of *gecekondu*s.[8] The outcome, however, was far less than the government anticipated as only 20 per cent of building owners applied to legitimise their buildings according to the new law. Apart from this legal initiative, the *gecekondu* problem continued to evolve in the 1980s. Until that time, *gecekondu* had been an arbitrary solution to housing shortages in the big cities, which were under serious impact from the growing number of migrants from the countryside. In this sense, the *gecekondu* dwellings were generally primitive structures made from basic and mostly recycled materials. The inhabitants of such settlements were unsophisticated migrants who were desperately looking for shelter. As noted earlier, the *gecekondu* phenomenon had already begun to change in the 1970s with relatively better constructions and more organised management by the inhabitants and groups who benefited from such rapid and illegal building activities. In the 1980s, however, *gecekondu* neighbourhoods began to stretch vertically and the buildings in those districts gradually turned into multi-storeyed tenements. Ümraniye, Gülsuyu, Fikirtepe and Sultanbeyli on the Asian side and Kağıthane, Esenler and Güngören on the European side of Istanbul were the epicentres of

Image 63 *Gecekondu* areas on the European side of Istanbul stretch upwards, Aras Neftçi

such transformation. Local governments had no choice other than to provide civic services to these neighbourhoods, and this also fuelled a dramatic change in the *gecekondu* concept. On the eve of every election the *gecekondu* neighbourhoods grew in area and more floors were added to existing buildings. The crude reinforced concrete structures with unplastered brick walls and reinforcement steel rods on the roof (waiting for future vertical extension with additional floors at the time of the next election) monopolised the scenery of the built environment of those districts.

While *gecekondu* neighbourhoods were being transformed, other parts of Istanbul experienced a different kind of change in the 1980s. In line with the growing economy, the middle and upper middle classes of Turkish society experienced new levels of comfort created by automobiles and better-equipped housing. Traditional districts of Istanbul, such as Üsküdar, Beşiktaş and Fatih which were primarily occupied by middle-class inhabitants, were the areas where the transformation had the most impact. The narrow streets with aged building stock were unable to cope with the emerging demands of their inhabitants, who now looked for parking for their automobiles and better quality apartments equipped with central heating, lifts, modern kitchens and bathrooms. In the growing economy the construction industry was eager to meet these demands, and thousands of new apartment buildings were erected between Kadıköy and Bostancı on the Asian side and in Bakırköy, Yeşilköy and Florya on the European side of Istanbul. The apartmentisation that had started in the 1970s in those districts intensified and much taller residential blocks, mostly ten to 12 floors high, began to be constructed. With this intense development activity, the last remnants of houses located within gardens disappeared and the morphology of those areas changed dramatically. In parallel to this transformation, the concept of *ev* (house) in Turkish society became synonymous with apartment.[9]

Dalan's Istanbul

Özal's success in general politics was mirrored in the local elections held on 25 March 1984. The MP won the municipalities of 57 out of 67 cities, including the three largest Turkish cities, Istanbul, Ankara and İzmir. In Istanbul the MP's candidate was Bedrettin Dalan, a 43-year-old electrical engineer who did not have any political experience prior to his participation in the founding team of the MP in 1983. The Özal administration passed new laws in the parliament granting much wider responsibilities and resources for local governments

The 1980s: Istanbul encounters neo-liberalism

within their municipal borders. Istanbul, Ankara and İzmir were granted the status of Büyükşehir Belediyesi (Metropolitan Municipality). The new law brought into being a two-tiered local government model: the metropolitan municipalities and the district municipalities beneath them. In the new system the tutelage powers of the Ministry of Interior and the Ministry of Public Works and Resettlement over the local governments were greatly reduced, and the resources at the disposal of municipalities were significantly boosted. Evoking Menderes' ambition and receiving the full support of the Özal administration, Dalan began work soon after he took the office of mayor. During the five years under Dalan's administration Istanbul witnessed the second largest redevelopment programme in its modern history, after Menderes' urban renewal project. Dalan conducted large infrastructure projects, carried out extensive demolitions to open up new boulevards and littoral roads, and implemented landfill projects to construct public recreation areas.

The rehabilitation of the Golden Horn was the centrepiece of Dalan's redevelopment. Once called the 'sweet waters of Istanbul', the Golden Horn, in Dalan's own words, had been turned into 'a huge cesspit' in the middle of Istanbul.[10] This description was not an exaggeration. Indeed, this narrow gulf was experiencing an environmental disaster, and something had to be done urgently to prevent further threat to public health. The industrialisation of the Golden Horn had begun in Ottoman times as the natural port opening to the Bosphorus was an ideal place for shipyards, an arsenal and other pre-modern manufacturing plants. In the nineteenth century new factories were founded along its shores to produce cloth and other goods for the new army and military establishments. The Feshane was founded for the production of *fez*, a new type of headgear adopted by Mahmud II for his new army. The textile manufacturing plant was moved to its new location in Eyüp, on the upper shores of the Golden Horn, in 1839 and this marked the starting point for the industrialisation of the area in a modern sense. This was followed in the late nineteenth century by the establishment of new industrial sites along the shores of the Golden Horn, including factories, powerhouses, dockyards and abattoirs. All this industry gradually contaminated the water and polluted the surrounding land.

The industrialisation of the Golden Horn district accelerated during the twentieth century, especially after the 1960s, with the opening of new factories and other plants along the shores. Prost designated the Golden Horn as the principal industrial zone in his master plan. He saw the shores of the Golden Horn as the ideal location for industrial sites, and proposed heavy industry at the end of the

gulf towards the west.[11] This was perhaps the most controversial decision taken by the French urban planner. As a typical representative of urban designers of his era, whose decisions were generally driven by aesthetic concerns, Prost did not foresee the significant consequences of his decision to open up the low-lying land in the Golden Horn to industrial development. The Golden Horn remained an industrial zone in subsequent planning proposals made in the mid-twentieth century, and the industrial establishments, without any basic precautions for filtering their waste, used the old port as a 'rubbish bin'. The result was devastating. By the 1970s the whole area had become a very serious risk to the public health of the inhabitants of Istanbul. The highly poisoned water created a foul odour that affected a very large area surrounding the Golden Horn, especially in summer months. There was no marine life left and navigation was only possible in the western part of the aged harbour since toxic mud filled the inner parts of the gulf and the water level was reduced to as little as 15 cm in other areas. The surrounding neighbourhoods were also adversely affected by the industrialisation. Docks, small manufacturing facilities and related buildings had occupied the districts alongside the shores of the Golden Horn since the Byzantine times. Yet the establishment of heavy industry in the late nineteenth and twentieth centuries brought serious social and physical degradation in the existing built environment of the region.

The miserable condition of the Golden Horn's environment prompted various proposals in the 1960s and 1970s targeting its rehabilitation. In 1977, for example, a master plan aiming to rehabilitate the Golden Horn and its environs was prepared by a group of academics and practitioners led by Semih Tezcan from the Bosphorus University. The plan included a detailed analysis of the existing conditions and proposed a comprehensive implementation plan and a legal framework to guide the proposed works.[12] However, neither the unstable political atmosphere nor the weak financial structure of the state in the late 1970s allowed for the implementation of such a costly and extensive work and, therefore, it remained at the planning stage. Under military rule, the recovery of the Golden Horn was again on the table. In order to seek alternative schemes, many groups were set up under the governor's office and their proposals were considered by the Golden Horn High Council, which was chaired by Nevzat Ayaz who was then the governor of Istanbul. The council's priorities were prevention of further pollution, relocation of the shipyards to Tuzla on the Asian side of Istanbul and demolition of the buildings and wharves intruding onto the shoreline. Despite all these plans, no serious works were undertaken and the degenerated condition of the Golden Horn remained unchanged.

The 1980s: Istanbul encounters neo-liberalism

Dalan's proposal for the Golden Horn encompassed two phases. The first work on his agenda included wholesale demolitions alongside the banks of the Golden Horn. Rather than a delicately planned surgery that would call for a time-consuming programme to save the building fabric in the area, the young mayor opted for a shortcut and thereby sealed the future of the Golden Horn. The aim was to wipe out the sources of pollution in the area with a radical demolition programme. In order to obtain support from the different segments of society, an effective media campaign was conducted. Dalan himself met with various stakeholders such as the Istanbul Commerce of Trade and Commerce of Industry. His frequent interviews with the media were published with sensational headings such as 'I will turn the Golden Horn into the blue colour of my eyes', 'I will give my head for this project' and 'I am not Nero, he was only destroying. But I both demolish and construct'.[13] The demolitions began in May 1984 in Eminönü and continued until 1988. During this period around 2,000 buildings were bulldozed. Apart from some monumental historic buildings, such as the Bulgarian Church, Balat Jewish Hospital, Silahtarağa Power Plant, Sütlüce Abbatoir and the Lengerhane (old Ottoman anchor workshop), all other buildings, many of them with heritage significance of various degrees, were razed. The demolished areas were transformed into green spaces, and large recreational facilities were constructed along both the

Image 64 New parks constructed by the Dalan administration along the shores of the Golden Horn, Aras Neftçi

northern and southern banks of the Golden Horn. Large traffic roads encircling the gulf were also created.[14]

The second phase of the Golden Horn programme included the establishment of a modern sewerage system that would help prevent further pollution in the area.[15] In fact, the Golden Horn system was part of a larger waste water scheme prepared for the entire city. Istanbul had seen various sewerage proposals since the late Ottoman period. The first notable project bears the signature of André Auric, the French engineer who was appointed chief of the Infrastructure Department for Istanbul Municipality in 1910. Auric recommended constructing two main sewer lines ending near Seraglio Point at the easternmost end of the Istanbul Peninsula, where the presence of a strong and permanent current would allow the discharge of waste waters without preliminary treatment. The first sewer was to run along the Golden Horn starting near Eyüp, and the second along the shores of the Sea of Marmara starting near Yedikule where the Theodosian Walls merge with the sea. In Pera, Auric proposed similar principles for the discharge of sewage and believed it would be necessary to go as far as Ortaköy, where there was a permanent and sufficiently strong current to discharge the waste waters into the Bosphorus.[16] This was followed by a sewer project prepared by M. Wild, an engineer from Berlin, in 1925. The next notable proposal came in 1959 by another German, Professor Dietrich Kehr. His plan proposed discharging waste water not into the Golden Horn but into the Sea of Marmara. The 1970s also saw various proposals made by several consortiums supported by the World Health Organisation. Yet none of these proposals stood a chance of being implemented properly, and by the 1980s Istanbul still did not have a modern sewerage system. Dalan's plan for waste water management included an enclosed drain system along the shores of the Sea of Marmara, the Bosphorus and the Golden Horn. According to the scheme, waste water would be directed to those trenches and then collected in sewerage plants and, following decontamination, it would be pumped into the Sea of Marmara. The works commenced in 1983 and were substantially completed in 1988. This mega project was financed with US$88 million of credit from the World Bank in 1982 and an additional US$143 million was canalised for the project by the Istanbul Municipality.[17]

The second large venture for Dalan was the construction of Tarlabaşı Boulevard in Beyoğlu. This project too was first proposed by Auric in 1911 and then recommended by Prost in his master plan of 1939.[18] The 50-metre-wide Atatürk Boulevard, which slices through the Historic Peninsula creating two distinct areas, was linked to Beyoğlu by the construction of the Atatürk Bridge in 1940 under

The 1980s: Istanbul encounters neo-liberalism

Prost's recommendations. The next stage of the project was to extend this major artery up to Taksim Square. Prost suggested two options for this vital connection. The first alternative included the opening of a large boulevard, which would require the removal of many buildings, including the former British Embassy in Tepebaşı. The second option proposed an underground tunnel linking the Atatürk Bridge to Taksim.[19] Opening a large boulevard parallel to İstiklal Street was also proposed, both in the Müşavirler Heyeti Plan of 1952 and in Menderes' redevelopment scheme of the late 1950s.[20] However, none of those projects was implemented, and the connection between Taksim and Atatürk Boulevard was postponed.

Dalan's project was called the 'Essen Plan' in Turkish newspapers since the new roads opened under his leadership were based on the recommendations of a plan prepared by a group of German technical experts who had previously worked at the University of Duisburg in Essen.[21] The demolitions for Tarlabaşı Boulevard began on 29 May 1986, the 533th anniversary of the Turkish conquest of Constantinople. As part of the project, 368 buildings were removed, including approximately 130 heritage-listed items. These were mostly late-nineteenth-century apartment blocks of multiple storeys, representing different shades of Neo-classism in this most Westernised part of Ottoman Istanbul.[22] The construction of the 36-metres-wide, eight-lane boulevard was completed and opened with a grand ceremony on 4 March 1989. With the opening of the new boulevard, İstiklal Street, the famous Grande Rue de Pera of Ottoman Istanbul, was closed to vehicular traffic and this iconic street became a pedestrian thoroughfare.

Although Dalan's Golden Horn project had drawn general support from the public, this intense demolition programme attracted severe criticism from different groups. Similar to the reactions of those affected by Menderes' redevelopment programme, many property owners protested the demolitions. Dalan's insouciant response to these criticisms ensured the project would not be impeded. According to the mayor, there were thousands of buildings that had some degree of heritage significance in Istanbul. In order to solve the social and physical problems of the city, a small portion of that building stock would be sacrificed.[23] In many instances the municipality carried out the works in a hurry and various decisions for land expropriation were taken to court by the property owners. Dalan's answer to such denunciations was also sensational. Even if he lost the cases, declared Dalan, he would personally pay the compensation by selling all of his assets, including 'his jacket'. The demolitions and Dalan's enthusiasm gave him the popular nickname

of the 'Bulldozer' and he was portrayed in weekly magazines as 'Superman' flying over Istanbul.[24]

The most severe criticisms, however, came from the architectural community which was concerned about the loss of heritage buildings and the harm to the urban grain of this very old part of the city. According to the Chamber of Architects, which was under the control of a group of leftist architects who had radically positioned themselves against the government, Dalan was governing Istanbul as if it was his own house or garden and his political ambition led him to conduct the works hurriedly, without any noticeable input provided by qualified expertise.[25] The works carried out by the municipality, in the eyes of these groups, were turning Istanbul into Beirut. According to Yücel Gürsel, the head of the Istanbul Chamber of Architects, foreign investors had already plundered the Bosphorus district and now the same people wanted to create new business opportunities in Perşembe Pazarı, the neighbourhood earmarked for the most controversial demolitions of the Goldern Horn.[26] For many in architectural circles, the demolitions, especially in the Tarlabaşı district, were not based on a properly prepared plan and the main motivation behind the project was merely land speculation based on increasingly permissible floor space for the lots facing the newly opened large boulevard. According to claims made by those critics, the existing average of seven or eight floors in Tarlabaşı would be increased to 15 storeys, and this change would bring speculative benefits to the new property owners in the area who had bought existing buildings prior to the project.[27] In the absence of an overarching development plan for the whole city, all the works conducted by Dalan, according to many architects, would create serious urban and environmental problems in the future.[28]

Dalan's response to his critics was to open an urban design competition for the new Tarlabaşı Boulevard. Following demolitions, the new streetscapes often incorporated strange views since the rear or side facades of many buildings now faced onto the new boulevard. The municipality's intention was to maintain the urban quality of the street facades and increase the urban domain of this part of Istanbul.[29] Ten Turkish and international offices were invited to join the competition, and the selection panel was comprised of leading bureaucrats, architects and academics. However, rather than selecting a single proposal, the municipality wanted to create a new scheme by using 'good aspects' of all the participating projects. Yet none of these suggestions were put into action and Tarlabaşı Boulevard was left to undergo a gradual transformation, without any design scheme.

Dalan's third large project was a series of road enlargements on the European shores of the Bosphorus. The widening of the road between Karaköy and Kabataş

The 1980s: Istanbul encounters neo-liberalism

was proposed by Prost and completed by Menderes in the late 1950s. The upper part of the road following the European shores of the Bosphorus had some problematic sections, and this situation resulted in severe traffic jams, especially between Kuruçeşme and Arnavutköy and Çayırbaşı and Sarıyer. Dalan's solution to this problem was a new road constructed over piles anchored to the seabed. The construction of the 1,200-metre-long and 22 metres wide road in Arnavutköy began in late 1986 and was completed in March 1988. The 1,850-metre-long road in Sarıyer was also completed in mid-1988. Without a doubt, the new roads lessened traffic congestion and offered a chance for the public to appreciate a very scenic view of the Bosphorus. But, at the same time, they significantly altered the relationship between a group of *yalıs* (old waterfront mansions) and the sea. Arnavutköy was especially affected as many *yalıs* were separated from the sea by the large road, and a noticeable swell of discontent was created amongst property owners at these locations.

Dalan's fourth large project was on the Asian side of Istanbul. A coastal road was constructed connecting Üsküdar to Harem, the location of Istanbul's largest port at the time and the intercity bus terminal. Like the roads along the Golden Horn, this littoral avenue was also created as a landfill construction. Building the road involved the demolition of the late nineteenth-century tobacco factories in Üsküdar operated by Tekel, the state-owned tobacco and alcohol monopoly which was a major blue-collar employment destination for the inhabitants of the Asian side of Istanbul. The coastal road connecting Kadıköy to Kartal along the shores of the Sea of Marmara was the second significant project conducted by Dalan in Anatolian Istanbul. Like Menderes' Kennedy Street between Sarayburnu and Bakırköy on the European side, the road between Caddebostan to Maltepe was a large land reclamation project and was associated with many parks and recreation areas along its route. The opening of this road also resulted in significant alteration to the coastline and separated many buildings, mostly large waterfront villas, from the sea.

Lastly, the fifth major endeavour of the Dalan era was the construction of the second suspended bridge over the Bosphorus which came about as a central government initiative. As the vehicular traffic in Istanbul dramatically increased, the Bosphorus Bridge became insufficient to deal with the intercontinental trips. In the mid-1980s the average number of vehicles passing over the bridge every day reached 130,000, exceeding the bridge's capacity.[30] Although some practical measures were taken, such as restricting heavy vehicles using the bridge at peak hours and implementing one-way tolls, the congestion on the bridge could not be reduced. Thus, as anticipated by those in the circles that had opposed the

construction of the first bridge, calls for another bridge crossing the Bosphorus began to be voiced in various segments of society. The second bridge was built almost five kilometres north of the Bosphorus Bridge, spanning the strait from Hisarüstü on the European side to Kavacık on the Asian shore, and forming a vital link in the Trans-European Motorway that connected Edirne to Ankara. A near-identical twin to the 1973 Bosphorus Bridge, the second bridge was designed by the same British firm of structural engineers, Freeman Fox & Partners. It was built in three years by a consortium of Japanese, Italian and Turkish companies. The foundation stone was laid on 29 May 1985 on the 532nd anniversary of the Turkish conquest of Constantinople and the bridge, which was named after Fatih Sultan Mehmet, opened on 3 July 1988. On the opening night Istanbul's inhabitants saw a spectacular fireworks show, the biggest of its kind ever presented in Turkey. The bridge's two major gravity-anchored cables were carried by steel towers, and its aerodynamically designed deck was supported by two vertical steel cables. Unlike the Bosphorus Bridge, its towers were located on hilltops at both ends, which gave the bridge an awkward appearance. Again, in contrast to its older sibling, the steel cables carrying the deck were vertically positioned, a return to a conventional suspension bridge design seen in other parts of the world. The bridge was 1,510 metres long (including the approaching spans and the main span of

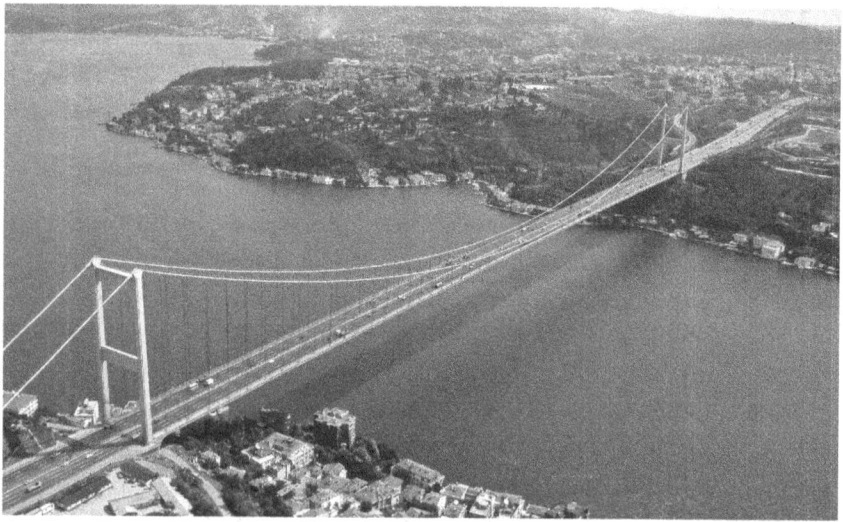

Image 65 Fatih Sultan Mehmet Bridge, Aras Neftçi

1,090 metres) and was slightly wider than the Bosphorus Bridge with four traffic lanes and one pedestrian lane in each direction.

Three squares, three urban design competitions

While the debates over the demolitions and new roads continued, the municipality announced in 1987 three international urban design competitions for three major public squares. The competitions were open to invited designers only and, along with a group of leading Turkish architectural practitioners, some very famous international architects were invited to compete.[31] The first competition called for the reorganisation of Taksim Square. Taksim's urban history began in 1732 under the reign of Sultan Mahmud I with the construction of the *maksem*, a water distribution building from which the square took its name. Water was supplied to Pera by canals constructed in the eighteenth century and Taksim, being the most prominent point in Beyoğlu, became a water distribution centre for the three major dams that supplied the city. In the late eighteenth century, Beyoğlu expanded as far as the *maksem*, with the boundary marked by the road connecting Pera to Taksim, the Grande Rue de Pera or today's İstiklal Street.

The modernisation policies of the Ottoman Empire made Taksim one of the most sought-after destinations in Istanbul. The Artillery Barracks, constructed in 1806 and renovated in the mid-nineteenth century during the reign of Sultan Abdülmecid, marked Taksim's importance in the urban morphology of Istanbul. Mecidiye and Gümüşsuyu Barracks and Gümüşsuyu Military Hospital were the other large-scale buildings constructed in the Taksim district during the late Ottoman period. Many other noteworthy buildings were constructed in Taksim during the first two decades of the twentieth century to take advantage of the transport connections made possible by the electric tram network completed in 1914. Taksim, however, gained its prominence during the early decades of Republican Turkey. With the Republic Monument located in Taksim, the square became the site for official celebrations on national days. As mentioned in earlier chapters, the demolition of the late Ottoman Artillery Barracks and the construction of İnönü Promenade and Taksim Square were among the most significant works completed by French urban designer Prost in the late 1930s and 1940s. These works made Taksim the most fashionable place in the city and an urban locality that represented the spirit of the Kemalist cause.

Taksim retained its importance as the city's most popular urban space from the 1950s. President İnönü's public speech on the eve of the 1950 elections marked

the first significant political gathering in Taksim. A flood of people filled the entire square and Governor-Mayor Fahrettin Kerim Gökay, pointing at the large crowd, made his famous introduction to İnönü, '*İşte İstanbul paşam*' (Here is Istanbul), presupposing a victory in the upcoming election for the ruling Republican People's Party. As noted earlier, this assumption would soon prove to be wrong as the Democrat Party gained an overwhelming victory over the Republicans. From that time Taksim saw numerous political rallies, public meetings and demonstrations. The ideological struggles of the 1960s and especially the 1970s brought with them an additional layer of symbolism for Taksim as it became synonymous with socialist ideology and the labour movement in Turkey. The Labour Day demonstration of 1 May 1977 in Taksim marked another major turning point in Turkish political history. During the demonstrations, an incident occurred that resulted in the deaths of 34 people and injuries to hundreds more at the hands of an unidentified gunman concealed in one of the surrounding buildings. This tragedy underlined Turkey's political instability in the 1970s when volatile conditions brought anarchy and street fighting amongst militant political groups.[32] The Labour Day demonstration was a pivotal event in the history of the square and established a strong psychological link between Taksim and leftist ideology in Turkey.

Despite its importance as the largest public space in Istanbul, over time Taksim lost its Republican identity and gradually turned into a large bus interchange. The construction of the Tarlabaşı Boulevard in 1988 brought to the square an increasing vehicular traffic load, which further intensified the dilapidated condition of the place. As expounded in the design competition's booklet, the municipality wished to renovate the square and reintegrate its pivotal status in the morphology of the city: 'Taksim once more [has] become a showcase of modern Istanbul and a symbol of the Republican era'.[33] First prize in the design competition was awarded to Vedat and Hakan Dalokay's project. This father-and-son architectural team proposed a wholesale redesign of the square. They proposed moving some of the roads underground, together with the construction of a large bus terminal for the inner city lines departing from Taksim for other districts of the city. İnönü Promenade, was to be renamed Taksim Gezisi (Taksim Promenade) and redesigned with a huge pool proposed at its centre. Since the traffic was to be redirected to underground tunnels, a large pedestrianised plaza would be created between İstiklal Street and the promenade. The most theatrical aspect of the winning project was a skyscraper proposed for construction behind the historic water distribution centre. It was intended to accommodate the new Istanbul Municipal Town Hall and was envisaged as the tallest building of Turkey.[34]

The 1980s: Istanbul encounters neo-liberalism

Image 66 The winning design scheme for Taksim Square by Vedat and Hakan Dalokay, Murat Gül personal archives

The second urban design competition was organised in Üsküdar, on the Asian side of Istanbul. Sitting directly across the Historic Peninsula, it was one of the oldest settlements of the ancient Roman province of Bithynia. Üsküdar was ruled by the Persian king, Darius I, in the sixth century BC and then captured by Alcibiades of Athens around 440 BC. In the following period this ancient settlement saw many new rulers, including Arabs who attempted, but twice failed, to conquer Constantinople in the seventh and eighth centuries. In the eleventh

century the Crusaders who marched towards Jerusalem occupied the settlement, and finally the Ottoman Turks captured Üsküdar almost a century before they conquered Constantinople. Under Ottoman rule Üsküdar was the most important settlement on the Asian side of the Bosphorus and was one of the *Bilâd-ı Selâse* or the Three Towns of Istanbul administered by a separate *kadı*, the Islamic judicial authority in cities. It was also the ceremonial departure point for annual pilgrimages to Mecca. The importance of Üsküdar is reflected in its architectural portfolio, which includes many mosques, *hamams*, *medreses* and other public buildings constructed by members of the ruling family and high-ranking pashas from the fifteenth century onwards. The significance of Üsküdar was further strengthened in the eighteenth and nineteenth centuries with the construction of large-scale military and public buildings, including the Selimiye Barracks and the Imperial Medical School. In the second half of the twentieth century Üsküdar, like many parts of Istanbul, was adversely affected by rapid population growth. As a result, concrete tenements replaced many timber dwellings, and its urban character was significantly altered. A great void located in the centre of the district was opened up according to Prost's master plan in the 1940s. However, similar to what had happened in Eminönü, no further works were completed and this large area turned into a bus and *dolmuş* interchange without any basic aesthetic qualities.

For Üsküdar, Doruk Pamir's proposal was favoured by the selection panel. The winning design proposed a large car-free plaza adorned with motifs derived from classical Turkish architecture, an approach consistent with the rising popularity of the retrospective branch of postmodern architecture across the world in the 1980s. Reflecting on the historical significance of Üsküdar, Pamir saw this square as a gateway opening to Asia and this interpretation was signalled by a symbolic gate proposed by the architect. Similar to the Taksim proposal, Pamir's design proposed the main traffic road, connecting the Asian shores of the Bosphorus to Üsküdar, be moved underground, thereby creating above a huge pedestrian square.[35]

The third urban design competition targeted Beyazıt Square, which was one of the most important centres of old Istanbul, both in Byzantine and Ottoman times. Called Forum Tauri, it was the largest of the five ancient squares located on the route of the famous Byzantine *mese*, or the colonnaded street lined with porticoes of early Constantinople, stretching from the ancient hippodrome in the east to the city walls in the west. The significance of the place continued under Turkish rule and the first Ottoman palace was constructed in the vicinity of this old square immediately after the conquest of the city. The construction of a great sultanic mosque and complex by Beyazid II in 1505 made this square the most

The 1980s: Istanbul encounters neo-liberalism

significant centre in Istanbul and gave the square and surrounding neighbourhood its Turkish name. In the following centuries, Beyazıt retained its status and saw the construction of important buildings such as the Ministry of War building and a fire watchtower. This ancient square was amongst the few places in Istanbul to earn the attention of the early Republican administration, and it was ornamented by the construction of an oval decorative pool in the 1920s. The road enlargements conducted in the 1950s resulted in the demolition of some historic buildings to the west of the square and linked it to Aksaray by Ordu Street. Following the coup of 1960, the military junta changed the square's name to Hürriyet Meydanı (Freedom Square) and assigned Turgut Cansever to redesign this significant place as a ceremonial piazza. Yet, like many other works in Istanbul, Cansever's proposal could not be fully implemented, and the ancient square was turned into a large car parking area and bus interchange at the very centre of the Historic Peninsula. The Beyazıt Square design competition was awarded to Vedia Dökmeci and Yaprak Karlıdağ. Their proposal created a two-layered square which was stepped by high walls decorated with retrospective stylistic elements that drew upon Ottoman architecture.[36]

None of the award-winning proposals for the three significant urban squares of Istanbul were implemented. Despite all the good will, the winning design schemes were rudimentary in form and went no further than to provide basic design ideas for these highly problematic junctions in Istanbul. The principles touched upon in the plans needed further elucidation and delicate detailing. Yet neither the municipality nor the central government was able to conduct such large projects on the eve of the 1989 municipal elections.

The architecture of the 1980s

The 1980s for Istanbul marked not only some large-scale urban infrastructure works and road making but also saw significant pieces of architecture that reflected the social, political and economic spirit of the time. As noted above, liberal economic policies and integration with the world financial system brought substantial alterations in the social structure of Turkish society. These developments were mirrored in Istanbul's architectural landscape, with notable projects designed both by Turkish and foreign architects.

In terms of public architecture, one of the most prominent projects of the 1980s was the new international terminal building at Yeşilköy Airport. Established in the 1910s, Istanbul's airport was used initially as a military air

base in the early Republican years and then, in the 1930s, began to serve as a civilian airport for the first domestic flights providing services between Ankara and Istanbul. The airport was renewed by an American firm in the late 1940s and with a new terminal, runway and other facilities began to service international flights in 1953. The airport, however, could not cope with the increasing air traffic of the 1960s and 1970s when Istanbul was connected to major European cities by air.[37] A master plan for a new airport first came into existence in the early 1970s and proposed four terminal buildings, as well as hangars, technical departments and a large undercover car park. The project was scheduled for completion by 1975. However, only a transit terminal was constructed and opened for service in 1974. Following a long period during which progress languished, the international terminal building was completed and opened in 1983. Designed by Hayati Tabanlıoğlu, the triangular building was roofed by a steel-frame structure containing repeating, polygonal copper-coated vaults. This was the first airport terminal facility in Turkey that fully complied with international aviation standards and, in many respects, it incorporated state-of-the-art characteristics of its time. Nine air bridges, modern luggage handling units, computerised check-in desks, modern passenger amenity services and duty-free kiosks were all new amenities in the Turkish aviation industry. In 1985 the airport, like many large public buildings in Turkey, was renamed in honour of Atatürk and became known as Atatürk International Airport.

Construction of the first shopping mall in Turkey was another inspiring project in Istanbul in the 1980s. In fact, the enclosed shopping centre was not a new phenomenon for Turkey. The commercial life of the traditional Ottoman city was centred around the *çarşı*, or the market place. In Istanbul the same scheme applied and, immediately following the Turkish conquest, a *bedesten* (central marketplace) was constructed in a former Byzantine commercial district between the former Forum Constantini (present-day Çemberlitaş) and the Forum Tauri. With its 15 domes and fortress-like structure, the *bedesten* was surrounded by various *hans* (lodges for accommodation and storage) for merchants who engaged in regional trade. It was gradually extended over the next two centuries and became an immense marketplace (Kapalı Çarşı) containing thousands of shops, with covered streets and 32 gates leading to the city in every direction. Other parts of Ottoman Istanbul had smaller market districts with *hans* servicing their quarters.

In line with the modernising society, European-style arcades appeared along the Grande Rue de Pera in the nineteenth century. Known as *pasaj* (derived from the French word *passage*) and representing the latest fashions, the arcades became

The 1980s: Istanbul encounters neo-liberalism

the most popular shopping destinations in the late Ottoman era. This pattern of commercial life continued into the twentieth century and Istanbul saw many arcades constructed, especially after the 1960s. Many of those buildings, however, had moved far from their predecessors in terms of artistic quality as they were simply built on the ground floors of ordinary reinforced concrete office buildings and burgeoned on every corner of the city.

The changing social dynamics and Turkey's growing integration with the world economy in the 1980s enabled Turkish society, or at least some segments, to adopt contemporary Western social traits. Shops packed into concrete arcades were no longer satisfactory for the Turkish consumer and the increasing demands

Image 67 Galleria Shopping Centre in Ataköy, SALT Research, M. Ekrem Çalıkoğlu Archive. Photo: M. Ekrem Çalıkoğlu

of consumerism brought about the construction of Turkey's first Western-style mall in 1987. Called Galleria Shopping Centre, it was part of a larger complex in Ataköy consisting of hotels, marinas, entertainment facilities and a beach. Designed by Hayati Tabanlıoğlu, Galleria followed the traditional covered-street scheme of Ottoman bazaars. The two-storey mall had a longitudinal layout with large corridors facing a lofty void that ended with large covered atriums. A multi-storey covered car park, a rare facility for 1980s Istanbul, was placed behind the shopping mall and awkwardly faced the sea.[38] The mall became an urban landmark for the wealthier inhabitants of the city. Many new facilities, such as an enclosed ice skating rink, a food-court presenting international cuisines and air-conditioned shops stocked with imported goods, were offered to the Turkish elite who were deeply captivated by the new consumerism. In this context, low-priced brands of the Western fast-food industry became popular with the well-to-do of Turkish society. Turkey's first Pizza Hut restaurant, for example, opened its doors at Galleria Shopping Mall in 1989, and soon became a popular dining destination for wealthier Istanbulites. Galleria Shopping Centre also accommodated the famous French department store, Printemps. All its facilities made Galleria the most sought-after destination for affluent citizens who poured into the mall at nights and weekends, not only for shopping but also for the new modes of recreation that would soon become very popular for all inhabitants of the city.

New hotels, new tall buildings

Economic liberalisation and Turkey's closer cooperation with the West brought other significant projects, mostly in the form of hotels and high-rise office blocks. Without doubt, one of the most controversial projects of 1980s Istanbul was the Swiss Hotel Bosphorus. The site selected for this luxurious hotel was the sloping grove just behind Dolmabahçe Palace. Designed by Turgut Alton in consultation with Japanese architect Kanka Kikaku Sekkeisha, the construction of the hotel required the demolition of Eldem's Taşlık Coffee House and the removal of a large portion of the greenery.[39] Although Alton's design was based on a fragmented approach, with the aim of reducing the visual impact, the building envelope of the large hotel hovered above the old palace and changed dramatically the vista of Dolmabahçe Palace as seen from the Bosphorus.

The reconstruction of Çırağan Palace as a luxurious hotel was another noteworthy development in Istanbul architecture in this period. Constructed in

The 1980s: Istanbul encounters neo-liberalism

Image 68 Swisshotel Bosphorus located above Dolmabahçe Palace, Murat Gül

1869–72, the original palace was built for Sultan Abdülaziz and was one of a number of imperial residences constructed along the shores of the Bosphorus in the nineteenth century. Smaller than its forerunner Dolmabahçe, Çırağan's stylistic genre was Orientalist which, as noted in earlier chapters, became popular in the second half of the nineteenth century. Çırağan had a tragic history, as four

years after its completion Abdülaziz was found dead in the palace complex, soon after being deposed by his nephew, Murad V. Suffering from significant psychological problems, Murad reigned only 93 days and was replaced by Abdülhanid II who ruled the Ottoman Empire for 33 years from his newly built Yıldız Palace. During this period Çırağan hosted Murad who lived out the rest of his miserable life in the palace as a prisoner until his death in 1904. Çırağan later regained its popularity under the rule of Sultan Mehmed Reşad who housed the Ottoman Parliament there during the Second Constitutional Era. Soon after, in early 1910, a great fire destroyed the palace, leaving intact only the external walls. For a long period, the ruins of the palace were neglected and it was even used as a football field.

The reconstruction of Çırağan Palace as a lavish hotel was first proposed by Menderes in the mid-1950s.[40] Yet nothing happened until the government leased the ruined palace to a Japanese company in the 1980s. The derelict building was reconstructed and a six-storey modern addition was built to provide guest rooms for the hotel. Although the external walls were successfully restored, the interior reconstruction attracted severe criticism from conservation experts as the details and, in particular, the very rich colour palette represented a Western fantasy of Arabian nights. Another controversial aspect of the project was the partial demolition of the palace walls which had separated the sumptuous palace complex from the road behind.[41] According to Dalan, this was not merely the demolition of a physical wall but the 'abolition of a mentality'.[42] He extended his view and claimed that all similar walls that encircled historic buildings, including Dolmabahçe Palace, should be demolished so as to pull down the curtain hiding the splendours from the people of the city. Then all the beauties of the Bosphorus would be available for general public appreciation. Dalan's proposal, however, bitterly annoyed the architectural community in Istanbul.[43]

Concurrently, the late 1980s Istanbul saw numerous skyscraper projects proposed for different parts of the city. Maslak was the part of Istanbul most dramatically transformed during this period. Once just a small rural settlement on the periphery of European Istanbul, Maslak's redevelopment began with a master plan drafted by Kemal Ahmet Aru in 1970–1 for Istanbul Technical University campus. The initial signals of the commercialisation of Maslak, however, came in the late 1970s with the construction of Alarko Holding Headquarters. One ten-storey and two eight-storey buildings were the tallest buildings constructed by Sedad Hakkı Eldem and were the first corporate office blocks in this district. The opening of the second bridge over the Bosphorus and its connecting highways

The 1980s: Istanbul encounters neo-liberalism

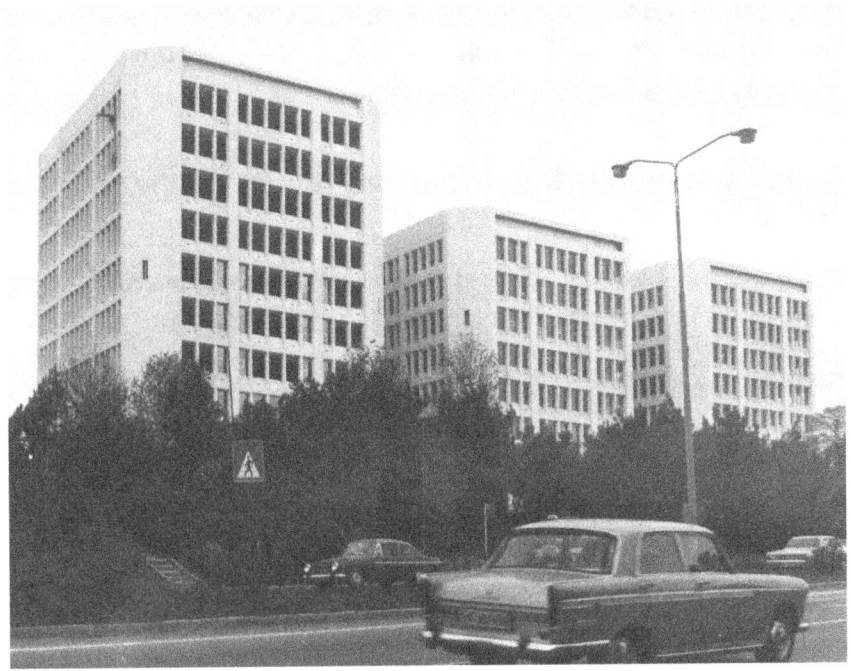

Image 69 Alarko Holding Headquarters in Maslak, Rahmi M. Koç Archive & SALT Research, Sedad Hakkı Eldem Archive

made Maslak more accessible and boosted many new constructions, with the result that the area between the Fourth Levent and Maslak gradually became the new business hub of the city. The Yapı Kredi Bank Plaza by Haluk Tümay and Ayhan Böke, Kale Seramik Headquarters by Nişan Yaubyan and the Mövenpick Hotel (now operated by Sheraton Group) by Ertem Ertunga were all new towers constructed in Büyükdere Street. These modest skyscrapers of the 1980s were the forerunners of their much taller siblings which would soon mushroom in this area in the following decades.

While the Fourth Levent and Maslak were gradually becoming the new financial heart of Istanbul, some other large-scale developments were also being proposed for different parts of the city. Cevahir Centre, for example, was a noteworthy development that was proposed for a site in Şişli formerly used as a public bus depot. Designed by Minoru Yamasaki Associates in 1988, the project comprised a total floor space of 544,000 square metres and included the construction of seven high-rise office towers, one hotel tower and a five-storey shopping mall associated with

a car park with a capacity for 3,300 vehicles. The execution of the project, however, was delayed and, after major alterations resulting in the removal of the towers, the shopping mall was completed in the mid-2000s.

Gated community housing: a new model for the urban rich

The economic growth and increased awareness of Western urban culture in the 1980s brought the first significant example of an enclosed luxury residential project in Istanbul's real estate market towards the end of the decade. The existing urban form and socially mixed residential patterns were no longer attractive to the new urban elite, who had benefited significantly from the liberal policies of the government. Although its residential arrangement was primarily formed by a dual structure of multi-storey apartment blocks for the middle and upper middle classes and *gecekondu* for the poor and migrants, Istanbul was still a 'softly segregated' city where residents from different social groups still mixed to a certain degree. While luxurious apartments were very different to their counterparts occupied by the lower middle class and to *gecekondu* apartments in terms of location, size and building materials, they were not totally isolated from the city. Now economic development made possible much more attractive options for the upper income groups that culturally and socially distanced them from the 'ordinary' inhabitants of the city. Such groups now looked for secluded quarters exclusively designed for their needs.

Located within the Belgrade Forest in the upper north of European Istanbul, Kemer Country housing complex was the first full-scale gated community established in Istanbul. The concept design bears the signature of a Florida-based architectural practice, Andres Duany and Elizabeth Plater-Zyberk, who were among the pioneers of 'new urbanism' theory. Emerging in the United States in the early 1980s as a reaction to the postwar 'suburban sprawl', new urbanism was based on the principles known as 'neotraditional development'.[44] Traditional architectural styles were often employed within an environment that created a very interactive social atmosphere by basing development on a street pattern that allowed people to get together and establish 'face-to-face' contact so as to minimise isolation. In this scheme, narrow tree-lined streets, slow vehicular traffic, corner shops and a diversity of building types and sizes encouraged a wide spectrum of resident profiles from all age groups. Schools and social centres in walkable distances were often prioritised. In Kemer

The 1980s: Istanbul encounters neo-liberalism

Country Duany and Plater-Zyberk sought the establishment of a 'lost Ottoman neighbourhood', with the housing models inspired by the external appearance of traditional Turkish houses with wide roof overhangs, modular windows and oriels. The narrow streets, courtyards and small squares that were typical features of the Ottoman city were also used as they complied with the emerging model of new urbanism.

The luxurious housing compound, however, was designed as an enclave behind secured walls with no contact with its locality. It was deliberately established 'in the middle of nowhere' as a self-contained spatial environment for selected inhabitants, with superb quality services and infrastructure. A newly constructed highway allowed the residents of Kemer Country to reach the city centre without any interaction with the nearby villages and rural settlements. The sumptuous houses were placed within manicured gardens and the complex's landscape included large green fields, privatised forests, artificial lakes and a golf club for exclusive use by the residents and privileged members. The demographic make-up of Kemer Country was also homogeneous, mostly Western-oriented and secular, and comprised small families with, at the most, one or two children. This structure, however, was not random as the founders of the project conducted a carefully planned marketing strategy and devised selection criteria to prevent 'undesirable' types of people from purchasing property within the complex, even if they could afford such an expensive estate.[45] By the implementation of such strategic tactics it would be possible to retain the socio-cultural integrity of the 'heaven' created for the designated inhabitants.

The pattern introduced by Kemer Country was so embraced by upper income groups that the area saw the development of many similar gated communities in the following decades. Hence the remote rural settlement on the outskirts of metropolitan Istanbul became a prestigious suburb containing many gated residential complexes surrounded by high walls and separated from each other by 'dead' streets used only by vehicles travelling to and from those developments. Furthermore, the security and sense of privilege introduced by Kemer Country and similar gated complexes nearby prompted a new fashion that affected the entire city of Istanbul. The following decades saw hundreds of gated enclaves established in every part of the city for almost all segments of society, ranging from upper income groups to the lower middle classes.

Apart from the large-scale projects above and gated residential compounds, the changing social dynamics and growing economy were not mirrored in mainstream architectural practice. The transition from the highly politicised

atmosphere of the 1970s to the post-1980 social and economic order was not easy for many intellectual groups, which felt deeply the impacts of military rule and the subsequent neo-liberal policies. Turkish architects, who had been actively engaged with social and political developments in the preceding decades, were not exempt from this challenge, and their adaptation to the new conditions would take some time. In this sense, the 1980s was a sterile time for projects other than 'architecture with a capital A' in Istanbul. Perhaps the most inspiring project of the era in architectural terms was an infill building designed in the Maçka district of Istanbul.[46] Commissioned by Milli Reasürans, the oldest Turkish reinsurance company, this building was erected as its national headquarters. Designed by wife and husband architects Sevinç and Şandor Hadi, who were the winners of a limited design competition in 1984, the project showed many new aspects in Turkish architecture. Construction began in 1987 and the building was completed in 1992. For its time, the building displayed state-of-the-art architectural ideas in its use of space, building technology and materials. On a site bounded by busy streets to the east and west, the complex included offices, a small shopping arcade, cafes, restaurants, recreational open spaces, a bank and a conference and exhibition hall. A 12-metre-wide setback along Maçka Street provided a lofty public space in this heavily built-up area. Above, the top two storeys spanned an impressive 47 metres, with only one intermediary support. An internal garden at the centre separated the insurance company's premises from other tenants. The success of its design as a modern infill project brought the building two major awards from the Turkish Chamber of Architects.

Istanbul's population in 1980 was around 4.7 million. In the 1980s the city continued to grow and in 1985 the population increased by 20 per cent to reach 5.8 million. By the end of the decade the figure had further accelerated and reached 7.3 million.[47] In many aspects, the five-year period between 1984 and 1989 under the Dalan administration recalled prime minister Adnan Menderes' urban redevelopment programme. Similar to the strong DP governments of the 1950s, Dalan operated under, and received unconditional support from, politically powerful MP governments in the 1980s. In both periods Turkey exhibited noticeable economic growth and a relatively calm political atmosphere. And both Menderes and Özal were key political figures who saw Istanbul as the most challenging and promising task on their political agenda. From this perspective, the support and criticism of the works carried out by Dalan show parallels to the responses to the works completed by Menderes in the late 1950s. Many of

The 1980s: Istanbul encounters neo-liberalism

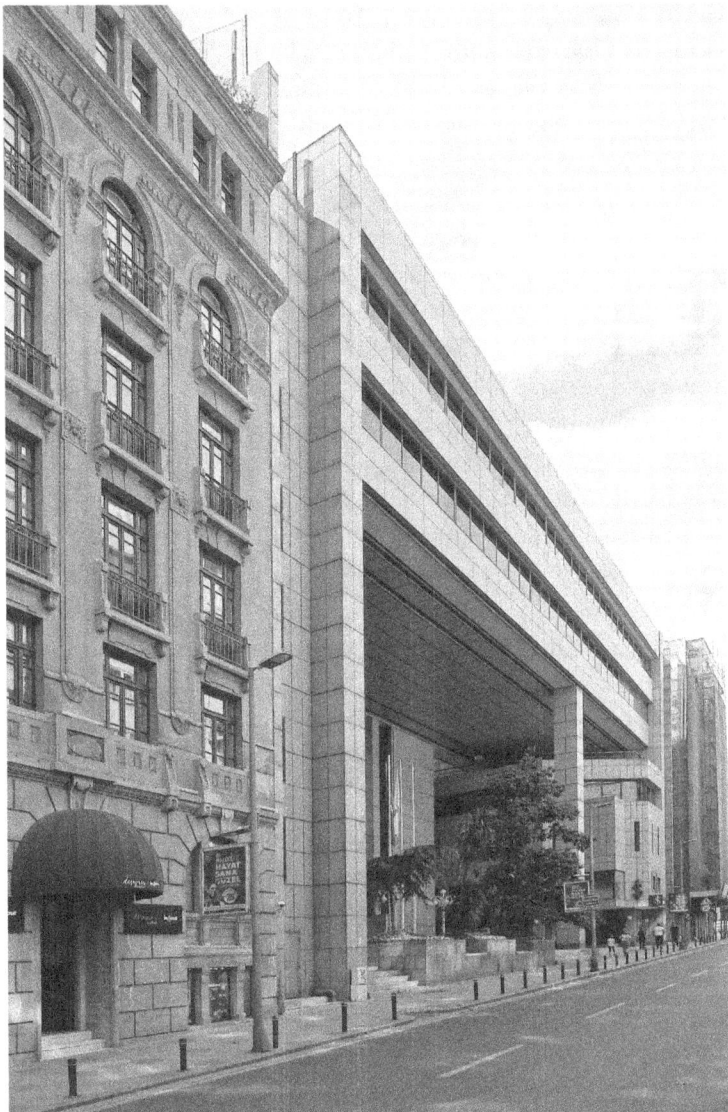

Image 70 Milli Reasürans building in Maçka, Aras Neftçi

the projects carried out in the 1980s in Istanbul drew deep condemnation from architectural circles.[48]

The mass clearance of historic buildings in the Golden Horn area and Tarlabaşı changed the morphology of those districts significantly. What was lost in the

Golden Horn was not only the 'dirty' physical fabric but also the *genius loci* representing the multilayered history of one of Istanbul's oldest areas. The construction of roads raised above the sea along the Bosphorus and other littoral avenues on the Asian shores of the city also dramatically changed the existing relationship between the city and the sea. The second suspended bridge and the connecting motorways pushed the limits of the urbanised area towards the north, and this created adverse impacts on the green areas of Istanbul. The new high-rise buildings constructed, or proposed, further challenged the existing skyline of the city. These were all negative aspects of the works carried out by Dalan and his administration. On the other hand, there is different picture to consider. Istanbul, for the first time in its history, saw a modern sewerage system in the 1980s. The long-lasting environmental problems in the Golden Horn began to be addressed, and the area was rehabilitated and saved from further contamination. Although their design quality was well below contemporary landscape design principles, the parks and green areas constructed in the demolished areas around the Golden Horn and along the coastal road between Caddebostan and Maltepe provided Istanbul's inhabitants with large recreational spaces. Again, during Dalan's time, a modern underground line was constructed linking Aksaray to Esenler, the first in Istanbul since the 1875 tunnel between Karaköy and Galata.

From the first perspective, Dalan was a typical political opportunist whose mind was driven primarily by policies focusing on land speculation and political expediency. Unquestionably, some of the major projects conducted by Dalan harmed Istanbul's natural and historic characteristics, and his pragmatism did not always bring about the desired outcome. From the second point of view, however, Dalan can be seen as an energetic and ambitious technocrat who courageously pointed out significant issues and successfully addressed centuries-old problems. Without doubt, both views have some degree of validity. Dalan's projects opened the doors to further interventions into Istanbul's historic character and natural beauty. Yet, at the same time, the sewerage systems, new transportation modes and recreational areas that he created were essential amenities for a city that wanted to meet contemporary urban standards. These contradictory images have made Dalan one of the key figures in Istanbul's history and he has contributed substantially to the emergence of modern Istanbul, both in positive and undesirable ways.

6

The 1990s: political instability, financial crises and architecture adrift

By the end of the 1980s, alarm bells began to ring for those watching developments in Turkey's financial and political arenas. Despite all the promising investments in roads, telecommunications and other industries and the implementation of liberal economic reforms and polices, the 1980s were marked by economic difficulties, in particular the second half of the decade. Inflation figures returned to their pre-1980 levels of around 80 per cent, resulting in the gradual erosion of the purchasing power of the urban middle classes. Political scandals, nepotism and corruption allegations against Özal's family members and those in his close circles were also leading themes in the political agenda of the late 1980s. Such drastic economic indications eroded Özal and his party's popularity, although the Motherland Party (MP) won the 1987 general elections against the opposition parties, which were led by pre-1980s political leaders who were now free to engage in political activities after their ban was overridden by a public referendum earlier the same year.[1]

The first serious signal for the MP was the outcome of the 1989 municipal elections when it suffered a bitter defeat. According to the results of the elections of 26 March, the Social Democratic People's Party (SDPP) led by Erdal İnönü, the son of İsmet İnönü, won 28.7 per cent of the vote. Demirel's True Path Party (TPP) came second with 25.1 per cent. Özal's MP gained only 21.8 per cent of the vote and became the third party in the election. More importantly, the MP lost municipalities in the large cities, including Istanbul, Ankara and İzmir. The loss in Istanbul was particularly startling. The SDPP took 35.9 per cent of the vote, while the MP could attract only 26.1 per cent.[2] Despite the bitter anti-Özal atmosphere, nobody expected a defeat for Dalan in Istanbul. This included the winning SDPP representatives who had gone into the elections without any genuine optimism. Notwithstanding all the controversial works, Dalan's popularity amongst

Istanbulites was still considered to be very high.³ Yet the growing antipathy for Özal in the general population brought a surprising victory to Nurettin Sözen, a professor of medicine, in Istanbul. The MP also lost the great majority of the district municipalities in Istanbul, even the previously impregnable strongholds of the central-right and conservative parties such as Üsküdar, Fatih, Eyüp and Ümraniye. Although unexpected, Dalan's loss created great joy and optimism in some university circles and the Chamber of Architects, both of which had confronted him over a large number of projects in the preceding years.

Sözen's Istanbul

As soon as he took office, Sözen targeted his predecessor's mega projects, a strategy based primarily on anti-Dalan rhetoric. The Golden Horn Rehabilitation Project was cancelled as, according to the Sözen administration, the highly contaminated water of the Golden Horn would cause an even greater environmental disaster once it reached the Sea of Marmara. Therefore, rather than pumping the polluted water into the sea, efforts should be directed towards rehabilitating the creeks, which were among the major sources of contamination in the Golden Horn.⁴ Opting for a populist discourse, Sözen also promised that his priority was not to construct five-star hotels but to provide electricity and water for the city.

The partial demolition of the new Park Sürmeli Hotel construction was perhaps the most attention-grabbing act conducted by Sözen during his entire term. Located at Ayazpaşa, to the south of Taksim, the original Park Hotel was designed initially as the chancellery for the Italian Embassy in the late nineteenth century but, due to financial difficulties, the half-completed building was purchased by the Ottoman government and converted into an official residence for the minister for foreign affairs. Following a devastating fire, the building was reconstructed and transformed into one of the most sought-after hotels in Istanbul in the 1930s. Frequently favoured by Atatürk, the Park Hotel was also a beloved accommodation destination for the former prime minister, Adnan Menderes, during his frequent visits to Istanbul in the 1950s to inspect and conduct his redevelopment projects. His extensive stays at the Park Hotel were turned against him at the infamous Yassıada Trials when the prosecutors accused him of spending public resources irresponsibly at the hotel.⁵

The sparkling days of the Park Hotel, however, came to an end with the opening of more luxurious rivals in the city, and the hotel was closed down in 1979. The derelict building was first listed as a heritage item and saw various attempts at

The 1990s: political instability, financial crises and architecture adrift

renovation. However, in the late 1980s a new project was proposed consisting of the construction of two towers: a 69-metre-high hotel block and an 89-metre-high office block. The proposed development was excessive in all respects. Although it generally followed the old building's footprint, the new development's floor space was very large and did not conform to any other building lot in its vicinity, which was mostly comprised of Neo-classical and Art Deco apartments dating back to the late nineteenth and early twentieth centuries. The height of the new development was even more alien to the neighbourhood, since the proposed skyscrapers were to rise among buildings of five to seven storeys at most. Despite severe opposition from many local residents and members of architectural circles, the construction began in 1989 and the hotel structure rose quickly in the following years. As the construction progressed, the impact of this enormous building became visible to all. The half-completed building did not conform to any reasonable standards, both in terms of planning or aesthetics.[6] After lengthy debates and numerous court decisions, the hotel was finally declared as unauthorised by the High Court in 1992. The public resistance to this development grew into an organised campaign to halt the construction which was the first of its kind in Turkey. Mirroring the Green Ban movements in Sydney and grass-roots battles in other parts of the world, the solid public opposition was coordinated, and effective campaigns were conducted by a large stratum of the Turkish society to stop this monstrous construction. Finally, backed by zealous local residents, the architectural community and members of academia, Sözen launched the demolition of the hotel construction at a crowded ceremony in November 1993.[7] In the following months the municipality demolished the excessive sections of the construction and it was reduced to the height of the neighbouring German Consulate building.

The other significant project commenced by the Sözen administration was an underground line in Istanbul. Since the opening of the Tünel in 1875, constructing an underground line was a dream that had been voiced vehemently by political leaders for many decades. Yet despite various proposals being prepared, none of these initiatives were implemented, apart from the light-metro line connecting Aksaray to Topkapı and then Esenler, which was completed in 1989 during Dalan's term. The construction of the new seven-kilometre line connecting Taksim to Levent was launched in 1992 and the project was managed by an international consortium in collaboration with a number of Turkish firms.[8] The completion of Istanbul's first world-class underground rail line took eight years and services began in late 2000. In addition, a tramline between Sirkeci and Topkapı was put into service the same year.[9] The new line cut through the Historic Peninsula and

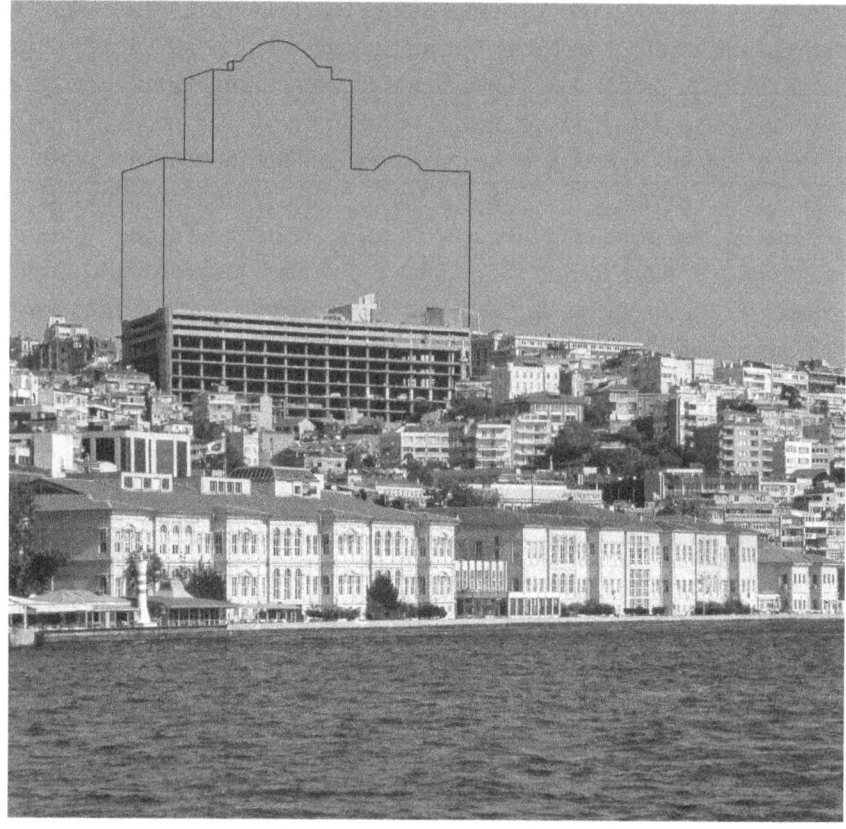

Image 71 The Park Hotel construction, following partial demolition (the line indicates the proposed building envelope), Aras Neftçi, Ebru Şevkin (drawing)

quickly became a popular mode of transport for both local residents and tourists. All these works were pioneering steps in the transportation history of Istanbul. In the early 1990s public transport in Istanbul was provided primarily by thousands of buses, minibuses and *dolmuş*, as it had been in the preceding decades. Maritime transport provided for less than 3 per cent of public transport and the only suburban railway transport in this mega city was two lines running alongside the shores of the Sea of Marmara on the European and Asian sides of Istanbul, both of which were constructed in the nineteenth century and electrified in the 1950s. Although the total length of the new lines was moderate, only 16 kilometres, Istanbul had finally attained its modern underground system. In this period Istanbulites also saw the return of the old trams in Beyoğlu. After 11 months of

The 1990s: political instability, financial crises and architecture adrift

renovation works, the rails were laid along İstiklal Street, and vintage trams were put in service between Taksim and Tünel in early 1991.[10]

Another significant venture that marked the early 1990s in Istanbul was the replacement of the ageing Galata Bridge. Bridging the Golden Horn was one of the most exciting projects in the history of Ottoman Istanbul. The first connection to span the two banks of the gulf was constructed in 1836 between Unkapanı and Azapkapı. Noted in Helmuth von Moltke's memoirs, the bridge was constructed over a 'forest of timber piles' driven into the seabed.[11] The first bridge was followed by its sibling linking Eminönü to Galata in 1846 which was constructed as a floating pontoon structure. Providing rapid transportation between two significant centres of Istanbul, these two bridges were ground-breaking. The two banks of the Golden Horn were linked to each other and this boosted the development of Galata and Beyoğlu in the second half of the nineteenth century. Although the old Galata Bridge had been replaced by a new pontoon bridge in 1875, it was not sufficient to accommodate the increasing pedestrian and vehicular traffic crossing the Golden Horn. Following various projects prepared by European engineering companies, the construction of the new bridge was finally tendered to the German firm Maschinenfabrik Augsburg-Nürnberg in 1907. The political pandemonium during the last years of Abdülhamid II's rule, however, caused several years of delay, and the bridge was finally completed in 1912.[12] Since it was first constructed, Galata Bridge had always been one of the most colourful elements of Istanbul's urban landscape. Street vendors selling a wide array of goods ranging from fruits and snacks to electronics, hopeful fisherman dropping their lines into the waters below, the cheap bars and taverns located along the lower decks and, most importantly, the wharves servicing inner city ferries – all contributed to the popularity of the bridge, which was one of the most sought-after destinations for both local residents and foreign visitors. Over the years, and particularly after the 1970s, the increased vehicular traffic pushed the limits of the ageing bridge and, as a result, a new project for a replacement bridge was prepared in 1987. A fire destroyed the old bridge in 1992 and accelerated the slowly progressing construction, and the new bridge was finally completed in 1994. Although the new bridge was wider than its predecessor and provided better traffic flow, its design was outdated for the time. Concerned predominantly with the loss of the old bridge, the architectural community did not thoroughly discuss the design of the new structure. Also, neither the municipality nor the central government was worried about the architectural aesthetics of the bridge, which sailed over a visually dominant location. Therefore, the new pontoon bridge did not go beyond being a poor copy of its predecessor.

More shopping malls, more high-rise buildings

Despite all the rhetoric about saving the city from overdevelopment and 'planned and scientific' land use policies, Istanbul continued to have an increasing number of large-scale developments during Sözen's term, mostly in the form of shopping malls and high-rise buildings, which not only impacted the city's urban morphology but also paved the way for similar developments in the following decades. Shopping centres were one of the most iconic symbols of the paradigm shift that had occurred in Turkish society since the 1980s, and a phenomenon that Turkey shared with many countries that came late to capitalism. The newly emerging middle classes in the big cities, who were mesmerised by the consumerist lifestyle, required more shopping malls in their neighbourhoods. The malls provided sterile and shiny places that were non-existent in the traditional market places, streets, parks and promenades. Moreover, these strictly controlled private–public spaces created secure havens for those who no longer wanted to mix with ordinary citizens. In this sense, the commercial success and popularity of Galleria prompted the opening of new shopping malls in Istanbul. The Capitol Shopping Centre in Altunizade, on the Asian side of Istanbul, was the rising star of consumerist society in Istanbul in the 1990s. Planned in 1989, the building was designed by Mutlu

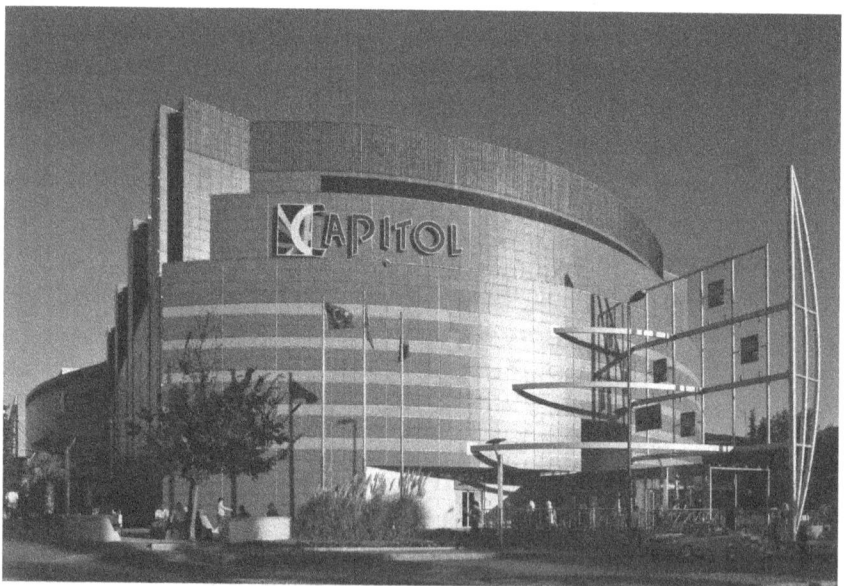

Image 72 Capitol Shopping Centre, Aras Neftçi

The 1990s: political instability, financial crises and architecture adrift

Çilingiroğlu and Adnan Kazmaoğlu and consisted of a three-storey shopping mall with luxurious shops, cinemas and a large food court, all encircling a longitudinal atrium covered by a semi-transparent roof. The mall also included a two-storey underground car park, the largest of its kind ever built in Istanbul. The unpenetrated, large terracotta-coloured facades were skilfully fragmented, with the aim of breaking the block effect of the building as viewed from the outside. When it was opened in 1993, the Capitol Shopping Centre became the most attractive shopping destination in the city. While wealthy citizens of the city shopped for luxury brands, young Istanbulites poured into the cinemas and the food court to treat themselves to a variety of fast food, which was then still a new phenomenon in Turkey.

The same year saw the opening of a big sibling of Capitol; this time the shopping mall was on the European side of Istanbul in Etiler, a posh suburb which had begun to develop within the vicinity of the Levent housing scheme in the 1950s. Designed by Fatin Uran, Akmerkez became Istanbul's first mixed-use development where a large shopping mall, offices and luxurious apartments were all part of a single development. Two cylindrical office towers and one triangular residential tower were positioned on the corners of a triangular podium that housed a large shopping mall. Glass facades and polished granite floors were the two principal building materials and were representative of the time. Three atriums located at each corner of the triangular podium mass were enriched by attractive decorative elements, such as aquatic pools with refreshing water jets, indoor planting elements and sparkling lighting fixtures, all of which were new architectural features in Turkey in the early 1990s. Akmerkez's pattern of combining different uses in a single development came to be so beloved by wealthy city dwellers that many similar projects were constructed in Istanbul during the following decades.

The early 1990s also witnessed the construction of luxury hotels on valuable lands owned by the public in the central districts. The Conrad Hilton Hotel was constructed in Yıldız Park in 1992 and, similar to the Swiss Hotel, had a significant impact, both on the greenery and the city's silhouette as viewed from the Bosphorus. Stretching over a huge site overlooking the Bosphorus, Yıldız was the last Ottoman palace and was constructed in the late nineteenth and early twentieth centuries.[13] The Conrad Hilton's site was located at the edge of the palace's outer garden and its construction required the demolition of many mature trees. Designed in collaboration by Erol Aksoy, Ergin Akman, Mehmet Beset and American architect William Tabler as an S-shaped building, its curvilinear form was a vivid sign of the

larger buildings which would come to dominate the skyline of the city in the next 20 years.[14]

While new shopping centres and hotels emerged in various part of Istanbul, the upper sections of Büyükdere Street between the Fourth Levent and Ayazağa/Maslak also continued to see in the early 1990s the erection of high-rise buildings owned by giant Turkish companies, strengthening the importance of the area as a modern business district in the city. Without doubt, the Sabancı Centre was the most iconic building project of the 1990s, not only because of the size of the buildings but also due to the advanced techniques used in their construction. Strategically located on the junction of Büyükdere Street and the TEM Motorway exit, the complex was completed in 1992. It was designed collaboratively by Haluk Tümay and Ayhan Böke. The shorter tower of 34 storeys is occupied by Sabancı Holdings, named after a local tycoon and the largest conglomerate of Turkey which, with its diverse interests in industry, retail, banking, education and many other fields, had grown rapidly under the state-sponsored, protective economic policies of the 1960s and 1970s. The taller 39-storey tower is the headquarters of Akbank, one of the largest private banks in Turkey and also part of the Sabancı group. At the ground level, the two towers are linked by a large and lofty glazed central foyer and a large conference hall, together with restaurants, cafeterias and other associated services. With its towers clad with blue glass-curtain walls, and protruding service cores of grey granite, the Sabancı Centre, like many tall buildings in Istanbul, reveals Late Modernist features. Beyond their architectonic manifestation, the twin towers employed state-of-the-art technologies that grabbed the interest of many young Turkish architects and academics who were introduced to the building through site visits proudly organised by the company administration.

İşbank Towers in the Fourth Levent is the other significant development in this most sought-after business district of Istanbul. Established immediately after the proclamation of the Turkish Republic, İşbank or Türkiye İş Bankası was financed primarily through financial assistance provided by Indian Muslims during the national resistance years. Over time İşbank grew and became the largest bank of Turkey. As Istanbul regained its prominence by means of the policies conducted by various governments from the 1950s, İşbank, similar to many Turkish enterprises, relocated its headquarters from Ankara to Istanbul and commissioned this prominent building complex. İşbank Towers was a mixed-use, high-rise development incorporating three towers designated 1, 2 and 3, respectively a 52-storey office skyscraper and two identical 36-storey office blocks. All towers rise from a

The 1990s: political instability, financial crises and architecture adrift

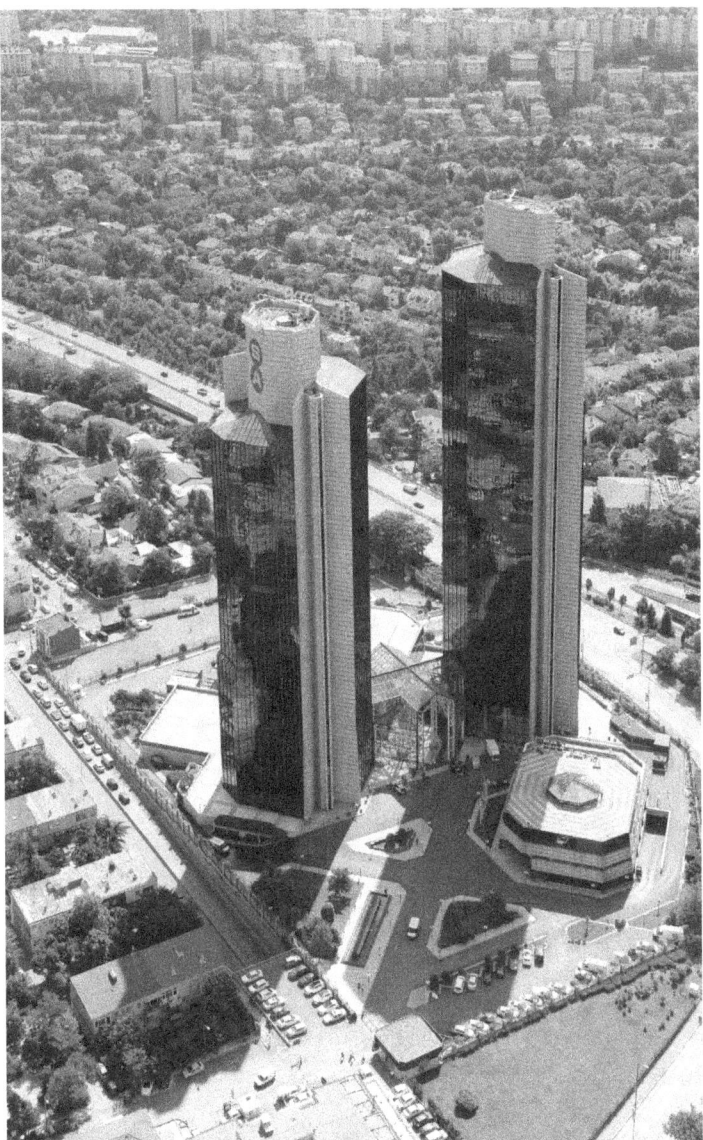

Image 73 The Sabancı Centre, Murat Gül

shared stone-clad podium which contains a medium-sized shopping arcade, a large auditorium, an exhibition gallery and a reception hall. At the time of its construction, Tower 1 at 181 metres was Istanbul's tallest building. The original design concept was developed in 1988 by a very productive and prestigious local architectural

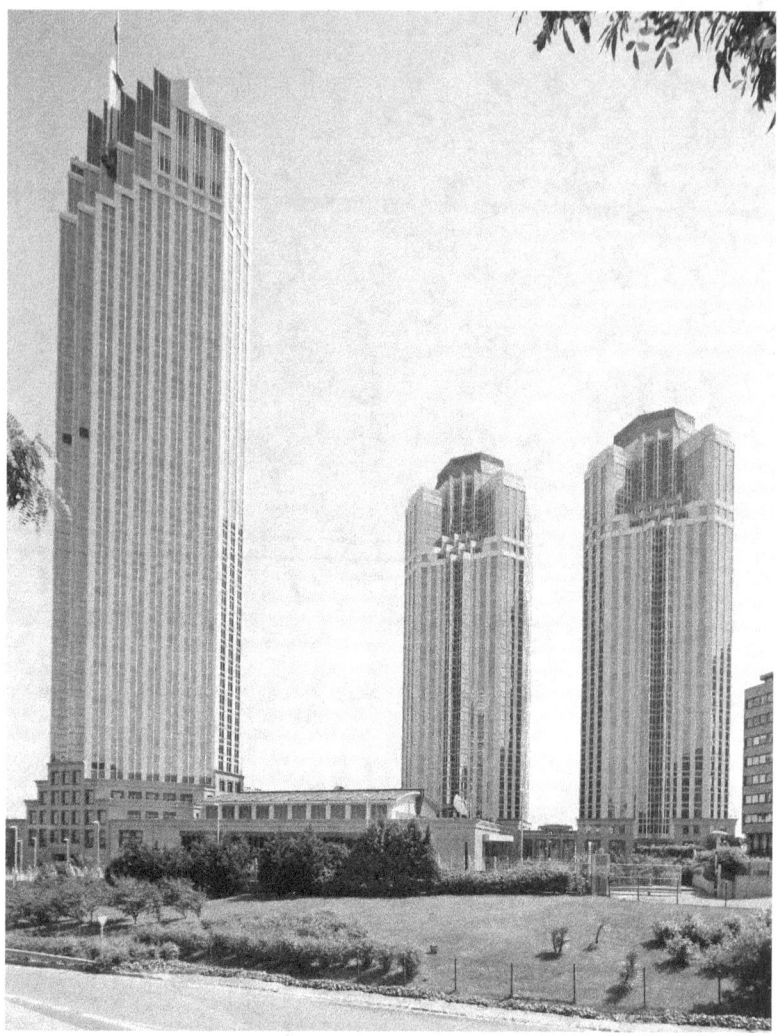

Image 74 İşbank Towers, Aras Neftçi

practice, Doğan Tekeli and Sami Sisa. The final design of the three skyscrapers, however, bears the signature of New York architects Swanke Hayden Connell who were strongly influenced by one of their earlier iconic works, Manhattan's Trump Tower, completed in 1983. The construction started in 1993 but was not completed until seven years later in 2000. The bold geometric articulation of the buildings, highlighted by faceted surfaces, chamfered corners and metal-clad trimmings, represents a touch of Art Deco reminiscent of the 1930s architecture of New York.

The 1990s: political instability, financial crises and architecture adrift

The end of the Sözen era

The political atmosphere of the 1990s was not very optimistic. Despite his eroding popularity, Özal was elected the second civilian president of Turkey in October 1989 by the Grand National Assembly.[15] In the following years, the governing MP gradually weakened and lost the elections in 1991 and a coalition government formed by Demirel's TPP and Erdal İnönü's SDPP took office. Anti Özal feelings ran high among the population and the populist promises announced by the new government during their election campaign brought a degree of sanguineness to the people. The honeymoon period for the government, however, was short-lived as Turkey heard the approaching footsteps of a deep economic crisis. President Özal died in 1993 and Demirel was elected as the new president by the parliament. Tansu Çiller, a professor of economics, became Turkey's first and only female prime minister. Her academic expertise evidently provided no advantage as under Çiller's coalition government, Turkey saw in 1994, one of the worst economic crises in its history. International creditors reduced Turkey's rating twice in a row, the Turkish lira crashed against the US dollar, interest rates rocketed, tens of thousands of people lost their jobs and inflation climbed to 120 per cent.[16]

In Istanbul Municipality the situation was equally dire. The population of Istanbul in 1990 had already risen to 7.3 million, and this figure was projected to reach around 8.5 million in the mid-1990s.[17] Istanbul's acute problems, such as *gecekondu*, poor infrastructure and inadequate public transport, continued unabated. Since taking office, Sözen had followed a populist path and had conducted many short-sighted practices that had appeased some groups, but he had not generated any genuine policy for the megacity. The municipality, for example, announced the distribution of free milk to babies and bread to the poor but, apart from ineffectual distributions to some areas for a very limited time, no real distribution was ever made.[18] In another case, the municipality conducted a poll about a new colour scheme for the public buses. This exercise attracted criticism from Istanbul's inhabitants who did not have any problem with the traditional 'red paint' on the buses which had been one of the symbols of the city for decades, and the alternatives offered in the poll (pale orange and dark blue) were not found attractive. For many, Sözen's initiative was merely an act to generate opportunities for business groups close to Sözen and his party. As to the *gecekondu* problem, Sözen, rather than seeking solid solutions, followed a populist path, in a similar way to his forerunners, and worked to legitimise many illegal buildings by distributing their titles to occupants, an act that often took place in front of media and large crowds.[19]

The mismanagement of municipal affairs and allegations of corruption significantly reduced the popularity of Sözen, as well as many district municipalities. A severe drought emptied Istanbul's dams and reservoirs, and the whole city faced extreme water shortages. Water could not be distributed to a large part of Istanbul for weeks and the municipality could not provide any genuine solution to this severe problem. In addition to this alarming situation, waste collection could not be undertaken for weeks due to a strike by municipal workers. Istanbul's streets turned into a huge rubbish bin. On top of these very unpleasant situations, a corruption scandal exploded at the municipality's Water and Sewage Directorate and this became the straw that broke the camel's back. The mismanagement and corruption made Sözen a very unpopular, even hated, political figure. Many people, including a great majority of those in the architectural community who had been vehement supporters of Sözen during his candidature, now experienced great disappointment. Only two years after Sözen had taken office, Doğan Hasol, the editor of the architectural magazine *Yapı*, criticised the municipality with very emotive words and stated that 'Istanbul needed a mayor not a doctor'.[20] Sözen, a professor of medicine, had used the rhetoric of *Tek çare doktor* (The only remedy is the doctor) in his election campaign against Dalan in 1989. Soon after, he became *Biçare doktor* (Nebbish doctor) for the great majority of the inhabitants of the city. As a result of these dramatic events, SDPP lost the municipal elections in 1994 and the candidate of the Islamist Refah Partisi (Welfare Party or WP), Recep Tayyip Erdoğan, became the mayor of the megacity. The harsh competition between the three major parties, the MP, SDPP and TPP, brought Erdoğan a surprising victory, although he won only 25.19 per cent of the total vote.[21]

For many Istanbulites, especially those in Kemalist and secular circles, Erdoğan's election was shocking as, in their minds, he and his party would erode the secular order of the state and eventually introduce Islamic Sharia law. Many Western-orientated Turkish citizens were genuinely fearful and demoralised by this psychological victory of political Islam in Turkey.[22] Born in 1954 in Kasımpaşa, a rough-and-tumble district of Istanbul along the shores of the Golden Horn, Erdoğan had a humble background as one of five children of a modest family. His father was a coastal captain and mother a homemaker. Following his primary education at Kasımpaşa Piyale Public School, Erdoğan went to İstanbul İmam Hatip Lisesi (Islamic Vocational High School) and completed his tertiary education at Istanbul Economy and Commerce Academy (now Marmara University) where he studied business administration. He had engaged in politics since his teenage days and became the head of the youth branch of the Milli Selamet Partisi (National

The 1990s: political instability, financial crises and architecture adrift

Salvation Party) led by Necmettin Erbakan, the pioneer of Islamic politics in Turkey. After the 1980 military coup he continued to follow Erbakan and became the head of the Istanbul branch of Erbakan's new WP.

Initially, his competitors believed Erdoğan had little chance of winning. Coming from the periphery and representing an Islamist party, he was not expected to overthrow his shining rivals in the elections. However, as he progressed his campaign Erdoğan increased his popularity by using sweeping Islamic rhetoric blended with strong leftist messages. Erdoğan, for example, offered reduced fees for municipal services for the poor and promised to challenge corruption in the municipality with determination. As the election day approached, the mainstream media took a strong anti-Erdoğan position and challenged his pledges. Erdoğan was accused of trading illegal buildings in Sultanbeyli, an emerging *gecekondu* suburb on the Asian side of Istanbul.[23] Every step or statement he made was under close scrutiny. During his visit to Paris, for example, the media reported that he refused to eat a meat dish since he was not sure whether the meal was prepared according to Islamic dietary requirements.[24] Such observances, in the eyes of extreme secular groups, were the sign of archaic customs and clear evidence of Erdoğan's religious fanaticism. In his press conferences, journalists asked him contentious questions on sensitive topics, such as how he would manage the legal sex trade in the city under his potential mayorship.[25] For the elites of the regime, the two significant canons of modern Turkey since the early Republican period were the rejection of the headscarf as part of the modern woman's outfit and the consumption of alcohol. The WP and particularly Erdoğan, who strictly followed Islamic dietary requirements and whose wife wore a headscarf, were targets of the establishment which accused Islamist politicians of destroying Atatürk's republic. In many instances such attacks were embellished with absurd claims that aimed to portray the young candidate as an uncivilised fanatic. In a newspaper interview just days before the municipal election three female activists described students wearing headscarves as 'creatures' who should banned from admittance to the universities, and alleged that Erdoğan had a hidden agenda to establish Sharia law and 'slaughter modern women'.[26]

Despite all this political clamour, Erdoğan, as soon as he took office, implemented a comprehensive rehabilitation programme in order to address acute problems such as the water shortage, waste management and transportation. During his term as mayor hundreds of kilometres of pipes were laid along the streets of Istanbul, modern recycling plants were established for waste management, air pollution was significantly reduced through the introduction of natural

gas, public transport was improved by the addition of modern buses and hundreds of thousands of trees were planted in the parks. These successful works resulted in Erdoğan being awarded the prestigious United Nations Human Settlement Program (UN-HABITAT) award in 1996.

Regardless of all the improvements made in municipal affairs, Erdoğan's relationship with the establishment, which controlled Turkey's economy and a great portion of the media and passionately followed Kemalist principles, always remained sour. Some of Erdoğan's conservative rhetoric and steps such as banning the serving of alcohol at municipal restaurants and cafes irritated the modern elites.[27] His speeches and declarations containing different shades of religious consciousness were harshly criticised in the media and caused consternation amongst the Kemalist intelligentsia. In addition to this psychological battle over cultural traits, Erdoğan's relationship with the bureaucracy in Ankara was extremely problematic. The coalition government was still running the central administration and, in many cases, Erdoğan had to overcome serious hurdles put in his way by Ankara.

The construction of a campus for Koç University, for example, led to one of the first serious confrontations between the young mayor and the government. The Koç family are powerful entrepreneurs in modern Turkey, and their interests comprise a wide range of commercial activities ranging from industry to banking, health and tourism. Initially a modest grocery shop owner in 1920s Ankara, Vehbi Koç, the founder of the Koç Group, prospered rapidly under the protective polices of successive governments and became a tremendously successful businessman. When the Koç family decided to establish a foundation university, they selected a secluded site located in Rumelifeneri in the upper Bosphorus area of European Istanbul. The university hired Mozhan Khadem from Boston Design Collaborative to prepare the campus master plan and to design their buildings. Stretching over 160 hectares on a greenfield site, Khadem's design employed a retrospective architectural language inspired by, in the architect's own words, 'Iranian/Bahai heritage' together with 'Ottoman architectural styles'.

What was more crucial than the campus's architectural expression was its location in the forest and the highly controversial approval process. The central government allocated the land within Mavramoloz forest for the use of the university for 49 years. The site, however, was marked as a natural heritage zone in the municipality's master plans and other planning control instruments. Any construction on the site was strictly forbidden. Accordingly, the municipality did not issue the approval, as the proposed campus development would have a serious environmental impact on the well-preserved, remaining green forest of Istanbul. As the municipality's

The 1990s: political instability, financial crises and architecture adrift

struggle continued, the government intervened and removed the site from the jurisdiction of the Istanbul Metropolitan Municipality and placed it within that of Bahçeköy District Municipality, which soon granted approval for the campus project. The campus, which was estimated to have caused the destruction of over ten thousand trees, was completed in 1999 and opened by President Demirel. The Istanbul Metropolitan Municipality took the project to court. However, similar to many other cases, the legal procedure took a long time to finalise and the government's allocation of the forest land to the university was outlawed after the campus was completed.[28] In this battle the Erdoğan administration was left isolated. Aside from the opposition to the project by the Chamber of Architects and the legal actions taken against the campus project, neither the mainstream media nor academic circles conducted a genuine campaign against the campus development.

Another confrontation between Erdoğan and the central government erupted over a new high-rise development. Designed by Doruk Pamir in the 1980s, the Süzer Plaza, more commonly known as Gökkafes (Sky-cage), was proposed as the tallest building of Istanbul, rising 34 storeys above the ground. Although Istanbul had seen many high-rise buildings since the 1950s, Gökkafes would be its most visually dominant project as the building was located on a site with a commanding view of the Bosphorus. The story of Gökkafes is a prime example showing how land speculators can push the limits of planning control instruments in Turkey. The site of the building was originally owned by a *waqf*, or mortmain property, established by Adülhamid II and was part of the nearby Taşkışla, an old Ottoman military barracks designed by Englishman William James Smith in 1852. An annotation in the land title strictly prohibited any kind of new development on the site as it was located in close proximity to many strategic buildings, such as military buildings, a gasometer and Dolmabahçe Palace. In 1983 the Süzer group purchased the land, applied to the court to remove the restrictions on construction on the land title and secured permission to construct a hotel on the site. The approved project was an eight-storey hotel, not exceeding the height of the neighbouring Taşkışla building. During the Dalan administration, the municipality significantly increased the building height from 24.5 metres to 153 metres and construction of this Postmodern skyscraper commenced in 1987. Sözen's municipality stopped the construction works in 1989 and took the project to court. From that time the project was subject to a lengthy and laborious legal procedure. In 1992 the Beyoğlu District Municipality reduced the permissible building height once again to 24.5 metres. When Erdoğan took office, he halted construction once more and went to court in 1997 to request the reinstatement of the annotation prohibiting

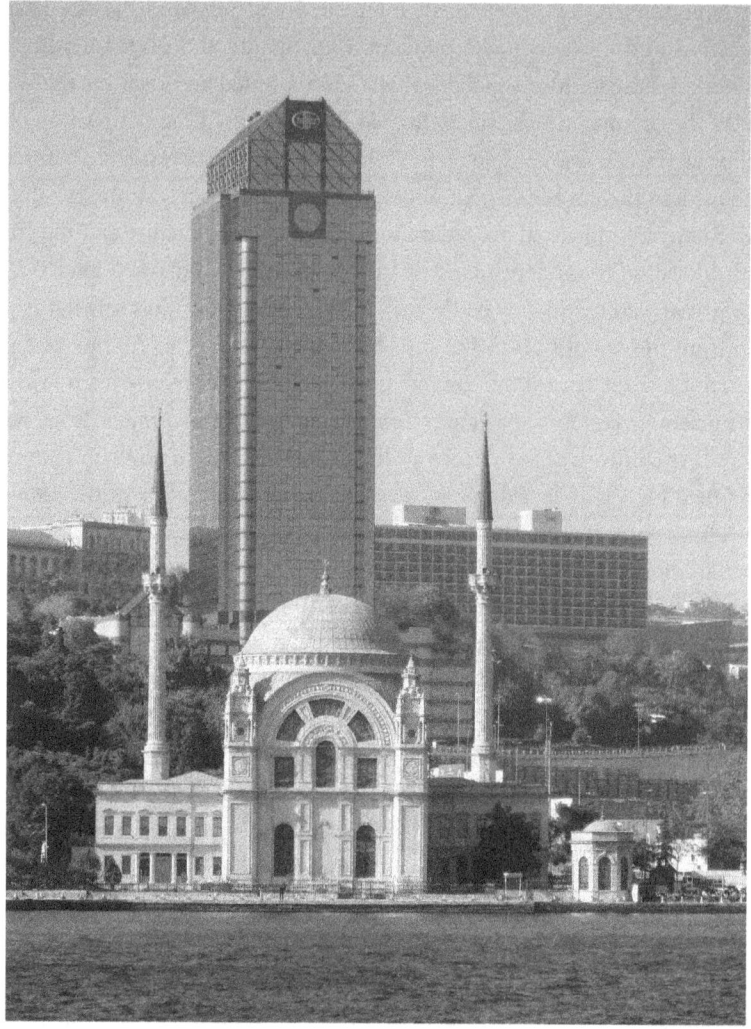

Image 75 Süzer Plaza or Gökkafes overlooking the mid-nineteenth-century Bezmi Alem Valide Sultan Mosque in Dolmabahçe, Murat Gül

any building activity on the site. This legal process came to an end when the central government stepped in and transferred the site from the borders of Beyoğlu District Municipality to Şişli District Municipality which had a mayor from the MP, the coalition partner running the country at that time. Erdoğan would never forget this sly political stratagem, and many years later when an international meeting was held in Gökkafes during his prime ministership, he refused to attend.

The 1990s: political instability, financial crises and architecture adrift

Erdoğan's third defeat at the hands of the central government was over a railway proposal on the Asian side of Istanbul. The municipality wanted to construct a light-rail line linking Harem on the Anatolian shores of the Bosphorus to Pendik, the easternmost suburb of Istanbul. The project proposed to lay an above-ground railway line on the large safety island that ran along parts of the D100 motorway in the metropolitan districts of Asian Istanbul. The project was very feasible since the dividing safety island was otiose, other than dividing the two major directions of traffic on the motorway. In addition, neither excavation nor expropriation was required to establish the rail tracks, making this proposal financially viable. However, the central government, which then held ownership of the motorway, did not allow the municipality to realise the project. In contrast, the General Directorate of Highways immediately took a decision to enlarge the motorway by removing the safety island and adding one extra traffic lane in each direction.

Erdoğan's trouble with the system was not limited to the projects above, and in the upcoming years he would confront much more serious problems. The political chaos of the 1990s brought many coalition governments to power, one after another, with life spans of no more than a couple of months each. In this political pandemonium the 1995 elections saw Erbakan's WP win first place with 21.4 per cent of the vote. The by-elections in the following year gave the party more than 30 per cent of the vote and Erbakan became the prime minister of a coalition government with Çiller as deputy prime minister. This clear victory for political Islam in Turkey led Erbakan and his high-ranking party officials to operate under a sense of false security. The political instability since the death of president Özal had placed the Turkish economy under stress. All the economic indicators – local and international capital investment, budget deficit, high inflation – were alarming and, as a result, the Turkish lira depreciated 65 per cent against the US dollar by the end of 1995. Although Erbakan and his high-ranking party officials followed moderate policies – which were at odds with their strong rhetoric against Kemalist principles and avowed disapproval of Turkey's flourishing relationship with the West – the lower-level party representatives continued to practise in accordance with their ideological mindsets. Populist and symbolic acts based upon strong Islamic rhetoric led to a deterioration in the already sour relationship between the party and the bureaucracy and, even more crucially, between the party and the military, which had a dominant role in the political affairs of Turkey.

The increasing tension between the government and the military ended with a decisive victory for the latter. The military gave the government an ultimatum at a National Security Council meeting on 28 February 1997, and dictated a series

of steps for it to take against religious-oriented and reactionary movements.[29] The following weeks were even more difficult for the government which was faced with hostile campaigns by the bureaucracy, the judiciary, mainstream media, large companies and professional organisations, all of which had been mobilised by the military against the government. Mainstream Turkish media played a vital role in this anti-Islamist campaign. In particular, the daily newspapers *Hürriyet* and *Milliyet*, owned by Aydın Doğan, and *Sabah*, owned by Dinç Bilgin, conducted very effective propaganda campaigns against Erbakan and his party. The newspapers and TV channels owned by the same groups published and screened sensational and, in some cases, fabricated news with the aim of eroding the image of the ruling WP and their coalition partner, the TRP. As a result of this campaign, Erbakan was forced to quit in an event known as a 'post-modern coup' in Turkish political history, and Turkey entered another phase of political destabilisation. In the following months the new coalition government, under the directions of the army and the Kemalist establishment, conducted a series of radical steps, which became known as the '28 February Process'.[30] Measures included the closure of the middle section of İmam Hatip schools, a strict ban on the wearing of headscarves by university students and the targeting of commercial companies owned by conservative businessmen. Many other groups and individuals were not able to escape the witch-hunt, and the list of those who lost their jobs included bureaucrats, public servants and military officers with any kind of religious association. In early 1998 the constitutional court closed the WP and banned Erbakan from politics for five years. The campaign also targeted Erdoğan, a powerful figure of the WP. He was accused of inciting religious hatred by quoting lines from a poem written 86 years ago by Ziya Gökalp, a prominent figure in the founding of modern Turkey, and he was sentenced to ten months' imprisonment.[31] This legal action meant the end of Erdoğan's mayorship and became an encumbrance for the rest of his political life.

New media architecture

The relationship between the press, politics and various power groups in Turkey had been tangled since the early years of the Republic. The neo-liberal polices of the 1980s intensified this complexity and media channels became powerful tools in the hands of large business groups that now wanted to own newspapers and TV channels in order to increase their influence over politics and propagate their interests in the public arena. The support lent by large media groups in Turkey to the military-led campaign against the Islamic government escalated the power of

The 1990s: political instability, financial crises and architecture adrift

the media owners. In return for their support, the owners of the media groups were offered very generous contracts and they became giant entrepreneurs with huge investments in banking, tourism, energy and many other businesses. Their newspapers and TV channels gradually became effective tools by which to apply political pressure on the weak coalition governments of the 1990s and early 2000s.[32] The transformation of the Turkish media was mirrored in the buildings they occupied. From the late 1980s many large media groups left their offices in Babıali at the very centre of the Historic Peninsula and moved to Güneşli and İkitelli, new business and light-industrial districts emerging on the western fringes of European Istanbul. As part of this transformation, the modest headquarters of Turkish newspapers in the old city were replaced by lavish plazas in their remote new location near Atatürk Airport and, therefore, the new era of Turkish media became known as *plaza basını* (the press of the plazas) or *İkitelli basını* (İkitelli press).

The first newspaper to construct its new headquarters in this remote part of Istanbul was *Sabah*. Designed by Mehmet Konuralp in 1988, the four-storey rectangular building vividly illustrated the new status of the Turkish media industry. Externally shallow, protruded glass bays lined the side elevations, while finely detailed exposed concrete facades and a lofty atrium faced by a large glass curtain

Image 76 Sabah Newspaper Building, courtesy of Mehmet Konuralp

wall on the front facade completed the simple but otherwise elegant design. The same architectural vocabulary continued inside the building with exposed concrete walls and coffered ceilings, semi-transparent glass blocks and controlled use of landscape features. The steel space-framed roof that covered both the atrium and the printing press also portrayed vividly the building's dual function as both an office and a printing press.[33] *Sabah* vas soon followed by other major Turkish newspapers, and *Hürriyet*'s new headquarters emerged in the same district in 1990. Designed by Aydın Boysan, the new centre comprised two office towers connected by a large corridor, with a vertical circulation shaft and printing facilities located behind them. The fully glassed side facades were balanced by narrow exposed concrete facades which faced the main road. In a similar way to *Sabah*'s new gem, this building too was equipped with modern facilities such as nicely decorated cafeterias, auditoriums and high-tech office spaces, all representing the new status of the Turkish press.[34] Designed by father and son architects Hayati and Murat Tabanlıoğlu in 1993, Milliyet Newspaper Headquarters, later called Doğan Media Centre, comprised contemporary offices, a printing press and packing and distribution facilities. The six-storey triangular office block contained a large glazed atrium which allowed for the extension of the external landscaped area into the building. The external facades, apart from the rear elevation, were completely covered by blue glass curtain walls, a striking sign of the new status of the newspaper.[35] As the media group grew, a larger complex was constructed in 1998. Called Doğan Mediatown and designed by Tabanlıoğlu Architects and Chris Owen, the complex combined an existing printing press with two four-storey rectangular office blocks. A large glazed atrium linking the office blocks provided a crystalline effect to the building, especially when illuminated at night.

Another distinguished example of late 1990s architecture was constructed by Korkmaz Yiğit, one of the key figures of the 28 February Process. Originally a businessman who made his fortune in the construction industry, Yiğit entered the financial sector and purchased the Bank Ekspres, an investment bank established in 1994. Similar to many other key players of the post-28 February military intervention, he also expanded into media and purchased a group of newspapers and TV stations. Soon after, Yiğit became embroiled in a serious corruption scandal that involved a group of politicians, bureaucrats and mafia leaders. The bank was then seized by the government and the building was never occupied by its intended users. Designed by San Francisco-based architects Sandy & Babcock and constructed in 1999, the Bank Ekspres building sat on Maslak's high-rise precinct. Stylistically, it adopted the aesthetic of Art

The 1990s: political instability, financial crises and architecture adrift

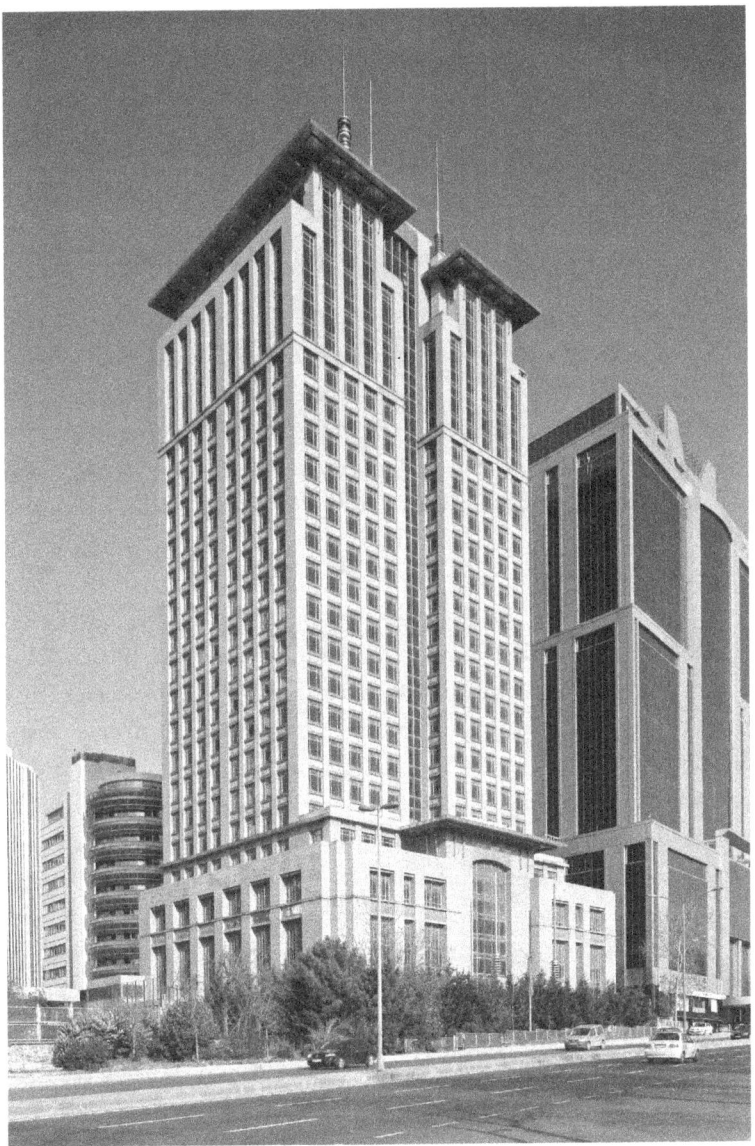

Image 77 Bank Ekspres building in Maslak, Murat Gül

Deco skyscrapers of 1930s New York, whilst echoing the form and massing of Beaux-Arts hotels and apartment buildings of the early twentieth century. Its tall base, topped by two bays with symmetrically configured facades and deep cornices that sailed over the podium, made it one of the most eye-catching

examples of Postmodernism in Istanbul, a style that has garnered wide acceptance in contemporary Turkey. Clad in light pink granite, the large podium provided a solid base for the 21-storey tower above. Also, the grey granite cladding and stainless steel metal trimming on the tower facades adorn the building in a simple yet elegant manner.[36]

The inclination to look to the past

Stylistically, many buildings constructed in the 1990s in Istanbul, and in Turkey generally, represented different shades of Postmodernism. A booming economy under the auspices of neo-liberal politics created a fertile environment for architecture. Many architects, both in the West and Turkey, had grown weary of writing and talking on the social and political aspects of architecture that had dominated architectural discourse since the early decades of the twentieth century and now embraced the chance to practise their profession with larger budgets and ample opportunities. In line with the rapidly changing society, many practitioners rediscovered the masterpieces of historic styles and distanced themselves from the unshakable pillars of Modern architecture. Rather than locking themselves within rigid 'philosophical' or 'scientific' sets of rules, architects in general felt much freer, and consequently, ambiguity became one of the fundamental themes of Postmodernism. Furthermore, utilising historical themes provided architects with opportunities to communicate with the society in a more direct way. In the end, the well-defined manifestos of Modernism could only be effective for those within a narrow architectural elite and their close circles. In contrast, postmodern historicism, in a similar way to seventeenth-century Baroque art and architecture, was propagandistic and amused a much wider stratum of society, which was happily engaged with the mesmerising impacts of neo-liberal policies. Post-1980 Turkey was not an exception and stylistic inspiration from historic periods found a wide range of acceptance, both within the architectural community and amongst the general public. Hence the Turkish architects of the 1980s and 1990s zealously employed retrospective features to beautify their buildings. The pseudo-historic facades and fabricated nostalgia blended with populist manifestos became powerful tools in the hands of Turkish architects.

In some cases the connection with the past was established delicately by the use of abstract features interpreted in a contemporary manner. Reminiscent of the design philosophy of Swiss architect Mario Botta or Austrian architect Hans Hollein, these buildings, rather than direct copying historic building elements

The 1990s: political instability, financial crises and architecture adrift

Image 78 Former Shell Headquarters in Nakkaştepe, Murat Gül

and decorative features, established a discrete link with the conventional orders of old architecture and provided a very interesting synthesis. Designed collaboratively by Nevzat Sayın and Gökhan Avcıoğlu, Shell Headquarters in Nakkaştepe on the Asian side of Istanbul is a gallant example of this approach. The precinct was formed by four rectangular prisms arranged around a partially-enclosed cruciform courtyard, with a semicircular block attached to this group on the courtyard's shorter leg, and another freestanding rectangular block located to the north. Roofed by metal-clad, shallow barrel vaults and veneered by alternating courses of yellow and terracotta-coloured stones, the buildings illustrate a simple dignity. Rectangular, square and circular window openings, stainless steel chimney pipes mounted to the facades, unadorned cylindrical columns and controlled use of dark glass on the courtyard facades all complete the overall architectural discourse.

While some Turkish architects used this interpretive approach, others opted for a shorthand method and established a more visible link between their works and selected features of past architecture in an eclectic manner. If their works included residential architecture, the source of inspiration was mainly the traditional Turkish house. Terracotta tiled pitched roofs with wide overhangs, rectangular window casements and enclosed cantilevered bays were the primary figurative

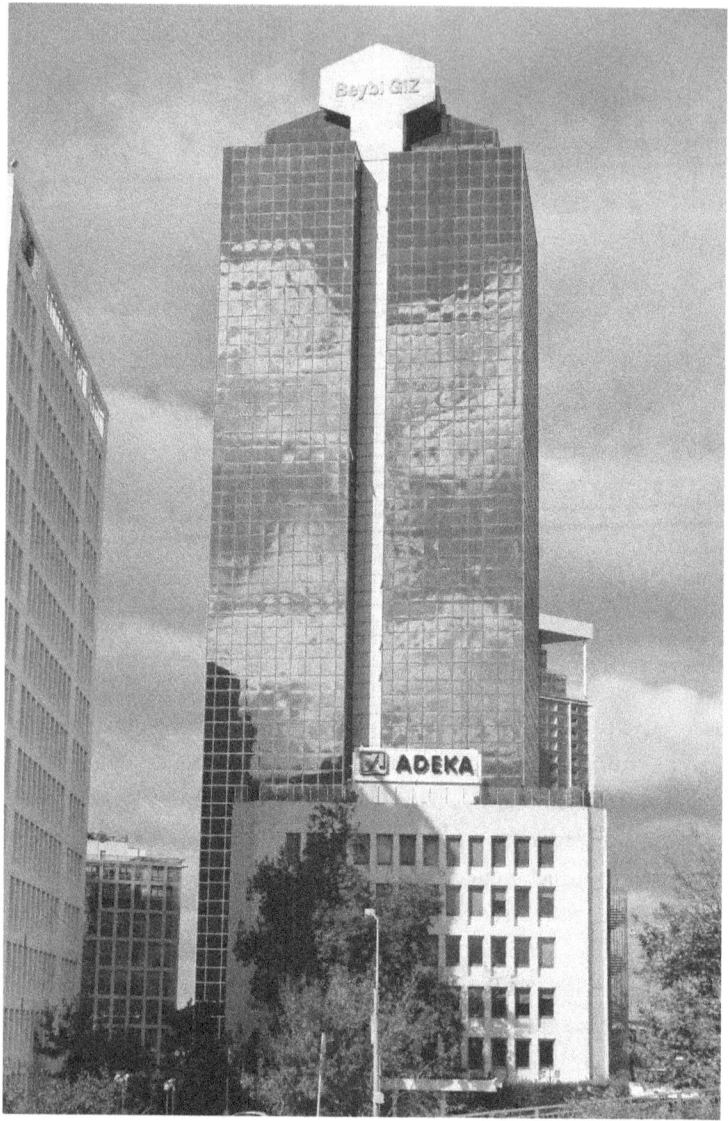

Image 79 Beybi Giz Plaza in Maslak designed by Can Elgiz, Murat Gül

features derived from vernacular timber houses and used in reinforced-concrete residential buildings. For the larger developments, such as offices, schools or other non-residential projects, stimulus came from a wide range of sources, ranging from the ancient Greek, Egyptian and Roman to classical Ottoman architecture.

The 1990s: political instability, financial crises and architecture adrift

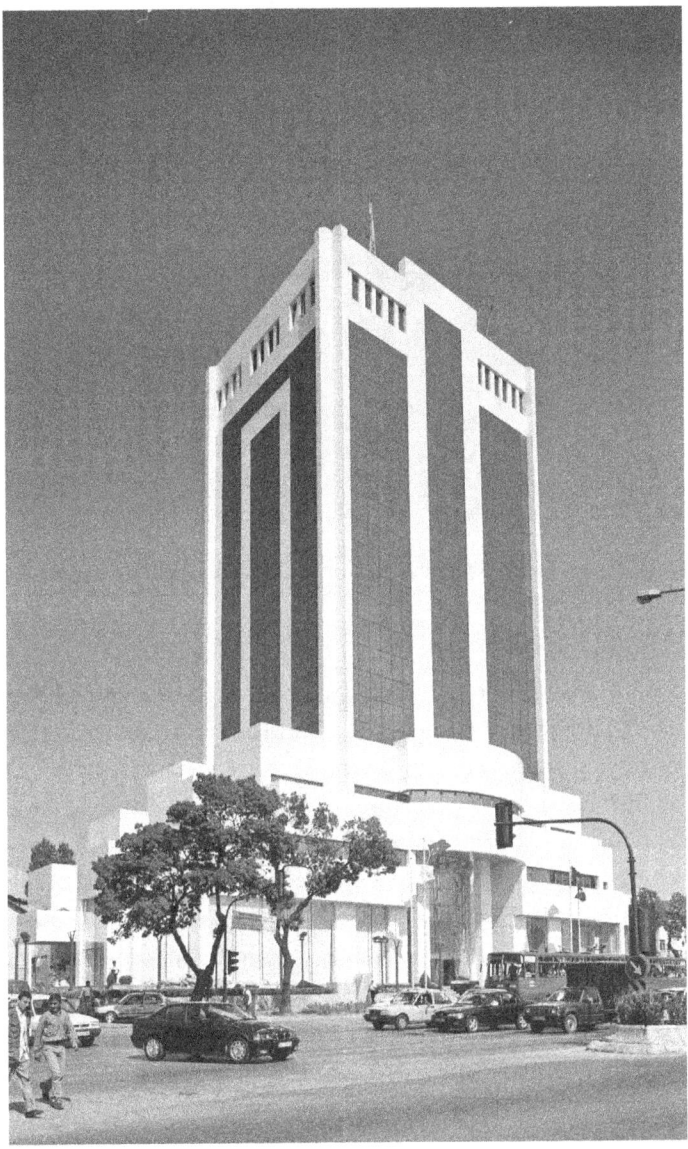

Image 80 HSBC Headquarters in Levent designed by Haluk Tümay, Aras Neftçi

Concomitant with the shrinking economy, the second half of the 1990s was quieter for building construction in Istanbul than the preceding years. The economic crises and political instability affected many large companies, with direct consequences felt in the construction industry. Thus the number of large

Architecture and the Turkish City

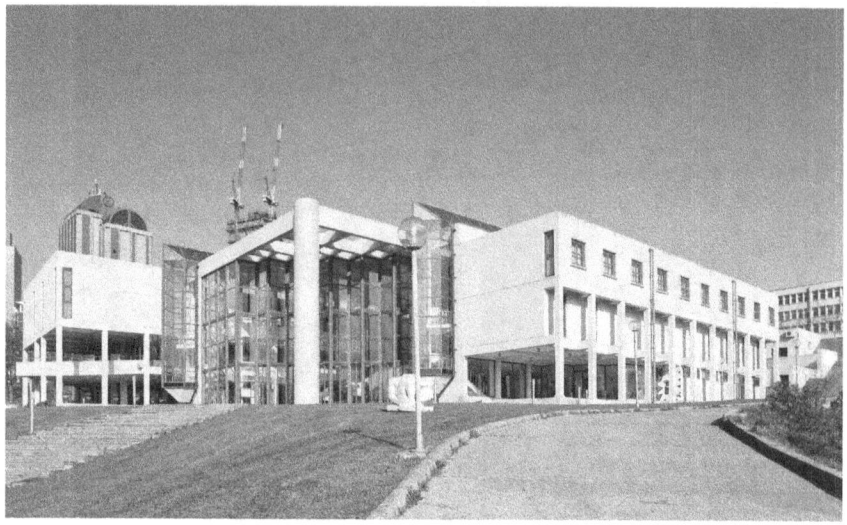

Image 81 Süleyman Demirel Cultural Centre at Istanbul Technical University's Ayazağa campus, Aras Neftçi

developments in Istanbul reduced significantly. Despite the unstable conditions, a few new buildings were erected along Zincirlikuyu-Maslak. The HSBC Bank Headquarters and Levent Plaza in Levent, Yapı Kredi Plaza in the Fourth Levent (all lining Büyükdere Street) and Nurol Plaza, Beybi Giz Plaza and Park Plaza in Maslak were the largest examples constructed in the late 1990s. However, neither their size nor design qualities could compete with their predecessors constructed in the same district in the 1980s and early 1990s. Considering the unpromising financial structure of Turkey at the time, a retrospective design approach was also a pragmatic alternative for many Turkish architects of the era. Covered by glass facades, the new buildings were mainly utilitarian office buildings, barely enlivened with features such as pediments, stylised columns or *muqarnas* details, and were evidently constructed within tight budgets. Possibly the only notable feature of the buildings was that almost all were named 'plaza', a term that became very popular for office buildings in 1990s Turkey.[37]

Offering an exciting array of architecture, a group of buildings constructed at Istanbul Technical University's (ITU) Ayazağa campus was the most prolific example of those infertile years. Originally the School of Naval Engineering in 1773, the ITU is one of the oldest higher-educational institutions in Turkey. Converted into an engineering academy in 1883, the school became a university in 1928 and took

The 1990s: political instability, financial crises and architecture adrift

its present name in 1946. As noted earlier, its new campus in Ayazağa was developed from a master plan created by a team led by Kemal Ahmet Aru in the early 1970s. Over time the University campus expanded and became the headquarters of one of the biggest universities in Turkey. The initial components were prefabricated buildings on modular systems laid out in a grid pattern. Later the campus was expanded by the addition of new buildings, many of them of no more than average design and construction quality. This early phase of the campus was enriched by the addition of a series of new buildings in the 1990s and early 2000s, making ITU one of the most significant modern architectural groupings in Istanbul. A new cultural centre was designed by Uğur Erkman and Hasan Şener and named after Süleyman Demirel, who graduated from ITU's Faculty of Civil Engineering in 1949. Other notable buildings are the dormitory blocks designed by Nurbin Paker Kahvecioğlu and Hüseyin Kahvecioğlu, the student centre by Cafer Bozkurt and Hasan Şener, the annexe to the Central Library by Hülya Yürekli and Meltem Baslo and, lastly, the Natuk Birkan Primary School by Selim Velioğlu. Many of these designers were members of ITU's Faculty of Architecture and the buildings make the campus an interesting study for students of contemporary Turkish Architecture.

The aftermath of the 1999 earthquake

Earth tremors are an inescapable reality of life in Istanbul. Its close proximity to the North Anatolian Fault has caused several seismic catastrophes over the centuries. The 1509 earthquake, known as the 'Little Doomsday', was among the most devastating to strike the city. Estimated to have measured 7.2 on the Richter scale, the earthquake resulted in the collapse of thousands of buildings, including more than a hundred mosques and other public buildings, and the loss of over 10,000 lives. The tsunami generated in its aftermath destroyed the city ramparts along the Sea of Marmara. Centuries later, in 1894, another earthquake caused further destruction, smashing thousands of buildings in and around the Historic Peninsula, ruining most of the Grand Bazaar and the nearby *hans*. Despite its long history, this inexorable threat was long forgotten by the modern inhabitants of Istanbul. Although small earthquakes had shaken the city sporadically, no major seismic activity had been recorded for a century. This quiet period, however, came to an abrupt end when a very powerful earthquake hit Istanbul in the early hours of 17 August 1999. In fact, the epicentre of the earthquake was in Gölcük, a town located 80 kilometres to the south-east of Istanbul. It measured 7.4 on the Richter scale and many cities in the eastern Marmara region were shattered during this

catastrophic event. The physical impact of the earthquake in Istanbul was relatively minor. Apart from some buildings in Avcılar, one of the westernmost suburbs of Istanbul on the shore of the Sea of Marmara, no serious damage occurred in the city. The psychological impact on the population of Istanbul, however, was great. The earthquake shook the whole city for 45 seconds in the middle of the night and caused widespread panic as millions of people poured onto the streets. The electricity supply was disrupted immediately and telephone networks could not cope with the heavy traffic, resulting in severe cuts to communications. More tragically, there was no adequate public notification by government agencies and, therefore, the general public had no access for days to reliable information about the location and real impacts of the earthquakes. The days following were also extremely disorganised. Speculative comments made by some experts on the television and official announcements by Kandilli Observatory, the earthquake research and monitoring centre of Turkey, prompted millions of people to spend days and nights in the parks or any open spaces they could find.

Although the material harm in Istanbul was limited, the earthquake affected the neighbouring regions dramatically. It is estimated that over 17,000 people died and about 50,000 were injured. Many cities in the region were severely damaged and about 110,000 housing units and business premises were completely destroyed, and another 250,000 damaged to varying degrees. Numerous schools and health facilities were severely damaged, as well as infrastructure such as roads, bridges, water pipes, power lines, phone lines and gas pipelines. More than half a million people were forced to leave their homes, thousands of the homeless lived in tents for months, and many of the survivors, especially children, were left deeply traumatised. Furthermore, the area hit by the earthquake was Turkey's industrial heartland; Istanbul and its nearby provinces account for approximately one third of Turkey's overall output. Almost three months later, on 12 November, another powerful earthquake of magnitude 7.2 on the Richter scale hit Düzce, 100 kilometres east of the epicentre of the earlier earthquake, further threatening Istanbul and the whole Eastern Marmara region.

This catastrophic tragedy revealed in the bitterest way significant shortcomings in both the state institutions and the private sector. It became obvious that neither the government nor the general public was prepared for such an enormous natural disaster. In the first 48 hours, which are the most critical in terms of limiting human casualties, the government was not able to organise any kind of basic rescue plan. The chaos lasted for days, and only piecemeal rescue efforts were performed. The earthquake also showed vividly the serious deficiencies in Turkey's building

The 1990s: political instability, financial crises and architecture adrift

industry. Firstly, it became clear that large-scale urbanisation in the affected cities, including those parts of Istanbul to suffer the most damage in the earthquake, had been permitted on liquefiable soils, without any geodesic scanning. The inadequate foundation systems of thousands of buildings caused tragic loss of life. Secondly, it became clear that many buildings were constructed immediately over, or near to, fault lines, especially in Gölcük. Poor engineering practice was the third major reason for the scale of the disaster. Weak ground-level floors, mostly used as commercial or retail spaces, with fewer retaining walls and higher ceilings, caused the collapse of ground floors in many multi-storey buildings. The usual practice in the Turkish building industry of making internal and external walls from unreinforced, hollow clay bricks also had lethal effects on the performance of reinforced concrete structural frames during the earthquake. And, lastly, the use of poor construction material was the fourth and, at the same time, the most common deficiency of the construction industry of Turkey. Even a preliminary visual inspection of the wreckage showed explicitly that the quality of the concrete used in the great majority of the buildings was unacceptably weak and poor. The use of contaminated beach sand (often containing sea shells) and reinforcing details that were smooth, as well as poorly engineered, were the most common faults observed in the great majority of the buildings that had either collapsed or been heavily damaged.[38]

Despite this dark picture, the great tremor galvanised all segments of society. The government's ineffectual management of rescue operations taught the country a lesson. Building codes that granted permits for the construction of poorly engineered structures and urban plans that ignored even the most basic principles of the seismic reality of Turkey were subjected to long debates in academic circles and the mass media. Almost every day experts, mostly university professors, were invited onto TV programmes to discuss all aspects of the earthquakes, the possibility of a reoccurrence and the steps to be taken to prevent the devastating impacts of such catastrophic natural disasters. Many of the professors, who prior to becoming 'media stars' had been unknown to the general public, now appeared on state-owned and private TV channels and gave interviews to daily newspapers. Professional organisations, such as the Chamber of Geophysical Engineers, the Chamber of Civil Engineers and the Chamber of Architects, discussed extensively the problems and shortcomings of the existing system. More importantly, ordinary citizens now became aware that the greater part of Turkey, including Istanbul and its environs, was sitting on highly active fault lines. The majority of people, traumatised by the earthquake and its devastating impact, became much more sensitive to, and conscious of, the dangers of earthquakes.

The intensive debates and endless discussions, however, could not bring about an overarching plan to canvass all aspects of the earthquake issue. According to some estimates, almost 60 per cent of the buildings in Istanbul are not adequately designed or constructed to comply with contemporary building standards. This means that a potential earthquake measuring 7.0 or higher on the Richter scale, which is expected to happen in the mid-term future, would cause human casualties and material losses in Istanbul on an unimaginable scale. Estimates for the number of buildings in Istanbul that would be demolished or heavily damaged in the event of such a natural disaster range between 30,000 and 60,000. In this scenario, 20,000 to 50,000 people could be expected to lose their lives and hundreds of thousands injured. All the figures and approximations show that a great majority of the buildings in Istanbul should be demolished and reconstructed in accordance with improved building codes and standards. The infrastructure of the city, such as bridges, viaducts, energy transmission lines and natural gas pipelines should also be checked and strengthened. Of course, dealing with these huge undertakings would be an extremely difficult task for the government and municipalities, both financially and logistically. In order to organise such a transformation, billions of dollars would be required, as well as the establishment of a very finely tuned plan to reduce the social impacts of such a major reorganisation.

Despite the difficulties of setting up an overarching master plan, Turkey still saw some noteworthy improvements in the years immediately following the 1999 earthquake, regarding both the building standards and codes and the planning instruments regulating development activities in seismically sensitive areas. Many public buildings – namely schools, hospitals, energy and telephone switches, bridges and viaducts – have been strengthened according to the improved standards. The building codes now require more precisely prepared engineering solutions and new constructions are now better scrutinised by municipal officials. Above all, the growing consciousness among the general public of the potential threat of an upcoming earth tremor means that people are now looking for better built developments, those containing not only luxurious finishing materials, such as chic tiles and expensive taps, but also sound construction systems. Consequently, building standards have improved considerably, both in Istanbul and in many other cities of Turkey. The rehabilitation of existing, non-complying building stock, however, remained almost untouched for a long period after the natural disaster, and dealing with this huge task is an enormous challenge, both for Turkish architects and engineers as well as the public authorities in charge of managing the whole process.

7

From 2000: marching towards a global city

The early years of the third millennium opened a new chapter in the history of modern Turkey. After Erbakan's removal from the government in 1997, Turkey entered another stage of political instability in which both the economy and society were very fragile. The short-lived coalition governments, which were under the strong influence of the military, the entrenched bureaucracy and media groups owned by large commercial conglomerates, became dysfunctional amidst the growing social, economic and international problems. The political disarray triggered a series of financial hardships, climaxing with a devastating economic crisis in February 2001.[1] The Istanbul Stock Exchange plunged 7 per cent in minutes, interest rates rose by up to 6,200 per cent and the Central Bank lost one fifth of its foreign reserves in days. The gross national product shrank 9.4 per cent and the Turkish lira lost 40 per cent of its value against the US dollar in ten days.[2]

The situation deteriorated even further in the following months. A savings programme was drafted by Kemal Derviş, the vice-president of the World Bank who had returned to Turkey as minister of economic affairs, and was put into action by the desperate government. The rescue plan required a series of radical and, at the same time, bitter measures such as intense privatisation of state-owned assets, including Turkish Airlines, petrol distribution chain Petrol Ofisi, oil-refining company Tüpraş, savings bank Vakıfbank, the electricity distribution system, natural gas pipelines and the alcohol and tobacco monopoly Tekel. In these drastic conditions a number of private banks collapsed, hundreds of factories closed down, many companies went bankrupt and, as a result, hundreds of thousands of blue-collar and white-collar workers lost their jobs. The devastating economic developments brought huge public unrest and Turkey saw large-scale public demonstrations against the coalition government, which was led by the ageing Bülent Ecevit who was also dealing with serious health problems.

The weak coalition government could not survive any longer and Turkey went to an early election on 3 November 2002. The economic crisis and social unrest brought a sweeping victory in the elections to the newly established Adalet ve Kalkınma Partisi (Justice and Development Party), popularly known as the AK Party.[3] With 34 per cent of the vote, the AK Party won 363 seats in the 550-seat parliament.[4] The AK Party was founded in 2001 by a group of young reformist politicians who saw Erbakan's political standing as too rigid and outdated and, therefore, broke with Erbakan to establish a new political formation. Led by Recep Tayyip Erdoğan, who was at the time still banned from all political activities due to his speech in Siirt in 1997, the new party attracted many key figures who had played important roles in Özal's MP in the 1980s and Demirel's TRP in the early 1990s. After the general elections the parliament made an amendment to the law enabling Erdoğan to enter the by-elections. He won the by-elections in March 2003 and became the official head of the AK Party and the prime minister of Turkey.

The political identity of the AK Party was an intense topic of discussion in Turkey. For the Kemalist elites and the groups under their ideological influence, including the mainstream media, a sizeable portion of academics in Turkish universities and some large business groups that had exerted weighty influence in Turkish politics in the preceding decades, the AK Party was the latest version of political Islam which had been striving to challenge Republican attainments and, in particular, posed a serious peril to the secular foundations of the state. For this reason, past statements critical of Kemalist ideology made by Erdoğan, and those of his close colleagues who were also of former Islamist parties, were frequently cited in the media and extensively debated on different platforms. Conversely, Erdoğan and his colleagues in the party repudiated such labels and described themselves as conservative democrats. In their eyes, although the founders of the AK Party had emerged from parties that passionately followed the principles of political Islam, the new party was a blank page in Turkish politics.[5] Moreover, according to senior AK Party management, the new party was similar to Christian democratic parties in Western Europe, where social conservatism was happily married with economic liberalism.[6] In Erdoğan's own words, he took off his 'National Vision [the ideology of political Islam in Turkey] shirt' and positioned himself and his party at the centre-right of the political spectrum.

The party's programme included the implantation of liberal economic, yet at the same time, socially conservative policies. In other words, unlike the previous Islamic-orientated parties, the AK Party was able to place itself between

From 2000: marching towards a global city

neo-liberal economic policies and conservative cultural ideas based on communitarianism. The party devised a Turkish version of the 'Third Way', which was a political position reconciling right-wing economic policies with left-wing social policies, not unlike the version generally adopted by social democratic parties in Europe. In this model, Islamic values could be favourably employed in privileging the neo-liberal capitalist economic order.[7] This approach worked well and enabled the AK Party to consolidate its political success in the municipal elections held in 2004, increasing its vote to 42 per cent and winning 58 out of 81 cities. In the following years the popularity of the AK Party further increased, and it took 47 per cent of the total vote in 2007. All this growing political success made the AK Party the key player in Turkish politics.

This impressive achievement, however, was not easily won. As noted above, since the early days of the party the bureaucracy, mainstream media, universities and business circles in general had harboured doubts about the 'hidden agenda' of Erdoğan and his party. After all, despite repeated declarations made by Erdoğan and his high-ranking officials about their change of policy direction towards liberalism, for the first time since the establishment of the Republic in 1923 a party arising from the roots of political Islam had secured the absolute majority in the parliament and established a powerful government. Thus every step, decision, statement or even appearance by Erdoğan was under close scrutiny in media and business circles.[8] The military, in particular, were unhappy with the results of the 2002 elections, and rumours were circulating in the background that the army would interfere at any moment if the new government crossed a line. The AK Party, therefore, tried strenuously to dispel this strong mistrust that struck at the core of its existence. Two significant tools were available to the new government to win the psychological war with the establishment: successful economic management and noticeable progress in Turkey's long-lasting journey towards membership of the European Union (EU). In both arenas the AK Party could achieve outstanding success.

In overall economic management, the AK Party governments generally followed the economic programme drafted by the IMF and Derviş after the 2001 financial crisis. The programme required strict anti-inflationary fiscal management, controlled public services, cuts in expenditure and privatisation of financially unviable state-owned enterprises. The main tool available to the government was to create a vibrant economy based primarily on large-scale infrastructure projects. The flux of international politics, particularly after the tragedy of 9/11 and Turkey's new role in the Middle East and the Balkans

also helped the government to achieve some spectacular economic success. Therefore, the AK Party embarked on major structural changes to the Turkish political system. After 11 years of rule by inefficient coalition governments, Turkey finally saw political stability, allowing the AK Party governments to make remarkable improvements in the economy, education, health, transport and many other sectors.[9]

The economic success was rivalled by that in international politics, in particular within the first six years of the AK Party government. Without doubt, a remarkable achievement in this field was the start of official negotiations with the EU.[10] Indeed, this was one of the most significant accomplishments ever made by Turkey in foreign policy, and his success increased Erdoğan's popularity and that of his party amongst liberal, intellectual and academic circles in Turkey and boosted Erdoğan's reputation in the international arena.

Perhaps, more importantly, its achievements in public administration and economic management enabled the government to consolidate its powerbase and reshape relationships between the Kemalist state apparatus and Turkish political institutions. The most vital change concerned the triumvirate relationship between the pro-Kemalist army, the secularist bureaucracy and the government, which since the mid-twentieth century had been presided over predominantly by centre-right and conservative parties. Unlike the previous military interventions in 1960, 1971, 1980 and 1997, this time the AK Party government was able to unravel various plots and stop attempts to usurp political power by the military and their supporters in the bureaucracy. In particular, the government's response to an ultimatum concerning Abdullah Gül's presidential candidature made by the Turkish Armed Forces on 27 April 2007 and published on their official website was an important milestone in Turkish politics.[11] In contrast to previous coups and attempts at intervention by the army, this time the government did not step back and instead publicly rebuffed the attack by the army in a live broadcast by a spokesperson for the government. This event and subsequent political developments in effect brought an end to the hegemony of Kemalist ideology in Turkish political affairs, representing a radical shift in power relations.[12]

Istanbul during the AK Party years

In the first decade of the new millennium, Istanbul continued to grow and the population of the city, which had topped ten million in 2000, saw a sharp increase of 30 per cent over ten years and reached over 13 million in 2010.[13] During the

From 2000: marching towards a global city

AK Party years Istanbul was in the hands of Kadir Topbaş, who was first elected as the mayor in 2004. Topbaş's background as an architectural graduate (although he never practised) and his doctorate in art history brought to him a kind of confidence and, therefore, he played a more active role in many projects, such as the rail bridge crossing of the Golden Horn as part of an underground line linking Taksim to Yenikapı. Designed by Hakan Kıran, the bridge's visual impact on the perspective of the Historic Peninsula, and in particular the Süleymaniye complex, became a hot topic, not only for the architectural groups that vehemently criticised the bridge but also with UNESCO which expressed its concerns about the impact of the project on Istanbul, a city partially listed on the World Heritage List. During Topbaş's mayorship Istanbul also hosted the 2005 International Union of Architects Congress. On many other occasions Topbaş actively participated in discussions on a range of architectural topics. Many works, however, were conducted collaboratively by the central government and the municipality, with active participation by the prime minister, Erdoğan. According to Erdoğan, the projects he had wanted to realise when he was the mayor were all sabotaged by the central

Image 82 The rail bridge spanning the Golden Horn, Aras Neftçi

government, but now the municipality and the central government were in the same hands. This offered a great opportunity to make Istanbul a global city.[14] That is why almost all projects and initiatives in Istanbul of this period were either developed, or approved and publicly promoted, by Erdoğan, making him a de facto mayor of the city.

Istanbul's transformation in accordance with neo-liberal policies gained a new momentum under the AK Party administration. From the outset, Istanbul had been the major player in the government's economic development model and, therefore, the goal was to transform Istanbul into a global city and an international financial centre. In order to facilitate this vision and formulate strategies, a new office in the municipality was set up to draft a new master plan for Istanbul. According to the concept created by this office, Istanbul would no longer be a city of manufacturing but a hub for the service industry, tourism and finance. This would require a wholesale transformation of the city and the creation of a brand new identity for Istanbul. The fundamental principles enunciated to achieve this goal included the relocation of industrial sites out of Istanbul, the redevelopment of redundant government-owned sites throughout the city by offering them to domestic and international investors, and the provision of incentives to attract international capital to the city.

An important step in this new vision was to improve the infrastructure of Istanbul and its standard of living. For this reason, the prevailing work conducted by the municipality was enhancing the transportation network. Backed by the central government, Istanbul Municipality made a series of investments in transportation. For example, the rail network, including underground lines, light-rail and trams, was extended significantly and the total length of rail track increased from 45 kilometres in 2004 to over 145 kilometres in 2015.[15] New lines were tendered and are now being constructed, and the municipality aims to have a rail network of more than 400 kilometres by 2023, the centenary of the establishment of the Turkish Republic. Five thousand new buses were added to the bus fleet and a 52-kilometre *Metrobus* line, a rapid bus system operated by large vehicles on separated lanes, has been constructed along the D100 highway.[16] The municipality established an integrated ticketing system that can be used on all public transport modes, including the privately operated buses and ferries. All the investments in public transport brought about a considerable decrease in the use of *dolmuş* (including minibuses) which fell to about 27 per cent of all public transport in 2015.[17] The investments in public transport were coupled with improvements

made in roads, including the construction of three tunnels on the European side of Istanbul which have reduced traffic congestion at various junctions in the city.

Undoubtedly, the most ambitious transportation project of the AK Party governments was the construction of a railway line linking the European and Asian shores of the city underneath the Bosphorus. Named Marmaray, a word created by the combination of the Sea of Marmara and *ray* (the Turkish word for rail), the project's foundation stone was laid in 2004. The Marmaray project proposes to turn Yenikapı into one of the world's largest inner city transportation hubs, a concept first suggested in urban design proposals made by Agache, Lambert and Prost in the 1930s. Light rail, underground lines, passenger trains and ferries will converge there. Initially, the Marmaray project was expected to be finished in five years but archaeological relics discovered in Yenikapı caused significant delays, and after a ten-year construction period the first phase of the railway was put into service on 29 October 2013.[18] While government officials, and Erdoğan himself, frequently complained about the delays caused by long-lasting archaeological excavations, the project made Yenikapı one of the most significant and largest archaeological sites in the world. The findings were incredible and proved some of the earlier assumptions held about the foundation of Istanbul, as well as altering some of the facts previously accepted unanimously by scholars. Conducted by a large team led by the Istanbul Museum of Archaeology and the Istanbul University Archaeology Department, the digs revealed solid evidence about the fourth-century Harbour of Eleutherios, such as shipwrecks and artefacts, as well as traces of the city walls constructed by Constantine the Great. More importantly, the relics uncovered by the excavations suggest that Istanbul might have been inhabited as early as 6,000 BC, extending the city's known history from 2,700 years to 8,000 years ago.

Architecturally, the works carried out in Yenikapı stimulated a very large project consisting of a transfer centre, an archaeological museum, city archives and archaeological park. In order to identify an apposite project, Istanbul Municipality in 2012 invited designs from a group of leading architectural practices, both from Turkey and around the world.[19] The limited design competition attracted more than 40 proposals and, after the selection panel had determined a short list of three contestants, the municipality awarded the tender to the internationally recognised American practice Eisenman Architects, in partnership with the Turkish firm Aytaç Architects.[20] Selection of a world-famous architect for the project was an effective answer to the criticism made of the city administration on architectural grounds. Since the mid-1990s, Istanbul has been in the hands of the same political groups, which have been led either by Erdoğan or his successors and have

shared the same political vision. Despite the many significant achievements made in transport, infrastructure and the social welfare of its inhabitants, the city has not seen any striking piece of public architecture financed by the municipality or central government. In order to promote Istanbul as a global financial hub, architecture is required as an effective tool to establish the city's new identity. Projects bearing the signatures of world-renowned architects are desperately needed to achieve this goal. From this perspective, the Eisenman-Aytaç partnership was seen by the municipality as a good opportunity to fill the gap. What the winning team offered was a rather complex scheme that responded to the need to delicately establish a hierarchy, beginning on an urban design scale and descending to the level of an exhibition of artefacts discovered at the excavations in the museum. The design reorganises the multifactorial structure of the site over two jointly rotated grid systems and proposes a composite building planned along an east-west axis. Fragmented facade articulations and multilayered pathways would crisscross the sizable landscaped areas and provide a dynamic architectural expression for this large development.[21]

Projects to create the image of a global city

The main motive for making Istanbul a global centre was to establish a dynamic real estate market. In order to achieve this goal, all government agencies were asked to review their portfolios to determine properties available for privatisation or long-term lease for new developments. As a result, many redundant public properties in various parts of the city have been transformed into new development sites. This policy choice also included the relocation of some public institutions from their original buildings and locations in the old city centre. As a result, the Historic Peninsula, especially its eastern part, has become a destination solely for tourists and is now visited less frequently by Istanbulites. In the meantime, amendments to both planning and privatisation legislation, as well as incentives, were brought in to encourage the private sector to take part in this urban transformation by entering the real estate business. This offer has been well accepted by many Turkish industrialists, banks and other businesses, which have eagerly entered the real estate market and made significant investments in Istanbul in the recent years.

Two of the most interesting rehabilitation initiatives came in 2007 from celebrated architects and both are vivid illustrations of this transformation. The first design bears the signature of Iraqi-born British architect Zaha Hadid, a

winner of a limited design competition. Hadid created a master plan offering a wholesale transformation of Kartal, an eastern suburb on the Asian shores of the Sea of Marmara. With the aim of transforming a former industrial site into a new suburban centre, the master plan provided for a business district, residential quarters, cultural and recreational precincts and a marina, all represented in futuristic abstract forms consistent with Hadid's design philosophy. The master plan included a group of lateral connections merging with a longitudinal main axis and offered a smooth grid pattern consisting of various building envelopes which read together to create an organic urban character. The second initiative came from prolific Malaysian architect Ken Yeang who proposed a massive regeneration of Küçükçekmece, a western suburb of Istanbul on the European shores of the Sea of Marmara. Yeang's proposal offered a pleasant urban environment based on a traffic-free ecosystem with large green areas created between the sea and a huge lake. It is interesting to note that all six competitors for the master plans were selected from outside Turkey as, according to Mayor Topbaş, there was no architect in Turkey with the capabilities to undertake such a huge task.[22] This sharp statement angered Turkish architects who since the late Ottoman period have been in competition with their foreign counterparts. In the end, the Kartal plan was taken to the court, both by the Chamber of Architects and RPP representatives in the Municipal Assembly, on public interest grounds. After vitriolic debates, the plan was substantially revised and secured the green light from Istanbul Municipality in early 2015. The revised plan, however, no longer represented the spirit and design motivations envisaged by Hadid. The Yeang proposal lay forgotten in the deep drawers of the bureaucracy and, after many years of silence, the district municipality prepared a new plan for the region. Recalling the late nineteenth-century large-scale proposals for Ottoman Istanbul, these initiatives remain on paper only, although they created both excitement and anger in Turkey's architectural community at the time.

One of the key, and at the same time more realistic, projects in the government's portfolio is creating a brand-new financial centre in Ataşehir, on the Asian side of Istanbul. In a similar way to Canary Wharf in London or La Défense in Paris, the project aims to establish a brand-new business and international finance centre to attract not only the local players of the Turkish economy but also to entice the major global financial giants to settle in Istanbul.[23] As a starting point, it is planned to relocate the headquarters of all state-owned public banks, including the Central Bank of Turkey and other financial institutions, from

Ankara to Istanbul. Like many other initiatives by the government, the intention to relocate the Central Bank to Istanbul also brought some objections from political opponents. For those in opposition circles, the relocation of the Central Bank, an important symbol of national sovereignty, would be the first step in the AK Party's hidden agenda to move the capital from Ankara to Istanbul.

While the political debates raged, a master plan for the financial centre was prepared by the US-based international architectural, engineering and planning firm HOK. The project aims to carry out improvements in infrastructure on the 700,000 square metres of state-owned land by establishing a new underground line, as well as constructing sustainable power, water, data and security systems. Once completed, the international finance centre will form a hub that covers a floor space of four million square metres of mixed use, including offices, hotels, retail and residential uses, all housed in a group of state-of-the-art, high-rise towers and other associated buildings. Each building in the centre is individually tendered but the leitmotif, according to the master plan guidelines, is to reflect stylistic inspirations drawn from the 'domestic' qualities of Istanbul. This persuasive tactic recalls Eldem's modest but, at the same time, symbolic contributions to the Istanbul Hilton Hotel in the early 1950s. This time, however, the references are more explicit and the manner of applying them more overwhelming. So far HOK has been given the task to design two towers and New York-based firm Kohn Pedersen Fox Associates (KPF) has been assigned to design the state-owned Ziraat Bank headquarters. Working in collaboration with local firm A Tasarım Architects, KPF has produced a design that includes a pair of 40 and 46-storey towers, encompassing over 400,000 square metres of office space and connected at the base by a lofty plinth. As suggested by the master plan, and reflecting the government's overall cultural policy choice, the buildings' architectural manifestation adopts themes drawing on Ottoman motifs, such as geometrical patterns and *tuğra*, the monograms used by the sultans.[24] Inspiration for the concept project prepared for Vakıfbank headquarters in Ataşehir by Tabanlıoğlu Architects arises from a similar source as the Ziraat Bank headquarters, with 'the structural formation' of this building guided by 'an Oriental vision'.[25]

Waterfront reshaped

Waterfront regeneration has been an internationally popular topic as many redundant port facilities around the world have been converted into social, cultural and mixed-use precincts during the last couple of decades. Following

this popular trend, the government has declared three significant waterfront sites located on either side of the Bosphorus and in the Golden Horn as key urban regeneration projects. The first site is Istanbul's ageing port in Salıpazarı. The government intended to rejuvenate the old port as a new tourism, cultural and entertainment destination with a brand-new cruise terminal. The first initiative came in 2005 when the government tendered the site for a 49-year lease.[26] The project, named Galataport and designed by Tabanlıoğlu Architects, included the renovation of some historic buildings, the demolition of warehouses and construction of hotels, bars, restaurants and many other recreational facilities along this one-kilometre coastal strip on the lower European side of the Bosphorus. The project drew severe objections, led by the Chamber of Architects, from various community groups and professional organisations, and it was challenged in court. In the eyes of these groups, the project would change the relationship between the city and the shoreline, causing a disconnection between the two. In addition, the utilisation of public assets for semi-private use and its associated gentrification would create social problems in the vicinity, and the new buildings would generate an adverse impact on the existing silhouette of the city as viewed from the Bosphorus.

While the objection to the allocation of public assets to private companies and the concerns over social gentrification could have been argued on theoretical grounds, the other arguments against the project were less sound. In terms of public interaction with the shoreline, the current use of the land does not allow public access to the water's edge and, in terms of visual impact, the proposed buildings did not exceed existing building heights. The court, however, declared the project unauthorised on planning grounds.[27] The government then cancelled the tender and prepared a new master plan in 2007. However, the battle between the government and the groups objecting to the project did not end there and a rancorous debate ensued over a number of years. Finally, the works began in early 2016 and the renewed project is expected to be finished within three years.[28]

The second major revitalisation project proposed by the government is on the opposite side of the Bosphorus at Haydarpaşa Railway Terminus. The construction of the high-speed train line between Istanbul and Ankara made this monumental train station obsolete as the new line did not run to the station. The government intended to convert the train station into a hotel and cultural centre, as part of a larger urban regeneration project for the adjacent port area. The initial proposal was presented in the mid-2000s when images representing

the project appeared in newspapers. Stretching over one million square metres of coastal land, the project proposed a mixed-use development, comprising a cruise-ship port, seven very tall towers serving as hotels, offices and residences and cultural centres and associated recreational areas. Similar to Galataport, this proposal instigated a battle between the government and community groups and the Chamber of Architects, and it was widely debated in academic circles. Since then many other projects for the train station have been presented sporadically in the media. A conservation project has now finally been given the green light by the state authorities. According to the latest proposal, the train station will continue to serve its original function, as some suburban and intercity trains will be diverted to the historic building.[29] However, the fate of the rest of the urban regeneration project is unknown at this stage.

And, lastly, the third large-scale waterfront regeneration project was announced by the government in 2010 for the conversion of redundant shipyards in the Golden Horn into a large marina and up-market recreational facilities. Called Haliçport, this project launched a new battle between the government and community groups and the Chamber of Architects, in a similar way to the other regeneration proposals. These groups strongly objected to the proposals on planning grounds and argued that the proposed development would have serious impacts on the historic and natural characteristics of Istanbul's very old port area. Following intense debate and various court rulings, the project was tendered in 2013 and planning instruments were put on public notification in early 2016.

While the debate on the regeneration projects continues, the municipality has conducted a group of landfill projects that have resulted in significant changes to the physical morphology of the city. The first project in Yenikapı aimed to create a gigantic square with a capacity for a million people, along with associated recreational areas. Stretching over 700,000 square metres, the construction of the Yenikapı Miting ve Gösteri Alanı (Yenikapı Meeting and Performance Area) commenced in 2013 and was completed with great swiftness in early 2014, just before the municipal elections held in March.[30] In order to create such a large area, more than 500,000 square metres of land were reclaimed from the sea and, as a result, the shape of the Historic Peninsula has been changed by the addition of this uneven, semicircular 'nose' on the shore of the Sea of Marmara. The second landfill project was realised in Maltepe, a distant suburb located on the shores of the Sea of Marmara in Asian Istanbul. The municipality here also reclaimed a large area from the sea and created another meeting plaza and large recreational space.

From 2000: marching towards a global city

The 'Crazy Projects'

The remarkable successes in economic management and the improvements in health, education and other aspects of daily life increased the popularity of the AK Party in the first eight years of its government and, in particular, that of its leader, Erdoğan. This sparkling performance brought a landslide victory to Erdoğan in the 2011 elections when the AK Party took almost 50 per cent of the vote, a result not seen in Turkish politics since 1965. This success prompted the government to propose a number of gigantic infrastructure projects that would play a vital role in Istanbul's march towards becoming a global city. Accordingly, Istanbul and its development became one of the most frequent themes in the government's agenda during the election campaign for the 2011 general elections. The so-called '*Çılgın Projeler*' or 'Crazy Projects', which were introduced by Erdoğan himself as a campaign pledge, comprised a series of major projects, including the construction of a third bridge over the Bosphorus, a new waterway named 'Canal Istanbul' which would connect the Black Sea to the Sea of Marmara, and the construction of a new airport which was promised as one of the world's biggest.

The third suspension bridge linking the two sides of the Bosphorus at its northern mouth opening to the Black Sea began construction in 2013 and was finished in August 2016. Conceived by famous French bridge designer Michel Virlogeux, who worked with the Swiss company T-Engineering, the bridge has a

Image 83 Yavuz Sultan Selim Bridge, Murat Gül

total of four traffic lanes and a rail line in each direction, all placed on a 59-metre-wide deck, which is currently the widest in the world. The bridge is a vital part of the Northern Marmara Motorway (NMM), which will provide a vehicular and rail link passing along the northern edges of Istanbul. Notwithstanding its state-of-the-art design qualities and the impressive facts mentioned above, the location of the bridge and its associated motorways has created serious concern amongst the people of Istanbul since the route passes through the vast green areas that cover the northern fringes of the city. While the bridge, its approaches and connecting motorways will have only a partial impact on the greenery, the motorway and new highways will make the region easily accessible, thus attracting developers with the result that the green areas along the routes of the new highway would be opened eventually for new developments.

Despite the government announcing repeatedly that the NMM will be a transit road used primarily by heavy vehicles carrying goods between Europe and Asia and issuing guarantees that no new developments will be permitted around the motorways, many Istanbulites still remember similar promises by the government when the Fatih Sultan Mehmet Bridge was constructed in 1988. Similarly, at the time the government claimed that the second bridge and its connecting highways would serve primarily for transit traffic. Over time this intention gradually faded away and the motorway branched into nearby areas which have been occupied both by new *gecekondus* and by luxurious, gated residential compounds and high-rise office towers. As a result, the highway on both sides of the second bridge over the Bosphorus has been turned into a busy inner city motorway.

With every single detail of the third bridge creating controversy, its name also became a matter of passionate debate. The government titled the new bridge 'Yavuz Sultan Selim', in honour of the Ottoman sultan who ruled the empire between 1512 and 1520. During his reign the Ottoman Empire conducted a victorious campaign on the eastern front, in particular against Safavid Iran and Egypt. In this struggle a large number of Alevis, who belong to a branch of Islam popular in Anatolia and linked with Shia principles, were believed to be slain as a consequence of accusations that they were establishing an alliance with Iran against the Ottomans.[31] Therefore, bestowing the name of the sultan on the new bridge dismayed many of the Alevis minority, who generally support the RPP in modern Turkey, and it was read by the opposition groups as a symbolic act disregarding minority groups in society.

The third airport, another 'Crazy Project', was proposed for the northern coastal strip on the European side of Istanbul. In line with the growing economy,

From 2000: marching towards a global city

the Turkish aviation industry had grown significantly with 27 new airports constructed since 2003, bringing the total number of airports in Turkey to 55 in 2015. In this period the total number of passengers increased sevenfold and reached 150 million, making Turkey the eleventh busiest country in the world for air travel and the fifth in Europe. At the same time, Turkish Airlines, the national flag carrier of Turkey, grew rapidly and became the biggest carrier in the world by number of destinations. The largest load in this rapid increase has been placed upon the shoulders of Istanbul, and the capacity of the two existing airports, one on European side of the city and the other on the Asian side, has become insufficient to address the increasing demand. These conditions led the government to initiate plans for the construction of a brand-new airport for Istanbul.

With six runways and the world's largest passenger terminal, the new airport is proposed to serve 150 million passengers per year and, therefore, would strengthen Istanbul's position as a major hub for air traffic, not only in Europe but also at an intercontinental level. The new airport master plan has been produced by Arup and designed conceptually by a London-based consortium consisting of Grimshaw Architects, Haptic Architects and the Norwegian Nordic Office of Architecture.[32]

A site on the Black Sea coast on the northern European side of the city has been chosen as the location for the new airport, and this decision has opened a fresh battle between the government and community groups. According to many who severely criticise the project, the government, by building a new airport, is creating a magnet for new developments and, therefore, the green areas in the vicinity of the proposed airport will be adversely affected by this decision. A community group, the Northern Forests Defence Alliance, named the project 'aerotropolis' – derived from the amalgamation of the words 'aero' and 'tropolis' – and claimed that the government's intention is not only to construct a new airport but also to create a new small city on the northern green belt of Istanbul.[33] The government rebuffed all these criticisms and claimed that the site had seen previous disturbance, having been heavily worked by coalminers in the 1970s and 1980s during, and after, the oil crisis. According to the government's plans, the new airport will also be easily accessible by the NMM and its rail link via the new suspension bridge, and it will be interconnected to the city's public transport system by a light-rail. Amidst all the public debate, the new airport was tendered in May 2013 and construction began in 2014. The first phase of the airport is expected to be completed in 2018.

Lastly, the third mega project announced was the construction of Canal Istanbul, a new watercourse connecting the Black Sea and the Sea of Marmara.

When it was proposed by the prime minister the general view was that the project was only a fantasy aimed to create public favour before the elections. A master plan unveiled in early 2015, however, has shown that the canal is seriously on the agenda of the government, despite being quietly shelved for a couple of years since it was first announced in 2011. According to the master plan, the 400-metre-wide waterway would be 43 kilometres in length with a depth of 25 metres. The major aim is to reduce maritime congestion on the Bosphorus, the world's fourth-busiest strait and, therefore, reduce the risk and dangers created by tankers carrying oil to and from Russia, Ukraine, Romania and Bulgaria. Once the project is completed, two new towns would be built on either side of the canal and would be inhabited by up to 500,000 people. More importantly, if completed, Canal Istanbul would effectively turn the European side of Istanbul into an island between the two waterways. Similar to other large-scale projects, Canal Istanbul has become a hot topic, attracting criticism from many different groups, ranging from environmentalists who are concerned for the deforestation of the green belt on the northwest of Istanbul, to marine scientists who see the project as a serious threat to the marine environment. Some also criticise the project on economic grounds and claim that, contrary to the government's expectations, the proposed ship canal would not be financially viable.

A real estate heaven

As noted in earlier chapters, construction has always been the main driver for the Turkish economy since the early decades of the Republic. Yet in the AK Party era it became a much more powerful engine to stimulate the economy. Turkish contractors and developers had already gained valued experience through the works they had tendered for in Turkey and foreign countries since the 1980s, and the construction industry was the most logical choice to revive the economy, which was struggling with the impacts of the 2001 financial crisis.[34] For this reason, the construction of 15,000 kilometres of double-carriage highways along main arteries was specifically mentioned in the election statement of 2002, and as soon as Erdoğan took office a comprehensive road-making programme was put in action.[35]

In additional to road-making, building construction boomed in Turkey in the AK Party years. The total number of construction permits for new buildings, for example, was 43,000 in 2002, and dramatically increased to 106,000 in 2007 and 138,000 in 2014. In Istanbul the figures were 5,323 in 2002, 18,086 in 2007 and 20,005 in 2014.[36] The strict economic programme reduced inflation to less

From 2000: marching towards a global city

than 10 per cent, and this allowed the introduction in 2007 of a mortgage law allowing banks to offer long-term real estate loans at affordable interest rates. The new legislation gave middle income groups in Turkey the opportunity to increase property ownership and boosted the residential development industry in Turkey, especially in Istanbul. In 2001 the total value of mortgage loans issued by the banks was only 48 million Turkish liras. This figure became 15 billion liras in 2007 and reached over 36 billion liras in 2014.[37] The total number of sales of dwellings also showed a corresponding growth. The number of dwellings sold in Turkey was just over 427,000 in 2008. This figure reached over 1.6 million in 2014. The number of mortgages raised with the banks also saw a dramatic increase from 22,000 in 2009 to 389,000 in 2014. Istanbul took the biggest slice of this booming market with 239,767 dwellings sold in the city in 2015.[38]

Without doubt, the dominant force in the construction industry for the AK Party government was the Housing Development Administration of Turkey (TOKİ). The administration was first established in 1984 under the Özal government, but it was the AK Party government which transformed TOKİ into a very powerful instrument in the Turkish building industry. In 2002 the administration took over the properties and assets of the Emlak Bank, a public bank that aimed to provide cheap credit and housing projects but which was limited by the number of projects it could undertake. In 2004 TOKİ was tied to the office of the prime minister and provided with very generous financial support from public funds that had been specifically earmarked to finance mass housing developments in Turkey. In the same year, the General Directorate of the Land Office was closed down and TOKİ assumed the control of 64.5 million square metres of public land.[39] Empowered by a group of legislative arrangements passed by the parliament, TOKİ gradually increased its privileged status and field of activity in the following years. The administration was allowed to transfer the lands to private companies via either land sales or income sharing in exchange for land. More importantly, TOKİ's activities became completely independent from the central budget by the means of a law passed by the parliament in 2005. In the following period TOKİ further increased its power and autonomy through a series of new laws allowing the administration to receive foreign credits and issue stocks and bonds independent of state guarantee and provide credit to banks participating in the housing developments.

All these extraordinary legislative arrangements made TOKİ more powerful than local governments and gave the administration the right to prepare development plans and urban regeneration projects for *gecekondu* areas, historic

229

environments and agricultural lands. The total number of units constructed from the time of the administration's establishment in 1984 until 2002 was about 43,000. The number of units constructed by TOKİ since 2002 has shown a dramatic boom and climbed to over 750,000 in 2016, making TOKİ one of the largest collective residential contractors in the world.[40] TOKİ's projects aim to provide affordable housing alternatives, primarily for low and lower middle income groups, by way of mortgage loans with long maturities and low yields to the beneficiaries to the projects.

A sizeable portion of the residential developments for low-income groups is located in smaller cities, where private contractors would not consider investment feasible. Without doubt, the construction of social housing projects for low-income groups by TOKİ is one of the most popular practices of AK Party governments and much appreciated by the overall population. TOKİ units provide appealing opportunities for those in low-income groups who otherwise would never be able to afford to purchase property. Moreover, many of the occupants living in TOKİ units have had the opportunity to encounter housing built to certain standards, such as proper sanitary facilities, modern kitchens and neatly landscaped environments within the immediate environs of their homes.

Despite all these benefits, TOKİ attracted severe criticism on environmental and aesthetic grounds, especially from architectural and academic circles. The multi-floor residential blocks constructed throughout 81 provinces of Turkey were based on similar plan layouts and the external articulation made little response to local conditions or the cultural context of their localities. The financial concerns involved in aiming for a cost-effective practice produced copybook housing projects with little aesthetic merit. In particular, the high-rise towers constructed in slum areas as replacements for shanty dwellings prompted many to say that even *gecekondu* houses with their trifling scale and small gardens would be more sympathetic than TOKİ units. While such criticisms have a great deal of validity, it should not be forgotten that a lack of environmental consciousness or a contemporary architectural aesthetic are not confined exclusively to TOKİ housing but are also absent from the great majority of housing developments constructed by private enterprise, even those projects targeting upper income groups in popular locations in big cities. Without expensive finishing materials and fittings, such as kitchen and bathroom accessories and timber parquet flooring, or fashionable facade configurations, the great majority of those luxurious private housing developments are substantially the same as, or even worse than, TOKİ housing in terms of environmental performance, energy efficiency and smart architectural solutions that comply with such standards. TOKİ's response to such criticism in

From 2000: marching towards a global city

Image 84 TOKİ mass housing in Kayaşehir in European side of Istanbul, courtesy of TOKİ

recent years has been to develop alternative designs called *yatay mimari* or horizontal architecture, reduce building heights, use local building materials and seek stylistic inspirations from vernacular architecture.[41]

In big cities, especially in Istanbul, TOKİ played a different role and constructed housing projects for high-income groups on TOKİ-owned lands, in conjunction with the private sector, with the aim of financing social housing projects for low-income groups on the periphery and in Anatolian cities. In this regard, many valuable sites in Istanbul were allocated to TOKİ in order for it to enter into joint-venture projects with large private development companies. Gayrimenkul Yatırım Ortaklıkları or the Real Estate Investment Trusts (REIT) played a vital role in this process. The REITs were first established in Turkey in 1997 as closed-end investment companies managing portfolios composed of real estate, projects based on real estate and capital market instruments based on real estate, but they became popular after 2002. The public offering of the TOKİ-owned Emlak Konut in 2010 gave a boost to similar companies, and in 2015 there was a total of 31 REITs operating in Turkey with 38 billion Turkish liras in portfolio value. The REITs are now the most significant players in the real estate market in Turkey in the form of large developments such as residential projects, shopping malls and hotels in big cities, particularly Istanbul. Küçükçekmece, Halkalı, Bakırköy, Başakşehir and

Bahçeşehir on the European side and Ümraniye, Çekmeköy, Kurtköy, Kozyatağı and Ataşehir on the Anatolian side of Istanbul were the rising stars of the revenue-shared residential projects coordinated by TOKİ for upper middle income groups.

In parallel to this intensive residential development activity, building standards in Turkey have also showed a noticeable improvement. The sharp contrast in design and technology between the first phase of the Ataşehir housing complex of the 1990s and the later development, Ataşehir West, clearly illustrates this progress in the residential construction industry in Istanbul. In contrast to the robust architectural appearance of the first phase of Ataşehir, the recently completed buildings in Ataşehir West represent better articulated outcomes in terms of design and construction materials. Given fanciful names such as 'My World', 'My Towerland' or 'Avangarden', the residential developments constructed in these areas portrayed the latest architectural fashions and employed new technologies in the construction industry, although they mostly ignored environmental compliance with contemporary standards. The escalating demand for new design options from middle income groups, which had become bored with repetitive, box-like towers, brought with it alternative design schemes by both Turkish and foreign architects. Designed by New York-based RMJM Architecture, the Varyap Meridian in Ataşehir is one of the most popular and eye-catching projects demonstrating this phenomenon. As a mixed-use development comprising 340,000 square metres, Varyap Meridian includes 1,500 residential units, a 300-room hotel, a conference facility, and commercial office space, all contained within five high-rise towers and associated buildings set within manicured landscaped areas. The overall parabolic envelope of the towers and the dynamic facade arrangements with changing colours distinguish the development from the many other gated residential compounds constructed in the Ataşehir district. The building's curvilinear envelope became a fashion and consequently similar high-rise towers have started to be erected in the same region.

The Emlak Konut, Ağaoğlu, Sinpaş and Varyap companies are amongst the biggest players in the real estate market in Istanbul. In particular, Ağaoğlu, which has constructed a large number of upscale residential developments, is the most popular representative of the real estate boom in present-day Istanbul. The company president, Ali Ağaoğlu, who calls himself the *'yaşam mimarı'* (the architect of life) and stars in TV commercials for his projects, has become a 'real estate king' or the Donald Trump of Turkey. In one of his TV commercials for a mega project called 'Maslak 1453' he rode a white horse in the woods, emulating Mehmed II's famous ride to Hagia Sophia on 30 May 1453, the day after the sultan conquered

From 2000: marching towards a global city

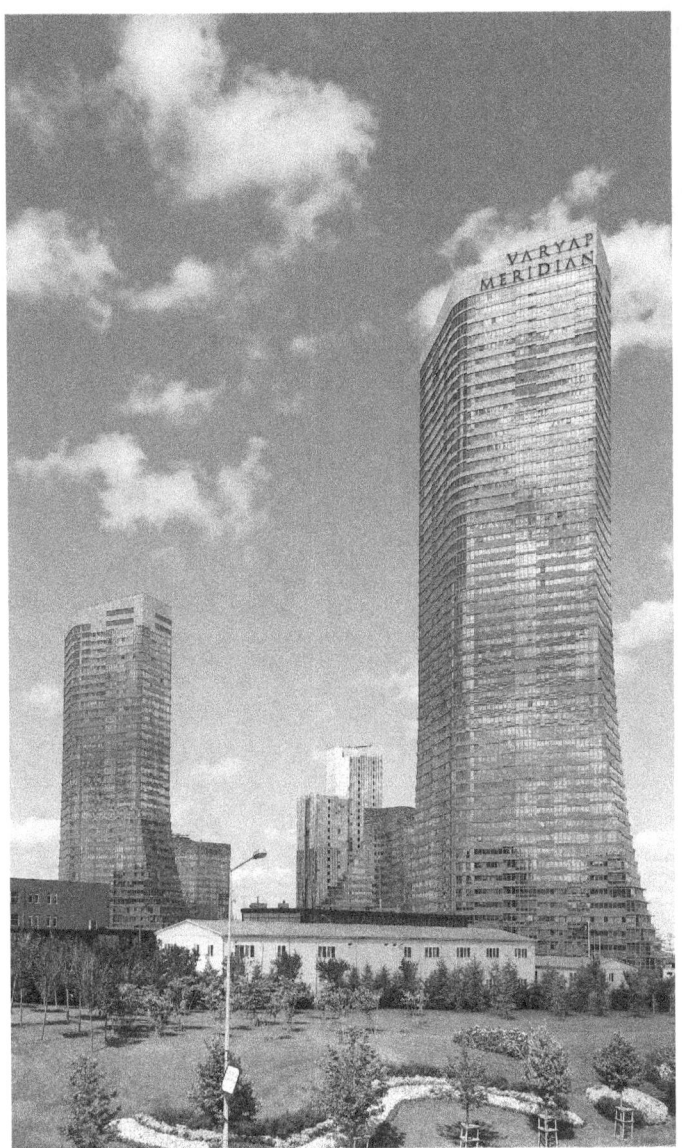

Image 85 Varyap Meridian in Ataşehir West, Murat Gül

Constantinople. In another commercial, which drew lots of criticism from architectural circles, he portrayed himself as an ambitious designer who angrily refutes many proposals offered by his design team and eventually finds the 'magical formula' for his dream project. What is hidden behind this 'show' is a very successful

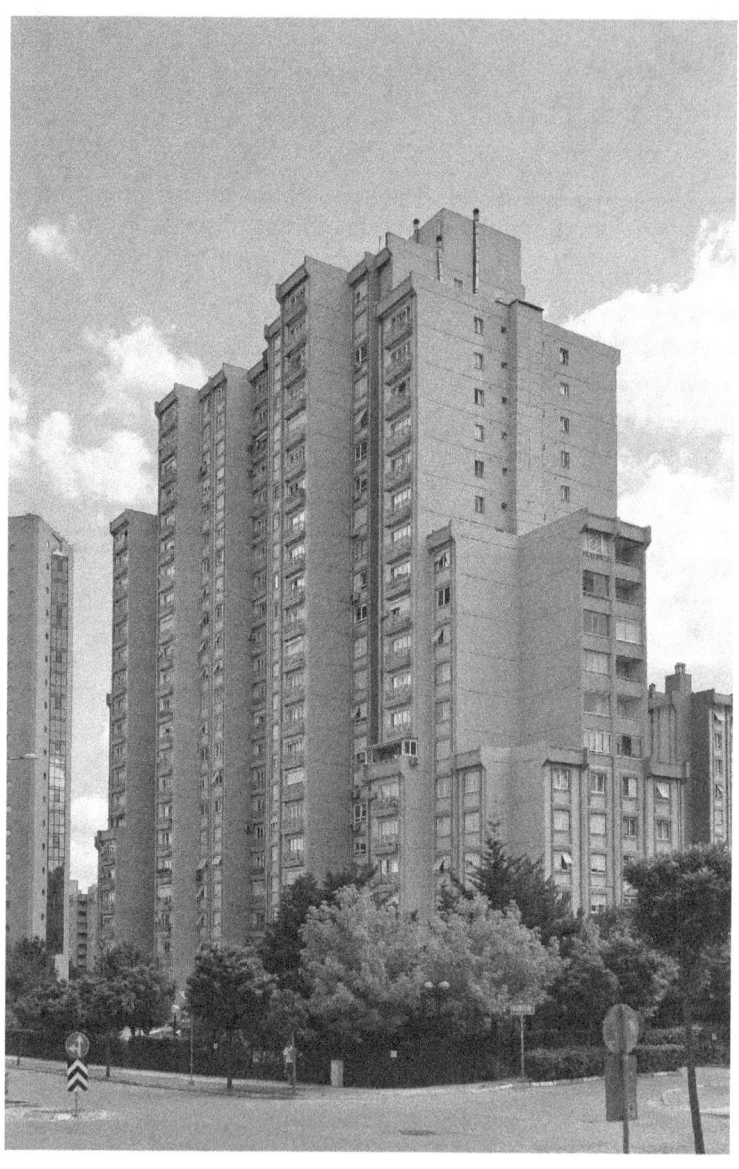

Image 86 Apartment blocks in the Ataşehir housing complex constructed in the 1990s, Murat Gül

From 2000: marching towards a global city

Image 87 Gated residential compounds in Ataşehir West, Murat Gül

strategy. The lifestyle which Ağaoğlu, and others, offer is meeting the demands of the new middle-class elite who have greatly benefitted from Turkey's economic development of the last 15 years and now want to transfer the prosperity and status they have acquired into environments specifically created for them. The gated compounds of sterile high-rise towers, set in manicured gardens and equipped with luxury shopping centres, upmarket restaurants, gyms and swimming pools, are self-contained within secured walls. Not surprisingly, in 2011 Istanbul was ranked as the most profitable city for real estate investment by international auditors and professional networking services.[42]

Urban Renewal: great hopes, unbearable hurdles

While Istanbul has been witnessing a rapid proliferation of luxurious residential compounds, the city retains much of its non-compliant building stock, and is waiting with trepidation for the great tremor which is expected to happen within the next three decades. As noted in previous chapters, while the 1999 tragedy awakened many stakeholders to the dangers of earthquakes and established widespread awareness amongst the general public about the methods needed to increase

building standards and the environmental planning tools required to comply with contemporary seismic requirements, the efforts formulated to solve the issue of existing building stock have brought only a little merit. Following a fierce debate, the *Afet Riski Altındaki Alanların Dönüştürülmesi Hakkında Kanun* (Act for the Revitalisation of the Areas under Natural Disaster Risk) was passed by parliament in 2012.[43] Commonly known as the *Kentsel Dönüşüm Kanunu* or Urban Renewal Act, the new legislation has brought some incentives such as long-term and low interest credit, waving of the levies and duties for the required permits to assist property owners and a group of measures streamlining the development approval processes.[44]

Notwithstanding all these efforts and goodwill, the renewal of the sensitive areas has been progressing slowly and the current outcome is far from that desired. The advantages brought about by the new legislation have been taken up primarily by those property owners who can already afford to renew their buildings. Suburbs occupied by upper income groups, such as the areas along, and in the proximity of, Bağdat Street on the Asian side of Istanbul, have been experiencing a construction boom. Thousands of buildings have now been demolished and are being reconstructed with additional floors as part of generous deals with developers, who offer better apartments to the existing owners at no extra cost. The new buildings will certainly provide greater safety against earthquakes, yet the increased density generated by the vertically stretched building envelopes on existing allotments will create significant adverse impacts on the relatively tranquil atmosphere of this area in Istanbul.

In other areas, such as Fikirtepe on the Asian side of Istanbul and Okmeydanı on the European side, where building stock consists primarily of either *gecekondu* or non-compliant buildings owned by low-income groups, the transformation is much more difficult. Some buildings have long been occupied by people without any official ownership. Others are jointly owned. Above all, the urban renewal is mostly seen as a land speculation opportunity by the stakeholders. The property owners or occupiers, in most cases, have unrealistic expectations when they sit down at the table with developers. Developers, on the other hand, put strong pressure on the municipalities to secure permissible floor space well above the limits. Finally, local governments often see the urban renewal as a magical formula for gentrification that will solve all physical and social problems in the areas within their jurisdiction. Under such disorder, dealing with the legal procedures requires a great passion as well as delicately tailored strategies, which neither the developers nor the legal bodies in charge of the renewal process have so far shown any evidence of.

From 2000: marching towards a global city

For these reasons, the projects in Sulukule and Tarlabaşı have created great distress and controversy amongst different segments of society. In Sulukule, an old settlement on the Historic Peninsula near the Theodosian Walls which was occupied by Romani settlers of Istanbul, the urban transformation project conducted jointly by the district and Istanbul municipalities and funded by TOKİ has concluded with the replacement of existing buildings by new residential buildings. The aim was to upgrade the undesirable environmental conditions of this old quarter and provide a better living environment for its inhabitants. The outcome, however, is highly controversial as it is claimed that many occupants have been driven out of their homes and the new physical appearance created by the 'McMansions' is totally out of context with the surrounding area. Similarly, the Tarlabaşı project is a topic of hot debate. The municipality aims to rehabilitate this area which is comprised of highly deteriorated buildings and has been settled by various disadvantaged groups for decades. A total of 269 buildings – some with varying degrees of heritage significance – is planned for wholesale reconstruction and only the facades of the heritage buildings would be retained. However, the project, called 'Tarlabaşı 360', has attracted severe criticism from the architectural community which claims that the proposal would not bring about any genuine solutions to the social and physical

Image 88 Copybook residential buildings constructed in Sulukule, Aras Neftçi

problems of the area. Instead, according to the critics, the reconstruction of historic buildings in the form of luxurious residential, commercial and other related functions will result in gentrification with no benefits to the existing users, who would be forced to leave. The developers, on the other hand, would acquire fortunes.

Shopping malls: the cathedrals of consumerism in global Istanbul

In the pre neo-liberal era the leading cities around the world were evaluated primarily by what they produced or manufactured. Eindhoven, for example, was identified as the home of the Dutch electronic giant Philips. Similarly, Detroit was the hub of the US car industry, BMW was an important part of Munich's urban identity and Fiat helped to define Turin's character. Today, however, the favourite cities of the world are primarily identified by the service sector of the white-collar middle class which has become more and more consumer dependent. This new image has shaped the morphology of cities and set the rules governing their function. As a result of this radical shift, the delicately planned, functionally zoned and controlled city of the post-World War II era has now transformed into a decentralised, split and hyperrealist milieu. Istanbul has not been an exception and, as well as large-scale residential edifices, shopping malls have become the significant marvel in Turkish architecture in the 2000s.

As noted in earlier chapters, the shopping centre is not a new phenomenon for Turkey as one of the largest and most well organised enclosed shopping hubs of the pre-modern era was the Grand Bazaar of Ottoman Istanbul. Similar to many late capitalist societies where consumerism has become the pivotal function in social life, in Istanbul shopping malls, since their first appearance in the late 1980s and 1990s, have become the most attractive places to offer not only appealing shopping alternatives but also a new lifestyle, all conducted in a privatised public space.[45] Like their counterparts in other parts of the world, the malls of today's Istanbul are spaces that do more than merely function as large shopping precincts. In addition to their primary function, the shopping centres provide a wide spectrum of activities and give these large developments a social focus for community groups from all strata of society, representing diverse social, cultural and economic backgrounds. In Turkey many shopping malls include attractive facilities, such as aquariums exhibiting exotic marine life, exhibition halls housing art works from the world's leading museums, sports facilities, ice rinks and prayer rooms, and embrace many other functions addressing a wide spectrum of the social and cultural needs of Turkish

society. Mostly constructed as part of a mixed-use development containing a mall, luxurious multi-floor residential blocks, office towers and sometimes hotels, the shopping centres offer the most promising work opportunities for Turkish architects and also for the leading international practices which focus on large commissions in countries experiencing high economic growth. With their large budgets and flexible and multifunctional programmes, shopping centres and mixed-use developments in Istanbul display the latest fashions of world architecture designed by Turkish and international architects.

The trend for shopping malls in Turkey intensified in the first years of the new millennium and a large number of new centres proliferated in the big cities, especially retail-hungry Istanbul. In the following years the shopping centre boom continued and spread to many Anatolian cities. Today, with 8.3 million square metres of floor space, Turkey is the third largest shopping centre market in Eastern and Central Europe after Russia and Poland.[46] In 2015, 93 out of 341 shopping centres in Turkey were located in Istanbul, and 22 new shopping malls are expected to enter the market in the following years. The shopping centres in Istanbul comprise 37 per cent of the total leasable floor space in Turkey.[47] There are two fundamental reasons for this incredible boom in shopping malls in Istanbul. The first impetus is the increased purchasing power of the middle and upper-income groups in Turkey, which has grown in tandem to the growing economy of the last 15 years. Parallel to this, the separation of middle income groups into residential districts has meant that as these groups become financially better off and socially more familiar with Western consumerism patterns, the traditional markets and shopping facilities lining the streets of Istanbul are no longer seen as suitable choices. Increased car ownership has also played a significant role in this massive inclination towards shopping malls, which are equipped with car parking. The second principal reason for the popularity of shopping malls is Istanbul's expansion towards the east and west, resulting in the formation of cities at the edge containing many mass-housing projects and gated-residential compounds. As noted above, the housing boom boosted by the projects initiated by TOKİ and other private companies stretched the limits of the city's expansion. The new satellite towns encircling old Istanbul brought with them mega shopping malls, with floor spaces between 40,000 to 150,000 square metres, sprawled beside highways or far-flung residential districts.

Istanbul's central districts have not been immune from this trend, and Büyükdere Street, linking Şişli-Mecidiyeköy to Fourth Levent, is the most popular axis for shopping malls and mixed-use developments. Eight large-scale shopping malls and associated towers, as well as many other tall office blocks, line up along

this five-kilometre road, giving the area a Singaporean character.[48] The Trump Towers, for example, are the first project to bear the Trump label in Europe, and are a striking example of the popular trend in Istanbul towards high-rise residential and office towers linked to large shopping malls. Designed by Istanbul-based Austrian architect Brigitte Weber and completed in 2010, the mixed-use development consists of two towers, which contain offices and luxurious apartments, rising over a large podium designed as a shopping mall. The first tower of 39 storeys faces Büyükdere Street and contains 200 luxury apartments of various sizes. Behind it, a second 37-storey tower accommodates offices. Both towers have a similar architectural semantic: a tall tower divided into two conjoined vertical blocks, enfolded around a service core. Set back at the base, the left part of the residential tower gradually flares outwards at the upper floors. The right part follows the reverse arrangement, starting as a large block at the base and gradually tapering towards the roof. The dynamic geometric form of the towers, together with the use of different colours and non-repetitive window patterns at each level, offer a vibrant building envelope.

Twelve hundred metres to the east are the Astoria Towers. The project, constructed in 2007, bears the signature of Ali Bahadır Erdin and consists of two identical 27-storey towers. With a silhouette reminiscent of the stepped pyramids of Mayan architecture, the Astoria Towers were designed to provide commercial office facilities combined with up-market, mid to short-term accommodation for visiting business people. A wide podium, containing a five-storey shopping mall with a lofty atrium, extends towards the rear of the site. The raking facades taper dramatically towards the top with plain white structural frames and tinted glazing.

The chain of shopping centres along Büyükdere Street continues with Metrocity in Levent. It is the oldest mixed-use development in this part of Istanbul and was designed by the famous Doğan Tekeli-Sami Sisa Architectural Partnership with Anthony Belluschi for the mall superstructure. Constructed between 1995 and 2003, the large development occupies an elongated site on Büyükdere Street and, in a similar way to its neighbours, follows the parcel allotments mirroring the former industrial plants that lined this large thoroughfare. A long, low podium covers the five-storey shopping mall, which contains a large atrium. The eastern end of the development facing Büyükdere Street is marked with an office tower. Two late modern residential towers of 35 storeys dominate the western end of the site and are crowned by small black-ribbed domes. A few metres away is the Özdilek Park İstanbul, the most recent shopping mall built in Levent, which was designed by Canadian B+H Architects and completed in 2014. Sitting on an

From 2000: marching towards a global city

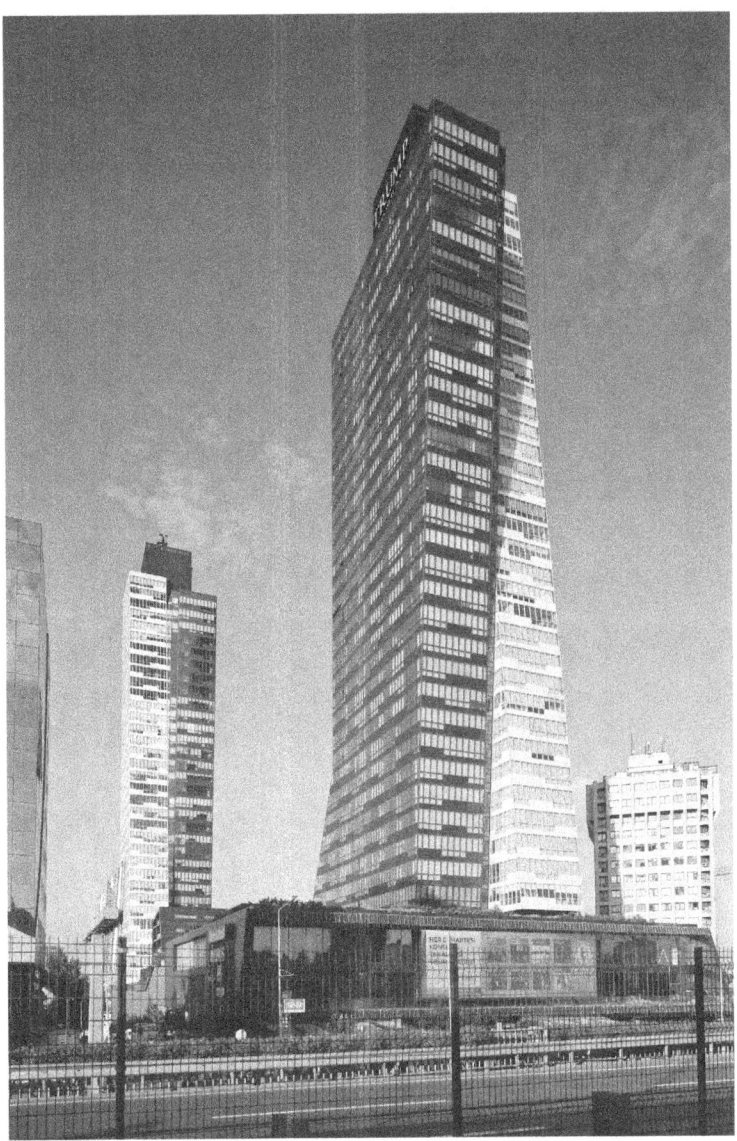

Image 89 Trump Towers in Mecidiyeköy, Aras Neftçi

elongated site, formerly occupied by a Roche pharmaceutical factory, Özdilek follows the layout of its neighbour Metrocity. A horizontal podium containing the shopping mall is anchored at opposite ends of the site by a 38-storey hotel and a 37-storey office tower.

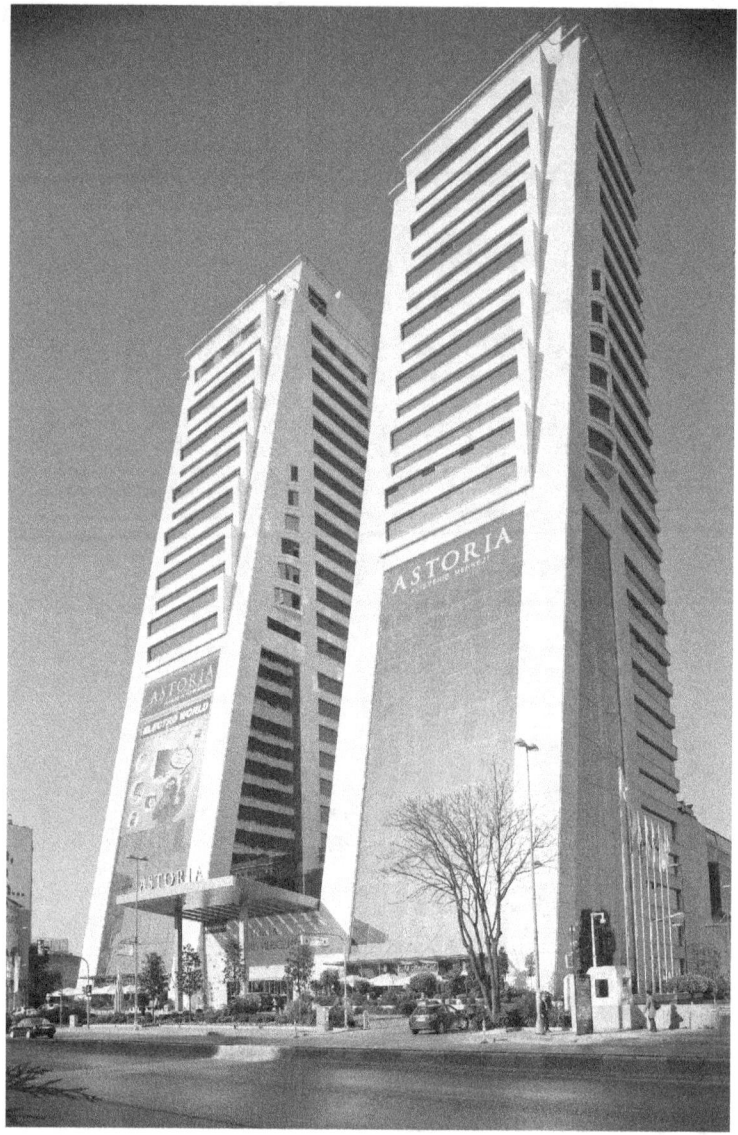

Image 90 Astoria Towers in Gayrettepe, Aras Neftçi

Located immediately to the north of Özdilek is Kanyon, the most upmarket and architecturally aspiring shopping mall of Istanbul. The development was a joint venture between İş Bank Real Estate Trust and the Eczacıbaşı Group, which is one of the leading entrepreneurial companies of Turkey and has a primary focus

From 2000: marching towards a global city

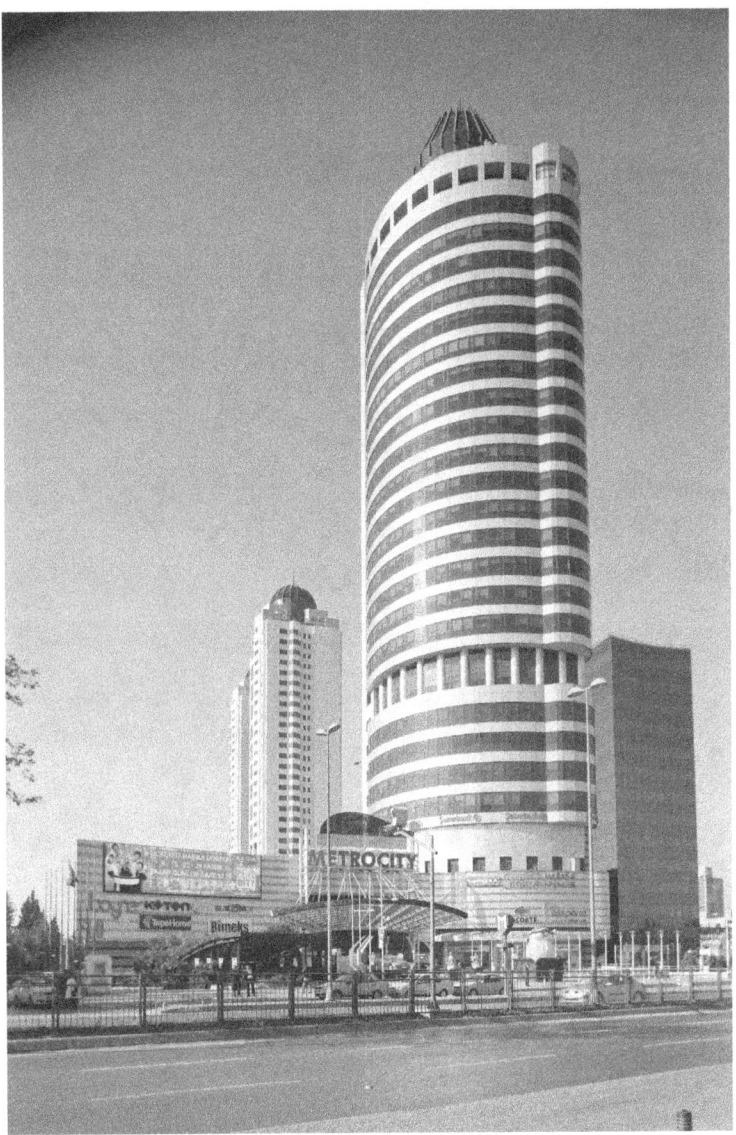

Image 91 Metrocity in Levent, Aras Neftçi

on pharmaceuticals, building products and consumer products. Designed by Tabanlıoğlu Architects, one of Turkey's foremost architectural practices, in collaboration with Jerde Partnership from Los Angeles, Kanyon is a popular high-end, mixed-use development that includes major retail, commercial and residential

Image 92 Kanyon Shopping Centre in Levent, Murat Gül

components. Its dynamic architectural form differentiates Kanyon from its immediate neighbours. A 26-storey office tower of Late Modern design and a 17-level curvilinear apartment building visually dominate the shopping core, which is positioned around the canyon-like void from which the complex derives its name.

From 2000: marching towards a global city

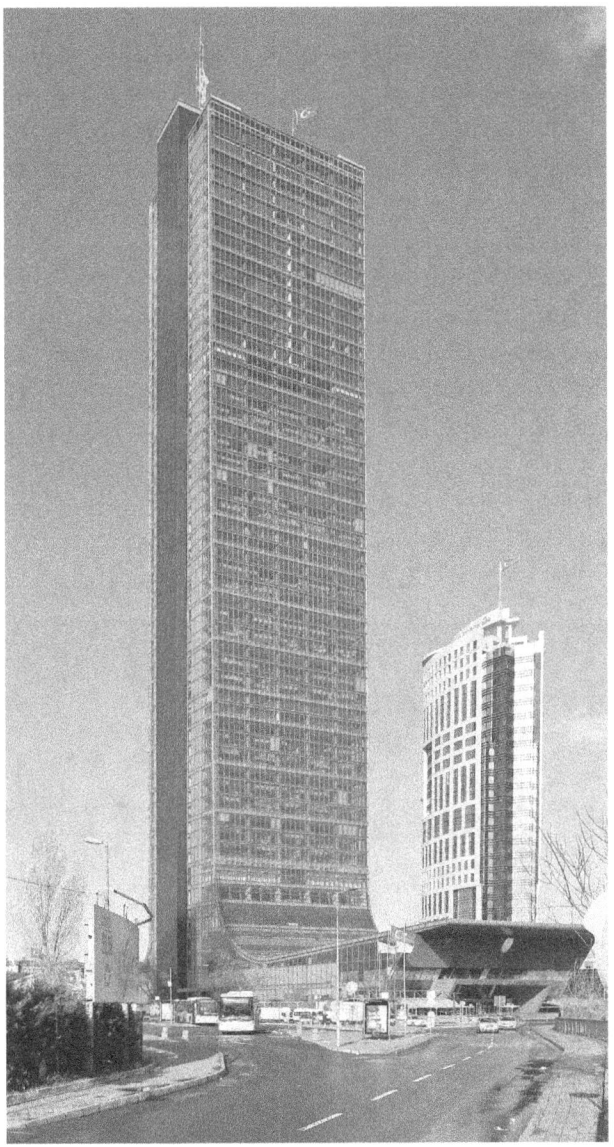

Image 93 Istanbul Sapphire in the Fourth Levent, Murat Gül

Lastly, 900 metres to the north is the Istanbul Sapphire, the final mixed-use development on the axis. Soaring 261 metres above the Fourth Levent, the 54-storey Istanbul Sapphire is currently Turkey's tallest building. Designed by Tabanlıoğlu Architects, it is the signature property of the Kiler Group, one of the

Architecture and the Turkish City

many construction-based conglomerates that achieved extraordinary success in the previous decade. The late modern building illustrates a restrained but otherwise smart architectural expression. Housing luxurious apartments, the tower tapers as it sprouts skyward, the glazed skin on its principal facade flaking away theatrically like a ski jump. The shopping mall, cinemas and restaurants are all located beneath the flared canopy.

While the shopping malls and their associated towers, together with the high-rise office blocks, that line the western side of Büyükdere Street establish a chain of delicately designed buildings, the immediate rear of these centres reveals a very different urban environment. In sharp contrast to the fancy and luxurious appearance of the shopping malls, behind them lies a jungle of densely packed tenements. In the last four decades the single-storey *gecekondu*s have been converted into multi-storey reinforced-concrete apartment buildings, many of which have been built illegally without any basic urban design guidelines. The contrast between the western side of Büyükdere Street, once occupied by a series of

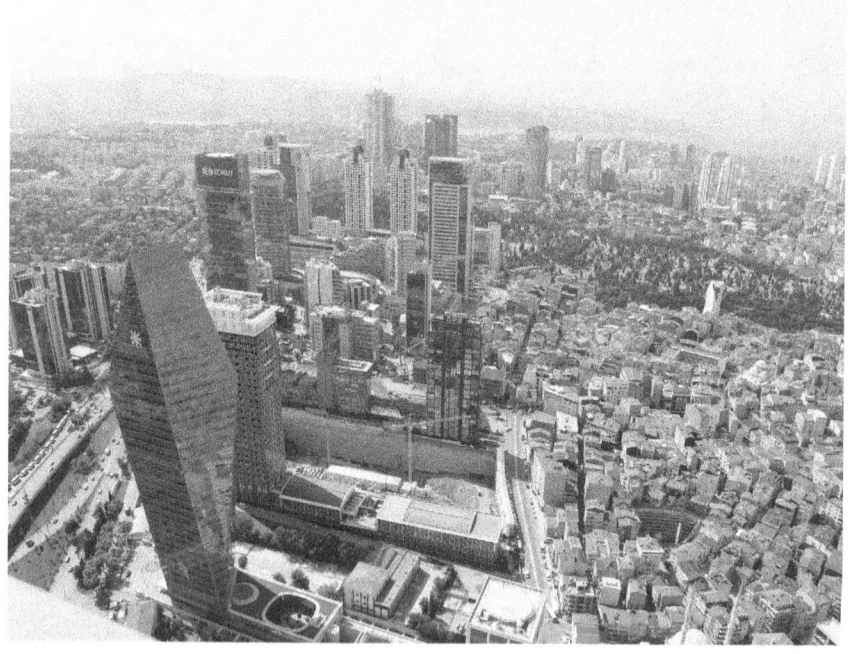

Image 94 Sharp contrast: the high-rise developments including the Crystal Tower by Pei Cobb Freed & Partners (bottom left) and the vast neighbourhood blanketed with tenements in Gültepe (right), Murat Gül

pharmaceutical and electrical factories with low-income housing behind them, and the eastern side which faces the Bosphorus was profound even before the construction of the luxurious, mixed-use developments. The recently completed buildings have deepened this contrast and created another layer to the barrier that separates these different groups of Istanbul's inhabitants. Indeed, the social make-up of the two spaces now displays an even greater and more poignant disparity. The well-to-do customers of the shopping malls, the residents of the smart apartments and the white-collar occupants of the high-tech office towers encounter the masses that live in the 'concrete heavens' only upon their arrival or exit from the secured undercover car parks which face the tenements.

A new skyline dominated by high-rise

Without a doubt, high-rise developments mushrooming at every corner of the city are the symbols of Istanbul in the early twenty-first century. While the government utilised redundant public lands for large promotional projects, private investors took advantage of the pro-development policies to construct the towers, hotels, offices and, in particular, the luxury residences that have become one of the most profitable investment options for Turkish entrepreneurs. In line with the fast-growing economy, many of these high-rise buildings were built on the back of the cheap loans that flooded Turkey, in a similar way to fast-growing markets in other countries which also saw low-cost credit as a result of record low interest rates in the US and economic stagnation in the other leading economies of the world.[49]

As a result, the large number of high-rise developments constructed in the last 15 years, particularly after 2007, has dramatically changed Istanbul's legendary skyline. Once dominated by the domes and slender minarets of the large sultanic mosques, the silhouette of Istanbul has now been conquered by the tall buildings that have burgeoned at every corner of the city. Today, with a total of 47 buildings higher than 150 metres (plus nine more currently under construction), Istanbul is ranked 23nd in the world and first in Europe in terms of building height. On the one hand, the high-rise buildings, like the fancy shopping malls, offer new opportunities for Turkish and international architects to introduce the latest architectural fashions and advanced building technologies and to make a significant contribution to the economic growth generated by construction. On the other hand, the skyscrapers bring with them serious environmental problems, both within their localities and in the city overall, and generate heavy burdens on

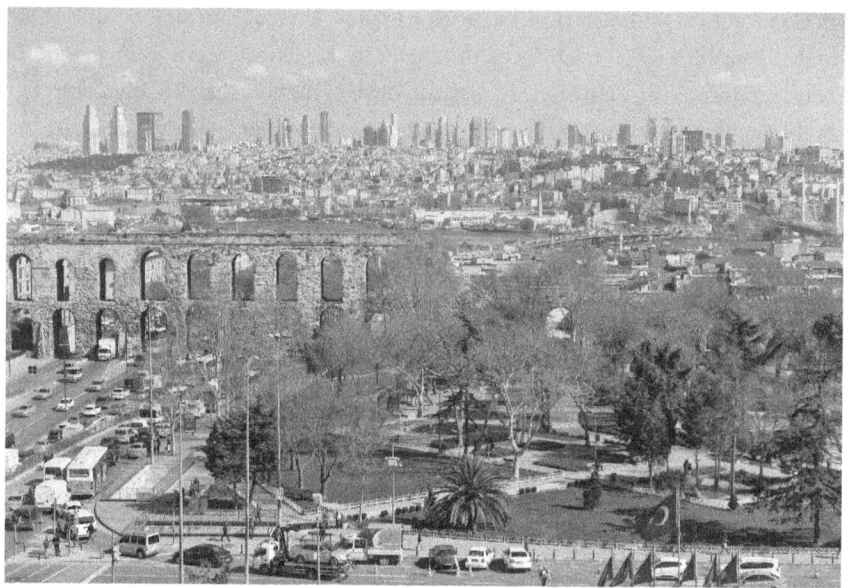

Image 95 Istanbul's new skyline as viewed from the Historic Peninsula, Murat Gül

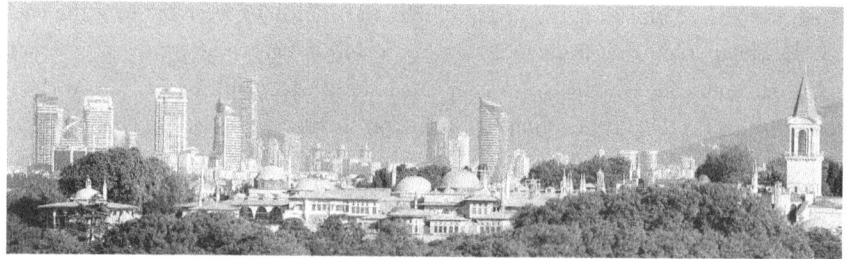

Image 96 The Topkapı Palace and high-rise buildings in Asian Istanbul, Ebru Şevkin

the already inadequate infrastructure, particular transport. And, lastly, they have had a significant visual impact on the appreciation of Istanbul's historic outlook.

From this perspective, the junction where the motorway leading to the Bosphorus Bridge meets Büyükdere Street in Zincirlikuyu is the location of one of the most recent and, at the same time, controversial developments of Istanbul. As part of the government's land disposal policies, the site previously occupied by the Directorate of Highways in Zincirlikuyu was tendered in 2007. Zorlu Group, one of the leading industrialists of Turkey specialising in electronics and

From 2000: marching towards a global city

household appliances, offered the highest bid to purchase this very valuable land with a commanding view of the Bosphorus. Subsequently, an international design competition was organised which attracted a total of 117 submissions. Thirteen projects passed the initial phase, and the competition was won by a proposal made conjointly by Tabanlıoğlu Architects and Emre Arolat Architects, the two leading architectural practices of contemporary Turkey.[50] The initial design was later detailed and applied by Emre Arolat Architects. The gigantic development houses five different functions – luxury residential dwellings, a five-star hotel, offices, a shopping mall and a performance centre. As the largest performance centre in Istanbul, Zorlu features a 2,200-seat concert hall and a 680-seat theatre. The four 100-metre towers housing residential units, offices and the hotel sit on an uneven, U-shaped podium that encircles a longitudinal public plaza. More than 200 shops, many of them high-end destination brands, are located in the shopping mall which is partially carved into the basement levels.

What lies behind this story is, however, a highly controversial planning process. The privatisation of the public land that was occupied by significant modern building groupings, including the heritage-listed tower of the Directorate of Highways, opened the debate. A second dispute then began about the size of the new development. According to many architectural critics, Zorlu Centre significantly exceeded the permissible construction rights and, therefore, the building complex was contentious on planning grounds. Indeed, the initial approval granted around 235,000 square metres of floor space for construction above the ground level. The underground levels, terraces, service areas and other ancillary spaces were not calculated as part of the permissible floor spaces according to the existing planning control instruments. Benefiting from the slope and differences in levels between the front and rear of the site, the project gained substantial basements, which contained a large portion of the shopping mall and other commercially leasable areas. The total floor space reached approximately 700,000 square metres. In other words, the project skilfully used the shortfalls in the planning control instruments to gain extensive extra floor space. This practice, however, is not limited to Zorlu Centre and almost all buildings in Turkey take advantage of either insufficient planning control instruments or poor control mechanisms, and in many cases both. The inflexible planning mechanisms, which attempt to precisely define every single detail by prescribing them in regulations and planning instruments, does not allow architects, planners and developers the room to manoeuvre and seek practical solutions to specific site conditions. Faced

with this rigid planning system, Zorlu Centre's developers took advantage of the shortcomings of the existing legislation. On top of all these planning tussles, the demolition on safety grounds of the Directorate of Highway's Istanbul headquarters crowned the controversy.

All these acerbic debates on legal and planning grounds, however, have overshadowed genuine architectural criticism of the Zorlu Centre. There is no doubt that the building has a controversial planning history and its mass generates a significant environmental and visual impact. Yet beyond those concerns, perhaps one of the critical questions that should be asked is whether the complex does good rather than harm. In other words, notwithstanding all the adverse effects, does the Zorlu Centre bring any contribution to the architectural portfolio of Istanbul? Unfortunately, the short answer to this question is 'no'. While designed by Turkey's leading architectural practices and financed by the country's technology giant, neither the building's overall design quality nor the technology used in its construction bring any significant advances to Istanbul architecture. And the overall architectural language is far from generating any excitement. A better articulated design, associated with technological advancements in the building

Image 97 Zorlu Centre in Zincirlikuyu, Aras Neftçi

From 2000: marching towards a global city

industry, could certainly have compensated to some extent for the negative aspects of the development. From this perspective, the complex can be described as a missed opportunity for one of the most financially valuable sites in the world, where an inspiring outcome could have helped to promote Istanbul's architecture in the international arena.

Another controversial development showing the inefficacies of the existing planning control regime in Istanbul is 16–9, a luxurious and high-rise residential development constructed in 2013. Located outside the ancient city ramparts, the development sits on a site in Kazlıçeşme which was formerly occupied by tanneries. Designed by Tahsin Alpar, the development consists of a total of 496 apartments located within three rectangular prisms of 27, 32 and 36 floors and 25,000 square metres of shopping and recreational areas. Like many of the other luxurious high-rise residential developments, 16–9 represents high-end building materials and manicured gardens secured by high perimeter walls. The construction began in 2010, in accordance with permits given both by the district and metropolitan municipalities. Construction progressed over the following years and in 2012, when the buildings were almost completed, their visual impact on the Historic Peninsula began to be discussed in the press, and by the architectural community and the general public. Despite all the objections, the 16–9 project continued and was occupied by its intended inhabitants in 2013. The debate on the impacts of the project, however, intensified and attracted widespread media coverage. Even the prime minister, Erdoğan, explicitly raised his concerns about the development and asked the developers to reduce the building heights by demolishing some floors on top of the three towers.[51] This request came too late, however, since by that time the buildings were fully occupied and reducing the building heights would not only be technically difficult but would also require expensive expropriations financed from public funds. In the meantime, the planning instruments that had allowed the construction of the development had been tested in the courts and declared not lawful. This malaise illustrates vividly that the existing planning regime is totally inadequate. Even very large developments next to the historic city centre are given approval in accordance with standard regulations that are applicable to every corner of the city, without taking specific site conditions into account. In the case of 16–9, a visual analysis at an earlier stage of the proposal assessing the potential impact of the proposed development on the appreciation of the historic skyline from a number of important vistas would have prevented the chaos that so badly affected all parties and created deep public discomfort.

Image 98 16–9 blocks, Sultanahmet Mosque (left) and Hagia Sophia (right) from Üsküdar, Aras Neftçi

Taksim and Gezi Park: an ideological battleground

While the debate over large-scale projects continued, the reorganisation of Taksim Square, one of the election pledges of the government in 2011, became the most controversial initiative on the public agenda. The proposal included the creation of a large pedestrianised plaza by the means of placing all roads converging on Taksim under the square and building a replica of the former Artillery Barracks, demolished in the early 1940s, to create İnönü Promenade, today known as Gezi Park. The underground road proposal was approved unanimously by the Municipal Assembly in September 2011, and subsequently given the green light in 2012 by the Council of Preservation of Cultural and Natural Heritage, subject to the cancellation of some of the proposed underground roads. As the works commenced in October of the same year, the government announced its intention to demolish the Atatürk Cultural Centre (AKM) and construct a new opera house.

Although the prevailing consensus was that the existing conditions of Taksim needed to be improved as the largest square in the city had become an ill-defined void functioning only as a bus depot, the project attracted severe criticism from architects, professional bodies and community groups. The view held in those

From 2000: marching towards a global city

Image 99 An aerial view of Taksim Square and Gezi Park in the mid-1990s, Aras Neftçi

circles was that the proposed tunnels would cause further traffic congestion while not actually improving the intended pedestrian circulation in Taksim.[52] The municipality's management of the proposed redevelopment of Taksim Square, particularly its lack of public consultation and disregard of relevant professional organisations, drew strong protests. The prime minister, who actively promoted the project, was also a target as he was accused of being caught by a 'syndrome to leave a permanent stamp on Istanbul'.[53]

The sturdiest objections, however, were directed at the proposed reconstruction of the Artillery Barracks. The reconstruction would remove the promenade and destroy many mature trees in the park, and this created deep public distress in various segments of society. Also, as claimed by heritage experts, the proposed reconstruction was highly debatable when viewed in line with the principles of modern conservation philosophy. Reconstruction of an old structure would require a very detailed study and needed to be based on sufficient archival records. And, more importantly, the reconstruction should only be carried out if the building targeted for revitalisation was of paramount significance.[54] The stories circulated in newspapers about the government's intention to use part of the barracks

as a shopping centre further fuelled objections on the grounds that a shopping centre would produce a change in the atmosphere and ambiance of the park from a public recreation area to a commercial precinct.⁵⁵

Behind these demurrals, lay an ideological battle between Kemalist circles and conservative groups. To the Kemalist elites and other secular groups, which formed a large part of academia and controlled the mainstream media, and the professional organisations that had voiced strong objections to the proposed reorganisation project. Taksim, as a purpose-built urban space, represented the spirit of the foundation of the Republic. Powerful symbolic meanings could be read in its physical manifestation that underlined the radical shift from the values associated with the 'aged' and 'corrupt' Ottoman identity to that of the new, modern and secular republic. As noted in earlier chapters, for the Republican reformers of 1930s Turkey, the narrow streets, cul-de-sacs, old timber dwellings lining crooked streets, minarets and domed silhouette of the Historic Peninsula represented the outmoded side of the Ottoman Empire. Taksim, on the other hand, with its large avenues, parks, pedestrian paths and modernist buildings, was a vivid symbol of a youthful, progressive and modern Turkish Republic. Furthermore, Taksim radiated a 'free status' where men and women could mix and participate equally in a secular atmosphere of social and recreational activities, a practice not possible in the narrow streets of old Istanbul. The socialist meaning of the square which was associated with the incidents of 1 May 1977, as mentioned in earlier chapters, also placed another layer of symbolism upon Taksim. This long and complex history and Taksim's strong association with the Republican movement in the eyes of Turkey's secular elites and leftist groups caused them to interpret the proposed pedestrianisation project as a direct attack on Republican and socialist ideological values.⁵⁶

While to the Kemalist establishment Taksim was an important bastion that represented the secular face of Istanbul, to Islamist and conservative circles this large square was a place that needed to be 'annexed' to the overall character of the historic city. In order to achieve this goal, conservative groups have worked tirelessly since the 1950s to have a mosque constructed in the square. As a strong Islamic symbol, the mosque's construction would be a stamp of Islamic identity on Taksim and provide a psychological victory for the Turkish political Islamist movement. For this reason, numerous mosque proposals have appeared in newspapers since the 1960s as pledges during almost all election campaigns, and it has been a recurring motif in the speeches of Islamist politicians when discussing Taksim.⁵⁷

From 2000: marching towards a global city

Conversely, for Republican elites a mosque proposal is a deliberate attack aiming to erode the secular character of the place. Despite the ostensible reasons claimed by those in Kemalist circles for objecting to a mosque in Taksim, such as the lack of functional necessity for a mosque in the area or its visual impact on the vicinity, the real motive behind this strong objection is anchored in a powerful ideological mindset. For many Kemalists and leftist groups, the construction of a mosque would not bring any benefit but would poison the Republican spirit of this most modernised district of Istanbul. Initiatives to construct a mosque were even described offensively as a smokescreen created by some 'uncivilised circles' to distract attention from the establishment of a large commercial space in Taksim Square.[58]

While the Taksim Square issues were being debated in academic circles and by some community groups, with the corresponding objective of establishing a public consciousness of the issue, the municipality began works to widen the pedestrian pathways along the northern boundary of Gezi Park. On 27 May 2013, the retaining wall between the park and road was demolished and in the process a number of trees were demolished. For the government it was probably a 'test drive' to gauge potential reactions to the project. This work alarmed a small group of environmental activists who stepped in front of the machines and tried to stop further tree removals. On the same day approximately 50 young people set up tents in Gezi Park for the night, and their protests became a minor news item in the press. In the early hours of the following morning municipal workers set the tents on fire and the protesters were forced to leave the park. This feckless action escalated the acts of protest to a larger scale, and attracted widespread media coverage. Thus, protests quickly spread, first in Istanbul and then to other cities across Turkey.[59]

Police responded to the protests with large amounts of tear gas and pepper spray and this intemperate reaction triggered even greater public apprehension. As in the Occupy Wall Street protests and the Arab Spring uprisings, social media was used effectively to further the cause. Protesters in Taksim and other parts of Turkey successfully employed social media and published more than two million tweets on 1 June 2013.[60] This intense digital media campaign enticed new groups, ranging from extreme leftists to Kemalists and 'anti-capitalist Islamists', as well as some violent extremist organisations, to join the protests. The demonstrations which had begun as an innocuous environmental protest then rapidly evolved into a violent uprising against government policy as different social groups used the Gezi Park protest to unleash their protests

into the general political domain. In fact, many groups and individuals who participated in the protest had no real interest in the environmental issues and merely used Gezi Park as a pretext to air their objections. During the incidents seven protesters and one police officer lost their lives, and in many cities across Turkey, banks, offices, shops, cars and public buses were looted and vandalised. Some violent groups even attempted to occupy and loot the prime minister's working office in Istanbul.

Alarmed by violent rebellions in many cities of Turkey, the government read the events as part of a larger, planned uprising against its existence by various groups that had lost their privileged status in Turkish politics. For many AK Party representatives, and the sizeable portion of the society that stood with the government, although the incidents had begun initially as an innocent protest by some environmental activists genuinely concerned about the future of the park, the control of the protests had passed rapidly to organised groups that were backed both by internal and external manipulators who were against Turkey's achievements.[61] According to the government, the events directed against Erdoğan and his party were tenaciously supported, or even organised, by Kemalist elites, some media groups and large companies that were no longer able to manipulate the social and economic life of Turkey. Koç Group, in particular, was in the firing line since the company owned the Divan Hotel at Taksim which had opened its doors to protesters who had escaped from police and the hotel management had provided them with free food and drinks.[62] Similarly, Koç University was also blamed for postponing scheduled exams to allow its students to participate in the protests.[63] Also, according to Erdoğan, an internationally backed 'interest lobby' that had tried to push the government to increase interest rates artificially for profit and to manipulate the stock market was behind the violent protests. To the AK Party, these organised tactics were deliberate attacks on the impressive achievements of the government. Indeed, just before the Gezi Park protests Turkey had paid its debt to the International Monetary Fund (IMF) and interest rates had been reduced to a record low of 4.6 per cent in May 2013. The government also saw the events as an assault on some of the mega projects intended to turn Turkey into a major hub in Europe, such as the third airport and Canal Istanbul.

The Gezi Park protests and the government's response were broadcast widely by international media, and the events created a diplomatic crisis for Turkey and its allied countries and international organisations. Numerous statements were published condemning the use of excessive police force against the protesters.[64]

From 2000: marching towards a global city

Indeed, the Gezi Park protests became a hot topic for many television stations and newspapers around the globe. In particular, the US-based television channel CNN International stationed its four correspondents in Turkey and conducted a total of nine hours live broadcast from Taksim Square and other locations in the country. Such extensive media coverage was, according to the government and the groups that supported it, clear evidence that the protests were backed by international groups. They suggested that these groups had organised the international media, which had then hired live broadcasting equipment and vehicles in advance of events, indicating prior knowledge of the uprisings.

The social unrest and political turmoil gradually calmed down following a court decision to temporarily halt the project, and the government held over its decision to reconstruct the old Artillery Barracks. The pedestrianisation project, however, was completed with the construction of the underground roads to Taksim Square from the north and south-west. In the meantime, some renovation works were undertaken in the highly damaged Gezi Park and Taksim Square, and the park was reopened for public use in August 2013. Since then, the municipality has been continuing to work unobtrusively to complete the paving, illumination and landscape features for the new Taksim Square, and the works are expected to be completed by late 2017.

Epilogue

The Gezi protests and subsequent political debates proved once again that architecture is invested with a strong symbolism that can be used as an effective tool in the hands of different social and cultural groups. The most recent and illustrative subject of this debate is a new mosque currently being constructed on the top of Çamlıca Hill on the Asian side of Istanbul. The controversial project has opened up a new battlefront between Erdoğan and his political opponents, including a sizable portion of the architectural community which sees constructing a large mosque at a topographically dominant location as an imprudent political undertaking. The architectural expression of Erdoğan's project further clinches such claims by his adversaries as, rather than a contemporary building, the design he has favoured, with its six minarets and domical superstructure, copies the large sixteenth-century mosques constructed by the Ottoman sultans to crown the prominent hills of Istanbul.

Behind this struggle over the mosque and its stylistic expression, however, is a wider political argument with international dimensions. The growing economy and the mobilisation of the peripheral stratum of society during the last 15 years has allowed Turkey to stand more confidently on its own feet. Combined with socially conservative political rhetoric, this wider financial freedom has stimulated Turkish interests in many different regions of the world, particularly lands once under Ottoman rule. Since taking office in 2002, the AK Party governments have tried continually to establish closer ties with the countries located in former Ottoman territories, including those in the Middle East, the Balkans and North Africa. Indeed, under the AK Party administration Turkey has galvanised its interests and established firm economic and cultural relationships with societies in those parts of the world which, for many decades, were

Image 100 The new mosque constructed on Çamlıca Hill, Aras Neftçi

largely forgotten by modern Turkey.[1] These developments have turned Turkey into a regional power which is now no longer merely following the path of its Western allies but is trying to establish its own political agenda in line with the country's interests.

Turkey's cultural, political and economic engagement with its former Ottoman territories has attracted some criticism and has been overstated as 'neo-Ottomanism' by both the AK Party's political opponents in Turkey and some international political analysts. From the viewpoint of these groups, Erdoğan, who had been paying increasing attention to the Middle East and the Balkans, was attempting a radical policy shift and seeking to divert Turkey's route from the West to the East. This attitude, according to these groups, is very much consistent with Erdoğan and his party's socio-cultural codes, which are strongly influenced by political Islam and the glorification of Turkey's pre-Republican past. Erdoğan's foreign policy direction is also considered an influential ingredient in his efforts to create a new kind of national identity in Turkey.[2] Some architectural groups see this as the reason behind the AK Party's advocacy of the use of Ottoman forms in architecture, especially in small-scale public buildings, such

as schools, court houses and governors' offices throughout Turkey. That is also why, according to this outlook, some early Republican buildings have been seen by AK party representatives as products that interrupt the cultural continuity of Turkish architecture.

What is often missed in this critical discourse is the observation that this predisposition to look to the past is not all-embracing. While it is true that the Ottoman masterpieces are often mentioned as sources of inspiration by government officials, some of the large-scale projects conducted by the AK Party administration have diverged radically from this approach, such as the railway bridge crossing the Golden Horn and the third bridge over the Bosphorus, both examples where such retrospective stylistic inspiration could easily have been employed but was not. In contrast, these bridges embody modern engineering designs which are confidently expressed in their overall shape and details. Furthermore, the statements made by Erdoğan or his supporters revealing their admiration for old architectural styles are not necessarily restricted to the Ottoman. The President's wish to replace the AKM with a new opera house is a suggestive example here. According to Erdoğan, the prismatic manifestation of the AKM does not suit the character of the space. However, rather than recommending a neo-Ottoman building, Erdoğan stated that the new opera house should take its inspiration from the buildings lining the adjoining Mete and İnönü streets, which represent different shades of late nineteenth and early twentieth-century architecture, including 1930s Art Deco.[3] Also, it should be taken into account that seeking stylistic inspiration from past cultures, including the Ottoman Empire, and canonising retrospective tendencies in architecture are practices not only restricted to conservative groups, but are often favoured by different segments of Turkish society.

From Gezi to the 'spirit of Yenikapı'

Since the Gezi protests, the political polarisation of Turkish society has intensified. For his supporters, who comprise about half of Turkish society, Erdoğan is a hero who has realised many reforms, abolished many taboos and taken serious steps towards the economic and social development of Turkey. The improvements in the Turkish economy, provision of better quality public health facilities, free distribution of school textbooks to all students, construction of first-class roads crisscrossing the entire country, affordable air travel and generous financial and in-kind assistance to poor families are all significant developments that have had a genuine impact on a

large portion of Turkish society. More importantly, Erdoğan has been a leader who has granted conservative people their democratic rights, such as abolishing the ban on wearing headscarves in schools and universities and removing restrictions on the participation of those groups in public affairs. Finally, he has normalised the turbulent relationship between the military and politicians in Turkey by lessening the army's role in the political system. Conversely, in the eyes of his political opponents, Erdoğan has gradually become an authoritarian leader and his active participation in almost every single decision reveals an arrogant figure. Furthermore, for Kemalist groups, the policies and practices of the AK Party governments over the last 14 years have stealthily eroded the foundations of the secular republic.

Against this background of political complexity, Istanbul has been once again the most significant propaganda tool of the four major elections held during the last two years, from 2014 to 2016. The municipal election held on 30 March 2014, in particular, was an important test for both the ruling and opposition parties. The mega infrastructure projects, such as Marmaray, the new underground lines, the third airport and the brand-new bridge over the Bosphorus, were presented as prestigious accomplishments by the AK Party administration. For Erdoğan and his party officials, Istanbul has a special meaning as it was his achievements as mayor of the city that paved the way for a very successful political career. During the election campaigns Erdoğan employed rhetoric about Istanbul intensely, and attracted the largest public gathering in the history of Turkey at that time in the newly constructed Yenikapı meeting area on 23 March where, according to some estimates, over a million people amassed. On the other hand, for the opposition, Istanbul represents a strategic tool to deliver a major blow to the AK Party's political hegemony of over a decade. Those not happy with the government's overall performance believed the 'spirit of Gezi' would deliver a serious lesson to Erdoğan and impede his gradual adoption of an authoritarian stance. For this reason, the opposition parties and groups, which had read the events of Gezi as bringing into existence a 'social awareness', supposed that the protests would precipitate a bitter loss for Erdoğan and his government. This assumption, however, proved incorrect as the AK Party, with the support of over 45 per cent of the vote, won the municipalities in the great majority of Turkish cities. In Istanbul the results marked the third consecutive victory for Kadir Topbaş, the AK Party's mayor, who attracted around 48 per cent of the vote.

The second major challenge was the presidential elections held on 10 August of the same year. Despite an alliance formed by 13 opposition parties which supported a single candidate, Erdoğan secured about 52 per cent of the vote and

Epilogue

became the first president of Turkey to be directly elected by the public.[4] Although the AK Party temporarily lost its governing position in the elections held in June 2015, the early elections of November the same year brought the party an even brighter victory.[5] The months following this landslide election victory, however, were politically intense. The brutal insurgency was revisited by terrorist groups which tried unsuccessfully to organise large-scale public uprisings in the Kurdish-dominated cities of south-east Turkey, causing human causalities and serious material damage . The Syrian civil war has also continued to generate serious difficulties for Turkey. Since the atrocity began in 2011, over three million Syrian refugees, who desperately fled from the brutal oppressions and mass killings organised by the Syrian regime and terrorist groups, have flooded into Turkey and settled both in camps and major cities, including Istanbul.

Yet the most shocking political incident in the recent history of modern Turkey came on 15 July 2016 when a faction within the Turkish Armed Forces organised a bloody coup attempt against the government.[6] Upon Erdoğan's call, hundreds of thousands of Turks flooded onto the streets and tried to stop military blockades in many Turkish cities. The army's response was unexpected and ruthless. Peaceful demonstrators were hit by mortars fired by tanks, helicopters opened machine gunfire and F16 fighter jets even dropped missiles.[7] Faced with unexpected public resistance, the coup attempt was successfully repulsed. During the rebellion, however, hundreds of people, mostly civilians, lost their lives and thousands were wounded. Protests continued in the streets of Turkish cities for over a month, capped by a colossal public gathering in Istanbul where Erdoğan, the prime minister and leaders of the opposition parties spoke to well over a million people gathered in the Yenikapı meeting area. This collaboration, a very rare concept in Turkish politics, brought about a harmony in the community that was named the 'spirit of Yenikapı'. Nevertheless, maintaining this very fragile national unification is seen as an impossibility by many observers who, with great despondency, see the political polarisation in Turkey continuing for decades.

In order to commemorate the traumatic events, the government has undertaken symbolic acts such as renaming the Bosphorus Bridge as 'The 15 July Martyrs' Bridge' and bestowing the names of people killed in the coup attempt to parks and streets in Istanbul and other parts of Turkey. Perhaps the most significant decision by the government to affect Istanbul's morphology is the relocation of military establishments out of Istanbul. As a result, a number of very large and intensely green areas within the metropolitan borders of the city have become

redundant, and provide opportunities for new functions. Many people hope the government will keep its promise and these areas will not be allocated for development, but instead used for recreational amenity, a much-needed facility in contemporary Istanbul.

Ultimately, Erdoğan once again came to grips with a serious problem and increased his popularity amongst Turkish society. The next political contest for Erdoğan is a public referendum which is scheduled for mid-April 2017 when the Turkish people will vote for a proposal to switch from a parliamentary system to a presidential system.[8] In the meantime, Taksim and Gezi Park have now re-emerged as powerful symbolic topics. Amid the many statements he made after the coup attempt, Erdoğan reiterated his previous reading on the Gezi Park protests as an internationally backed plot against Turkey's achievements. After all this political turmoil his reading on the Gezi protests has now attracted wider acceptance in the community as many believe that, although the incident may have begun as an innocent environmental protest on very sound grounds, it then turned into a violent uprising which was supported by some international groups against Turkey's march towards becoming a more independent and powerful country. Erdoğan, therefore, declared that the old Artillery Barracks would eventually be reconstructed and a new opera house would replace the obsolete AKM. The final step concerning Taksim came in January 2017 when the Heritage Council approved a proposal for a new mosque located behind the old water distribution building. As noted earlier, construction of a mosque in Taksim has been the subject of a long and vitriolic debate between different political groups in Turkey. After many decades of intense struggle, the AK Party government has finally secured the green light to construct a mosque in this most important public place of Turkey, and the foundation stone was laid with a modest ceremony on 17 February 2017. Designed collaboratively by Turkish architects Şefik Birkiye and Mehmet Dalaman, the mosque in its overall articulation represents characteristics of classical Ottoman design, with a lofty dome above a centrally located praying hall and twin minarets symmetrically positioned on the entry facade. According to its architects, the details will draw on Art Deco which is a popular style decorating many buildings around Taksim.

What is next?

As noted by the influential American writer Jane Jacobs, 'cities are an immense laboratory of trial and error, failure and success, in city building and city design'.[9]

Epilogue

The events and initiatives described in this book clearly illustrate that this is especially the case for Istanbul. The modernisation of the city during the last 150 years encompasses many attempts to reshape its physical morphology. Although many of the projects were never implemented, they show us the desire and passion of their creators and patrons, who wanted to improve the physical conditions of Istanbul. Some of the works completed were successful; others were not. The architectural styles favoured by architects over this long period were not merely fashions but rather significant gauges of the dominant political ideology shaping the country's destiny. Important figures, both politicians and architects or planners, have not only created the physical form of the city but also shaped the way Istanbul's inhabitants live and interact with each other. Construction of the General Post Office in the early years of the twentieth century, for example, brought about significant changes in the perception of public space for the dwellers of Istanbul. The lofty atrium of the post office was one of the largest enclosed spaces that an ordinary Ottoman citizen had ever entered, apart from the grounds of mosques. Almost 80 years later when Galleria, Istanbul's first shopping mall, opened its doors, no one anticipated that within two decades the city would turn into a shopping centre heaven. Extreme apartmentisation has significantly altered the lifestyle of the Turkish people. Traditional Turkish houses quickly faded from Istanbul's cultural landscape to a great extent, and today in the Turkish language 'house' means a unit in a multi-storey residential building. On a grander scale, the large boulevards constructed by Prost and Menderes dramatically changed the city's structure. Istanbul, once a city of pedestrians, gradually became a car-dependent metropolis. While they altered Istanbul's shoreline and caused the demolition of a large sum of heritage building stock, coastal roads built both by Menderes and Dalan provided Istanbulites with new opportunities to interact with the sea.

The macro form of Istanbul has also altered significantly in this process. In the late nineteenth century, Istanbul was a traditional city with its centre located in the Historic Peninsula and Galata. Today, with a population of over 14 million, Istanbul is a polycentric metropolis. Recent planning initiatives have encouraged this trend, with new spatial development axes, new underground lines and increased densities both in European and Asian Istanbul. This drift has provided Turkish architects with new opportunities but, at the same time, it has presented challenges. The money injected into large-scale developments, such as shopping malls, high-rise towers, hotels and luxury gated residential compounds, has created a very dynamic, and tempting, market for architecture. Many Turkish architects have not stood in the way and have

benefited significantly from the opportunities offered to them. Furthermore, the highly attractive real estate market in the city has whet the appetite of many international architectural practices. The economic stagnation in the West after the 2008 financial crisis led many leading architects to seek new prospects in other parts of the world. As an emerging economy, Turkey, and its leading city Istanbul, has become a centre of attention for these giant architectural practices. A sizeable portion of the large-scale buildings constructed in Istanbul in recent years bears the signatures of European or American architects, who have generally worked with a local architect. In this respect, the rivalry between Turkish and foreign architects, which has always been an intense topic of debate since the late Ottoman period, still retains its veracity.

Against a background of changing international financial conditions and recent political confusion, the Turkish economy has felt the impacts of the global financial crunch that has been affecting the world economy since 2008 and it has started to slowdown. In the light of the gloomy macroeconomic signs, many people estimate that an upcoming economic recession will soon affect the construction industry and they expect the real estate bubble to burst. However, investment in property development, especially in Istanbul, still retains its popularity. Real estate advertisements dominate the newspapers and many residential projects are presented in TV commercials. The figures illustrate a growing trend in sales and an increase in the median prices of real estate. These indicators suggest that the construction industry will probably retain its leading position in the Turkish economy for the foreseeable future. In the meantime, irrespective of political developments, the mega projects in Istanbul continue to progress. The third bridge over the Bosphorus has now been completed, gigantic machinery and lorries work feverishly to complete the new airport, and the Eurasia Tunnel beneath the Bosphorus has just been completed and now expedites vehicular transport between the two continents. Istanbul's skyline is still dominated by hundreds of cranes, a vivid illustration of feverish construction activity in the city.

The other important point that should be considered is whether this frenzied building campaign is sustainable into the future. Certainly, there will be eventually a saturation point. Yet, until that day comes, Istanbul still needs to deal with enormous challenges in order to address the inadequacies in its infrastructure. More underground lines are required to solve acute public transportation problems, larger green areas need to be created and smarter strategies are required for more environmentally friendly use of natural resources. From the architectural point of view, Istanbul, on its way to becoming a global city, is yearning for more museums,

concert halls and other cultural precincts. The city cries out for more green spaces where its millions of habitants can relax and breathe. More importantly, at least half of the residential building stock in the city must be replaced with better engineered and constructed buildings to minimise the swaying effects of the powerful earthquake which is expected to happen in the next 20 to 30 years.

These targets can be attained only by way of an intelligent plan implemented by the public and private sectors in collaboration. Securing support from all segments of society plays a pivotal role in this strategy. The government certainly needs to take a more inclusive approach and invite all stakeholders to provide input into the large-scale projects. Many of the strategic projects put into action in the recent years came as top-down initiatives with very little information shared with the people. A new transfer centre in Kabataş, a motorway tunnel in Maçka Park and land reclamation in Üsküdar, for example, are the newest major developments that Istanbulites have only heard about from the media after the decisions were taken. While the government's enthusiasm to improve the infrastructure of the city and make Istanbul an attractive centre for international investors is acknowledged, the way it handles the process needs fine-tuning. A better public relations strategy would undeniably strengthen the government's hand in delivering this message to the masses, and listening to the inputs and criticisms from different groups would certainly reduce the chance of making irreversible mistakes. Other stakeholders, including professional organisations, universities and the private sector, should also review their approach and roles in this process. The Chamber of Architects, for example, needs to reassess its politically motivated stance against all government initiatives and develop a more productive approach in order to play a serious role in this long-term endeavour. Similarly, the schools of architecture could also formulate methods to provide both the public and private sectors with alternatives that could be employed in the remaking of Istanbul. The challenges and urban renewal requirements facing the city offer a unique opportunity to achieve an authentic outcome. If this chance is cleverly grasped, Istanbul will strengthen its position as one of the most exciting urban centres in the world, not only due to its superb historical significance but also because of its cleverly articulated contemporary architecture that seamlessly integrates with its social, cultural and geographical context. As a city linking two continents, not only physically but also culturally, Istanbul certainly deserves this.

Notes

Introduction

1. A. D. Hamlin, *The Text Book of the History of Architecture* (New York, 1909), p. xxii.
2. It should also be remembered that although the 1966 conference at the University of Leicester marked the opening of a new era in urban history in Europe, particularly in the United Kingdom, the roots of urban history as a subdiscipline of general history in the United States go back as far as Albert Bushnell Hart's article, 'The rise of American cities', published in 1890. The first couple of decades of the twentieth century also saw some important developments in the field as many historians shifted their interests and concerns from wars and general politics to social, economic and geographic issues. Although 'urban history' was never a distinct part of these works, the attempts laid the foundation for subsequent studies. For a brief review of the development of urban history as a separate subject of general history in the United States see: B. M. Stave, 'In pursuit of urban history: conversations with myself and others – a view from the United States', in Derek Fraser and Anthony Sutcliffe (eds.), *The Pursuit of Urban History* (London, 1983), pp. 407–27.
3. Spiro Kostof, 'Cities and turfs', *Design Book Review* 10 (1986), p. 36.
4. Eric J. Hobsbawm, 'From social history to the history of the society', in Felix Gilbert and Stephen R. Graubard (eds.), *Historical Studies Today* (New York, 1972), pp. 14–16.
5. John Summerson, 'Urban forms', in Oscar Handlin and John E. Burchard (eds.), *The Historian and the City* (Cambridge, 1963), pp. 165–76.
6. Wim P. Blockmans, 'Reshaping cities: the staging of political transformation', *Journal of Urban History* 30/1 (2003), pp. 7–20.
7. Spiro Kostof, *The City Shaped: Urban Patterns and Meanings Through History* (London, 1999), pp. 222, 224.

Chapter One

1. Despite the financial and social difficulties, some significant projects were still implemented in a piecemeal fashion, such as local street regularisations in the areas destroyed by devastating fires, the drafting of some basic building regulations, and the introduction of street pavements and lighting. For detailed reading about urban planning works in the nineteenth century see: Murat Gül, *The Emergence of Modern Istanbul: Transformation and Modernisation of a City* (London, 2012), chapters 1 and 2.
2. For the development of telegraph technology in the Ottoman Empire see: Roderic H. Davison, *Essays in Ottoman and Turkish History 1774–1923: The Impact of the West* (Austin, 1990), pp. 133–65.

3. Stanford J. Shaw and Ezel K. Shaw, *History of the Ottoman Empire and Modern Turkey, Volume II, Reform, Revolution and Republic: The Rise of Modern Turkey, 1808–1975* (Cambridge, 1977), pp. 228–30.
4. Steam ferry services between the European and Asian shores of the Bosphorus were begun in 1850 by two foreign investors. A year later, the Şirket-i Hayriye, a maritime transport company owned by members of the ruling family, high-ranking bureaucrats and Galata bankers, was established to provide regular ferry services in the Ottoman capital. For detailed information see: Osman Nuri Ergin, *Mecelle-i Umûr-ı Belediyye* (Istanbul, 1995), vol. 5, pp. 2,288–95. In 1869 Istanbul welcomed a new mode of public transport with the establishment of the Dersaadet Tramvay Şirketi (Istanbul Tram Company) which operated a horse-drawn tram service in Istanbul. The first line was put in service between Beşiktaş and Tophane across the Golden Horn, with horses brought from Hungary and Austria. In 1871, new tram routes in Istanbul were opened between Azapkapı and Aksaray, Aksaray and Yedikule, and Aksaray and Topkapı. A detailed survey for the establishment of the tram lines in Ottoman Istanbul is given in: Ergin: *Mecelle-i*, vol. 5, pp. 2, 398–476.
5. For detailed information about the underground project: P. Oberling, 'The Istanbul Tünel', *Archivum Ottomanicum* 4 (1972), pp. 217–63.
6. In Turkey cinema was first screened to Sultan Abdülhamid II at Yıldız Palace in late 1896 by a Frenchman named Bertrand. Public screenings were also started in the same year by a Polish Jew named Sigmund Weinberg in a pub in the Grande Rue de Pera. For detailed reading see: Giovanni Scognamillo, *Türk Sinema Tarihi-I 1896–1959* (Istanbul, 1990), pp. 11–13.
7. The Turkish perception of the West changed significantly after the Ottoman defeats by the powerful European armies. The 1699 Treaty of Carlowitz, the peace settlement signed with Austria after the second unsuccessful siege of Vienna in 1689, forced the Ottomans not only to surrender long-held territories in Europe but also to accept the European countries as equal states. The Ottomans began to establish a new kind of relationship with Europe in order to understand the advancements of the Western world and sent exploratory ambassadors to European states. For detailed reading on Ottoman reforms between the Treaty of Carlowitz and 1808 see: Stanford J. Shaw and Ezel K. Shaw, *History of the Ottoman Empire and Modern Turkey, Volume I, Empire of the Gazis: The Rise and Decline of the Ottoman Empire, 1280–1808* (Cambridge, 1976), pp. 217–96. For detailed reading on Ottoman Westernisation see: Bernard Lewis, *The Emergence of Modern Turkey* (Oxford, 2002), pp. 21–174.
8. The *Sebil* (public fountain) of Hacı Bekir Ağa, constructed in 1738–9 within the Grand Bazaar, was the first known building ornamented with Baroque motifs in Istanbul. The *Sebil* of Mehmed Emin Ağa in Dolmabahçe, built in 1739–40, was the first known building constructed completely in Baroque style: Mustafa Cezar, *Osmanlı Başkenti İstanbul* (Istanbul, 2002), p. 271.
9. Although in many sources the designer of the Nuruosmaniye Mosque is given as Simeon Kalfa, a local Greek master, recent studies in the Ottoman archives reveal that the mosque was likely designed by Kara Ahmed Ağa, the chief architect, and Simeon

Kalfa worked under his patronage: Aras Neftçi, 'Nuruosmaniye Camii açılış töreni', *Sanat Tarihi Defterleri* 11 (2007), pp. 1–24.
10. Ergin: *Mecelle-i*, vol. 3, pp. 1,265–8.
11. For detailed reading on the Tanzimat see: Halil İnalcık, 'Sened-i İttifak ve Gülhane Hatt-ı Hümâyunu', *Belleten* 28/109–12 (1964), pp. 603–22.
12. For detailed reading on the reforms of the Tanzimat see: Erik J. Zürcher, *Turkey: A Modern History* (London, 2004), pp. 50–70.
13. Donald Quataert, *The Ottoman Empire: 1700–1922* (Cambridge, 2005), p. 68.
14. Traditionally, Ottoman Istanbul had four administrative districts: Istanbul Proper (often called Dersaadet or the Gate of Felicity), Galata, Eyüp and Üsküdar. The latter three were called Bilâd-ı Selâse, or the Three Towns. Istanbul Proper was the old triangular-shaped city surrounded by the Bosphorus to the east, Theodosian Walls to the west, the Golden Horn to the north and the Sea of Marmara to the south. Located across the Golden Horn is Galata where Genevese merchants had resided since Byzantine times. The upper part of Galata was called Pera (across the Golden Horn) by the Greeks and Beyoğlu (Son of the Bey) by the Turks. Eyüp is located outside the city walls to the west of the Golden Horn. It was named after Eyyûb el-Ensari, a companion of the Prophet Muhammad who is believed to have died there during the Arab siege of the city in 672. Üsküdar is located across the Bosphorus on the Asian shore. It was captured by the Ottoman Turks almost a century before the conquest of Constantinople. Until the 1980s the city dwellers had called the ancient walled city Istanbul. Today the whole metropolitan area, including those historic districts and surrounding suburbs, is named Istanbul. In contemporary usage the ancient walled city, Istanbul Proper, is named the Historic Peninsula.
15. During this period Pera became a 'boom town'. According to the 1882 census records, a quarter of the entire urban population, more than 200,000 people, lived in Galata, turning it into the second most populous district of Istanbul after Fatih. The population of Galata was also heterogeneous, as almost half of its inhabitants were foreign subjects, Europeans and non-Muslim Ottoman citizens. They enjoyed the privileges they had gained under the capitulations, as well as immunity from Ottoman law as they were under the protection of their respective embassies: Steven T. Rosenthal, *The Politics of Dependency: Urban Reform in Istanbul* (Connecticut, 1980), p. 13; 'Foreigners and municipal reform in Istanbul: 1855–1865', *International Journal of Middle East Studies* 11/2 (1980), p. 243.
16. Since it was impossible to implement the new municipal model in the whole of Istanbul, the Ottoman administration selected Galata/Pera as an exemplar. Named the Sixth District, it was the place where European settlers, bankers and merchants were located, as well as European embassies. It was therefore aimed to collect taxes and other charges to fund the required works. For detailed reading on the Sixth District see: Gül: *The Emergence*, pp. 43–9.
17. The change in architectural profession in the Ottoman Empire first appeared well before the Tanzimat era, during the reign of Selim III. As early as the first years of the nineteenth century, architects began to be sent to *Hendesehane*, the Engineering School, for

their formal education in accordance with modern technical methods: Aras Neftçi, '19. Yüzyıl başında Hassa Mimarlar Ocağı'ndan Hendesehane'ye dönüşüme ilişkin önemli bir belge', *Mimarist* 50 (2014), pp. 48–51.

18. Born as a stone mason in Kayseri, an important city in Central Anatolia, Bali was the founder of the dynasty. He migrated to Istanbul in the latter half of the seventeenth century to work for Sultan Mehmed IV. Bali's son, Krikor (1764–1831), is regarded as the first architect of the family and the first of its members to assume the surname Balyan. Having served under three sultans (Selim III, Mustafa IV and Mahmud II), Krikor Amira Balyan is generally accepted to have been responsible for designing significant buildings such as the Nusretiye Mosque (1823–6) in Tophane and the Selimiye Barracks (1820–27) in Üsküdar. His younger brother, Senekerim, was a lesser known figure, often working in the shadow of Krikor. The Beyazıt Fire Tower in 1828 is attributed to him. Garabet Amira Balyan, son of Krikor, served three sultans (Mahmud II, Abdülmecid and Abdülaziz) and working with his son, Nikogos, is assumed to have been the designer of the Dolmabahçe Mosque (1855). Nikogos Balyan, the eldest son of Garabet, is thought to have been the designer of many elaborate buildings such as the Küçüksu Pavilion (1856–7), Ihlamur Pavilions (1849–55) and the Ortaköy Mosque (1853). Sarkis Balyan, second son of Garabet, studied in Paris with his brother Nikogos at the Collège Sainte-Barbe de Paris in the 1840s and, according to some sources, later received his architectural education at the École des Beaux-Arts. The Beylerbeyi Palace (1861–4) on the Asian shores of the Bosphorus, the new Çırağan Palace (1860–72) and the Akaretler Town Houses (1875) are the most notable examples that Turkish architectural history attributes to him. Agop Balyan, third son of Garabet, worked closely with his brother Sarkis but is less well known having died young at the age of 38. For a detailed reading about the Balyans see: Alyson Wharton, *The Architects of Ottoman Constantinople: The Balyan Family and the History of Ottoman Architecture* (London, 2015).

19. For example, the tomb of Mahmud II is generally attributed to Garabet Balyan. However, some primary source materials clearly indicate that it was designed by Abdülhalim Efendi in 1840–1: Mehmet Esat, *Mirat-i Mühendishane-i Berri Hümayun* (Istanbul, 1895), p. 53.

20. As noted by Selman Can, a new generation Turkish art historian who works on the changes in the architectural profession of the late Ottoman era, many buildings in Istanbul attributed to the members of the Balyan family were actually designed by different architects and, in most cases, the Balyans were simply acting as building contractors: Selman Can, *Bilinmeyen Aktörleri ve Olayları İle Son Dönem Osmanlı Mimarlığı* (Istanbul, 2010), p. 92.

21. For a brief summary of the origins of the Young Ottomans and their political ideology see: Zürcher: *Turkey*, pp. 66–70.

22. For the contemporary print of *Usul-i Mimari-i Osmani* in Turkish, French and German see: Raşit Gündoğdu, et al. (eds.), *Osmanlı Mimarisi: Usul-i Mi'mari-i Osmani* (Istanbul, 2010).

23. There are contrasting information regarding the designers of the Valide Mosque in Aksaray. Based on accounts of Halil Edhem, Montani was in the design team. Other

sources, based on Ottoman archives' invalidate this claim and state that the mosque designed by Sarkis and Agop Balyan and Montani undertake the decoration works: Ahmet Ersoy, *Architecture and the Late Ottoman Historical Imaginary: Reconfiguring the Architectural Past in a Modernising Empire* (Surrey, 2015), pp. 118–9.

24. During and after the 1877–8 Ottoman–Russian War, approximately 600,000 immigrants fled to Anatolia and Istanbul from former Ottoman provinces in Europe, the Caucasus and Eastern Anatolia: Stanford J. Shaw, 'The population of Istanbul in the nineteenth century', *International Journal of Middle East Studies* 10/2 (1979), pp. 265–77.

25. For detailed reading on Jasmund's life and works in Turkey see: Mehmet Yavuz, 'Mimar August Jasmund hakkında bilmediklerimiz / Biographische notizen zu architekt August Jasmund', *Sanat Tarihi Dergisi* 13/1 (2004), pp. 183–205.

26. Even electric lamps imported from the United States had to wait in customs for a long time and their clearance was only possible after issuing an imperial order secured following lengthy negotiations between their Western importers, who had the Sultan's trust, and custom officials: F. Diodati Thompson, 'Turkey under Abdul Hamid', *The New York Times*, 14 October 1900.

27. Prime Ministry Archives of the Turkish Republic, (Ottoman Archives, Istanbul): 102.120.Y.MTV, 19 August 1894.

28. Prime Ministry Archives of the Turkish Republic, (Ottoman Archives, Istanbul): 94.112.MF.MKT, 11 August 1887.

29. The first European-style building in Topkapı Palace was the Mecidiye Pavilion constructed in 1855. Designed by Sarkis Balyan, the building represented the fashionable tones of Baroque and Rococo styles but, similar to its contemporaries, the overall appearance is Ottoman.

30. Edhem Eldem, 'The (Imperial) Ottoman Bank, Istanbul', *Financial History Review* 6 (1996), pp. 85–95.

31. Prime Ministry Archives of the Turkish Republic, (Ottoman Archives, Istanbul): 728.5.A.MKT.MHM, 31 May 1893. Although a major earthquake struck the city in 1894 and brought about the cancellation of the exhibition, D'Aronco stayed in Istanbul and worked on reconstruction projects for many damaged buildings. His architectural career in Turkey continued until the end of Abdülhamid II's reign when the long-serving sultan was overthrown by a military coup in 1909.

32. For German interests in the Ottoman Empire and the role of the Baghdad railways see: Murat Özyüksel, *Osmanlı-Alman İlişkilerinin Gelişim Sürecinde Anadolu ve Bağdat Demiryolları* (Istanbul, 1988).

33. Salih Münir Pasha, the Ottoman ambassador in Paris, offered a commission to Bouvard to draw up an urban renewal plan for Istanbul: Osman Nuri Ergin, *İstanbulda İmar ve İskân Hareketleri* (Istanbul, 1938), pp. 46–7.

34. Prime Ministry Archives of the Turkish Republic, (Ottoman Archives, Istanbul), MV.121/74, 26 October 1908.

35. According to Louis How, James B. Eads visited Istanbul and made his proposal upon the request of the Grand Vizier. However, the proposal could not proceed because of

the change in viziers: Louis How, *James B. Eads* (Boston, 1900), p. 78. Eads's visit to Istanbul was also mentioned in an engineering journal published in 1877: *Engineering News-Record* 4 (1877), p. 261.

36. The Eads and Lambert bridge would have been 1,828 metres long, 30.5 metres wide and had 15 spans. The 228-metre-wide central span would have been the longest span yet constructed in the world. The cost of the project, which was proposed to be completed in six years, was an estimated $US25 million. The proposed bridge was also considered an extension of the intra-city transportation between the European and Asian sectors of the city, which had been provided by steamships since the early 1850s. According to the investors, the construction of the bridge would make the Asian side of the city easily accessible, which in turn would open up new residential areas for the city's wealthier citizens who had their businesses in Pera and Galata. The revenue generated from the sale of new building allotments was intended to finance the bridge. A detailed description of the project appeared in an article: 'Bridging the Bosphorus', *The New York Times*, 25 August 1877.

37. 'To Bridge the Bosphorus', *The New York Times*, 21 January 1890 and 'Bridging the Bosphorus', *The Times*, 12 April 1890.

38. For a detailed description of Arnodin's project see: Gül: *The Emergence*, pp. 59–62.

39. The last decade of the Ottoman Empire saw the loss of the remaining territories in Europe, following the sequential Balkan Wars. The first war saw the Ottomans lose the entire region of Western Thrace. This was traumatic for the empire's intellectuals and elites as almost all modernisation and nationalist movements, including the CUP, had strong roots in cities such as Thessaloniki, Manastir (present-day Bitola) and Skopje. Although the Ottomans regained some of the territories, such as Edirne, after the second war, the dramatic defeat brought another significant wave of immigrants as Turkish people flooded into Istanbul, increasing the city's population to 1.6 million.

40. For Gökalp's ideology see: Ziya Gökalp, *The Principles of Turkism* (Leiden, 1968); Taha Parla, *The Social and Political Thought of Ziya Gökalp: 1876–1924* (Leiden, 1985).

41. Şerif Mardin, *Religion, Society and Modernity in Turkey* (Syracuse, 2006), p. 272. This deliberate transformation was much evident in the writings of Turkish intellectuals published in a new journal called *Türk Yurdu* (Turkish Homeland) and in the organisation they established as Türk Ocakları (Turkish Hearts) in 1912.

42. In documents found in the archives regarding the approval of Kemalettin Bey's travel to Europe it is indicated that he was sent to Berlin for two years and Rome for one year. Although no other document has been found, it is likely that Kemalettin Bey also spent some time visiting Rome during his years in Germany. Prime Ministry Archives of the Turkish Republic, (Ottoman Archives, Istanbul): İ..HUS.30/104, 29 October 1894; BEO. 529/39670, 30 October 1894; BEO.564/42258, 22 January 1896.

43. For detailed reading on Kemalettin Bey's life and professional career see: Yıldırım Yavuz, *İmparatorluktan Cumhuriyete Mimar Kemalettin* (Ankara, 2009); Afife Batur, *İstanbul Vakıflar Bölge Müdürlüğü Mimar Kemaleddin Proje Kataloğu* (Ankara, 2009); Ali Cengizkan (ed.), *Mimar Kemalettin ve Çağı, Mimarlık/Toplumsal Yaşam/Politika* (Ankara, 2009).

44. For detailed reading on Vedat Bey's life and architecture see: Afife Batur, *M. Vedad Tek: Kimliğinin İzinde Bir Mimar* (Istanbul, 2003).
45. For Mongeri's life and works in Turkey see: Özlem İnay Erten, *A Mansion in Şişli and Architect Giulio Mongeri* (Istanbul, 2016), pp. 53–117.
46. Although the Society of Ottoman Engineers and Architects was reunited briefly in 1919, no significant achievements were made and it was permanently dissolved in 1922.
47. For detailed reading about the infrastructure works conducted in the late Ottoman period see: Gül: *The Emergence*, pp. 63–7.
48. The large boulevard between Yenikapı and Aksaray was opened according to the replanning of Aksaray after a great fire that occurred on 23 July 1911. The project bears the signature of André Auric, a French engineer who came to Istanbul from the Municipality of Lyon in 1910 and worked three years as the head of the Infrastructure Department of Istanbul Municipality. This street later became part of a major traffic route of modern Istanbul. For detailed reading about Auric's works in Istanbul see: Gül: *The Emergence*, pp. 67–70.
49. Kemalettin Bey, 'Eski İstanbul ve imar-ı belde belası' *Türk Yurdu* 3/12 (1913), pp. 381–4; 'İmar-ı belde fikrinin yanlış tatbikinden mütevellid tahribat', *Türk Yurdu*, 4/3 (1913), pp. 490–5, both cited in İlhan Tekeli and Selim İlkin (eds.), *Mimar Kemalettin'in Yazdıkları* (Ankara, 1997), pp. 113–20.
50. Mehmed Ziya Bey, *İstanbul ve Boğaziçi* (Istanbul, 1917), pp. 394–6.

Chapter Two

1. In order to cope with the adverse impacts of the Great Depression, Turkey made significant cuts in its expenditure between 1929 and 1934. The total expenditure in 1929 of TL 214.5 million was gradually reduced and became TL 173.6 million in 1934: Zvi Yehuda Hershlag, *Turkey: the Challenge of Growth* (Leiden, 1968), p. 61. Despite the drastic financial conditions, the total funds allotted to the Office of Redevelopment and Ankara Municipality increased from TL 1.8 million in 1929 to TL 2.1 million in 1930 and TL 2.6 million in 1931: Gönül Tankut, *Bir Başkentin İmarı* (Istanbul, 1993), pp. 232–7.
2. Professor J. Brix from the Charlottenburg Technische Hoschule in Germany, Leon Jausseley, a French government architect who graduated from the École de Beaux Arts in Paris, and Hermann Jansen, a Berlin-based architect and professor who was a student of the famous late nineteenth-century architectural theoretician Camillo Sitte, were invited to the urban design competition for Ankara. Jansen's master plan, influenced by Sitte's planning principles, proposed major axes, public spaces and the preservation of the old citadel. In this plan the most significant characteristic of the new capital was its substantial public spaces, including large parks, entertainment venues, modern hotels and other outdoor recreational spaces. For detailed information: Tankut: *Bir Başkentin*, pp. 66–81.
3. Cemil Topuzlu, *İstibdat-Meşrutiyet-Cumhuriyet Devirlerinde 80 Yıllık Hatıralarım* (Istanbul, 2002), pp. 186–94.

4. *Census of Population, Social and Economic Characteristics of Population*, 20.10.1985, p. xxii.
5. Nebahat Tokatlı and Yonca Boyacı, 'The changing morphology of commercial activity in Istanbul', *Cities* 16/3 (1999), pp. 181–93; Hershlag: *Turkey*, p. 24; Alexis Alexandris, *The Greek Minority in Istanbul and Greek–Turkish Relations 1918-1974* (Athens, 1992), p. 104.
6. *Türkiye Büyük Millet Meclisi Zabıt Ceridesi*, D.II, C.IX (Ankara, 1975), p. 43.
7. The Armenian citizens of the Ottoman Empire gained some rights to improve their status in accordance with the 1878 Berlin treaty, signed between the Ottoman Empire and Russia after a humiliating defeat by the Russians. Claiming the implementation of such reforms, Armenian paramilitary groups organised various demonstrations and revolts in Anatolian cities, which intensified the tension between the Muslim population and the Armenians of the empire. The increasing hostility between the groups culminated in a forceful occupation of the Ottoman Bank headquarters in Istanbul by a group of armed Armenian militants on 26 August 1896. They took bank staff and some customers hostage and claimed that they would blow up the bank if their demands were not met. The bloody incident came to an end the following day as a result of efforts made by Western diplomatic missions in Istanbul, and the militants left Istanbul for Marseilles on a French ship. The occupation brought several deaths on both sides but the violence spread to the city and bloody confrontations occurred between Muslim and Armenian inhabitants of Istanbul. For detailed reading see: Edhem Eldem, '26 Ağustos 1896 'Banka Vakası' ve 1896 'Ermeni Olayları'', *Tarih Toplum* 5 (2007), pp. 113–46.
8. One of the markers of this impact was the shrinking traffic at Istanbul Port. The total cargo load of imported goods landed at Istanbul Port decreased dramatically from 471,696 tonnes in 1928 to 229,902 tonnes in 1932. The cargo indications for imported goods at İzmir Port during the same period do not show such a dramatic drop (from 235,788 tonnes in 1928 to 207,140 tonnes in 1932): 'Türkiyede 10 Yıl Cumhuriyet Hayatı: 1923-1933', *T. C. İstanbul Ticaret ve Sanayi Odası Mecmuası*, Cumhuriyetin Onuncı Yıl Dönümü Fevkalade Nühsası, 1933, pp. 174, 180.
9. Hershlag: *Turkey*, p. 81.
10. Niyazi Ahmet Banoğlu, *Taksim Cumhuriyet Abidesi Şeref Defteri* (Istanbul, 1973), p. 44.
11. Sedat Murat, Mahmut Bilen, Cahit Şanver, Halis Y. Ersöz (eds.), *İstanbul Külliyâtı/ Cumhuriyet Dönemi İstanbul İstatistikleri, 13-Sanayi I (İmalat) (1932-1982)* (Istanbul, 1998), pp. x–xii.
12. Sedat Murat, Cahit Şanver, Halis Y. Ersöz (eds.), *İstanbul Külliyâtı/Cumhuriyet Dönemi İstanbul İstatistikleri, 10-Ulaştırma (1933-1996)* (Istanbul, 1998), p. 141.
13. Behçet and Bedrettin, 'Türk inkilap mimarisi', *Mimar* 9–10 (1933), pp. 265–6.
14. Bülent Kumral, 'Zeki Sayar'la söyleşi', *Yapı* 152 (1994), pp. 44–52.
15. Hermann Ehlgötz, *General Bebauung Plan Istanbul*, held in the Atatürk Library, Catalogue No. B.403; for his report in Turkish see: Hermann Ehlgötz, *İstanbul Şehrinin Umumi Planı* (Istanbul, 1934).

16. For the subcommittee's report to the competition panel see: 'İstanbul şehir planı', *Arkitekt* 2 (1935), pp. 61–8.
17. Şemsa Demiren, 'Le Corbusier ile mülâkat', *Arkitekt* 19/11–12 (1949), pp. 230–1.
18. Henri Prost, 'İstanbulun nâzım plânını izah eden rapor', 15 October 1937. This report was also published in book form by the Municipality of Istanbul in 1938: *İstanbul Nâzım Plânını İzah Eden Rapor* (Istanbul, 1938).
19. Henri Prost, 'İstanbul', *Arkitekt* 3–4 (1948), p. 84.
20. Although Istanbul's population decreased significantly in the 1920s, multi-unit residential building construction in the early 1930s showed conversely a rapid increase. Between March and July 1931, for example, the number of permits issued for the construction of apartment buildings in Istanbul was more than 100. Mimar Servet, 'Apartman inşaatı', *Mimar* 7 (1931), pp. 217–19.
21. 'İstanbul'da yapılar 1928–1934', *Mimar* 5 (1934), pp. 153–4.
22. Murat Balamir, 'Kira Evi'nden Kat Evleri'ne apartmanlaşma: Bir zihniyet dönüşümü tarihçesinden kesitler', *Mimarlık* 260 (1994), pp. 29–33.
23. Despite its popularity, Turkish architects did not pay attention to this new style in their writings. The most notable comment on this subject was authored by Burhan Arif in his article published in *Mimar* in 1930. Burhan Arif, 'Türk mimarisi ve beynelmilel mimarlık vasıfları', *Mimar* 11–12 (1931), pp. 365–6.
24. 'Sinema Binaları', *Mimar* 2 (1931), pp. 51–9.
25. It is interesting to note that although this small coffee trader and brewer's shop in Istanbul skilfully represents characteristics of Art Deco, the architect, writing his own article about the building, does not mention this style. He simply states that he inspected similar precincts in Europe and tried to design his project to address the local needs. Mimar Zühtü, 'Bir kuru kahveci ticarethanesi', *Mimar* 4 (1933), pp. 105–8.
26. The seaside lifestyle was introduced by the White Émigrés who had escaped from the Bolshevik Revolution of 1917 and began to come to Istanbul as early as 1919. Their number reached more than 150,000 in a couple of years. Many of these immigrants were from a rich and educated stratum of Russian society that felt insecure in Bolshevik Russia. Although their stay in Istanbul was temporary, and in many respects miserable, the White Émigrés introduced many new aspects to Istanbul's social and cultural life in fashion, music and the entertainment industry. One of the new concepts they brought to Ottoman Istanbul was beach culture. New beaches opened in Florya making this remote rural settlement a sought-after destination for the modernising elite of Ottoman Istanbul. For detailed reading on the White Émigrés in Istanbul see: Jak Deleon, *The White Russians in Istanbul* (Istanbul, 1995); Svetlana Uturgauri, *Boğazdaki Beyaz Ruslar* (Istanbul, 2015).
27. The beach project was prepared by Arkan in consultation with Prost and Martin Wagner, a prominent German architect and theorist who resided in Turkey between 1935 and 1938: 'Florya'yı imar için hummalı faaliyetler', *Cumhuriyet*, 11 June 1935; 'Florya dünyanın sayılı plajlarından biri olacak', *Cumhuriyet*, 16 June 1935.
28. Adil Denktaş, 'Kira evi', *Arkitekt* 5–6 (1936), pp. 133–8.

29. M. Cavid Baysun, 'Mustafa Reşid Paşa'nın siyasi yazıları', *Tarih Dergisi* 11/15 (1960), pp. 121-42.
30. Yahya Kemal Beyatlı, *Aziz İstanbul* (Istanbul, 2006), pp. 152-60.
31. Osman Nuri Ergin, *İstabul'da İmar İskan Hareketleri* (İstanbul, 1938), p. 56.
32. Sedad Hakkı Eldem, '1inci Türk Mimarlık Kongresi mimarlık grubu Vinci kol raporu', *Arkitekt* 7-8 (1946), pp. 194-7. It is interesting to note that Eldem, who designed one of the significant apartment buildings in Talimhane in 1933, took the leading role in the preparation of this anti-apartment report.
33. For a detailed anyalsis of the foreign architects and their perception in Turkey see: Bülent Özer, *Rejyonalizm Üniversalizm ve Çağdaş Mimarimiz Üzerine Bir Deneme* (published PhD thesis, İTÜ, 1970), pp. 51-4.
34. Mimar Abidin, 'Bugünün Türk mimarı', *Mimar* 26 (1933), pp. 33-4.
35. Burhan Arif, 'İstanbulun plânı', *Mimar* 3/5 (1933), pp. 155, 160.
36. Aptullah Ziya, 'Sanatta nasyonalizm', *Mimar* 2 (1934), pp. 51-4.
37. Mimar Abidin, 'Memlekette Türk mimarının yarınki vaz'iyeti', *Mimar* 5 (1933), pp. 129-30.
38. Behçet and Bedrettin, 'Mimarlık ve Türklük', *Mimar* 1 (1934), pp. 17-20.
39. The government took numerous measures to consolidate the single-party character of the regime. As a result, the last remaining separation between the party and the state was removed in the 1930s. Almost all public servants were members of the ruling RPP, the secretary-general of the party became the Minister for Internal Affairs and the provincial party chairmen served as the governors of their respective cities. The principles were eventually incorporated into the constitution in 1937.
40. Before their closure in 1950 there were 473 People's Houses and over 4,300 People's Rooms (a smaller version of the People's House that opened in small towns and villages) established in Turkey.
41. To establish the basis for these claims, the Turkish Historical Society and the Turkish Language Society were founded in 1931 and 1932 respectively, under the personal leadership of Mustafa Kemal. The Faculty of Linguistics, History and Geography at Ankara University was founded to theorise the Kemalist theses further and departments of Sumerology and Hittitology, Ancient Greek and Latin were established to support the assertion that many civilisations in Anatolia were founded by the Turks. School textbooks were written to include this new historical perspective which formed the basis of primary and secondary educational curricula.
42. For detailed reading on the Turkish theses see: *Birinci Türk Tarih Kongresi, Ankara 2-11 Temmuz 1932* (Ankara, 2010).
43. Behçet and Bedrettin: 'Türk inkilap', pp. 265-6
44. B. O. Celâl, 'Büyük inkilâp önünde milli mimari meselesi', *Mimar* 6 (1933), pp. 163-4.
45. Behçet Ünsal, *Turkish Islamic Architecture in Seljuk and Ottoman Times* (New York, 1973), p. 90.
46. Burhan Arif, 'Türk şehirlerinin bünyesi', *Mimar* 1 (1932), pp. 1-3.
47. In the 1930s Turkey was overwhelmingly an agrarian country, with more than 80 per cent of the population living in rural areas. Despite massive migration, over 65

per cent of the Turkish population was still living in rural settlements. The urban population would only exceed the rural population in the mid-1980s. For detailed information see: *İstatistik Göstergeler/Statistical Indicators, 1923-2006* (Ankara, 2007), p. 17.

48. The first opposition party in the Turkish Republic was the Terakkiperver Cumhuriyet Fırkası (Progressive Republican Party) founded in November 1924. This new party promoted Western liberal tendencies and opposed the authoritarian character of the new regime. This first democratic experiment, however, was short-lived and after a Kurdish rebellion broke out in Eastern Anatolia in February 1925, the party was banned in June the same year. The second attempt to establish a multi-party system came in August 1930 with the foundation of the Serbest Cumhuriyet Fırkası (Free Republican Party FRP) by Ali Fethi Okyar with the encouragement of Atatürk. However, the unexpected popularity of the FRP in the society and a religious-oriented revolt which occurred in the small Aegean town of Menemen in December of the same year forewarned the government that its public support was neither guaranteed nor unconditional. Therefore, the FRP was closed down in November 1930. For detailed readings about the opposition parties in the early Republican period: Erik J. Zürcher, *Turkey: A Modern History* (London, 2004), pp. 166-75 and 176-9; Feroz Ahmad, *The Making of Modern Turkey* (London, 1993), pp. 57-60; Cem Emrence, 'Dünya krizi ve Türkiye'de toplumsal muhalefet: Serbest Cumhuriyet Fırkası' in Murat Yılmaz (ed), *Modern Türkiye'de Siyasi Düşünce: 7 Liberalizm* (Istanbul, 2005), pp. 213-16.
49. For detailed reading about the Village Institutes: M. Asım Karaömerlioğlu, 'The Village Institutes experience in Turkey', *British Journal of Middle Eastern Studies* 25/1 (1998), pp. 47-73
50. Sibel Bozdoğan, *Modernism and Nation Building: Turkish Architectural Culture in the Early Republic* (Seattle, 2001), pp. 97-105. German agricultural colonies and model farms were used as successful examples for the Turkish architects who prepared the ideal village projects for Turkish peasants. Site plans and photographs of the model German villages and model farms were presented in the journal *Arkitekt* in the 1930s. The authors of these articles mostly emphasised the importance and success of the German practices. Zeki Sayar, for example, argued that 'we, like the Germans, must give a great significance to science, specialisation and organisation' to create ideal Turkish villages. Zeki Sayar, 'İç kolonizasyon – Başka Memleketlerde', *Arkitekt* 8 (1936), pp. 231-5.
51. Bozdoğan: *Modernism*, pp. 255-6.
52. Abdülaziz's proposed mosque was never built but the project brought about one of the early and grander examples of terraced housing in Istanbul in order to provide an income for the mosque. Designed by Ottoman-Armenian architect Sarkis Balyan in 1875, the houses were called *Akaretler* (meaning rented properties) and consisted of a total of 133 three-storey dwellings of two plan types in European Neoclassical style.
53. Sedad Eldem, 'Taşlık Kahvesi', *Arkitekt* 11-12 (1950), pp. 207-10.
54. 'Beylerbeyinde bir yalı', *Arkitekt* 8 (1938), pp. 213-17.

55. Although Turkey successfully maintained its neutrality during World War II, it declared war on Germany and Japan on 23 February 1945 in order to qualify for an invitation to the founding conference of the United Nations in San Francisco.
56. Mahmut Makal, *Bizim Köy: Bir Öğretmenin Notları* (Istanbul, 1950).
57. As part of the strict political measures during World War II, the government imposed the *Varlık Vergisi* (Capital Levy) in 1942 as a wealth tax on non-Muslim businessmen and large farm owners in order to finance expenditure on defence. For detailed information about these taxes and their impacts on Turkish society see: *Varlık Vergisi Kanunu ve Bu Kanun Hükümlerinin Şerhi* (Istanbul, 1942). For its implementation and impact on society see: Bernard Lewis, *The Emergence of Modern Turkey* (New York, 2002), pp. 297–302; Kemal Karpat, *Turkey's Politics: The Transition to a Multi-party System* (Princeton, 1959), pp. 114–17; Faik Ökte, *The Tragedy of the Turkish Capital Tax* (London, 1987).
58. The financial difficulties affected Istanbul's public transport severely. For example, the Municipality of Istanbul ordered 23 new buses from the United States and Britain but due to the war only nine of them were delivered. The solution was to convert 15 lorries into buses. In a similar way, the Istanbul Tunnel could not operate for a period of 118 days in 1941 because of a lack of spare parts: *Güzelleşen İstanbul* (Istanbul, 1943), no page number.
59. Turkey's first multi-party election was held in 1946 and brought a victory to the RPP. However, the elections were highly controversial and totally controlled by government officials rather than the independent judiciary. People were forced to vote openly and ballots were counted by police, gendarmes and RPP officials, without the presence of representatives from opposition parties. The ballots were also destroyed immediately after the results were announced, and the opposition parties did not have the opportunity to lodge appeals.
60. Although it is generally attributed to the Democrat Party, this phrase was actually first used by Nihat Erim, the RPP's deputy prime minister who declared, 'If we are not involved in an external disaster, I am very hopeful for the future of the country. In the near future Turkey will become a Little America': 'Erimin İzmitteki demeci', *Cumhuriyet*, 20 September 1949.
61. The US funds diverted to Turkey between 1946 and 1950 reached around 3 per cent of GNP, allowing imports to increase by 270 per cent over the wartime average: Çağlar Keyder, *State and Class in Turkey: A Study in Capitalist Development* (London, 1987), p. 119; 'Economic development and crisis: 1950–1980', in Irvin C. Schick and Ertuğrul A. Tonak (eds), *Turkey in Transition: New Perspectives* (New York, 1987), p. 294; Hershlag: *Turkey*, pp. 150–1.
62. Establishing an effective road network in Turkey was the action most prioritised in the Turkish–American relationship in the postwar era. Turkey's insufficient road network, therefore, was scrutinised by US experts and proposals were made to improve the road conditions. The report drafted by the US deputy commissioner, H. E. Hilts, proposed that national roads in Turkey be increased by 5,000 km and provincial routes by 30,000 km. It also suggested the establishment of a semi-autonomous Turkish highway

department to carry out the programme. The report was very much appreciated by both the US and Turkish governments and the first works started in 1948 under the Turkish Department of Public Works: H. E. Hilts, 'The highway situation in Turkey: A report of the United States Public Roads Mission to Turkey to the Minister of Public Works of Turkey', Ankara, February 1948. For the Turkish road programme: Robert W. Kerwin, 'The Turkish roads program', *The Middle East Journal* 4 (1950), pp. 196–208. The full text of the Turkish–American Roads Agreement is given as Appendix D in the *Fourth Report to Congress on Assistance to Greece and Turkey*, Department of State (Washington, 1948).

63. Initially, the Istanbul Court occupied the former *Darülfünun* (University) building site next to Hagia Sophia. A fire destroyed the building in 1933, and since then various sites had been considered for the new justice complex. First a site near the governor's office was chosen and a design competition was organised in 1935. Asım Kömürcü's proposal won the first prize but his design was not executed. Later in 1943 a site on the newly constructed Atatürk Boulevard was considered but this initiative did not proceed. The following six years saw an intense debate between the governmental offices, architects and academics about the sensitivity of the site in Sultanahmet Square. The second design competition was organised in 1947 but no project was given an award. This long debate came to an end when the third design competition was organised in 1949. For the first design competition in 1935 see: 'Adliye Sarayı', *Arkitekt* 5 (1935) p. 156; for the second design competition in 1947 see: 'İstanbul adalet sarayı proje müsabakası', *Arkitekt* 5–6 (1947), pp. 103–14. For the final design competition, see, 'İstanbul adalet binası proje müsabakası', *Arkitekt* 7–10 (1949), pp. 179–94.
64. 'Adalet Sarayı'nın temeli dün atıldı', *Milliyet*, 13 July 1951.

Chapter Three

1. The most comprehensive account of the period leading to multi-party democracy in Turkey after World War II is written by Kemal Karpat, *Turkey's Politics: The Transition to a Multi-party System*, (Princeton, 1959). For a briefer account on the elections in 1950, see, Feroz Ahmad, *Turkey: The Quest for Identity* (Oxford, 2003), pp. 102–4; Erik J. Zürcher, *Turkey: A Modern History* (London, 2001), pp. 206–18.
2. Even when he was a deputy of the RPP in 1945, Menderes severely criticised the peasantist policies of the 1940s and accused them of being inspired by the Erbhof regulations of Nazi Germany. For him, 'setting unbreakable barriers between the village and the city' would mean 'the continuation of the backwardness of the country': Halûk Kılçık, *Adnan Menderes' in Konuşmaları-Demeçleri-Makaleleri: 9* (Ankara, 1992), pp. 1–17.
3. *Tarım İstatistikleri Özeti, 1942-1963* (Ankara, 1964), p. 3; Ruşen Keleş, *Türkiyede Şehirleşme Hareketleri 1927-1960* (Ankara, 1961), p. 35; Zvi Yehuda Hershlag, *Turkey: The Challenge of Growth* (Leiden, 1968), p. 356.
4. For detailed reading on political developments in the early years of the DP era see: Zürcher: *Turkey*, pp. 221–40.

5. Edwin J. Cohn, *Turkish Economic Social and Political Change: The Development of a More Prosperous and Open Society* (New York, 1970), p. 173.
6. Hershlag: *Turkey*, p. 366.
7. Malcolm D. Rivkin, *Area Development for National Growth; The Turkish Precedent* (New York, 1965), pp. 110, 113.
8. The ratio of the population living in cities rose from 25 per cent in 1950 to 32 per cent in 1960. The increase between 1927 and 1950 was marginal and the ratio hovered around 25 per cent: *İstatistik Göstergeler/Statistical Indicators 1923-2011* (Ankara, 2012), p. 9.
9. Prime Ministry State Institute of Statistics Turkey, Census of Population, 20 October 1985, p. xxii.
10. *İstatistik Göstergeler/Statistical Indicators 1923-2011*: p. 18.
11. Hershlag: *Turkey*, p. 375.
12. Kemal H. Karpat, 'Political developments in Turkey, 1950-70', *Middle Eastern Studies* 8/3 (October, 1972), p. 355.
13. For detailed reading on the emergence of modern heritage conservation legislation in Turkey see Nuran Zeren, 'Türkiye'de tarihsel değerlerin korunmasında uygulanmakta olan yöntem çerçevesinde uygulayıcı kuruluşların görüşlerine dayanan bir araştırma', unpublished PhD thesis, İstanbul Teknik Üniversitesi, 1981.
14. Jale G. Akipek, 'Türk hukukunda kat mülkiyeti', *Ankara Barosu Dergisi* 23/3 (1966), pp. 475-90.
15. The DP's criticism of the previous government's disregard for Istanbul can be seen in the speech for the municipal elections by Samet Ağaoğlu, the spokesman and minister for the state: *Cumhuriyet*, 28 August 1950.
16. For a detailed reading on Prost's dismissal see: Murat Gül, *The Emergence of Modern Istanbul: Transformation and Modernisation of a City* (London, 2012) pp. 134-6.
17. The establishment of the Revision Commission was discussed by the Municipal Assembly of Istanbul at its meeting on 27 February and 15 March 1951: Municipality of Istanbul, General Assembly Records, 27 February, and Municipality of Istanbul, General Assembly Resolution, 15 March 1951. The commission included representatives from several official institutions and universities: Kemal Ahmet Aru from the Istanbul Technical University; Cevat Erbel and Mithat Yenen from the İller Bankası (Bank of Provinces); Mukbil Gökdoğan from the Türk Yüksek Mühendisleri Birliği (Turkish Union of Engineers); Muhittin Güven from the Türk Yüksek Mimarlar Birliği (Turkish Union of Architects); Mehmed Ali Handan from the Fine Arts Academy; and Behçet Ünsal from the Technical School. The Municipality of Istanbul was also represented in the commission by architects Ertuğrul Menteşe and Faruk Akçer and, as an observer, Seyfi Arkan.
18. 'Revizyon Komisyonu Raporu – H. Prost'un İstanbul şehri için tanzim ettiği imar planlarını tetkik etmek üzere kurulmuş bulunan heyet tarafından hazırlanmıştır', Istanbul, 1954.
19. The plan for Beyoğlu District was prepared at 1:5,000 scale, comprising an area of 3,400 ha. The plan covered the whole European section of the city to the north of the Golden Horn. The total population within the boundaries of this area was 347,488 in 1952.

In addition to the general plan, detailed implementation plans were also prepared at 1:500 scale. The plan was first endorsed by the Municipal Assembly and then approved by the Department of Public Works on 17 February 1954: *İstanbul İmar Plânı İzah Raporları: I. Beyoğlu Ciheti* (Istanbul, 1954). The plan covered the total area of 6,625 ha (the Istanbul Peninsula and Bakırköy and Eyüp districts). The total population was 582, 276 in 1955. The plan estimated its future population as 1,081,080, and was accompanied by a detailed industrial plan for the areas of the Golden Horn and the coastal belt between Yedikule and Bakırköy: *İstanbul İmar Plânı İzah Raporları: 2. İstanbul Ciheti* (Istanbul, 1956).

20. In 1952 there were 3,703 private motorcars, 322 buses, 3,213 trucks and pick-ups, 724 motorcycles and 4,251 taxis in Istanbul. M. Langevin and L. Meizonnet, Étude des Transports d'Istanbul, unpublished typescript report, September 1952, p. 8. The total number of motor vehicles (excluding military vehicles) reached 20,868 in 1955: *İstanbul Vali ve Belediye Reisi Ord. Prof. Dr. F. K. Gökay'ın 1956–1957 Konuşmaları* (Istanbul, 1958), p. 17. Çağlar Keyder also estimates the total number of motor vehicles in Istanbul to be 17,000 in 1955 and 35,000 in 1960: 'A tale of two neighbourhoods', in Çağlar Keyder (ed.), *Istanbul Between the Global and the Local* (Lanham, 1999), p. 175.
21. *Akşam*, 24 September 1956; *Hürriyet* and *Cumhuriyet*, 24 September 1956; and *İstanbul Ekpres*, 23 September 1956.
22. For detailed reading on Menderes' redevelopment plan see: Gül: *The Emergence*, pp. 140–71.
23. For detailed reading on the works of Islahat-ı Turuk Komisyonu see: Osman Nuri Ergin, *Mecelle-i Umur-ı Belediyye* (Istanbul, 1995), vol. 2, pp. 937–62.
24. The decisions for the partial demolitions of the Simkeşhane and Han of Hasanpaşa could only proceed after hot debates between the municipality, the High Council of Immoveable Heritage Items and Monuments and the Turkish Historical Society, which were extensively covered by the press. After vitriolic debates, the Council finally approved the demolitions in July 1956. Republic of Turkey, High Council of Immovable Heritage Items and Monuments Resolution No. 514, 17 July 1956. The decision for demolition was reached by seven votes against six. Tahsin Öz, Orhan Çapçı, Ekrem Akurgal, Kamil Su, Ahmed Hamdi Tanpınar, Osman Turan and Behçet Ünsal voted for the demolitions. Kemali Söylemezoğlu, Ali Saim Ülgen, Ali Müfit Mansel, Zeki Faik İzer, Celâl Esad Arseven and Orhan Alsaç voted against the resolution.
25. Although the total number of buildings demolished during Menderes' operations is unknown and different estimates are given in various sources, a detailed reading of the records of the Yassıada Trials, Menderes's speeches and other relevant sources suggest that around 5,000 buildings were flattened.
26. Sıddık Sami Onar, a professor of administrative law at Istanbul University, supported the redevelopment works in the 1950s. In an article he penned, Onar advocated for the role and responsibilities of the central government over local governments in the redevelopment of cities, and he described the demolition of the fish market in Eminönü a *Vak'a-i Hayriye* (Benevolent Event) in the history of urban redevelopment in Turkey.

According to Onar, the redevelopment works in Turkey's biggest cities could only happen because of the 'energetic initiatives of some statesmen': Sıddık S. Onar, 'Mahalli ademi merkeziyet prensibi ve imar işleri', *Cumhuriyet*, 2 July 1957. Onar was given the task of drawing up a new constitution after the 1960 military coup and created a formula to legalise the military coup according to the constitution. Ironically, the central government's involvement in the redevelopment programme was extensively used against Menderes at the Yassıada trials.

27. Metin Toker, *Demokrasimizin İsmet Paşalı Yılları 1944-1973: DP'nin Altın Yılları 1950-1954* (Ankara, 1990), p. 230.
28. Zeki Sayar, 'İstanbul'un imârı münasebetiyle', *Arkitekt* 2 (1956), pp. 49-51.
29. *Havadis*, 9 January 1957.
30. Until the 1950s all leading architects in Turkey were either employed by government offices or working in the universities as academicians. In line with the growing economy and political liberalisation, architects began to act independently from public institutions and opened their own private practices. For a summary of the redevelopment of architectural practice in Turkey in the twentieth century, see Uğur Tanyeli, '1950'lerden bu yana mimari paradigmaların değişimi ve reel mimarlık', in Yıldız Sey (ed.) *75 Yılda Değişen Kent ve Mimarlık* (Istanbul, 1998), pp. 235-54.
31. Between 1948 and 1959 Turkey was granted a total of US$1,210 million in financial assistance as grants or long-term loans. The allocations decreased gradually from 1950 onwards but started to rise again after 1956, with the significant amount of US$359 million granted in 1958. In addition, Turkey was granted a total of US$60.2 million by the International Bank of Reconstruction and Development between 1956 and 1960. Hershlag: *Turkey*, p. 150.
32. Robert W. Kerwin, 'The Turkish roads program', *The Middle East Journal* 4 (1950), pp. 196-208.
33. *The Middle East Journal* 4 (1950), p. 218.
34. In order to qualify for full membership of NATO, Turkey sent its troops to Korea in 1950 and became a member of NATO in 1952. For detailed reading about Turkey's membership to NATO. Behçet K. Yeşilbursa, 'Turkey's participation in the Middle East Command and its admission to NATO, 1950-52', *Middle Eastern Studies* 35/4 (October, 1999), pp. 70-102.
35. Annabel J. Wharton, *Building the Cold War: Hilton International Hotels and Modern Architecture* (Chicago, 2001). In her book Wharton provides a detailed account of Istanbul Hilton and other hotels constructed by Hilton in Europe and the Middle East.
36. 'Şehrimizde yapılacak 300 odalı otel', *Milliyet*, 11 November 1950.
37. 'Hilton oteli mukavelesi imzalandı', *Milliyet*, 16 December 1950; *Cumhuriyet*, 16 December 1950.
38. 'Mimar Sedat Hakkı Eldem müşavir olarak inşaatı kontrol edecek', *Milliyet*, 21 December 1950.
39. Financing Istanbul Hilton hotel attracted a wide interest in the press: 'Turistik otel meselesi', *Cumhuriyet*, 3 December 1950; 'Yeni otelin inşaat hazırlıkları', *Cumhuriyet*, 18 December 1950.

40. 'Turistik otel', *Arkitekt* 3-4 (1952), pp. 56-63.
41. Zeki Sayar, 'Yabancı teknik elemanlar meselesi', *Arkitekt* 7-8 (1953), pp. 119-20.
42. Sibel Bozdoğan, 'The Americanization of Turkish architectural culture', in Sandy Isenstadt and Kishwar Rizvi (eds.) *Modernism and the Middle East: Architecture and Politics in the Twentieth Century* (Seattle, 2008), p. 121.
43. 'İstanbul Belediye Sarayı Projesi', *Arkitekt* 11-12 (1945), p. 262.
44. The selection panel included many leading figures of Turkish architecture of the 1950s: Kemal Ahmet Aru, Orhan Alsaç, Mukbil Gökdoğan, Asım Mutlu, Sedat Erkoğlu, Enver Berkman, Sedat Eroğlu and Turgan Sabisten: 'Belediye Sarayı', *Milliyet*, 18 April 1953.
45. 'İstanbul Belediye Binası proje müsabakası', *Arkitekt* 5-6 (1953), pp. 71-88.
46. Rüstem Duyuran, 'Belediye sarayı mozaikleri', *Arkitekt* 9-12 (1954), pp. 166-70.
47. The number of apartment blocks constructed in Istanbul was only 67 in 1945. This figure increased dramatically and became 1,025 in 1950 and 1,722 in 1955: *7 Yıl İçinde Vilâyet ve Belediyece Yapılan İşler 1949-1955* (Istanbul, 1956), p. 112.
48. European architects who migrated to Turkey in the 1930s, such as Bruno Taut and Martin Wagner, tried to formulate solutions to develop various mass housing projects. Also in the 1950s various proposals were made, this time by American experts, yet none of these proposals had a chance to be implemented: Sibel Bozdoğan and Esra Akcan, *Turkey: Modern Architectures in History* (London, 2012), p. 148.
49. While the bank's origin goes back to 1926 as Emlak Eytam Bankası, the bank began to work effectively in the late 1940s with new housing projects in Ankara and Istanbul.
50. Kemal Ahmet Aru and Rebii Gorbon, 'Levend Mahallesi', *Arkitekt* 9-10 (1952), pp. 174-81.
51. Kemal Ahmet Aru, 'Levend 4. Mahallesi', *Arkitekt* 3 (1956), pp. 140-53.
52. 'Hukukçular Sitesi', *Arkitekt* 4 (1961), pp. 163-72; Halûk Baysal and Melih Birsel, 'Hukukçular Sitesi', *Arkitekt* 4 (1970), pp. 157-8.
53. Similar to Prost, Piccinato had a considerable experience in Muslim countries: Ruben Abel Bianchi, 'The works of Luigi Piccinato in Islamic countries 1925-1981', *Environmental Design: Journal of the Islamic Environmental Design Research Centre* (1990), pp. 184-91.
54. Ertuğrul Menteşe, 'Ataköy Sitesi hakkında rapor', *Arkitekt* 2 (1958), pp. 79-82.
55. 'Ataköy Sitesi 1. Kısım inşaatı', *Arkitekt* 2 (1958), pp. 61-6.
56. The celebrative tone of Sayar, the editor of *Arkitekt*, during the early days of Menderes' redevelopment programme changed. The later articles he published in *Arkitekt* criticised the urban redevelopment works for their lack of adequate preparation and detailed programming and for their uncoordinated implementation: Zeki Sayar, 'İstanbul'un imârında şehirci mimarın rolü', *Arkitekt* 25 (1956), pp. 97-8; 'İstanbulun imarı hakkında düşünceler!', *Arkitekt* 26 (1957), pp. 3, 11. Sayar also published several other articles criticising the urban redevelopment of Istanbul: 'İstanbul'un imârında şehirci mimarın rolü', *Arkitekt* 25 (1956), pp. 97-8; 'İmar ve eski eserler', *Arkitekt* 26 (1957), pp. 49-50; 'Beyazıt Meydanından alacağımız ders!', *Arkitekt* 27 (1958), pp. 53-4.
57. The relationship between the government and the military had been turbulent since the very early days of the DP. Immediately after the elections in 1950 some army officers

who had accused Menderes and his party officials of communist activities offered a plan to İsmet İnönü to conduct a coup against the DP. While the plan was not successfully carried out as İnönü refused to be involved, the resentment against the DP grew deeper in the army. Like the civil establishment, many army officers saw the DP as undermining the fundamental secularist principles and constitutional foundations of the Turkish state.

58. For detailed reading on Menderes' trial at Yassıada, see Gül: *The Emergence*, chapter 6.

Chapter Four

1. For a detailed reading on political developments after the 1960s coup see: Erik Zürcher, *Turkey: A Modern History* (London, 2001), pp. 241-50.
2. TBMM Genel 1961 Genel Seçim Sonuçları: https://www.tbmm.gov.tr/develop/owa/secim_sorgu.secimdeki_partiler?p_secim_yili=1961 (accessed on 10 July 2014).
3. 'Dünkü tasnife göre durum', *Milliyet*, 20 November 1963.
4. 'Erodğan'ın başkanlığı iptal edildi', *Milliyet*, 8 December 1963.
5. TBMM Genel 1965 Genel Seçim Sonuçları: https://www.tbmm.gov.tr/develop/owa/genel_secimler.secimdeki_partiler?p_secim_yili=1965 (accessed on 10 July 2014).
6. For detailed reading on the changes in the RPP during the 1960s see: Zürcher: *Turkey*, pp. 252-3.
7. For detailed reading on the import subsidised economic model in Turkey see: Şevket Pamuk, 'Economic change in twentieth-century Turkey: Is the glass more than half full?', in Reşat Kasaba (ed.), *The Cambridge History of Turkey, Volume 4: Turkey in the Modern World* (Cambridge, 2008), pp. 283-5.
8. For a detailed reading on the economic development in the 1960s see: H. Tolga Bölükbaşı, 'Political economy', in Metin Heper and Sabri Sayarı (eds.), *The Routledge Handbook of Modern Turkey* (Abingdon, 2012), pp. 343-9.
9. TV broadcasting in Turkey begun at Istanbul Technical University in 1952. The programmes were generally recorded at studios and could only be watched by a limited number of people who had TVs in Istanbul.
10. For further reading on migration in Turkey in the twentieth century see: Kemal Karpat, *The Gecekondu: Rural Migration and Urbanization* (Cambridge, 1976), pp. 48-77; Ahmet İçduygu and İbrahim Sirkeci, 'Cumhuriyet dönemi Türkiye'sinde göç hareketleri', in Oya Köymen (ed.), *75 Yılda Köylerden Şehirlere* (Istanbul, 1999), pp. 249-68.
11. Karpat: *The Gecekondu*, pp. 59-60; İlhan Tekeli, 'Gecekondu', *İstanbul Ansiklopedisi* (Istanbul, 1994), vol. 3, pp. 381-5.
12. Trams began to lose their popularity in many Western cities in the 1930s, but this trend intensified after World War II. Trams were seen as a cause of traffic congestion and to be economically unviable, especially for servicing the outer suburban districts. In London the last tram lines were closed in 1952. In France the dismantling of the tram lines began in the 1930s and was completed after World War II. In North America many cities ceased their tram services in the mid-twentieth century. The trend was similar in many other parts of the world. In Sydney the extensive tram

network was closed down in 1961, Wellington abandoned its tram service in 1966, and Buenos Aires ceased tram services in the 1960s.

13. The last tram service in European Istanbul operated on 12 August 1961: 'Emektar tramvaylar için yapılan veda töreni', *Cumhuriyet*, 13 August 1961. With the closure of services on the Asian side on 14 November 1966, Istanbul completely ceased its tram network: 'Kadıköy'de dün vatmanlar ağladı', *Cumhuriyet*, 15 November 1966.
14. In 1976 more than 19,000 *dolmuş* vehicles were in service in Istanbul, providing around 50 per cent of the total public transport in the metropolitan area: H. İbrahim Şanlı, *Dolmuş-Minibus System in Istanbul: A Case Study in Low-Cost Transportation* (Istanbul, 1981), p. 36.
15. For more detailed reading on the emergence and evaluation of *arabesk* music in Turkey see: İren Özgür, 'Arabesk music in Turkey in the 1990s and changes in national demography, politics and identity', *Turkish Studies* 7/2 (2006), pp. 175–90.
16. Cited in Oktay Ekinci, *İstanbul'u Sarsan On Yıl* (Istanbul, 1994), p. 26
17. Zeki Sayar, 'Yapı ve imarda yeni ruh', *Arkitekt* 2 (1960), pp. 51–2.
18. Hulusi Güngör, 'Belki 5 yıllık planın sayesinde...', *Mimarlık* 3 (1963), pp. 1–2.
19. 'Vali: bu şehrin planını yapacak adam yok dedi', *Milliyet*, 12 October 1961.
20. For a succinct summary of the debate within architectural circles in the 1960s regarding the architect's role in the new society see: Sibel Bozdoğan and Esra Akcan, *Turkey: Modern Architectures in History* (London, 2012), pp. 173–4.
21. For a detailed analysis of regionalism in Turkish architecture see: Bülent Özer, *Rejyonalizm Üniversalizm ve Çağdaş Mimarimiz Üzerine Bir Deneme* (published PhD thesis, İTÜ, 1970).
22. Eldem expressed a similar approach in his design of a group of modern *yalı*s along the Bosphorus in the same period. Kıraç Yalı (1965–6) and Fuat Bayramoğlu 'apartment *yalı*' (1969–74) on the Anatolian shores of the Bosphorus are the two distinct examples where Eldem employed a revealing perspective drawn from old Turkish waterfront mansions.
23. 'İstanbul Manifaturacılar Çarşısı proje müsabakası', *Arkitekt* 2 (1958), pp. 87–92.
24. 'Vakıflar İdaresi tarafından Taksim'de inşa ettirilecek turistik otel proje müsabakası', *Arkitekt* 3 (1959), pp. 88–93.
25. 'Başbakan dün 7 temel daha attı', *Cumhuriyet*, 29 March 1968.
26. 'Taksim Oteli', *Mimarlık* 8 (1967), pp. 26–7.
27. 'Demirel İsvan ile Shereton Oteli için tartıştı', *Milliyet*, 3 August 1975.
28. Demirel would repeat his approach and officially inaugurate the campus of Koç University (a private university founded by Turkish tycoons, the Koç family) in Rumelifeneri on the northern European shores of the Bosphorus in 1999 when he was the president of Turkey. As discussed in the following chapters, the campus, without obtaining approval from Istanbul Municipality, was constructed within a dense forest and resulted in the loss of thousands of trees and therefore created a huge controversy.
29. 'Orduevi sitesi mimarî proje yarışması', *Arkitekt* 3 (1967), pp. 128–35.
30. 'Inter-Continental İstanbul Hoteli projesi', *Arkitekt* 4 (1972), pp. 172–81.

31. Turhan Damlacı, 'Etap oteli İstanbul', *Arkitekt* 1 (1980), pp. 4–7.
32. 'Odakule İş Merkezi binası İstanbul', *Arkitekt* 2 (1976), pp. 53–8.
33. For a detailed reading on Xerxes' pontoon bridge see: N. G. L. Hammond & L. J. Roseman, 'The Construction of Xerxes' Bridge over the Hellespont', *The Journal of Hellenic Studies* 116 (1996), pp. 88–107.
34. The zig-zag patterned cables carrying the Bosphorus Bridge's dock were replaced by perpendicular rods during the major restoration works carried out in 2015–16.
35. The total number of vehicles passing over the Bosphorus by car ferries was around 15,000 per day in 1972. After the construction of the Bosphorus Bridge this figure rose to 56,000 per day. Eighty per cent of the vehicular traffic passing over the bridge was automobiles: *İstanbul Ulaşımında 50 Yıl* (Ankara, 1974), p. 175; İlhan Tekeli, *İstanbul ve Ankara İçin Kent İçi Ulaşım Tarihi Yazıları* (Istanbul, 2010), p. 68.
36. *İstatistik Göstergeler/Statistical Indicators 1923–2011* (Ankara, 2012), pp. 423–4.
37. 'İstanbul Reklam Sitesi proje yarışması', *Mimarlık* 3 (1969), pp. 28–37.
38. For a detailed reading on the 1971 military intervention and its consequences in Turkish politics see: Zürcher: *Turkey*, pp. 258–64.
39. Kemal Demir and Suat Çabuk, 'Türkiye'de metropoliten kentlerin nüfus değişimi', *Sosyal Bilimler Enstitüsü Dergisi* 28/1 (2010), pp. 193–215.
40. Turkish Statistical Institute: https://biruni.tuik.gov.tr/nufus80app/idari.zul (accessed on 12 July 2014).
41. For a detailed reading on the evolution of *gecekondu* in Turkey see: Rıfkı Arslan, 'Gecekondulaşmanın evrimi', *Mimarlık* 6 (1989), pp. 34–7.
42. In Örnek Mahallesi, for example, there were only 390 units constructed by 1979 by the government. At the same time, 1 Mayıs Mahallesi had already reached 4,000 *gecekondus* in total: 'Karaaslan: İstanbul'da gecekondu yapımına izin verilmeyecek', *Milliyet*, 3 August 1979.
43. 'AP Türkiye'nin itibarını zedeledi', *Cumhuriyet*, 2 July 1973.
44. 'Demirel: Damgayı kır atın böğrüne basın, gecekonduları şehir yapalım', *Milliyet*, 20 May 1977.
45. Although the first stock exchange in Turkey was established in 1866, this institution had a very limited capacity and served as an agent for foreign creditors who provided financial loans to the weak Ottoman economy. During the early Republican period the stock exchange in Istanbul continued to operate, but the strict statist economic system did not allow the stock market to operate in a modern sense.
46. *Kat Mülkiyeti Kanunu* was passed by the parliament on 23 June 1965 and published in the *Resmi Gazete* (Official Gazette) on 2 July 1965.
47. Yıldız Sey, *Türkiye Çimento Tarihi* (Istanbul, 2004), pp. 70–81.
48. For the popularity of reinforced concrete in Turkey see: İlke Tekin and İpek Akpınar, 'Betonarmenin anonimleşmesi: Türkiye'de İkinci Dünya Savaşı sonrası yapılı çevrenin inşası', *Mimarlık* 377 (2014), pp. 70–4.
49. Amongst the noteworthy artwork integrated with major buildings were: mosaic wall panels by Bedri Rahmi Eyüboğlu, ceramic wall panels by Füreyya Koral, metal sculpture by Kuzgun Acar and a marble fountain by Yavuz Görey in İMÇ; a stainless steel

figurine named 'Göktaşı' (Meteoroid) by Turkish sculptor Atilla Onaran placed in front of the Odakule in İstiklal Street.

Chapter Five

1. The military mayors serving in Istanbul following the 1980 coup were: İsmail Hakkı Akansel between 12 September 1980 and 30 August 1981; Ecmel Kutay between 30 August 1981 and 24 September 1982; and Abdullah Tırtıl between 24 September 1980 and 26 Mart 1984.
2. 'E-5'te estetik uygulaması başladı', *Milliyet*, 20 March 1983.
3. For a detailed review of the army's sovereign status in Turkey and the ideological forces behind it see: Ümit Cizre Sakallıoğlu, 'The anatomy of the Turkish military's political autonomy', *Comparative Politics* 29/2 (1997), pp. 157–66.
4. The hyperinflation, which travelled at around 80 per cent, and the US$ 3 billion deficit in foreign trade in the late 1970s forced the government to take serious measures, known as the 24 January Decisions, in 1980. The basic aim was to establish an economic system in which the private sector would become a key player and which would link the Turkish economy to the world economic system. Rather than the system of state intervention whereby the state played the key role in the economy, this model economy was run by real supply and demand, according to the market conditions, with either minimal or no government interference. The key policies undertaken in accordance with the 24 January Decisions, drafted by Özal, were: devaluing the Turkish lira by 80 per cent, supporting foreign investment and exports, increasing prices for goods produced or manufactured by state-owned companies such as oil, coal, steel, cement, paper and sugar, and following a tied monetary and fiscal policy. For further reading see: Meral Tecer, *Türkiye Ekonomisi* (Ankara, 2005), pp. 81–4.
5. For a detailed assessment of Özal's economic performance see: Ziya Öniş, 'Turgut Özal and his economic legacy: Turkish neo-liberalism in critical perspective', *Middle Eastern Studies* 40/4 (2014), pp. 113–34.
6. The total value of contracts for Turkish companies operating abroad in 1986 reached over US$15 billion and the number of Turkish technical personnel and labourers working in those projects grew to 230,000: Amir Tavakoli and Şevket Can Tülümen, 'Construction industry in Turkey', *Construction Management and Economics* 8/1 (1990), pp. 77–87.
7. 'İmar ve Gecekondu Mevzuatına Aykırı Yapılara Uygulanacak Bazı İşlemler ve 6785 Sayılı İmar Kanununun Bir Maddesinin Değiştirilmesi Hakkında Kanun', 24 February 1984: http://www.mevzuat.gov.tr/MevzuatMetin/1.5.2981.pdf (accessed on 15 February 2014).
8. 'Özal: parasını vermeyenin gecekondusunu yıkacağız', *Milliyet*, 21 August 1984.
9. Since the number of houses in Turkish cities, especially in large cities such as Istanbul, has been eroded significantly in the last 50 years as a result of massive apartmentisation, the Turkish word 'ev' (house) has begun to be used to also describe residential

units or flats, which is 'daire' (unit) in the Turkish language. The difference in meaning between 'home' and 'house' does not exist in Turkish as 'ev' is used on both occasions. The word 'yuva' which is 'home' in English is also occasionally used in contemporary Turkish language.

10. 'Dalan: Bu şehir sahipsiz değildir', *Milliyet*, 1 November 1985.
11. Henri Prost, *İstanbulun Nâzım Plânını İzah Eden Rapor* (Istanbul, 1938), p. 3. For Prost's assessments about the Golden Horn: Prost, 'Note No. 7', (undated).
12. Semih S. Tezcan, 'Haliç master planı ve uygulama programı kesin raporu' (Istanbul, 1977).
13. *Milliyet*, 13 October 1985; *Milliyet*, 1 November 1985.
14. The commercial spaces in the demolished areas were relocated to the Perpa building, which was constructed in 1988 in Şişli. Designed by Alaettin Yener, Perpa, with its 700,000 square metres of floor space and fortress-like appearance, is one of the largest monolithic buildings in the world.
15. For detailed reading on Dalan's Golden Horn rehabilitation programme see: *Amaç Yeşili ve Maviyi Kurtarmak: Haliç* (Istanbul, 1988).
16. André Auric, 'Rapport général du service technique de la préfecture', *Génie Civil Ottoman* 1 (1911), pp. 1–4; 'La reconstruction de Stamboul', *Génie Civil Ottoman* 1 (1912), pp. 4–5.
17. 'The World Bank Project Completion Report, Republic of Turkey, Istanbul Sewerage Project (Loan 2159-TU), 20 November 1991', unpublished report: http://documents.worldbank.org/curated/en/396281468316458186/pdf/multi-page.pdf (accessed on 21 June 2015).
18. Auric: 'La reconstruction', pp. 4–5.
19. Prost: *İstanbulun Nâzım*, p. 16.
20. Murat Gül, *The Emergence of Modern Istanbul: Transformation and Modernisation of a City* (London, 2012), p. 139.
21. The so-called Essen Plan was prepared by Oskar Gerdom, Aachen Traffic Department, Michael Geiler, a psychologist on traffic from the University of Duisburg, Wolfgang Bielke, a traffic engineer, and Peter Philip, a signalisation expert: 'İstanbul trafiğine Alman planı', *Cumhuriyet*, 1 August 1986.
22. Although the High Council of Immovable Cultural and Natural Heritage Items initially outlawed the proposed demolitions, the Council itself changed this decision and the demolitions were given approval on 23 January 1987.
23. 'Soğukçeşme platoları tarihi surları rezil etti', *Milliyet*, 27 September 1987.
24. 'Süper başkan: Türkiye'nin en başarılı yöneticisi Bedrettin Dalan', *Nokta* 4/14, 13 April 1986.
25. 'İMO'dan Dalan'a Suçlama', *Milliyet*, 9 October 1986
26. 'Hayali… Yanlış… Acı…', *Milliyet*, 15 November 1987.
27. Yücel Gürsel, 'Tarlabaşı yıkımının perde arkası', *Mimarlık* 2 (1986), pp. 21–2.
28. Ali Rüzgar, 'Beyoğlu Otoyol Planı', *Mimarlık* 2 (1986), pp. 20–1.
29. 'Tarlabaşı için mimari yarışma', *Yapı* 84 (1988), p. 14. In addition to Dalan and municipal bureaucrats, Professor Gündüz Gökçe, Professor Esad Suher, Professor İsmet Ağaryılmaz, Professor Muhteşem Giray, Professor Metin Sözen, Professor Ümit

Serdaroğlu and leading architect Doğan Tekeli were appointed as the panel members. 'Tarlabaşı Yarışması', *Milliyet*, 24 July 1988.
30. Karayolları Genel Müdürlüğü, 'Fatih Sultan Mehmet köprüsünün tarihçesi': http://www.kgm.gov.tr/SiteCollectionDocuments/KGMdocuments/Bolgeler/1Bolge/FatihSultanMehmetTarihce.pdf
31. Hans Hollein (who did not participate), Charles Moore, William McMin, Vittorio Gregotti, Aldo Rossi, Brown-Root Partnership, Conder Partnership and Gino Valle were the international designers invited to the design competitions.
32. Since 1977 the perpetuators of the bloody incident have remained unknown. However, many people believe that the incidents on 1 May were one of the many dark events secretly conducted by contra-guerrillas, a NATO-supported military sect that acted in all member states, including Turkey, during the Cold War era. The aim, according to such opinion, was to fuel anarchy and public disorder and thereby pave the way to the military takeover which followed in 1980.
33. *Taksim Meydanı Kentsel Tasarım Yarışması* (Istanbul, 1987).
34. 'Taksim Meydanı Proje Yarışması', *Yapı* 78 (1988), pp. 29–39.
35. 'Üsküdar Meydanı Proje Yarışması', *Yapı* 78 (1988), pp. 40–9.
36. 'Beyazıt Meydanı için proje yarışması', *Yapı* 83 (1988), p. 7.
37. The total volume of air passenger traffic at Yeşilköy Airport increased by 25.4 per cent in the 1960s and by 18 per cent in the 1970s: Hayati Tabanlıoğlu (ed.), *Yeşilköy Havalimanı Yeni Terminal Binası – Yeşilköy Airport New Terminal Building* (Ankara, 1983), p. 6.
38. 'Galleria Ataköy açıldı', *Yapı* 84 (1988), p. 11.
39. 'Şark Kahvesi yıkıldı', *Yapı* 78 (1988), p. 3.
40. 'Başvekil beklenen basın toplantısını dün yaptı', *Cumhuriyet*, 24 September 1956. Also see: *Akşam* and *Hürriyet*, 24 September 1956, *İstanbul Ekspres*, 23 September 1956.
41. 'Çırağan Sarayı'nın duvarları dikildi', *Yapı* 83 (1988), p. 11.
42. 'Yalı duvarlarını yıkacağım', *Milliyet*, 9 September 1988.
43. 'Dalan'ın yeni savaşı', *Milliyet*, 14 September 1988.
44. The principles of 'new urbanism' had been developed since the 1980s and were formalised by a congress organised in 1993 by Peter Calthrope, Stefanos Polyzoides, Daniel Solomon, Elizabeth Moule, Andres Duany and Elizabeth Plater-Zyberg. For detailed reading see: Emily Talen (ed.), *Charter of the New Urbanism: Congress for the New Urbanism* (New York, 1999).
45. Şerife Geniş, 'Producing elite localities: the rise of gated communities in Istanbul', *Urban Studies* 44/4 (2007), pp. 771–98.
46. The late nineteenth and early twentieth centuries in Istanbul saw the emergence of new suburbs surrounding Taksim which gradually expanded the city's borders to Beyoğlu: Cihangir and Gümüşsuyu to the south and Harbiye, Şişli, Maçka, Teşvikiye and Nişantaşı to the north. These were the places where large numbers of city dwellers first encountered modern residential apartment buildings. In parallel with Turkish modernisation, these parts of the city became destinations for wealthy citizens escaping the traditional timber houses and narrow streets of the Historic Peninsula. The new suburbs presented a Western-style urban environment with apartments equipped with

running water, central heating and lifts and shops containing appealing European goods. Offering a broad spectrum of styles from Neo-classicism to Art Deco and International Style, they were immediately popular. Over time, Teşvikiye and Nişantaşı, with their cafes, luxury restaurants and high-end fashion boutiques that attracted a wealthy population living in spacious apartments, became two of the most sought-after suburbs of Istanbul.

47. Turkish Statistical Institute: https://biruni.tuik.gov.tr/nufus90app/idari.zul (accessed on 25 July 2014)
48. A comprehensive summary of all the critics opposed to Dalan's urbanism in architectural circles can be found in Oktay Ekinci's writings. He was an active member and director of the Chamber of Architects in the 1990s and early 2000s: Oktay Ekinci, *İstanbul'u Sarsan On Yıl: 1983–1993* (Istanbul, 2009).

Chapter Six

1. Despite Özal's rhetoric of empowering the middle class in society, the purchasing power of an average wage owner had declined by 47 per cent since the early 1980s. For a detailed reading on the decline of the MP see: Erik J. Zürcher, *Turkey: A Modern History* (London, 2001), pp. 285–8.
2. http://www.yerelsecim.com/Detays.asp?ID=34&SY=1989 (accessed on 15 November 2015).
3. Although Dalan was the MP's candidate, the relationship between Özal and Dalan was almost non-existent before the 1989 municipal elections. Dalan distanced himself from the MP and conducted an autonomous election campaign. In the propaganda posters the MP's emblem was reproduced at the smallest possible size.
4. 'Mavi Haliç projesi rafa kalktı', *Yapı* 111 (1991), p. 13.
5. In the Yassıada Trials Menderes was accused of using the redevelopment of Istanbul to mask his extensive stays in Istanbul rather than Ankara. According to the prosecutors, Menderes settled down in the Park Hotel, and his visits were financed by the discretionary fund: İstimlak Yolsuzluğu Davası Tutanakları -Esas No. 961/8 (Records of the Case of Corrupt Expropriation), p. 351.
6. 'İstanbul siluetine yeni bir darbe', *Yapı* 118 (1991), p. 15.
7. The Chamber of Architects gave Sözen a Certificate of Gratitude on 22 November 1993 for his dedication to demolishing the excessive parts of the Park Hotel and his resistance to other controversial developments: 'İstanbul şubesi'nden Nurettin Sözen'e Teşekkür Belgesi', *Mimarlık* 225 (1993), p. 10.
8. 'Metro için geri sayım', *Milliyet*, 12 September 1992.
9. 'Ücretsiz tramvay Sirkeci'de', *Milliyet*, 11 July 1992.
10. 'İstiklal Caddesi nihayet açıldı', *Yapı* 111 (1991), p. 13.
11. Helmuth von Moltke, *Briefe über Zustände und Begebenheiten in der Türkei aus den Jahren 1835 bis 1839* (Berlin, 1893), pp. 82–3.
12. Osman Nuri Ergin, *Mecelle-i Umûr-ı Belediyye* (Istanbul, 1995), vol. 5, p. 3,022.

13. Conceptually, Yıldız followed the organisation of Topkapı Palace and was built over 50 years. The layout of the palace included various courtyards containing pavilions, pools, glasshouses, aviaries, workshops and servants' quarters.
14. 'İstanbul siluetine yeni bir ek', *Yapı* 113 (1991), p. 17.
15. The opposition boycotted the presidential election, yet Özal could easily be elected by the votes of MP members in the parliament.
16. For a detailed reading of the 1994 economic crisis see: Zürcher: *Turkey*, pp. 313–4. See also: Fatih Özatay, 'The 1994 currency crisis in Turkey', *The Journal of Policy Reform* 3/4 (2000), pp. 327–52.
17. Since there was no census conducted in 1995, the figure is estimated by calculating the average between the 1990 and 2000 censuses: https://biruni.tuik.gov.tr/nufusapp/idari.zul (accessed on 10 September 2014)
18. 'Sözen: Bedava süt 1 Ağustosta', *Cumhuriyet*, 20 July 1989.
19. A brief survey of the newspapers of the early 1990s illustrates that legalisation of *gecekondu* was an effective political tool for Sözen, as it was for many politicians before him: 'Sözen ve Fato tapu dağıttı', *Milliyet*, 5 May 1989. Gecekondulara çifte bayram'.
20. Making a comparison between Vedat Dalokay's mayorship in Ankara in the 1970s and Sözen's in Istanbul, Hasol harshly criticises the Istanbul Municipality in his article published in *Yapı*. During his election campaign Sözen's rhetoric was 'Tek çare Doktor!' (Sole remedy is the doctor) as he was a medical professor. Hasol concludes his article with the following remarks: 'Istanbul needs a mayor, not a doktor': Doğan Hasol, 'Zavallı İstanbul', *Yapı* 113 (1991), p. 9.
21. http://www.yerelsecim.com/Detays.asp?ID=34&SY=1994 (accessed on 15 May 2015)
22. As soon as ballots were counted and Erdoğan's victory became certain, many Western-orientated Turkish people, who passionately admired Kemalist principles, organised symbolic campaigns such as a 'facsimile chain' circulating between big financial companies: 'Atatürkçüler RP'nin kazanmasına öfkeli', *Cumhuriyet*, 30 March 1994.
23. Construction of illegal villas in the forest was one of the most frequent themes placed in front of Erdoğan during his election campaign. This topic was widely covered in the Turkish dailies: 'RP'li başkan mahkeme kararına rağmen villaları yıkmıyor', *Cumhuriyet*, 18 February 1994; 'Vay Tayyip ağa vay', *Hürriyet*, 18 February 1994; 'Olaylı başkan Kanal D'de', *Milliyet*, 24 February 1994; 'Erdoğan suçlamaları yalanladı', *Milliyet*, 18 February 1994; 'Villalar RP'nin mi?', *Milliyet*, 11 March 1994.
24. 'Erdoğan Paris'te et yemedi', *Milliyet*, 10 December 1994.
25. 'Taksim'e cami yapacağım', *Milliyet*, 29 March 1994.
26. 'Kadın bugününü Ata'ya borçlu', *Cumhuriyet*, 6 March 1994.
27. The ban on alcoholic beverages in Cemal Reşit Rey Recital Hall prompted a heated discussion between Erdoğan and Ertuğrul Özkök, a columnist in the daily newspaper *Hürriyet*. Özkök blamed Erdoğan for forcing him and many other people to drink sherbet at an exhibition opening at the hall. The municipality's response to Özkök was to accuse him of coming to the opening only to drink *rakı* (an alcoholic aniseed drink very popular in Turkey): 'Parkalı yazıya takma isimle yanıt geldi', *Milliyet*, 25 November 1994.

28. 'Onlar artık gecekondu', *Yenişafak*, 15 September 2000.
29. Svante E. Cornell, 'Turkey: return to stability?', in Sylvia Kedourie (ed.), *Seventy-five Years of the Turkish Republic* (New York, 2007), pp. 216–8.
30. For a detailed reading on the political events before and after the 28 February 'postmodern coup' see: Zürcher: *Turkey*, pp. 298–301.
31. Erdoğan read the poem in a public meeting in Siirt, his wife's home city in the southeast of Turkey, on 12 December 1997. Gökalp's poem, titled *Asker Duası* (Soldiers' Prayer), was penned in 1912 and employed intense nationalistic rhetoric blended with religious symbolism, all of which was wholly in step with the dire political atmosphere during the Balkan Wars. Erdoğan read his poem (or a revised version according to some sources) in south-east Turkey under a similar political atmosphere when Turkey was struggling with terrorism in Kurdish dominated cities in south-east Turkey. In fact, the poem was not considered prejudicial by public authorities and, to the contrary, was placed in school books for many years. Yet Erdoğan's reading gave the secular establishment an opportunity to accuse him of propagating religious fanaticism.
32. For a detailed reading of the relationship between media and politics in Turkey, see Raşit Kaya and Barış Çakmur, 'Politics and the mass media in Turkey', *Turkish Studies* 11/4 (2010), pp. 521–37.
33. Mehmet Konuralp, 'Gazete tesisi tasarımı ve çağdaş teknoloji', *Tasarım* 29 (1992), pp. 48–59.
34. 'Hürriyet Güneşli tesisleri', *Yapı* 148 (1994), pp. 59–62.
35. 'Doğan Medya Center', *Yapı* 149 (1994), pp. 50–8.
36. Following a long period of neglect, the Bank Ekspres building was demolished in August 2016.
37. Etymologically, the word 'plaza' means field and, in architecture, an open-air public square. The word began to be used to name shopping malls as early as the 1920s in the United States and later became associated with mixed-used buildings where a tall office block is located above a shopping mall or arcade. In Turkey the first phase of the Yapı Kredi Bank buildings, constructed in 1989 in Levent, was called 'plaza' and the term was then applied to almost all new office blocks constructed in the city.
38. For a detailed reading on the impact of poor building quality during earthquakes in Turkey see: Ercüment Erman, 'Earthquake failure of reinforced concrete buildings: the case of the 1999 earthquakes in Turkey', *Architectural Science Review* 47/1 (2004), pp. 71–80.

Chapter Seven

1. The crisis was sparked when president Ahmet Necdet Sezer rebuked prime minister Bülent Ecevit in a meeting for turning a blind eye to the corruption in the cabinet and for preventing a genuine investigation into the issue. Ecevit stormed out of the meeting and announced a 'state crisis' in front of TV cameras broadcasting live.
2. For detailed reading on the economic crisis of 2001 and the ensuing rescue efforts see: Ziya Öniş, 'Beyond the 2001 financial crisis: the political economy of the new phase

of neo-liberal restructuring in Turkey', *Review of International Political Economy* 16/3 (2009), pp. 409-32.
3. Although the formal shorthand for the party is AKP, the party administration prefers to abbreviate it as AK Party. In addition to the acronym of 'Adalet ve Kalkınma', AK also means white, pure or uncontaminated in Turkish, indicating a fresh start in the politics of Turkey. Like everything else in Turkish politics, this use of the abbreviation is a matter of controversy. Despite the party officially declaring its shorthand name as AK Parti, or in English AK Party, members of the opposition parties and individuals who have distanced themselves from the party deliberately use AKP as the acronym.
4. The outstanding result was only possible because, apart from the AK Party and RPP, all other parties had failed to pass the 10 per cent hurdle to enter the parliament. TBMM 3 Kasım 2002 Tarihli Milletvekili Genel Seçim Sonuçları: https://global.tbmm.gov.tr/docs/secim_sonuclari/secim3_tr.pdf (accessed on 15 November 2015)
5. For a detailed summary of the AK Party's political outlook see: Yalçın Akdoğan, 'The meaning of conservative democratic political identity', in M. Hakan Yavuz (ed.), *The Emergence of a New Turkey: Islam Democracy and the AK Parti* (Utah, 2006), pp. 49-65.
6. A detailed summary of political Islam and AK Party's struggle, challenges and weaknesses is given in: Hootan Shambayati, 'Democracy, secularism and Islam: examining the Turkish model', in Lucia Volk (ed), *The Middle East in the World: An Introduction* (New York, 2015), p. 173.
7. Marcie J. Patton, 'The Synergy between Neoliberalism and Communitarianism: "Erdoğan's Third Way"', *Comparative Studies of South Asia, Africa and the Middle East* 29/3 (2009), pp. 438-49.
8. Shortly after he took office, Erdoğan made an official visit to Italy on 13 November 2002 to seek support for Turkey's membership of the EU. His visit was in Ramadan and whether or not Erdoğan would give up fasting during his stay in Italy became a popular topic and was extensively discussed in the Turkish media. Eventually, Erdoğan did not fast in Italy and participated in a business lunch with Silvio Berlusconi, the Italian prime minister: 'AB için oruç bozacak', *Hürriyet*, 12 November 2002.
9. The gross national income per capita, for example, increased from US$3,480 in 2002 to US$10,850 in 2014. Turkey's exports were US$36 billion in 2002 and this figure increased fivefold in 12 years and reached an impressive US$143 billion in 2015. Furthermore, Turkey had undertaken significant infrastructure projects in transportation, energy, mining, agriculture and many other fields. These achievements brought about a steady 6.8 per cent average growth in the Turkish economy between 2002 and 2007. Although the world economic crisis adversely affected Turkey in 2008 and 2009, in the following years the Turkish economy regained its momentum, with an average growth rate of 4.8 per cent between 2002 and 2014. For detailed statistics on the Turkish economy see World Bank, Turkey country profile: http://data.worldbank.org/country/turkey (accessed on 18 November 2015); Turkish Statistical Institute: http://www.tuik.gov.tr/PreTablo.do?alt_id=1046 (accessed on 18 November 2015).

10. Turkey's long path to EU membership began in 1959 when the Menderes government applied for association to the European Economic Community (EEC). Subsequently, many agreements were signed between Turkey and the EEC, and in 1987 during the Özal administration Turkey applied for full membership of the European community. Despite many efforts, no significant progression was made in the following 17 years. The Erdoğan government finally secured membership negotiations with the EU upon the decision taken in Luxembourg on 3 October 2005. For a brief chronology of the Turkey–EU relationship see: Republic of Turkey, Ministry of EU Affairs: http://www.abgs.gov.tr/files/chronology.pdf.
11. Abdullah Gül was a senior AK Party member who was amongst the party's founders and was its first prime minister at the time of the ban on Erdoğan from political activities in 2002. In the 2007 ultimatum the army clearly stated that a person who had not genuinely accepted secularist principles and who was married to a woman wearing a headscarf would not be accepted as the president of secular Turkey. As a result of firm resistance by the government, Gül was elected as the new president of Turkey in the following months, after early parliamentary elections.
12. A good number of essays regarding the AK Party and Erdoğan are contained in: Ümit Cizre (ed.), *The Turkish AK Party and its Leader: Criticism, Opposition and Dissent* (New York, 2016).
13. Turkish Statistical Institute demographic statistic: http://tuik.gov.tr/UstMenu.do?metod=temelist (accessed on 25 January 2016).
14. Recep Tayyip Erdoğan, 'IMF–Dünya Bankası Yıllık Toplantıları, AK Parti Genel Başkanı, Başbakan Recep Tayyip Erdoğan', (2009): http://www.akparti.org.tr/basbakan-erdogan-imf-dunya-bankasi-yillik-toplantilari-cerc_6371.html (accessed on 15 May 2014).
15. İstanbul Ulaşım AŞ: http://istanbulunmetrosu.com/ (accessed on 20 February 2016).
16. For a detailed reading on Metrobüs and its impacts on Istanbul's public transport see: Pelin Alpkokin & Murat Ergün, 'Istanbul Metrobüs: first intercontinental bus rapid transit', *Journal of Transport and Geography* 24 (2012), pp. 58–66.
17. İETT, İstanbul'da Toplu Taşıma: http://www.iett.gov.tr/tr/main/pages/istanbulda-toplu-tasima/95 (accessed on 20 February 2016)
18. Once fully completed, the Marmaray will be a 76-kilometre rail link running on the East–West axis. The remainder of the project, comprised of upgrading the railway line first constructed in the late Ottoman era, is under construction and is expected to be completed by 2017.
19. After reviewing the initial submissions, the selection panel invited nine architectural firms both in Turkey and abroad to the competition: 'Yenikapı Transfer Noktası ve Arkeopark Alanı Uluslararası Ön Seçmeli Davetli Mimarlardan Proje Temini': http://www.ibb.gov.tr/tr-TR/Pages/Haber.aspx?NewsID=20159#.VbyTuBOqqko (accessed on 15 February 2015).
20. Other shortlisted projects proposed by consortiums include 'Atelye 70 + Cellini Francesco + Insula Architettura E Ingegneria' and 'Cafer Bozkurt Mimarlık + Mecanoo Architects': 'Yenikapı Transfer Noktası ve Arkeopark Alanı projesi için üç isim':

http://www.ibb.gov.tr/tr-TR/Pages/Haber.aspx?NewsID=20169#.VbyTRhOqqkp (accessed on 15 February 2015).
21. The future of the project, not unlike many other large-scale development proposals since the late Ottoman era, is uncertain as although it has been approved by the municipality, construction has not yet commenced.
22. In explanation of why the municipality did not call Turkish architects for the competitions, Topbaş stated that 'Not all tailors can stitch silk fabric': 'Kadir Topbaş meslektaşlarını kızdırdı: 30 bin Türk mimar Özür bekliyor', *Milliyet*, 7 April 2006.
23. Istanbul International Finance Centre Strategy and Action Plan (2009), *Official Gazette* No. 27364, 2 October 2009.
24. https://www.architectsjournal.co.uk/home/kpf-reveals-images-of-two-tower-turkish-debut/8657219.article (accessed on 19 October 2015).
25. http://www.tabanlioglu.com/project/vakifbank-headquarters/ (accessed on 20 October 2015).
26. The first tender was submitted in 16 September 2005 and the highest bid was made by a consortium formed by Royal Caribbean Cruise and Global Investment Holding. The bid included a total payment of 3.5 billion euros for 49 years of lease: 'Royal Galataport'a 3.5 milyar euro teklif etti', *Milliyet*, 17 September 2005.
27. The site-specific master plan was made by the Ministry of Tourism and Culture rather than the Office of Privatisation which, according to the court's ruling, was legally obliged to deal with such planning amendments.
28. The new master plan was rejected by the Council of Protection of Cultural and Natural Items in 2007 and the following year the court, acting upon an application made by the Chamber of Architects, cancelled the Beyoğlu Master Plan. The next move by the government came in 2010, resulting in the legislation governing the shorelines being amended, including switching the heritage legislation off at the designated shorelines. At the end of this long struggle between the government and the NGOs and professional organisations the site was tendered once more in 2013. In the new tender documents the leasing period was reduced to 30 years and the permissible floor space was reduced by 25 per cent. Also, a new project has been commissioned from a partnership between the San Francisco-based architecture firm Gensler and New York-based Studio Dror, although the details of the new design have yet to been publicly released.
29. 'Haydarpaşa'da tren düdükleri yine duyulacak', *Yeni Şafak*, 17 August 2014.
30. The new square was first used by prime minister Erdoğan in his public speech on the lead-up to the municipal elections which were held on 30 March 2014. In his speech Erdoğan spoke to a large crowd, according to some estimates 1.5 million people: 'AK Parti'den Yenikapı'da dev miting', *Sabah*, 23 March 2014.
31. Alevi groups in Turkey, as well as some scholars, claim that during Yavuz Sultan Selim's campaign against Iran around 40,000 Alevis were massacred in Eastern Anatolia. The Ottoman archival documents, however, do not verify these claims and, according to many historians, while leaders of the insurgent Alevi groups were killed, it was the impact of this act that affected the social memory of the Alevis. For detailed reading see:

Colin Imber, 'Persecution of the Ottoman Shi'ites according to Mühimme Defterleri 1565–1585', *Islam* 36 (1979), pp. 245–73.

32. According to the images released in architectural platforms and the media, the extremely large Terminal 1 will be covered by a vaulted ceiling rising over slender columns, and generous skylights will penetrate the roof, maximising the amount of natural light: https://nordicarch.com/project/istanbul-new-airport (accessed on 15 September 2016)
33. 'Havalimanı değil Aeropropolis', *Radikal*, 26 March 2015.
34. The growth in the construction industry during the AK Party years was significantly higher than the growth in the GNP, except for 2014. In 2008 and 2009, when the Turkish economy showed a negative growth rate, the construction industry shrank more than the average general economic performance: Türkiye Müteahhitler Birliği, *İnşaat Sektörü Analizi*, April 2015, p. 13.
35. 'AK Parti Seçim Beyannamesi 2002: Herşey Türkiye İçin', p. 96: http://www.akparti.org.tr/site/dosyalar#!/secim-beyannameleri (accessed on 14 November 2014). The total length of dual carriageways in Turkey in 2002 was 4,326 kilometres, which increased fivefold to 21,874 kilometres in 2015: Karayolları genel Müdürlüğü: http://www.kgm.gov.tr/SiteCollectionDocuments/KGMdocuments/Projeler/BolunmusYolProjeleri/BolunmusYolProjeleri.pdf (accessed on 18 September 2016).
36. Turkish Statistical Institute: https://biruni.tuik.gov.tr/yapiizin/giris.zul (accessed on 25 February 2015).
37. Türkiye Bankalar Birliği İstatistiki Raporlar: www.tbb.org.tr/tr/banka-ve-sektor-bilgileri/istatistiki-raporlar/--2014---tuketici-kredileri-ve-konut-kredileri-/2427 (accessed on 15 February 2015).
38. Turkish Statistical Institute: http://www.tuik.gov.tr/UstMenu.do?metod=temelist (accessed on 25 June 2016).
39. '5273 Sayılı Arsa Ofisi Kanunu ve Toplu Konut Kanununda Değişiklik Yapılması ile Arsa Ofisi Genel Müdürlüğü'nün Kaldırılması Hakkında Kanun', *Official Gazette* No.25671, 15 December 2004.
40. TOKİ Konut Üretim Raporu: http://www.toki.gov.tr/AppResources/UserFiles/files/FaaliyetOzeti/ozet.pdf (accessed on 20 October 2016).
41. 'TOKİ'nin ilk "Yerel Mimari Uygulama Projesi" tamamlandı': https://www.toki.gov.tr/haber/tokinin-ilk-yerel-mimari-uygulama-projesi-tamamlandi (accessed on 15 March 2016).
42. Lucy Scott and et. al., *Emerging Trends in Real Estate Europe*, PricewaterhouseCoopers & the Urban Land Institute (Washington D.C., 2011).
43. The Ministry of Environment and Urbanisation: http://www.csb.gov.tr/gm/altyapi/index.php?Sayfa=sayfa&Tur=banner&Id=114 (accessed on 20 October 2016).
44. As of 2016 a total of 1,106.25 hectares of urban land has been declared as an area under risk. The Ministry of Environment and Urbanisation: http://www.csb.gov.tr/iller/istanbulakdm/index.php?Sayfa=sayfa&Tur=webmenu&Id=10108 (accessed on 20 October 2016).

45. In line with the increasing popularity of shopping malls over traditional marketplaces, and gated communities over traditional neighbourhoods, scholars from various disciplines have described how the change has brought with it a new phenomenon: semi-public space. For detailed reading on how such private spaces have been taking over the traditional places in the case of shopping centres and gated community precincts, see: Margaret Kohn, *Brave New Neighborhoods: The Privatization of Public Space* (New York, 2004).
46. *European Shopping Centre Development Report*, Cushman & Wakefield Research Publication, April 2015: http://www.cushmanwakefield.com/~/media/global-reports/European%20Shopping%20Centre%20Development%20Report%20April%202015.pdf (accessed on 25 June 2016).
47. Maptriks databases cited in http://www.yapi.com.tr/haberler/iste-turkiyenin-avm-haritasi_129996.html (accessed on 15 June 2016).
48. Cevahir Shopping Mall, Trump Towers and Shopping Centre, Astoria Towers, Zorlu, Metrocity, Özdilek Park İstanbul, Kanyon and Sapphire are the extremely large-scale, mixed–use developments lined along Büyükdere Street. For a detailed reading on the shopping malls and mixed used development in this part of Istanbul see: Murat Gül and Trevor Howells, *Istanbul Architecture* (Boorowa, 2013), pp. 167–7.
49. Between 2010 and 2014 the real estate industry in Turkey received direct foreign investment to a total of US$16 billion which made up 22.5 per cent of total foreign investment made in Turkey in this period: *Invest in Turkey*, The Republic of Turkey Prime Ministry Investment Support and Promotion Agency: http://www.invest.gov.tr/en-US/investmentguide/investorsguide/Pages/FDIinTurkey.aspx (accessed on 20 September 2016).
50. Suha Özkan and Philip Jodidio, *A Vision in Architecture: Projects for the Istanbul Zorlu Center* (London, 2012).
51. 'Traş etmedi ben de küstüm', *Hürriyet*, 13 April 2013.
52. Cansu Kılınçarslan, 'Taksim yayalaştırma projesi nedir?', *Toplumsal Tarih Dergisi* 218/2 (2012), pp. 17–20; Ersen Gürsel, 'İstanbul kenti en önemli meydanını kaybedebilir!', *Mimarlık Dergisi* 364 (2012), pp. 23–6.
53. Esra Akcan, for example, made the point that 'architectural representation' was an important vehicle to leave 'a permanent stamp' on a country, and the government's attempts to replace the Republican-created Gezi Park and AKM with neo-Ottoman buildings was a vivid example of this 'syndrome'. Esra Akcan, 'Fiziksel ve sanal kamusal mekanın keşfi', *XXI* 121 (2013), p. 31. Also Korhan Gümüş, the president of the Human Settlements Association and a member of the Taksim Solidarity Group, described the project as an example of 'authoritarian urban management', Kılınçarslan: 'Taksim', pp. 17–20.
54. Nur Akın, 'Yeni Tarihi Yapı?: Taksim Topçu Kışlası', *Mimarlık Dergisi* 364 (2012), pp. 27–8.
55. Gülşen Özaydın, a professor in urban design with specialised knowledge of Istanbul's urban planning history, believed the proposal recalled the nineteenth-century concept of *sventramenti* in that it would create significant environmental problems, alter the

character of the space and not help the proposed pedestrianisation: Gülşen Özaydın, 'Taksim'in üstü altına iniyor', *Mimarlık Dergisi* 364 (2012), pp. 19–22.

56. Gümüş argues that the Prost project in the 1930s was not an ordinary planning activity, but more an implementation of the 'Republican manifesto' for Istanbul, making Taksim a fertile place for controversy between Republican ideology and conservative values: Hülya Ertaş, 'Taksim düğümü nasıl çözülür?', *XXI* 103 (2011), pp. 32–8. Betül Tanbay, a professor of mathematics and an active member of the Taksim Platform, for example, links the date of approval for the reconstruction of the barracks to a military intervention against the Islamic party government in 1997 that occurred on the very same day 15 years earlier. She further claims the decision was deliberately taken on that date for vengeance. Emre Kongar and Aykut Küçükkaya, *Gezi Direnişi* (Istanbul, 2013).

57. One of the passionate politicians who promoted the idea of the construction of a mosque in Taksim was Necmettin Erbakan. Before and during the highly problematic years of his short-lived prime ministership he frequently claimed that despite all the barriers set up by the bureaucracy, a mosque in Taksim Square would be built in line with the public's wishes: 'Taksim'de camiyi parka yapacağız' (no author), *Milliyet*, 9 January 1995.

58. 'Taksim'e cami adı altında çarşı', *Milliyet*, 12 August 1994.

59. For a detailed reading on the Gezi protests see: Murat Gül, John Dee & Cahide Nur Cünük, 'Istanbul's Taksim Square and Gezi Park: the place of protest and the ideology of place', *Journal of Architecture and Urbanism* 38/1 (2014), pp. 63–72.

60. P. Barbera and M. A. Metzger, 'Breakout role for Twitter in the Taksim Square protests?', *Al Jazeera*, 1 June 2013 [online], [cited 8 October 2013] http://www.aljazeera.com/indepth/opinion/ 2013/06/201361212350593971.html (accessed on 15 January 2014).

61. Prime Minister Erdoğan in his press conference on 1 June acknowledged the protestors right to express their opinion but, at the same time, stated that some extremist groups had manipulated the 'good will of the demonstrators'. He then blamed the extremists for being responsible for the vandalism: 'Başbakan'dan Gezi Parkı açıklaması', *Sabah*, 1 June 2013.

62. The Divan Hotel's support for protesters during the Gezi incidents brought the hotel the 'Hospitality Innovation Award' given by Munich-based PKF Hotelexperts: 'Divan Otel'e "Gezi protestolarındaki cesareti" için dev ödül', *Hürriyet*, 9 October 2013.

63. 'Koç Holding'e 'Gezi Parkı' şoku', *Star*, 14 June 2013.

64. One released by Laura Lucas, spokesperson for the White House National Security Council, warned that non-violent demonstrations were 'a part of democratic expression, and we expect public authorities to act responsibly and with restraint'. The European Parliament too released a resolution urging Turkey to consult with the public over issues related to the city and urban development plans and condemned the 'disproportionate and excessive use of force' by police in the Gezi Park protests: European Parliament JMR, 13 June 2013: http://www.europarl.europa.eu/oeil/popups/summary.do?id=1277156&t=d&l=en (accessed on 10 October 2013).

Epilogue

1. For a detailed reading on Turkey's politics in the Balkans see: Mehmet Uğur Ekinci, 'A golden age of relations: Turkey and the Western Balkans during the AK Party period', *Insight Turkey* 16/1 (2014), pp.103-25. Also, through TİKA, the Turkish Corporation and Coordination Agency, Turkey has conducted a large number of social and infrastructural works in the Balkans, the Middle East, Africa and many other parts of the world, including Central Asia, the Asia Pacific and even South America. For detailed reading on TİKA's projects and aims see: *Turkish Corporation and Coordination Agency 2013 Annual Report* (Ankara, 2014).
2. Cenk Saraçoğlu and Özhan Demirkol, 'Nationalism and foreign policy discourse in Turkey under the AKP rule: geography, history and national identity', *British Journal of Middle Eastern Studies* 42/3 (2015), pp.301-19.
3. Erdoğan, during the Gezi uprisings, publicly announced on various occasions his views on the replacement of the derelict AKM with a Baroque opera building. While this statement opened a fresh debate in the architectural community on the prime minister's stylistic choices, the recent proposals revealed in the media indicate that the government has changed its position and now proposes a new opera building representing contemporary architectural fashion.
4. A public referendum held in 2007 had introduced a series of amendments to the constitution, including direct election of the president by a public vote.
5. Although in a general election on 7 June 2015, the AK Party came first with 41 per cent of the vote, 15 percentage points ahead of the second party, it lost the absolute majority in the parliament and was forced to seek a coalition partner to form government. However, the optimism shared by AK Party opponents soon disappeared once it was understood that, except for animosity towards Erdoğan, the opposition parties shared very little and could not establish a coalition government. Therefore, the political marathon was completed by an early election on 1 November of the same year. Once again, the AK Party increased its vote, winning 50 per cent to secure an easy majority in the parliament and formed a new government.
6. All the evidence signalled that the coup attempt was secretly orchestrated by Fetullah Gülen, a former imam and preacher who has been in self-imposed exile in the United States since 1999. Gülen is known for his network of schools, which operate both in Turkey and many other countries, and for his 'charitable' activities undertaken through many NGOs, foundations and other institutions. Since the 1980s many governments, regardless of their political persuasion, have candidly supported Gülen, and he had received backing by Erdoğan. However, in 2012 the relationship between the AK Party and the Gülen movement began to sour and gradually became an overt battle when Gülen's supporters launched an undeclared war against the government and planned furtive attacks by police, judges and members of the media controlled by Gülen. While some segments of society had long voiced the belief that for many decades Gülen's supporters had been infiltrating the army, police, justice system, schools, universities, the

media and many other strategic institutions with the aim of gradually seizing control of the country, nobody was expecting the scale and vicious nature of the action.
7. During the coup attempt the National Assembly and Presidential Palace in Ankara were heavily shelled by airstrikes in the early hours of 16 July. Nobody expected such a harsh response from the military, which had always been held in high respect by the society. This fuelled anger amongst the Turkish people and protests soon spread in all cities across Turkey. The great majority of the media, regardless of political tendencies, stood firmly against the military takeover and supported the resistance organised by Erdoğan and the government through their live broadcasts. Opposition parties also condemned the coup attempt and braced the government. The clash between the military and the public continued until the following day and, finally, the leaders of the junta yielded or were captured by police forces or military groups which did not participate in the coup attempt and took sides with the government.
8. Since the 1980s the idea of a presidential system has been placed sporadically on the public agenda by various parties in Turkey. After many years of debate, the Turkish Parliament has recently passed a bill to change the constitution to enable a switch from a parliamentary system to a presidential system. According to the AK Party and its supporters, a presidential system will unify political power and provide a better system by which to govern the country, with separate branches of execution (president) and legislature (parliament). On the other hand, the opposition, which since 2002 has lost all elections against Erdoğan, severely criticises the bill and claims that the new proposal will eventually lead Turkey to one-man rule. According to the legislation, a public referendum to be held in mid-April will have the final word on this important proposal.
9. Jane Jacobs, *The Death and Life of Great American Cities* (New York, 1961), p.6.

Bibliography

7 Yıl İçinde Vilâyet ve Belediyece Yapılan İşler 1949-1955 (Istanbul: İstanbul Belediye Matbaası, 1956).
Ahmad, Feroz, *The Making of Modern Turkey* (London: Routledge, 1993).
Akcan, Esra, 'Fiziksel ve sanal kamusal mekanın keşfi', *XXI* 121 (2013), p. 31.
Akdoğan, Yalçın, 'The meaning of conservative democratic political identity', in M. Hakan Yavuz (ed.), *The Emergence of a New Turkey: Islam Democracy and the AK Parti* (Utah: University of Utah Press), 2006.
Akın, Nur, 'Yeni tarihi yapı?: Taksim Topçu Kışlası', *Mimarlık Dergisi* 364 (2012), pp. 27-8.
Akipek, Jale G., 'Türk hukukunda kat mülkiyeti', *Ankara Barosu Dergisi* 23/3 (1966), pp. 475-90.
Alexandris, Alexis, *The Greek Minority in Istanbul and Greek: Turkish Relations 1918-1974* (Athens: Center for Asia Minor Studies, 1992).
Amaç Yeşili ve Maviyi Kurtarmak: Haliç (Istanbul: İstanbul Büyükşehir Belediyesi, 1988).
Aptullah Ziya, 'Sanatta nasyonalizm', *Mimar* 2 (1934), pp. 51-4.
Arslan, Rıfkı, 'Gecekondulaşmanın evrimi', *Mimarlık* 6 (1989), pp. 34-7.
Aru, Kemal Ahmet, 'Levend 4. Mahallesi', *Arkitekt* 3 (1956), pp. 140-53.
—— and Gorbon, Rebii, 'Levend Mahallesi', *Arkitekt* 9-10 (1952), pp. 174-81.
Auric, André, 'La reconstruction de Stamboul', *Génie Civil Ottoman* 1 (1912), pp. 4-5.
—— 'Rapport général du service technique de la préfecture', *Génie Civil Ottoman* 1 (1911), pp. 1-4.
Banoğlu, Niyazi Ahmet, *Taksim Cumhuriyet Abidesi Şeref Defteri* (Istanbul: Büyük İstanbul Derneği, 1973).
Batur, Afife, *İstanbul Vakıflar Bölge Müdürlüğü Mimar Kemaleddin Proje Kataloğu* (Ankara: TMMOB Mimarlar Odası/Vakıflar Genel Müdürlüğü, 2009).
Baysal, Halûk and Birsel, Melih, 'Hukukçular Sitesi', *Arkitekt* 4 (1970), pp. 157-8.
Baysun, M. Cavid, 'Mustafa Reşid Paşa'nın siyasi yazıları', *Tarih Dergisi* 11/15 (1960), pp. 121-42.
Behçet and Bedrettin, 'Mimarlık ve Türklük', *Mimar* 1 (1934), pp. 17-20.
—— 'Türk inkilap mimarisi', *Mimar* 9-10 (1933), pp. 265-6.
Beyatlı, Yahya Kemal, *Aziz İstanbul* (Istanbul: İstanbul Fetih Cemiyeti Yayınları, 2006).
Bianchi, Ruben Abel, 'The works of Luigi Piccinato in Islamic countries 1925-1981', *Environmental Design: Journal of the Islamic Environmental Design Research Centre* (1990), pp. 184-91.
Blockmans, Wim P., 'Reshaping cities: the staging of political transformation', *Journal of Urban History* 30/1 (2003), pp. 7-20.
Bölükbaşı, H. Tolga, 'Political economy', in Metin Heper and Sabri Sayarı (eds.), *The Routledge Handbook of Modern Turkey* (Abingdon: Routledge, 2012).
Bozdoğan, Sibel, *Modernism and Nation Building: Turkish Architectural Culture in the Early Republic* (Seattle: University of Washington Press, 2001).

Bibliography

——— 'Democracy, Development and the Americanization of Turkish Architectural Culture', in Sandy Isenstadt and Kishwar Rizvi (eds.) *Modernism and the Middle East: Architecture and Politics in the Twentieth Century* (Seattle: University of Washington Press, 2008).

Bozdoğan, Sibel and Akcan, Esra, *Turkey: Modern Architectures in History* (London: Reaktion Books, 2012).

Burhan Arif, 'İstanbulun plânı', *Mimar* 3/5 (1933), pp. 155, 160.

——— 'Türk mimarisi ve beynelmilel mimarlık vasıfları', *Mimar* 11–12 (1931), pp. 365–6.

——— 'Türk şehirlerinin bünyesi', *Mimar* 1 (1932), pp. 1–3.

Can, Selman, *Bilinmeyen Aktörleri ve Olayları İle Son Dönem Osmanlı Mimarlığı* (İstanbul: Erzurum İl Kültür ve Turizm Müdürlüğü, 2010).

Celâl, B. O., 'Büyük inkilâp önünde milli mimari meselesi', *Mimar* 6 (1933), pp. 163–4.

Cengizkan, Ali (ed.), *Mimar Kemalettin ve Çağı, Mimarlık/Toplumsal Yaşam/Politika* (Ankara: TMMOB Mimarlar Odası/Vakıflar Genel Müdürlüğü, 2009).

Çetinsaya, Gökhan, *Büyüme, Kalite, Uluslararasılaşma: Türkiye Yükseköğretimi İçin Bir Yol Haritası* (Eskişehir: Yükseköğretim Kurulu, 2014).

Cizre, Ümit, 'The anatomy of the Turkish military's political autonomy', *Comparative Politics* 29/2 (1997), pp. 157–66.

——— (ed.), *The Turkish AK Party and its Leader: Criticism, Opposition and Dissent* (New York: Routledge: 2016).

Cohn, Edwin J., *Turkish Economic Social and Political Change: The Development of a More Prosperous and Open Society* (New York: Praeger, 1970).

Cornell, Svante E., 'Turkey: return to stability?', in Sylvia Kedourie (ed.), *Seventy-five Years of the Turkish Republic* (New York: Routledge, 2007), pp. 216–8.

Damlacı, Turhan, 'Etap oteli İstanbul', *Arkitekt* 1 (1980), pp. 4–7.

Davison, Roderic H., *Essays in Ottoman and Turkish History 1774–1923: The Impact of the West* (Austin: University of Texas Press, 1990).

Deleon, Jak, *The White Russians in Istanbul* (Istanbul: Remzi Kiabevi, 1995).

Demir, Kemal and Çabuk, Suat, 'Türkiye'de metropoliten kentlerin nüfus değişimi', *Sosyal Bilimler Enstititüsü Dergisi* 28/1 (2010), pp. 193–215.

Demiren, Şemsa, 'Le Corbusier ile mülâkat', *Arkitekt* 19/11–12 (1949), pp. 230–1.

Denktaş, Adil, 'Kira evi', *Arkitekt* 5–6 (1936), pp. 133–8.

Duyuran, Rüstem, 'Belediye sarayı mozaikleri', *Arkitekt* 9–12 (1954), pp. 166–70.

Ehlgötz, Herman, *İstanbul Şehrinin Umumi Planı* (Istanbul: Ali Sait Matbaası, 1934).

Ekinci, Mehmet Uğur, 'A golden age of relations: Turkey and the Western Balkans during the AK Party period', *Insight Turkey* 16/1 (2014), pp. 103–25.

Ekinci, Oktay, *İstanbul'u Sarsan On Yıl* (Istanbul: Anahtar Kitaplar, 1994).

Eldem, Edhem, 'The (Imperial) Ottoman Bank, Istanbul', *Financial History Review* 6 (1996), pp. 85–95.

——— '26 Ağustos 1896 'Banka Vakası' ve 1896 'Ermeni Olayları'', *Tarih Toplum* 5 (2007), pp. 113–46.

Eldem, Sedad Hakkı, '1inci Türk Mimarlık Kongresi mimarlık grubu Vinci kol raporu', *Arkitekt* 7–8 (1946), pp. 194–7.

——— 'Taşlık Kahvesi', *Arkitekt* 11–12 (1950), pp. 207–10.

Bibliography

Emrence, Cem, 'Dünya krizi ve Türkiye'de toplumsal muhalefet: Serbest Cumhuriyet Fırkası', in Murat Yılmaz (ed.), *Modern Türkiye'de Siyasi Düşünce: 7 Liberalizm* (Istanbul: İletişim Yayınları, 2005), pp. 213-6.

Ergin, Osman Nuri, *İstanbulda İmar ve İskân Hareketleri* (Istanbul: Bürhaneddin Matbaası, 1938).

────── *Mecelle-i Umûr-ı Belediyye* (Istanbul: İstanbul Büyükşehir Belediyesi Kültür İşleri Daire Başkanlığı Yayınları, 1995).

Ergün, Murat, 'Istanbul Metrobüs: first intercontinental bus rapid transit', *Journal of Transport and Geography* 24 (2012), pp. 58-66.

Erman, Ercüment, 'Earthquake failure of reinforced concrete buildings: the case of the 1999 earthquakes in Turkey', *Architectural Science Review* 47/1 (2004), pp. 71-80.

Ersoy, Ahmet, *Architecture and the Late Ottoman Historical Imaginary: Reconfiguring the Architectural Past in a Modernizing Empire* (Surrey: Ashgate, 2015)

Ertaş, Hülya, 'Taksim düğümü nasıl çözülür?', *XXI* 103 (2011), pp. 32-38.

Erten, Özlem İnay, *A Mansion in Şişli and Architect Giulio Mongeri* (Istanbul: Bozlu Art Project, 2016).

Esat, Mehmet, *Mirat-i Mühendishane-i Berri Hümayun* (Istanbul, 1895).

Geniş, Şerife, 'Producing elite localities: the rise of gated communities in Istanbul', *Urban Studies* 44/4 (2007), pp. 771-98.

Gökalp, Ziya, *The Principles of Turkism* (Leiden: E. J. Brill, 1968).

Gül, Murat, *The Emergence of Modern Istanbul: Transformation and Modernisation of a City* (London: I.B.Tauris, 2012).

Gül, Murat and Howells, Trevor, *Istanbul Architecture* (Boorowa: Watermark Press, 2013).

Gül, Murat, Dee, John and Cünük, Cahide Nur, 'Istanbul's Taksim Square and Gezi Park: the place of protest and the ideology of place', *Journal of Architecture and Urbanism* 38/1 (2014), pp. 63-72.

Gündoğdu, Raşit, et al. (eds.), *Osmanlı Mimarisi: Usul-i Mi'mari-i Osmani* (Istanbul, 2010).

Güngör, Hulusi, 'Belki 5 yıllık planın sayesinde…', *Mimarlık* 3 (1963), pp. 1-2.

Gürsel, Ersen 'İstanbul kenti en önemli meydanını kaybedebilir!', *Mimarlık Dergisi* 364 (2012), pp. 23-26.

Gürsel, Yücel, 'Tarlabaşı yıkımının perde arkası', *Mimarlık* 2 (1986), pp. 21-2.

Güzelleşen İstanbul (Istanbul: İstanbul Belediyesi, 1943).

Hamlin, A. D., *The Text Book of the History of Architecture* (New York: Longmans, Green and Co., 1909).

Hammond N. G. L., and Roseman, L. J., 'The Construction of Xerxes' Bridge over the Hellespont', *The Journal of Hellenic Studies* 116 (1996), pp. 88-107.

Hasol, Doğan, 'Zavallı İstanbul', *Yapı* 113 (1991), p. 9.

Hershlag, Zvi Yehuda, *Turkey: the Challenge of Growth* (Leiden: E. J. Brill, 1968).

Hobsbawm, Eric J., 'From social history to the history of the society', in Felix Gilbert, Stephen R. Graubard and Eric J. Hobsbawm (eds.), *Historical Studies Today* (New York: W. W. Norton, 1972).

İçduygu, Ahmet and Sirkeci, İbrahim, 'Cumhuriyet dönemi Türkiye'sinde göç hareketleri', in Oya Köymen (ed.), *75 Yılda Köylerden Şehirlere* (Istanbul: Tarih Vakfı Yurt Yayınları, 1999).

Bibliography

Imber, Colin, 'Persecution of the Ottoman Shi'ites according to Mühimme Defterleri 1565-1585', *Islam* 36 (1979), pp. 245-73.

İnalcık, Halil, 'Sened-i İttifak ve Gülhane Hatt-ı Hümâyunu', *Belleten* 28/109-112 (1964), pp. 603-22.

İstanbul İmar Plânı İzah Raporları: I. Beyoğlu Ciheti (Istanbul, 1954).

İstanbul İmar Plânı İzah Raporları: 2. İstanbul Ciheti (Istanbul, 1956).

İstanbul Ulaşımında 50 Yıl (Ankara: Karayolları Genel Müdürlüğü Matbaası, 1974).

İstatistik Göstergeler/Statistical Indicators, 1923-2006 (Ankara: Türkiye İstatistik Kurumu, 2007).

İstatistik Göstergeler/Statistical Indicators, 1923-2011 (Ankara: Türkiye İstatistik Kurumu, 2012).

Jacobs, Jane, *The Death and Life of Great American Cities* (New York: Vintage Books, 1961).

Karaömerlioğlu, M. Asım, 'The Village Institutes experience in Turkey', *British Journal of Middle Eastern Studies* 25/1 (1998), pp. 47-73.

Karpat, Kemal, *Turkey's Politics: The Transition to a Multi-party System* (Princeton: Princeton University Press, 1959).

—— 'Political developments in Turkey, 1950-1970', *Middle Eastern Studies* 8/3 (October, 1972), pp. 349-75.

—— *The Gecekondu: Rural Migration and Urbanization* (Cambridge: Cambridge University Press, 1976).

Kaya, Raşit and Çakmur, Barış, 'Politics and the mass media in Turkey', *Turkish Studies* 11/4 (2010), pp. 521-37.

Keleş, Ruşen, *Türkiyede Şehirleşme Hareketleri 1927-1960* (Ankara: Maliye Enstitüsü, 1961).

Kerwin, Robert W., 'The Turkish roads program', *The Middle East Journal* 4 (1950), pp. 196-208.

Keyder, Çağlar, 'Economic development and crisis: 1950-1980', in Irvin C. Schick and Ertuğrul A. Tonak (eds.), *Turkey in Transition: New Perspectives* (New York: Oxford University Press, 1987).

—— *State and Class in Turkey: A Study in Capitalist Development* (London: Verso, 1987).

—— 'A tale of two neighbourhoods', in Çağlar Keyder (ed.), *Istanbul Between the Global and the Local* (Lanham: Rowman&Littelefield, 1999).

Kılçık, Halûk (ed.), *Adnan Menderes' in Konuşmaları-Demeçleri-Makaleleri: 9* (Ankara: Demokratlar Kulübü Yayınları, 1992).

Kılınçarslan, Cansu, 'Taksim yayalaştırma projesi nedir?', *Toplumsal Tarih Dergisi* 218/2 (2012), pp. 17-20.

Kohn, Margaret, *Brave New Neighborhoods: The Privatization of Public Space* (New York: Routledge, 2004).

Kongar, Emre and Küçükkaya, Aykut, *Gezi Direnişi* (Istanbul: Cumhuriyet Kitapları, 2013).

Konuralp, Mehmet, 'Gazete tesisi tasarımı ve çağdaş teknoloji', *Tasarım* 29 (1992), pp. 48-59.

Kostof, Spiro, 'Cities and turfs', *Design Book Review* 10 (1986), p. 36.

—— *The City Shaped: Urban Patterns and Meanings Through History* (London: Thames & Hudson, 1999).

Kumral, Bülent, 'Zeki Sayar'la söyleşi', *Yapı* 152 (1994), pp. 44-52.

Bibliography

Lewis, Bernard, *The Emergence of Modern Turkey* (New York: Oxford University Press, 2002).
Makal, Mahmut, *Bizim Köy: Bir Öğretmenin Notları* (Istanbul: Varlık Yayınevi, 1950).
Mehmed Ziya Bey, *İstanbul ve Boğaziçi* (Istanbul: Maarif-i Umumiye Nezareti Telif ve Tercüme Dairesi, 1917).
Menteşe, Ertuğrul, 'Ataköy Sitesi hakkında rapor', *Arkitekt* 2 (1958), pp. 79–82.
Mimar Abidin, 'Bugünün Türk mimarı', *Mimar* 26 (1933), pp. 33–4.
—— 'Memlekette Türk mimarının yarınki vaz'iyeti', *Mimar* 5 (1933), pp. 129–30.
Mimar Servet, 'Apartman inşaatı', *Mimar* 7 (1931), pp. 217–9.
Mimar Zühtü, 'Bir kuru kahveci ticarethanesi', *Mimar* 4 (1933), pp. 105–8.
Moltke, Helmuth von, *Briefe über Zustände und Begebenheiten in der Türkei aus den Jahren 1835 bis 1839* (Berlin: E.S. Mittler&Sohn, 1893).
Murat, Sedat, Şanver, Cahit and Ersöz, Halis Y. (eds.), *İstanbul Külliyâtı/Cumhuriyet Dönemi İstanbul İstatistikleri, 10-Ulaştırma (1933–1996)* (Istanbul: İstanbul Büyükşehir Belediyesi Kültür İşleri Daire Başkanlığı, 1998).
—— *İstanbul Külliyâtı/Cumhuriyet Dönemi İstanbul İstatistikleri, 13-Sanayi I (İmalat) (1932–1982)* (Istanbul: İstanbul Büyükşehir Belediyesi Kültür İşleri Daire Başkanlığı, 1998).
Neftçi, Aras, 'Nuruosmaniye Camii açılış töreni', *Sanat Tarihi Defterleri* 11 (2007), pp. 1–24.
—— '19. Yüzyıl Başında Hassa Mimarlar Ocağı'ndan Hendesehane'ye dönüşüme ilişkin önemli bir belge', *Mimarist* 50 (2014), pp. 48–51.
Oberling, P., 'The Istanbul Tünel', *Archivum Ottomanicum* 4 (1972), pp. 217–63.
Ökte, Faik, *The Tragedy of the Turkish Capital Tax* (London: Groom Helm, 1987).
Öniş, Ziya, 'Beyond the 2001 financial crisis: the political economy of the new phase of neo-liberal restructuring in Turkey', *Review of International Political Economy* 16/3 (2009), pp. 409–32.
—— 'Turgut Özal and his economic legacy: Turkish neo-liberalism in critical perspective', *Middle Eastern Studies* 40/4 (2014), pp. 113–34.
Özatay, Fatih, 'The 1994 currency crisis in Turkey', *The Journal of Policy Reform* 3/4 (2000), pp. 327–52.
Özaydın, Gülşen, 'Taksim'in üstü altına iniyor', *Mimarlık Dergisi* 364 (2012), pp. 19–22.
Özer, Bülent, *Rejyonalism, Üniversalism ve Çağdaş Mimarimiz Üzerine Bir Deneme* (İstanbul Teknik Üniversitesi, published PhD thesis, 1970).
Özgür, İren, 'Arabesk music in Turkey in the 1990s and changes in national demography, politics and identity', *Turkish Studies* 7/2 (2006), pp. 175–90.
Özkan, Suha and Jodidio, Philip, *A Vision in Architecture: Projects for the Istanbul Zorlu Center* (London: Rizoli, 2012).
Özyüksel, Murat, *Osmanlı-Alman İlişkilerinin Gelişim Sürecinde Anadolu ve Bağdat Demiryolları* (Istanbul: Arba, 1988).
Pamuk, Şevket, 'Economic change in twentieth-century Turkey: Is the glass more than half full?', in Reşat Kasaba (ed.), *The Cambridge History of Turkey, Volume 4: Turkey in the Modern World* (Cambridge: Cambridge University Press, 2008).
Parla, Taha, *The Social and Political Thought of Ziya Gökalp: 1876–1924* (Leiden: Brill, 1985).
Patton, Marcie J., 'The Synergy between Neoliberalism and Communitarianism: "Erdoğan's Third Way"', *Comparative Studies of South Asia, Africa and the Middle East* 29/3 (2009), pp. 438–9.

Bibliography

Prost, Henri, *İstanbul Nâzım Plânını İzah Eden Rapor* (Istanbul, 1938).
Quataert, Donald, *The Ottoman Empire: 1700-1922* (Cambridge: Cambridge University Press, 2005).
Rivkin, Malcolm D., *Area Development for National Growth; The Turkish Precedent* (New York: Praeger, 1965).
Rosenthal, Steven T., 'Foreigners and municipal reform in Istanbul: 1855-1865', *International Journal of Middle East Studies* 11/2 (1980), pp. 227-45.
—— *The Politics of Dependency: Urban Reform in Istanbul* (Connecticut: Greenwood Press, 1980).
Rüzgar, Ali, 'Beyoğlu Otoyol Planı', *Mimarlık* 2 (1986), pp. 20-1.
Saraçoğlu, Cenk and Demirkol, Özhan, 'Nationalism and foreign policy discourse in Turkey under the AKP rule: geography, history and national identity', *British Journal of Middle Eastern Studies* 42/3 (2015), pp. 301-19.
Sayar, Zeki, 'Beyazıt Meydanından alacağımız ders!', *Arkitekt* 27 (1958), pp. 53-4.
—— 'İç kolonizasyon - Başka Memleketlerde', *Arkitekt* 8 (1936), pp. 231-5.
—— 'Yabancı teknik elemanlar meselesi', *Arkitekt* 7-8 (1953), pp. 119-20.
—— 'İstanbul'un imârı münasebetiyle', *Arkitekt* 2 (1956), pp. 49-51.
—— 'İstanbul'un imârında şehirci mimarın rolü', *Arkitekt* 25 (1956), pp. 97-8.
—— 'İmar ve eski eserler', *Arkitekt* 26 (1957), pp. 49-50.
—— 'İstanbulun imarı hakkında düşünceler!', *Arkitekt* 26 (1957), pp. 3, 11.
—— 'Yapı ve imarda yeni ruh', *Arkitekt* 2 (1960), pp. 51-2.
Scognamillo, Giovanni, *Türk Sinema Tarihi-I 1896-1959* (Istanbul: Metis, 1990).
Scott, Lucy and et. al., *Emerging Trends in Real Estate Europe*, PricewaterhouseCoopers & the Urban Land Institute, (Washington D.C., 2011).
Sey, Yıldız, *Türkiye Çimento Tarihi* (Istanbul: TÇMB Yayınları, 2004).
Shambayati, Hootan, 'Democracy, secularism and Islam: examining the Turkish model', in Lucia Volk (ed.), *The Middle East in the World: An Introduction* (New York: Routledge, 2015).
Shaw, Stanford J., 'The population of Istanbul in the nineteenth century', *International Journal of Middle East Studies* 10/2 (1979), pp. 265-77.
—— and Shaw, Ezel K., *History of the Ottoman Empire and Modern Turkey, Volume I, Empire of the Gazis: The Rise and Decline of the Ottoman Empire, 1280-1808* (Cambridge: Cambridge University Press, 1976).
—— *History of the Ottoman Empire and Modern Turkey, Volume II, Reform, Revolution and Republic: The Rise of Modern Turkey, 1808-1975* (Cambridge: Cambridge University Press, 1977).
Stave, B. M., 'In pursuit of urban history: conversations with myself and others - a view from the United States', in Derek Fraser and Anthony Sutcliffe (eds.), *The Pursuit of Urban History* (London: E. Arnold, 1983).
Summerson, John, 'Urban forms', in Oscar Handlin and John E. Burchard (eds.), *The Historian and the City* (Cambridge, 1963), pp. 165-76.
Tabanlıoğlu, Hayati (ed.), *Yeşilköy Havalimanı Yeni Terminal Binası - Yeşilköy Airport New Terminal Building* (Ankara: T.C. Bayındırlık Bakanlığı, 1983).

Bibliography

Talen, Emily (ed.), *Charter of the New Urbanism: Congress for the New Urbanism* (New York: McGraw-Hill, 1999).

Tankut, Gönül, *Bir Başkentin İmarı* (Istanbul: Anahtar Kitaplar Yayınevi, 1993).

Tanyeli, Uğur, '1950'lerden bu yana mimari paradigmaların değişimi ve reel mimarlık', in Yıldız Sey (ed.), *75 Yılda Değişen Kent ve Mimarlık* (Istanbul: Tarih Vakfı Yayınları: Türkiye Ekonomik ve Toplumsal Tarih Vakfı, 1998).

Tavakoli, Amir and Tülümen, Şevket Can, 'Construction industry in Turkey', *Construction Management and Economics* 8/1 (1990), pp. 77–87.

Tecer, Meral, *Türkiye Ekonomisi* (Ankara: TODAİE, 2005).

Tekeli, İlhan, *İstanbul ve Ankara İçin Kent İçi Ulaşım Tarihi Yazıları* (Istanbul: Tarih Vakfı Yurt Yayınları, 2010).

—— and İlkin, Selim (eds.), *Mimar Kemalettin'in Yazdıkları* (Ankara: Şevki Vanlı Mimarlık Vakfı, 1997).

Tekin, İlke and Akpınar, İpek, 'Betonarmenin anonimleşmesi: Türkiye'de İkinci Dünya Savaşı sonrası yapılı çevrenin inşası', *Mimarlık* 377 (2014), pp. 70–4.

Tokatlı, Nebahat, and Boyacı, Yonca, 'The changing morphology of commercial activity in Istanbul', *Cities* 16/3 (1999), pp. 181–93.

Toker, Metin, *Demokrasimizin İsmet Paşalı Yılları 1944–1973: DP'nin Altın Yılları 1950–1954* (Ankara: Bilgi Yayınevi, 1990).

Topuzlu, Cemil, *İstibdat-Meşrutiyet-Cumhuriyet Devirlerinde 80 Yıllık Hatıralarım* (Istanbul: Topuzlu Yayınları, 2002).

Ünsal, Behçet, *Turkish Islamic Architecture in Seljuk and Ottoman Times* (New York: St. Martin's Press, 1973).

Uturgauri, Svetlana, *Boğazdaki Beyaz Ruslar* (Istanbul: Tarihçi Kitabevi, 2015).

Wharton, Alyson, *The Architects of Ottoman Constantinople: The Balyan Family and the History of Ottoman Architecture* (London: I.B.Tauris, 2015).

Wharton, Annabel J., *Building the Cold War: Hilton International Hotels and Modern Architecture* (Chicago: University of Chicago Press, 2001).

Yavuz, Mehmet, 'Mimar August Jasmund hakkında bilmediklerimiz / Biographische notizen zu architekt August Jasmund', *Sanat Tarihi Dergisi* 13/1 (2004), pp. 183–205.

Yavuz, Yıldırım, *İmparatorluktan Cumhuriyete Mimar Kemalettin* (Ankara: Mimarlar Odası, 2009).

Yeşilbursa, Behçet K., 'Turkey's participation in the Middle East Command and its admission to NATO, 1950–52', *Middle Eastern Studies* 35/4 (October, 1999), pp. 70–102.

Zeren, Nuran, 'Türkiye'de tarihsel değerlerin korunmasında uygulanmakta olan yöntem çerçevesinde uygulayıcı kuruluşların görüşlerine dayanan bir araştırma', unpublished PhD thesis, İstanbul Teknik Üniversitesi, (1981).

Zürcher, Erik J., *Turkey: A Modern History* (London: I.B.Tauris, 2004).

Index

1 Mayıs Mahallesi (1 May Neighbourhood) 145–6, 154, 288n.45
16–9 Development 251

A Tasarım Architects 222
Abdülaziz 10, 17–18, 21, 78, 175–6, 272n.18, 279n.52
Abdülhamid II 14, 21–3, 25–7, 30–4, 48, 187, 270n.6, 273n.31
Abdülmecid 11, 167, 272n.18
Acar, Kuzgun 288n.49
Afet Riski Altındaki Alanların Dönüştürülmesi Hakkında Kanun (Act for the Revitalisation of the Areas under Natural Disaster Risk) or *Kentsel Dönüşüm Kanunu* or Urban Renewal Act 236
Aga Khan Award for Architecture 127
Agache, Donat Alfred 54, 219
Ağaoğlu, Ali 232, 235
Ağaoğlu, Samet 282n.15
Ağaryılmaz, İsmet, 290n.29
AHE (a consortium of architects including Kemal Ahmet Aru, Hande Suher, Mehmet Ali Handan, Yalçın Emiroğlu, Tekin Aydın and Altay Erol) 131
AK Party (AKP) 5, 256, 259–61, 263, 295n.3 and n.4, 296n.11
 establishment 214
 impact on Istanbul 216–19, 222, 225, 264
 policies and success 215–16, 228–30, 262–4, 298n.34, 301n.5 and n.6, 302n.8
Aka, Tarık 128
Akansel, İsmail Hakkı 289n.1

Akaretler Town Houses 272n.18, 279n.52
Akatlar 121
Akbank 190
Akçer, Faruk 282n.17
Akçura, Tuğrul 108
Akın, Ahmet 101
Akman, Ergin 189
Akmerkez 189
Aksaray 18, 43, 55, 92–3, 106, 171, 182, 185, 270n.4, 272n.23, 275n.48
Aksoy, Erol 189
Akurgal, Ekrem 283n.24
Akverdi, Özdemir 128
Alarko Holding Headquarters 176–7
Alcibiades of Athens 169
Aldıkaçtı, Orhan 154
Alevis 226, 297n.31
Alhambra Palace 20
Alpar, Tahsin 251
Alsaç, Orhan 283n.24, 285n.44
Alton, Turgut 174
Amcazade Hüseyin Paşa Yalısı 78
Anadol 119
Anadolu Club 101
Anadoluhisarı 32
Ankara 41, 54, 68, 89, 90, 95, 105, 117, 118, 120, 158–9, 166, 172, 183, 190, 196, 222, 285n.49, 292n.5, 293n.20, 302n.7
 in early republican years 50–1, 61, 64, 70, 275n.1 and n.2
 Erdoğan's troubles with 195–6
 high speed train 223
 selected as capital 46–9
 travel time to Istanbul 88, 154

Index

Ankara University 278n.41
Antwerp 55
Aptullah Ziya 71
Arab Spring 255
arabesk music 123, 130
Arçelik 119
Arkan, Seyfi 63, 67, 277n.27, 282n.17
Arkitekt 51, 70–1, 77–8, 94, 100, 124, 279n.50, 285n.56 (*see also Mimar*)
Arnavutköy 27, 29, 165
Arnodin, Joseph Ferdinand 32
Art and Architecture Building at Yale University 141
Artillery Barracks in Taksim 59, 167, 252–3, 257, 264
Aru, Kemal Ahmet 105, 131, 176, 209, 282n.17, 285n.44
Arup 227
Astoria Towers 240, 242, 299n.48
Asutay, Ümit 108
Ataköy housing complex 107, 109–10
Ataşehir 221–2, 232, 234
Ataşehir West 232–3, 235
Atatürk, Mustafa Kemal 4, 45, 47
 death 80
 did not visit Istanbul until 1927 48
 founding Turkish Historical and Turkish Language societies 278n.41
 house in Thessaloniki 113
 name given to the airport 172
 relationship with Islamist policy 195
 in Republic Monument 49–50
 stays in Park Hotel 184
 unsuccessful trial for multi-party system in early republican years 279n.48
 visits to Florya 67
Atatürk (Yeşilköy) Airport 108, 171–2, 201, 291n.37
Atatürk Boulevard 57, 92–3, 103, 106, 127–9, 162–3, 281n.63
Atatürk Bridge 57, 162–3

Atatürk Kültür Merkezi (Atatürk Cultural Centre), or AKM 110–12, 252, 261, 264, 299n.53, 301n.3
Atatürk Library 141–2
Athens 97, 144, 169
Auric, André 55, 57, 92, 162, 275n.48
Austria 34
 horses brought from 270n.4
 peace settlement with 270n.7
Austro-Hungarian Empire 38
Avcılar 210
Avcıoğlu, Gökhan 205
Ayaşlı Yalısı 77–8
Ayaz, Nevzat 160
Ayazağa 190, 208–9
Ayazpaşa 184
Aysu, Fazıl 82
Aytaç Architects 219–20
Azapkapı 187, 270n.4

B\+H Architects 240
Babıali 201
Bağdat Street 93, 149–50, 236
Bahçeköy 197
Bahçeşehir 232
Bakırköy 92, 107, 158, 165, 231, 283n.19
Balat Jewish Hospital 161
Balıkesir 124
Balkan Wars 32, 42, 274n.39, 294n.31
Balkans 5, 215, 259, 301n.1
Balyan family of architects 14–15, 24, 272n.18 and n.20
Balyan, Agop 272n.18, 273n.23
Balyan, Garabet Amira 15, 272n.18 and n.19
Balyan, Krikor Amira 272n.18
Balyan, Nikogos 15, 272n.18
Balyan, Sarkis 18, 20, 272n.18, 273n.23, and n.29, 279n.52
Balyan, Senekerim 272n.18
Bank Ekspres Building 202–3, 294n.36

Index

Bank of America 97
Bank of Provinces 125, 282n.17
Bankalar Street 26
Baran, Hüseyin 128
Barbaros Boulevard 93
Barkan, Ömer Lütfi 75
Barry, Charles 15
Başakşehir 231
Baslo, Meltem 209
Batum 21
Bayar, Celâl 47, 87, 108, 114
Baysal, Halûk 106
Bayur, Kamil 128
Beirut 164
Belgrade Forest 178
Belluschi, Anthony 240
Berkman, Enver 285n.44
Berlin,
 1878 Treaty 276n.7
 Ehlgötz's works 54
 German Fountain pre-fabric
 ated in 22
 Hilton hotel constructed 97
 Jansen's city 275n.2
 Kemalettin Bey's visit 36, 274n.42
 Le Corbusier's Unité d'habitation
 constructed 109
 M. Wild's drainage proposal 162
 Ottoman ambassadors were sent to 10
Beset, Mehmet 189
Beşiktaş 27, 148, 158
 in Menderes' works 93, 115
 trams were put in service 270n.4
Beyazıt 18, 171
 in Menderes' works 92
Beyazıt Fire Tower 272n.18
Beyazıt Square (Forum Tauri) 49
 Dalan's competition 170–1
 during Ottoman times 171
Beybi Giz Plaza 206, 208
Beylerbeyi Palace 272n.18

Beyoğlu (*see also* Pera)
 in 1930s 60–1, 64
 in early 1950s plans 91, 282n.19
 in 1960s 125
 in 1970s 130, 133–5
 in 2000s plans 297n.28
 in Dalan's works 162, 167, 197
 in Menderes' plans 115
 in Ottoman Istanbul 271n.14
 Ottoman Revivalist buildings
 constructed 52
 in Prost's master plans 55–7
 a rising star in late Ottoman period 13,
 28, 104, 187, 291n.46
 in Sözen's period 186
Bielke, Wolfgang 290n.21
Bilâd-ı Selâse 271n.14
Bilgin, Dinç 200
Birsel, Melih 106
Bithynia 169
Black Sea 4, 144, 225, 227
Blockmans, Wim 3
Blois, Natalie de 96
Blues Point Tower, Sydney 109
Boito, Camillo 41
Böke, Ayhan 177, 190
Bolshevik Revolution of 1917 277n.26
Bonatz, Paul 76, 103, 111
Bosnia-Herzegovina 21, 38
Bosphorus 3–4, 6, 9–10, 15, 29, 32, 34, 48,
 77–8, 96, 101, 121, 130, 142, 159, 162,
 164–5, 170, 174–6, 182, 189, 196–7,
 199, 219, 223, 228, 247, 249, 270n.4,
 271n.14, 272n.18, 287n.22 and n.28,
 288n.35
Bosphorus Bridge 6, 135–9, 148, 151,
 165–7, 248, 288n.34 and n.35
 in late Ottoman period 32
 proposals in 1960s 125
 renamed as 'The 15th July Martyrs'
 Bridge' 263

Index

Bosphorus University 160
Bostancı 93, 149, 158
Botta, Mario 204
Botter Apartment Building 27–8
Bourgeois, Marie-Auguste Antoine 18
Bouvard, Joseph Antoine 31, 273n.33
Boysan, Aydın 202
Bozkurt, Cafer 208
Brera Academy in Milan 41
Britain 37–8, 280n.58 (*see also* the United Kingdom)
Brix, J. 275n.2
Brown-Root Partnership 291n.31
Bulgaria 21, 228
Bulgarian Church 161
Bunshaft, Gordon 96
Burhan Arif 71, 277n.23
Bursa 41, 124
Büyükada 101
Büyükdere Street 121, 177, 190, 208, 239–40, 246, 248, 299n.48
Byzantine Empire 1
Byzantium 1

Caddebostan 165, 182
Cağaloğlu 140
Cairo 97
Caliphate 45, 47–8
Calthrope, Peter 291n.44
Çamlıca Mosque 259–60
Can, Selman 272n.20
Çanakkale 124
Canal Istanbul 4, 225, 227–8, 256
Canary Wharf 221
Canberra 54
Candela, Félix 104
Canonica, Pietro 49
Cansever, Turgut 101, 125–6, 171
Çapçı, Orhan 283n.24
Capitol Shopping Centre 188–9
Capitol, Washington DC 10

Çayırbaşı 165
Çekmeköy 232
Celâl Esad Bey (*Arseven*) 51, 283n.24
Çemberlitaş (Forum Constantini) 92, 172
Cemil (Topuzlu) Pasha 47, 94
Central Bank of Turkey 213, 221–2
Cevahir Centre 177, 299n.48
Ceylan Apartment Building 62–3
Ceylan Intercontinental Hotel 131 (*see also* former Sheraton Hotel)
Chamber of Architects
 in 1999 earthquake 211
 angered by Topbaş 221
 its award 180
 Certificate of Gratitude to Sözen 292n.7
 conduct campaigns against the Bosphorus Bridge 138
 in Erdoğan's mayorship 197
 establishment 89
 politicisation in the 1960 and 1970s 123–4, 126, 144–5
 struggle with AK Party projects 223–4, 267, 297n.28
 struggle with Dalan 164, 184
Chamber of Civil Engineers 211
Chamber of Geophysical Engineers 211
Charlottenburg School of Technology (Charlottenburg Technische Hoschule, Technische Hochschule in Berlin) 36, 54, 275n.2
Chicago 54
Church of Pantocrator (Zeyrek Mosque) 127
CIAM (Congrès Internationaux d'Architecture Moderne 1928–59) 109, 127
Cihangir 61, 64, 68, 70, 291n.46
Çilingiroğlu, Günay 139–40
Çilingiroğlu, Mutlu 188–9
Çiller, Tansu 193, 199
Çınar Hotel 101–2

313

Index

Çırağan Palace 20, 175–6, 272n.18
 converted into hotel 174–6
CNN International 257
Cold War 4, 95–6, 291n.32
Collège Sainte-Barbe de Paris 272n.18
Conder Partnership 291n.31
Connecticut 141
Conrad Hilton Hotel 189
Constantine the Great 219
Constantinople 1, 170
 Arab attempts to conquer 169
 changed to Istanbul 48
 Turkish conquest 163, 166, 170, 233, 271n.14
Crazy Projects (Çılgın Projeler) 225–8
Creil 54
Crimean War 10, 15, 21, 26
Crystal Tower 246
Cumhuriyet Avenue 96, 98
Cuno, Helmuth 30
Cyprus 21, 113, 143–4

d'Armi, J. 52
D'Aronco, Raimondo Tomasso 26–7, 34, 273n.31
Dalan, Bedrettin 158–9, 161–5, 176, 180, 182–5, 194, 197, 265, 290n.29, 292n.48 and n.3
Dalokay, Hakan 168–9
Dalokay, Vedat 126, 168–9, 293n.20
Darius I 169
Darülfünun 281n.63
De Leeuw Charter and Co. 137
Dedeağaç 10
Defter-i Hakani (Land and Titles Office) 38, 40, 84
Demirel, Süleyman 118, 131, 143, 146, 183, 193, 197, 209, 214, 287n.28
Demokrat Parti (DP) 87–90, 94–5, 112–15, 117–19, 124, 126, 137, 140, 180, 282n.15, 285n.57

Denktaş, Adil 68
Dersaadet 271n.14
Dersaadet Tramvay Şirketi (Istanbul Tram Company) 270n.4
Derviş, Kemal 213, 215
Detroit 238
Devlet Planlama Teşkilatı (State Planning Office) 119
Divan Hotel 256, 300n.62
Divanyolu (mese) 84, 92, 170
Doğan, Aydın 200
Doğan Mediatown 202
Dökmeci, Vedia 171
Dolmabahçe (Bezmi Alem Valide Sultan) Mosque 198, 272n.18
Dolmabahçe Palace 15–16, 20, 78, 82, 174–6, 197–8, 270n.8
Dolmuş 122–3, 170, 186, 218, 287n.14
Duany, Andres 178–9, 291n.44
Dunkerque 54
Dunne, Irene 98
Durkheim, Emile 33
Duyun-u Umumiye (Ottoman Public Debts Administration Building) 34–5, 130
Düzce 210

Eads, James Buchanan 32, 139, 273n.35, 274n.36
Eastern Roman Empire 1, 22
Ebniye-i Hassa Müdürlüğü 14
Ecevit, Bülent 119, 146, 213, 294n.1
École des Beaux-Arts Paris 23–4, 37, 272.n18, 275n.2
École Monge 37
Eczacıbaşı Group 242
Edhem, Halil 272n.23
Edirne 10, 124, 166, 274n.39
Egli, Ernst 51, 76
Egypt 38, 226
Ehle, Willi 111
Ehlgötz Hermann 54

Index

Eindhoven 238
Eisenman Architects 219, 220
Ekinci, Oktay 292n.48
Eldem, Sedad Hakkı 62–3, 77–8, 84, 96, 98–101, 127, 129, 141–2, 174, 176, 222, 278n.32, 287n22
Elgiz, Can 206
Elhamra Han 52
Elmadağ 96
Elsaesser, Martin 51
Emekli Sandığı (Turkish Public Servants' Pension Fund) 97
Emin Bey 49
Eminönü
 in the 1960s 122
 in Dalan's projects 161, 170
 in late Ottoman period 187
 in Menderes' operations 92, 283n.26
 in Prost's plans 55, 57–8
Emlak Eytam Bankası 285n.49
Emlak Konut 231–2
Emlak Kredi Bankası (EKB) 105, 108
Emre Arolat Architects 249
enosis 144
Erbakan, Necmettin 195, 199–200, 213–4, 300n.57
Erbel, Cevat 282n.17
Erbhof regulations and homesteads 76, 281n.2
Erdin, Ali Bahadır 240
Erdoğan, Kadri 101
Erdoğan, Recep Tayyip
 concerns on 16–9 development 251
 during and after the failed coup attempt 263–4, 301n.6, 302n.7
 early years in AK Party 214–19, 295n.8, 296n.10, n.11 and n.12
 launching 'Crazy Projects' 225
 mayorship in Istanbul 194–200, 228, 293n.22, n.23 and n.27, 294n.31

public referendum for presidential system 302n.8
 reaction to Gezi Park incidents 256, 300n.61, 301n.3
 in recent years 259–63, 297n.30, 301n.5
Ergin, Osman Nuri 68
Erhan, Vahit 128
Erim, Nihat 143, 280n.60
Erkman, Uğur 209
Erkoğlu, Sedat 285n.44
Erol, Nevzat 103
Ertan, Emin 101
Ertunga, Ertem 177
Esenler 157, 182, 185
Essen 54, 163
Essen Planı 163, 290n.21
Etiler 121, 189
Etiman, Rasin 140
European Economic Community (EEC) 296n.10
European Recovery Program 81
European Union (EU) 215, 295n.8, 296n.10
Evren, Kenan 153–4
Eyck, Aldo van 129
Eyüboğlu, Bedri Rahmi 288n.49
Eyüp 55, 159, 162, 184, 271n.14, 283n.19
Eyyüb el-Ensari 271n.14
ezan (call to prayer) 89

Fatih 49, 53, 148, 158, 184, 271n.15
Fatih Sultan Mehmet Bridge 166, 226
Feshane 159
Fevzi (Çakmak) Pasha 49
Fevzi Paşa Street 49
Fikirtepe 157, 236
Fındıkoğlu, Cihat 128
Fındıkoğlu, Ziayeddin Fahri 75
Florya 67, 158, 277n.26
Florya Sea Pavilion 67
Fourth Levent 105–6, 110, 177, 190, 208, 239, 245

Index

Fourth Vakıf Han 40-1, 43, 51
France 4, 17, 24, 64, 75, 77, 286n.12
Freeman, Fox & Partners 138, 166
Frunze, Mikhail 50
Fuat Bayramoğlu Apartment Yalı 287n.22
Fulbright agreement 95

Galata 10, 23, 26, 31, 52, 55, 182, 187, 265, 271n.14, n.15 and n.16, 274n.36
Galata Bridge 58, 187
Galataport 223-4
Galatasaray School 37
Galleria Shopping Centre 173-4, 188, 265
Gavand, Eugène Henri 10
gecekondu 5
 in the 1960s and 1970s 119-23, 130, 145-7, 151, 288n.42
 in the 1980s 153, 156-8, 178
 in the 1990s 193, 195, 226, 293n.19
 in the AK Party period 229-30, 236, 246
 in early Republican period 82
 in Menderes' era 91, 105
Gecekondu Kanunu (Gecekondu Act) 121
Gecekondu Önleme Bölgeleri (Gecekondu Preventing Areas) 146
Geiler, Michael 290n.21
Genç Osmanlılar 16
Genç Türkler (Young Turks) 32
Gencebay, Orhan 130
Geneva 47, 77
Gerdom, Oskar 290n.21
German Consulate building 185
German Fountain 21-2
German *Sozialpolitic* 76
Germany Ottoman alliance 4
 authoritarian regime 72, 74-6, 80, 83, 281n.2
 destination and source of inspiration for Turkish architects 36, 53, 69, 77, 274n.42
 imported building materials 98

social housing projects 146
Turkey declares war 280n.55
Gezi Park 252-3, 255-7, 264, 299n.53, 300n.64
Gilbert Murray Hall at the University of Leicester 2
Giray, Muhteşem 108, 290n.29
Glorya Cinema 64
Gökalp, Ziya 32-3, 200
Gökay, Fahrettin Kerim 55, 168
Gökçe, Gündüz 290n.29
Gökdoğan, Mukbil 282n.17, 285n.44
Gölcük 209, 211
Golden Horn
 in the 1960s and 1970s 121, 125, 128, 135
 in the AK Party years 217, 223-4, 261
 in Dalan's projects 6, 159-63, 165, 181-2
 in Menderes' era 92-3, 282n.19
 in Ottoman period 13, 23, 25-6, 34, 42-3, 56, 57, 187, 270n.4, 271n.14
 in Prost's proposals and early Republican period 56-7, 59, 84, 91
 in Sözen's term 184
Golden Lane Estate, London 109
Gorbon, Rebii 105
Görey, Yavuz 288n.49
Grand Bazaar (Kapalı Çarşı) 56, 209, 238, 270n.8
Great Depression of 1929 48, 275n.1
Green Ban movements in Sydney 185
Gregotti, Vittorio 291n.31
Grimshaw Architects 227
Gropius, Walter 146
Gül, Abdullah 216, 296n.11
Gülen, Fetullah 301n.6
Gülhane Park 47
Gülsuyu 157
Gültepe 121, 246
Gümüşsu Palace 68
Gümüşsuyu 61, 63, 68-9, 291n.46

Index

Gümüşsuyu Barracks 167
Gümüşsuyu Military Hospital 167
Güneş Dil Teorisi (Sun Language Theory) 73–4
Güneşli 201
Güney, Rükneddin 73, 104, 110, 130, 133
Güngör, Hulusi 124
Güngören 157
Gürsel, Cemal 123
Gürsel, Yücel 164

Hacı Bekir Ağa *Sebil* 270n.8
Hadi, Şandor 180
Hadi, Sevinç 180
Hadid, Zaha 220–1
Hagia Sophia 232, 252, 281n.63
Haliçport 224
Halkalı 231
Halkevleri (People's Houses) 72–3, 278n.40
Hamidiye Bridge 32
Hamlin, A. D. 2
Han of Hasan Paşa 92, 283n.24
Hancı, Abdurrahman 101
Handan, Mehmed Ali 131, 282n.17
Haptic Architects 227
Harbiye 291n.46
Harbiye Orduevi 131, 133
Harbour of Eleutherios 219
Harem 93, 165, 199
Harikzedegan Apartment Buildings 53
Hasol, Doğan 194, 293n.20
Hassa Mimarlar Ocağı (the Corps of Royal Architects) 14
Haydar Bey 49
Haydarpaşa–İzmit railway line 10
Haydarpaşa Railway Terminus 30, 223
Hellespont (modern day Gallipoli) 138
Hendesehane 271n.17
Hendese-i Mülkiye Mektebi (School of Civil Engineering) 23
Hepgüler, Metin 128, 131

Hilton Hotel 96–101, 130–1, 141, 222, 284n.35
Hilts, H. E. 280n.62
Hisarüstü 166
Historic Peninsula 13, 15, 18, 26, 40, 53, 66, 70, 79, 84, 127, 130, 140, 169, 171, 209, 254, 265, 271n.14
 abandoned by press 201
 in AK Party era 217, 220, 224, 237, 248, 251
 under Menderes' governments 92, 103, 115
 new tram lines 185
 in Piccinato's plans 125
 in Prost's plans 55–7, 61, 162
Hittites 74
Hobsbawm, Eric J. 2
Högg, Hans 94, 125
HOK 222
Hollein, Hans 204, 291n.31
Holzmeister, Clemenz 51, 76, 111
HSBC Bank Headquarters 207–8
Hukukçular Sitesi 106–7
Hürriyet Meydanı (Freedom Square, 171
 see also Beyazıt Square)
Hürriyet newspaper 200, 202

İbrahim Edhem Pasha 17
İbrahim Pasha Palace 38, 84
İETT housing complex 106, 108
Ihlamur Pavilions 272n.18
İhtisab Nazırlığı (Ministry of Taxation and Urban Affairs) 11
İkitelli 201
İlkünsal, Berkok 108
İller Bankası (Bank of Provinces) 282n.17
İmar Kanunu (Redevelopment Act) of 1956 89
İnönü, Erdal 183, 193
İnönü, İsmet 59, 94, 118–19, 143, 167–8, 183, 286n.57

Index

İnönü Football Stadium 82-3
İnönü Gezisi 59, 83, 96, 130, 132, 167-8, 252
(İnönü Promenade, see also Gezi Park)
International Cooperation Administration (ICA) 96-7
International Labour Day 145
International Monetary Fund (IMF) 155, 215, 256
İş Bank Real Estate Trust 242
İşbank Towers (Headquarters) 190, 192
İşcan, Haşim 118
İşçi Sigortaları Kurumu (Workers' Insurances Corporation) 127
Islahat-ı Turuk Komisyonu (Commission of Road Improvements) 92
Israel 143
Istanbul Chamber of Industry 135
Istanbul Economy and Commerce Academy (now Marmara University) 194
İstanbul İmam Hatip Lisesi (Islamic Vocational High School) 194
İstanbul İmar Talimatnamesi (Istanbul Redevelopment Regulation) 89
İstanbul Manifaturacılar Çarşısı (İMÇ) 128-30, 288n.49
İstanbul Mücavir Sahalar Planı (Plan of Istanbul's Adjoining Lands, 1961) 125
Istanbul Municipal Palace 103-4
İstanbul Nazım Plan Bürosu (Istanbul Master Plan Bureau) 124
İstanbul Reklam Ajansı (Istanbul Advertisement Agency) 140-1
Istanbul Sapphire 245, 299n.48
Istanbul Technical University (ITU) 176, 208, 282n.17, 286n.9
Istanbul University 75, 154, 219, 283n.26
Istanbul University Faculty of Science and Letters 78, 80
Istanbul-Edirne railway line 10

İstiklal Street (Grande Rue de Pera) 27, 48, 52, 135, 163, 167-8, 172, 187, 270n.6, 289n.49
İstimlâk Yolsuzluğu Davası (Case of Corrupt Expropriation at Yassıada Trials) 114
İsvan, Ahmet 131
Italy 41
 authoritarian regime 72, 74, 83
 building materials imported 98
 Erdoğan's visit 295n.8
İttihat ve Terakki Cemiyeti (The Committee of Union and Progress or CUP) 32-3, 72, 274n.39
İzer, Zeki Faik 283n.24
İzmir Palace Apartment Building 52
İzmir-Aydın railway line 10
İzmit 47, 124

Jacobs, Jane 264
Janissaries 11
Jansen, Herman 46, 275n.2
Japan 33, 155
 Turkey declares war on 280n.55
Jasmund, August 23, 36
Jausseley, Leon 275n.2
Jerde Partnership 243
Jerusalem 36, 170
Johnson, Lyndon 143
Justice Party (JP) 118, 140, 143, 146

Kabataş 93, 164, 267
Kadıköy People's House 73
Kadıköy,
 apartmentisation 139, 148-9, 158
 in Dalan's term 165
 in Menderes' operations 93
Kağıthane 121, 157
Kahn, Louis 127
Kahvecioğlu, Hüseyin 208
Kahvecioğlu, Nurbin Paker 209

Index

Kaiser Wilhelm II 21–2, 30
Kale Seramik Headquarters 177
Kandilli 32
Kandilli Observatory 210
Kanyon 242–4, 299n.48
Kara Ahmed Ağa 270n.9
Karaköy, in late Ottoman period 10, 182
 in Menderes' operations 93
 in Dalan's operations 164
Karayolları 17. Bölge Müdürlüğü
 (Seventeenth District Headquarters
 of the Directorate of Highways)
 135–6, 248–50
Karlıdağ, Yaprak 171
Kars 21
Kartal, in Dalan's operations 165
 in Zaha Hadid's plans 221
Kasımpaşa 194
Kavacık 166
Kayaşehir 231
Kazlıçeşme 82, 251
Kazmaoğlu, Adnan 189
Kehr, Dietrich 162
Kemalettin Bey 36–7, 39, 42–3, 50–1, 53,
 68–9, 76, 274n.42
Kemalism 72
Kemer Country housing complex 178–9
Kennedy Street 92, 107, 165
Khadem, Mozhan 196
Kiler Group 245
Kip, Feridun 110
Kıraç Yalı 287n.22
Kıran, Hakan 217
Kırdar, Lütfi 55, 110
Kırklareli 124
Koç Foundation 141
Koç Holding 139, 256
Koç University 196, 256, 287n.28
Koç, Vehbi 196
Kohn Pedersen Fox Associates 222
Kömürcü, Asım 281n.63

Konuralp, Mehmet 135–6, 201
Koral, Füreyya 288n.49
Korean War 95
Kostof, Spiro 2, 3
Koşuyolu Evleri 105
Köy Enstitüleri (Village Institutes) 75
Kozyatağı 232
Küçükçekmece, in Ken Yeang's
 proposal 221
 a rising suburb 231
Kurtköy 232
Kuruçeşme 165
Kurukahveci Mehmed Efendi 65
Kutay, Ecmel 289n.1

La Défense 221
Laleli 53, 78
Lambert, A. O. 32, 139, 274n.36
Lambert, Jacques-Henri 54, 219
Lausanne Treaty 47
Le Corbusier 54, 98, 101, 106, 109, 126,
 136, 139
Lengerhane (old Ottoman anchor
 workshop) 161
Levent 93, 110, 121, 139, 185, 207–8, 240,
 243–4, 294n.37
Levent housing complex 105–6, 189
Levent Plaza 208
Liverpool–Manchester railway line 10
London 10, 109, 221, 227, 286n.12
Loos, Adolf 146
Lörcher, Carl Christoph 49
Los Angeles 243
Lüküs Hayat operetta 61
Lumière brothers 10

Maçka 52, 65, 180–1, 291n.46
Maçka Park 59, 83, 96, 141–2, 267
Mahmud I 167
Mahmud II 11, 159, 272n.18 and n.19
Mahmud Nedim Pasha Tomb 141

Index

Makal, Mahmut 80
Makarios III 144
maksem 167
Maltepe 165, 182, 224
Manastir 274n.39
Mansel, Ali Müfit 283n.24
Marmara Regional Planning Office (MRPO) 124
Marmaray 219, 262, 296n.18
Marseilles 34, 98, 109, 276n.7
Marshall Plan 82, 96–7
Maschinenfabrik Augsburg-Nürnberg 187
Masjid Al-Aksa 36
Maslak 176–7, 190, 202–3, 206–8, 232
Mavramoloz forest 196
McMin, William 291n.31
Mecidiye Barracks 167
Mecidiye Pavilion 273n.29
Mecidiyeköy 106, 239, 241
Mehmed II 232
Mehmed IV 272n.18
Mehmed Emin Ağa *Sebil* 270n.8
Mehmed Reşad 176
Mehmed Ziya Bey 43
Mekteb-i Tıbbıye-i Şahane (Imperial School of Medicine) 34, 36, 170
Menemen 279n.48
Menteşe, Ertuğrul 108, 282n.17
Mesopotamia 74
Meşrutiyet Street 135
Metrobus 218
Metrocity 240–1, 243, 299n.48
Middle East 5–7, 215, 259, 284n.35, 301n.1
Middle East Technical University 95
Miller, Ann 97
Millet Street 92–3
Milli Reasürans building 180–1
Milliyet newspaper 200
Milliyet Newspaper Headquarters (Doğan Media Centre) 202

Mimar 51, 70–1 (*see also* Arkitekt)
Mimar Abidin Bey 70–1
Mimar Zühtü 66
Mimarlık 124
Ministry of Post and Telegraph Building (General Post Office) 27, 38–9, 41, 265
Ministry of War 18, 36, 171
Moltke, Helmuth von 187
Mongeri, Giulio 41, 49, 50–1, 77
Montani, Pietro 18, 272n.23
Moore, Charles 291n.31
Moore, Terry 98
Morris, William 43
Morse, Samuel 10
Motherland Party (MP)
 in 1983 elections 154
 in 1984 municipal elections 158
 in the 1990s and 2000s 198, 214, 293n.15
 in 1994 municipal elections 194
 losing power 183–4, 193, 292n.1 and 3
 support to Dalan 180
Moule, Elizabeth 291n.44
Mövenpick Hotel 177
Mt. Clare Depot in Baltimore 10
Mühendishane-i Berri Hümayun 23
Muhittin Bey 49
Muhittin Güven 282n.17
Munich 77, 238, 300n.62
Murad V 21, 176
Mustafa IV 272n.18
Mustafa Reşid Pasha 11, 68
Mutlu, Asım 285n.44
Müze-i Hümayun (Imperial Museum) 24–5

Nakkaştepe 205
Nari, Edoardo de 64
National Salvation Party (Milli Selamet Partisi) 194–5

Index

National Security Council
 after 1960 coup 117
 after 1980 coup 153
 in 28 February 1999 process 199
 US Security Council 300n.64
National Union Committee 117
NATO
 role in military interventions 291n.32
 Turkey becomes a member 95, 284n.34
Neo-Ottomanism 259
New Haven 141
New Turkey Party 118
New York 54, 137, 192, 203, 222, 232, 297n.28
Niemeyer, Oscar 104
Nişantaşı 60-1, 291n.46
Nordic Office of Architecture 227
North Africa 6, 55, 259
Northern Forests Defence Alliance 227
Northern Marmara Motorway 226
Nurol Plaza 208
Nuruosmaniye Mosque 11-12, 15, 270n.9
Nusretiye Mosque 272n.18

Oberon, Merle 98
Occupy Wall Street protests 255
Odakule 134-5, 289n.49
Okan, Yüksel 134-5
Ökeren, Turhan 104
Okmeydanı 106, 108, 236
Okyar, Ali Fethi 279n.48
Onar, Sıddık Sami 283n.26
Onaran, Atilla 289n.49
Onat, Emin 78, 84, 101, 103
open-air theatre 59, 82-3, 96
Ordu Street 66, 92-3, 171
Organisation for Economic Co-operation and Development (OECD) 155
Orient Express 26
Örnek Mahallesi 146, 288n.42
Ortaköy 162

Ortaköy Mosque 272n.18
Ottoman Bank 25-6, 135
 occupation by Armenian militants 48, 276n.7
Ottoman Empire 1, 4-5, 9-11, 13-17, 21-2, 25-6, 30-1, 33-4, 37, 41, 43, 45-6, 51, 72, 74, 80, 149, 167, 176, 226, 254, 261, 271n.17, 273n.32, 274n.39, 276n.7
Ottomanism 16-7, 33
Owen, Chris 202
OYAK (Armed Forces Assistance Fund) 134, 139
Öz, Tahsin 283n.24
Özal, Turgut in the 1980s 154-6, 158-9, 180, 289n.4, 292n.1 and 3
 eroding popularity 183-4
 elected as president 193, 293n.15;
 political instability after him 199, 229, 296n.10
Özdilek Park İstanbul 240-2, 299n.48
Özkök, Ertuğrul 293n.27

Pamir, Doruk 170, 197
Pan American Airlines 96, 98
Paris
 Balyan's education 272n.18
 Bouvard's post 31
 École des Beaux-Arts in 24, 275n.2
 Erdoğan's visit 195
 financial centre 221
 Lambert's works 54-5
 Orient Express destination 26
 Ottoman ambassadors sent to 10
 Prost's position 54-5
 Salih Münir Pasha's ambassadorship 273n.33
 Vedat Bey's education 37
Park Hotel 184, 186, 292n.7
 Menderes' stays 292n.5
Park Plaza 208

Index

Paşabahçe Glass and Bottle Factory 48
Pei Cobb Freed & Partners 246
Pendik 93, 199
Pera 14, 23, 31, 167, 271n.14 (*see also* Beyoğlu)
 in Auric's plans 162
 becomes a 'boom town' 271n.15
 in Eads and Lambert's proposal 274n.36
 first municipal model 271n.16
Pera Palace Hotel 26–7, 99, 135
Perpa 290n.14
Perret, Auguste 77, 110
Perşembe Pazarı 164
Pertevniyal Valide Mosque 18–20
Philip, Peter 290n.21
Piccinato, Luigi 94, 108, 125–6, 128, 131, 285n.53
Piyale Public School 194
Plater-Zyberg, Elizabeth 178–9, 291n.44
Poelzig, Hans 77
Poitiers 54
Polyzoides, Stefanos 291n.44
Princes' Islands 27, 55, 101
Printemps Department Store 174
Prophet Muhammad 271n.14
Prost, Henri
 his achievements and failures in Istanbul 56–7, 59–60, 70, 82–3, 167, 170, 265, 300n.56
 aims of master plan 55–6
 beach project in Florya 277n.27
 bridge proposal over the Bosphorus 137
 decommissioning and criticism from the Revision Commission 90–1
 proposal for Çemberlitaş-Beyazıt 92
 proposal for Yenikapı 219
 proposals for Karaköy–Kabataş road 165
 proposals for Tarlabaşı Boulevard 162–3
 reference to by Menderes at Yassıada Trials 114
 refusal to join the 1933 design competition 54
 second invitation and works prior to Istanbul 55, 285n.53
 visons for the Golden Horn 159–60
 works guided future plans 115

Ragıp Gümüşpala Street 92
Refah Partisi (Welfare Party or WP) 194–5, 199–200
Republic Monument in Taksim 49, 167
Republican People's Party (RPP) Third Congress and its emblem 72
 in 1946 elections 280n.59
 in 1950 elections 87, 168
 after 1960 coup 118–19
 in the 1970s 143, 146
 in the 2000s 221, 295n.4
 criticisms by DP about Istanbul 90
 İsvan's mayorship 131
 relaxation of social policies 89
 severe opposition to DP 113
 single-party rule 278n.39
 support from Alevi groups 226
Rey, Cemal Reşit 61
Rey, Ekrem Reşit 61
Ritter, Otto 30
Rıza Derviş house 101
RMJM Architecture 232
Rohe, Mies van der 136
Romania 228
Rome 36, 55, 274n.42
Rossi, Aldo 291n.31
Royal Institute of British Architects 37
Rudolph, Paul 141
Rumelifeneri 196, 287n.28
Rumelihisarı 32
Russia 21, 81, 228, 239, 276n.7, 277n.26

Sabah 200–2
Sabancı Centre 190–1

Index

Sabisten, Turgan 285n.44
Şahingiray, Şinasi 82
Şahinler, Orhan 128
Sakarya 124
Salih Münir Pasha 273n.33
Salonika 274n.39
Sanayi-i Nefise Mekteb-i Âlisi (Academy of Fine Arts) 23, 33, 41, 51
Sandy & Babcock Architects 202
Sarayburnu 10, 32, 165
Sarc, Ömer Celâl 75
Sarıyer 165
Sayar, Zeki 94, 100, 123, 279n.50, 285n.56
Sayın, Nevzat 205
Schütte, Wilhelm 51
Schütte-Lihotzky, Margarete 51
Sea of Marmara 4, 6, 30, 56, 67, 92, 101, 107, 124–6, 131, 148–9, 162, 165, 184, 186, 209–10, 219, 221, 224–5, 227, 271n.14
Şehremaneti (Municipality) 37
Şehzade Mehmed Mosque 103
Şehzadebaşı 56
Şehzadebaşı Street 103
Seidler, Harry 109
Sekkeisha, Kanka Kikaku 174
Selim III 11, 14, 271n.17, 272n.18
Selimiye Barracks 34, 170, 272n.18
Şener, Hasan 209
Serbest Cumhuriyet Fırkası (Free Republican Party FRP) 279n.48
Serdaroğlu, Ümit 290n.29
Şeyh Zafir Tomb 27
Sezer, Ahmet Necdet 294n.1
Shell Headquarters 205
Sheraton Hotel (now named Ceylan Intercontinental Hotel) 131
Siirt 214, 294n.31
Silahtarağa Power Plant 81, 161
Simeon Kalfa 270n.9
Simkeşhane 92, 283n.24

Sinpaş 232
Sirkeci 27, 30, 38–9, 51, 92, 185
Şirket-i Hayriye 270n.4
Sırrı Pasha 37
Sisa, Sami 128, 192, 240
Şişli 60–1, 177, 198, 239, 290n.14, 291n.46
Skidmore, Owings & Merrill (SOM) 96–7
Skopje 274n.39
Smith, William James 15, 197
Social Democratic People's Party (SDPP) 183, 193, 194
Sofia 10
Solomon, Daniel 291n.44
Sosyal Sigortalar Kurumu (Social Security Complex) 101, 127–9
Soviet Union (Soviets, Soviet Russia) 50, 81, 90, 96
Söylemezoğlu, Kemali 104, 283n.24
Sözen, Metin 290n.29
Sözen, Nurettin 184–5, 188, 193–4, 197, 292n.7, 293n.19 and n.20
Spice Bazaar 65
Spor ve Sergi Sarayı (Sports and Exhibition Palace) 83–4, 96
SS Normandie 68
St Raphael 55
St Tropez 55
Steinman, David, 137
Su, Kamil 283n.24
Suher, Esad 290n.29
Süleyman I 103
Süleyman Demirel Cultural Centre 208
Süleymaniye 55
Süleymaniye complex 217
Sultanahmet 22, 30, 55, 84, 92, 281n.63
Sultanahmet Justice Palace 85, 101
Sultanahmet Mosque 40, 252
Sultanbeyli 157, 195
Sulukule 237
Sumerians 74
Summerson, John 2

Index

Supreme Muslim Council of the Islamic State of Palestine 36
Sütlüce Abbotoir 161
Süzer Plaza (Gökkafes) 197–8
Swanke Hayden Connell 192
Swiss Hotel Bosphorus 174–5, 189
Sydney 109
 in Green Ban battles 185
 dismantling tram lines 286n.12
Syrian civil war 263

Tabanlıoğlu Architects 201, 222–3, 243, 245, 249
Tabanlıoğlu, Hayati 111, 172, 174, 202
Tabanlıoğlu, Murat 202
Tabler, William 189
Tahsin Günel Yalısı 77
Taksim Gazinosu 130
Taksim
 in the 1950s 96, 167–8
 in the 1960s and 1970s 112, 132, 168
 in the 1980s 156, 163, 167–70
 in the 1990s 184–5, 187
 in the 2000s 217, 252–7, 264
 in early Republican years 49, 167
 in late Ottoman era 291n.46
 in Prost's plans 56, 59, 83, 167, 300n.56
Taksim mosque proposals 254–5, 264, 300n.57
Talimhane 61–3, 70, 96, 278n.32
Taner, Ali 135
Tanpınar, Ahmed Hamdi 283n.24
Tanzimat Edict 11, 68
Tanzimat Period 13, 17, 21, 271n.17
Tapu Kanunu (Title Act) 89
Tarabya Hotel 101–2
Tarlabaşı 164, 181, 237
Tarlabaşı Boulevard 162–4, 168
Taşkışla 197
Taşlık Coffee House 78–9, 174
Taut, Bruno 51, 285n.48

Tayfun, Yümnü 108
Tayfur, Ferdi 130
Team X 127
Tecimen, Kaya 135
Tekel 165, 213
Tekeli, Doğan 128, 192, 240, 291n.29
Tekirdağ 124
T-Engineering 225
Tepebaşı 134, 163
Terakkiperver Cumhuriyet Fırkası (Progressive Republican Party) 279n.48
Tercüman Newspaper Building 139–40
Teşviki Sanayi Kanunu (The Industrial Support Act) 50
Teşvikiye 291n.46
Tezcan, Semih 160
Theodosian Walls 49, 92, 162, 237, 271n.14
Thessaloniki 113, 274n.39
TİKA (Turkish Corporation and Coordination Agency) 301n.1
Tırtıl, Abdullah 289n.1
Toker, Metin 94
TOKİ (Housing Development Administration) 229–32, 237, 239
Topbaş, Kadir 217, 221, 262, 297n.22
Tophane 270n.4
Tophane Barracks 272n.18
Topkapı 122, 185, 270n.4
Topkapı Palace 10, 15, 25–6, 47, 98, 248, 273n.29, 293n.13
Treaty of Carlowitz 270n.7
True Path Party (TPP) 183, 193–4
Trump, Donald 232
Trump Tower (Manhattan) 192
Trump Towers (Istanbul) 240–1, 299n.48
Tulga, Refik 125–6
Tulip Era 71
Tümay, Haluk 177, 190, 207
Tunca, Muhlis 139–40
Tünel 10, 185, 187

Index

Tüpraş 213
Turan, Osman 283n.24
Turgut, Leyla 108
Turin 238
Türk Ocakları (Turkish Hearts) 72, 274n.41
Türk Tarih Tezi (Turkish History Thesis) 73–4
Türk Yüksek Mimarlar Birliği (Turkish Union of Architects) 282n.17
Türk Yüksek Mühendisleri Birliği (Turkish Union of Engineers) 282n.17
Türk Yurdu 274n.41
Turkish Airlines 213, 227
Turkish Historical Society 278n.41, 283n.24
Turkish Language Society 278n.41
Turkish Radio and Television Corporation 119–20
Türkiye İş Bankası (İşbank) 190
Tüten Apartment Building 68–9
Tüten, Sabri 68

Üçler Apartment Building 63
Ukraine 228
Ülgen, Ali Saim 283n.24
Ümraniye 157, 184, 232
UNESCO 217
Uniform Penny Post 10
Unité d'habitation (Marseilles) 98, 106, 109
United Kingdom 10, 269n.2 (*see also* Britain)
United Nations Human Settlement Program (UN-HABITAT) award 196
United States of America 4, 38, 54, 81, 90, 95–9, 123, 143, 178, 269n.2, 273n.26, 280n.58, 294n.37, 301n.6
University of Pennsylvania 95
Unkapanı 127–8, 187
 in Menderes' redevelopment 92
 in Prost's plans 57
Ünsal, Behçet 282n.17, 283n.24
Uran, Fatin 133, 189

Üsküdar 271n.14
 in the 1970s and 1980s 148, 158
 in AK Party years 252, 267
 in Dalan's term 165, 169–70, 184
 in late Ottoman period 32, 34, 272n.18
 in Prost's plans 55
 after World War II 105
Üstündağ, Muhittin 49, 55
Usul-i Mimari-I Osmani 17, 19–20, 272n.22
Uysal, Nahid 82

Vak'a-i Hayriye (Benevolent Event) 283n.26
Vakıfbank 213, 222
Valens Aqueducts 127–8
Vallaury, Alexandre 24–6, 33–4
Valle, Gino 291n.31
Varlık Vergisi (Capital Levy) 135, 280n.57
Varyap 232
Varyap Meridian 232–3
Vatan Street 92–3
Vedat Bey 33, 37–8, 41, 50–1, 76
Velioğlu, Selim 208
Vienna
 1873 Exposition 17
 Ottoman ambassadors sent to 10
 unsuccessful siege of 1689 270n.7
Vietti-Violi, Paolo 82
Villa Medici in Rome 55
Villa Savoye 139
Viollet-le-duc, Eugène 17
Virlogeux, Michel 225
Vlora Han 27
Voroshilov, Kliment 50

Wagner, Martin 277n.27, 285n.48
Washington DC 10, 155
Weber, Brigitte 240
Weinberg, Sigmund 270n.6
West Point Military Academy 95
White Émigrés 277n.26
Wild, M. 162

Index

World Bank 155, 162, 213
World Health Organisation 162
World War I 33, 40, 43, 45–6, 48–9, 74
World War II 4–5, 56, 60, 64, 70, 80, 82, 95, 104–5, 110, 121, 123, 149, 238, 280n.55 and n.57, 286n.12
Wright, Frank Lloyd 127

Xerxes 138

Yahya Kemal (Beyatlı) 68, 90
Yamasaki, Minoru 177
Yapı 194
Yapı Fuarı (Building Fair) 156
Yapı Kredi Plaza 177, 208, 294n.37
Yassıada Trials 184, 283n.25, 284n.26, 292n.5
Yaubyan, Nişan 177
Yavuz Sultan Selim Bridge 225–6
Yeang, Ken 221
Yedikule 162, 270n.4, 283n.19
Yenen, Mithat 282n.17
Yener, Alaettin 290n.14

Yeni Mosque 57
Yenikapı
 in AK Party period 217, 219, 296n.19 and n.20
 in late Ottoman era 43, 55, 275n.48
Yenikapı Miting ve Gösteri Alanı (Yenikapı Meeting and Performance Area) 224, 261–3, 297n.30
Yeşilköy 101–2, 158
Yeşilköy Airport 171, 291n.37 (*see also* Atatürk Airport)
Yiğit, Korkmaz 202
Yıldız Palace 23, 27, 176, 270n.6
Yıldız Park 189
Yücel, Nihad 82
Yürekli, Hülya 209

Zeyrek 127–8
Zeytinburnu 82, 121
Zincirlikuyu 135–6, 208, 248, 250
Zıpçı, Rana 101
Ziraat Bank headquarters 222
Zorlu Centre 248–50, 299n.48

www.ingramcontent.com/pod-product-compliance
Lightning Source LLC
Chambersburg PA
CBHW072121290426
44111CB00012B/1734